D0001903

Passport Photos

R
~~179~~
1060

The publisher gratefully acknowledges the generous contribution to this book provided by the General Endowment Fund of the Associates of the University of California Press.

Amitava Kumar

Passport Photos

University of California Press *Berkeley Los Angeles London*

University of California Press
Berkeley and Los Angeles, California

University of California Press, Ltd.
London, England

© 2000 by the Regents of the University of
California

All photographs by the author.

Library of Congress Cataloging-in-Publication Data

Kumar, Amitava, 1963–
Passport photos / Amitava Kumar.
p. cm.
Includes bibliographical references and index.
ISBN 0-520-21816-7 (alk. paper).
ISBN 0-520-21817-5 (pbk.: alk. paper)
1. East Indian Americans—Social conditions.
2. Immigrants—United States—Social conditions.
3. East Indian Americans—Ethnic identity. 4. East
Indian Americans—Race identity. 5. Kumar,
Amitava, 1963– . 6. United States—Social
conditions—1980– . 7. India—Social conditions—
1947– . I. Title.
E184.E2K86 2000
305.8914073—dc21 99-31257
 CIP

Manufactured in the United States of America

08 07 06 05 04 03 02 01 00 99
10 9 8 7 6 5 4 3 2 1

The very process of constructing a narrative for oneself—of telling a story—imposes a certain linearity and coherence that is never entirely there. But that is the lesson, perhaps, especially for us immigrants and migrants: i.e., that home, community and identity all fall somewhere between the histories and experiences we inherit and the political choices we make through alliances, solidarities and friendships.

Chandra Talpade Mohanty

Contents

The passport that you hold in your hand as you approach the immigration officer has a purpose and coherence that is governed by its own rules. The passport chooses to tell its story about you. Is that story one of your own making? Can it ever be?

This book is a forged passport. It is an act of fabrication against the language of government agencies. If anything, it will help you enter only the zones of a particular imagination. The information provided here is very different from—and even opposed to—that which is demanded by the state and, for that matter, the traditional academy.

Most of this book took shape while the author, holding an Indian passport, was in the United States as a "foreign worker" in the H-1B category. This work is an attempt to understand and speak about the immigrant condition in an undeniably personal and political way.

Starting in 1830 Indian workers, mostly Sikhs, arrived on the western coast of North America; by 1910 there were thirty thousand Indian immigrants in the region between Vancouver and San Francisco. Taking their name from the *ghadar* or "rebellion" against the British in 1857, the struggle that came to be recognized as the First War of Indian Independence, some of these immigrants organized themselves under the banner of what they called the Hindustan Ghadar Party. Their goal was to overthrow the British rule in India, and every member of the party was "duty bound to take part in the struggle against slavery no matter where in the world it is taking place." In 1914 thousands had even returned home to Punjab to participate in a nationalist uprising. By contrast, contemporary Indian immigrants to the U.S. have shown very few signs of progressive large-scale mobilization. In fact, they have often been guilty of supporting deplorable practices in present-day India. Witness the contribution of gold bricks and funds from the United States and the United Kingdom to the fundamentalist campaign to build a Hindu temple where

a Muslim mosque stood till its demolition by mobs of zealots in the North Indian town of Ayodhya.

This book is an attempt to define aspects of what I have heard being called "immigritude." It joins others in the search for a new poetics and politics of diasporic protest. This is not a paean to the "model minority" status of Indian engineers and doctors in this country; nor is it a literary critic's celebration of the well-known successes of a handful of writers of Indian origin. Instead, this book asks: at what cost is this privileged status being celebrated? And at whose—or what—expense is this success being assumed? Suggesting the trajectory of my questions, the web page of a San Francisco-based performance group sets out its objectives in the following terms: "*Chaat* organizers revel in defying the docile Indian American penchant for middle-class nirvana. . . . The Indian American community prides itself on its success, but its narrow-minded fixation on the prerequisites of middle-class life have robbed the community of a narrative voice that can provide a much-needed mirror to its soul."

The author is an assistant professor in the English department at the University of Florida. In the current study of the humanities, "border crossing" is a popular metaphor. A literature professor decides to be an anthropologist for a day, a U.S. economist mixes an analysis of the World Bank–International Monetary Fund policies in Africa with a hip reading of the films of Ousmane Sembene, a musicologist comments on Beethoven by referencing heavy-metal music in late twentieth-century America.

Passport Photos provides a response to these practices, which are legitimate but somewhat lacking, by working in two different directions. On the one hand, it returns the metaphor of the border to the material reality of barbed-wire fences, entrenched prejudices, and powerful economic interests that regulate the flow of human bodies across national boundaries. On the other, it argues for a refinement of the metaphor. It suggests that disciplinary transgressions of the border remain merely that: genuine, transformative shifts will require the creation of new assemblages not only of forms but also of readers and, in a word, of communities.

Passport Photos is not an argument for or against immigration. Instead, it is a report on postcolonialism. Or, to be more precise, an expatriate Indian writer-teacher's response to a set of current pressing concerns in two nations and one world. In other words, a way of dealing, in a divided way, with what I want to call the "there and now" of history. At home in neither one discipline nor in one country, this book stakes its claims to citizenship in a variety of places—or perhaps in none.

The borders this book crosses again and again are also those where

academic critical theory meets popular journalism, and political poetry encounters the work of documentary photography. The argument for such border crossings lies ultimately in the reality of people's lives and experiences. Immigrants do not travel in one language alone. But I need not lay claim to goals of inventing hybrid tongues and sophisticated modes of address. The mixed nature of my presentation in this book has a fairly simple goal. To try, in different ways, to restore a certain weight of experience, a stubborn density, a *life* to what we encounter in newspaper columns as abstract, often faceless, figures without histories. And, having done that, to *then* remark on the limits of even that act.

Forgeries work only when they recall what is accepted as real. This book mimics the presentation of information about an individual in the pages of a passport: Name, Place of Birth, Date of Birth . . . Its forgery is most apparent in places where the information does not fit on the dotted line. Where the individual takes on the shape of a collective. Where the category, as with the question of nationality, splits. Where the answers beg only more questions. Where the rich ambiguities of a personal or cultural history perhaps resist a plain reply or, in still other cases, demand a complex though unequivocal response.

Passport Photos is marked by an event. In 1997–98 we celebrated the fiftieth anniversary year of Indian independence from British rule. This occasion by itself has forced me to make sense of the distance between India and the U.S., and my own place between them, in a personal way.

During the course of this past year, one small thought has recurred in my mind. I do not know whether it is a feeling common among expatriate writers living in lands where they speak other languages, but I want to grapple in a material way with the fact that while we have been away there are new words being minted on the streets of our native cities. But even as I write these words, I check myself. "Minted" betrays a fantasy of newness and, of course, unending wealth. There is very little happening in India today that would prompt such optimism about new words.

A report on Bombay, now called Mumbai, in a special issue of a magazine published to commemorate India's fifty years, mentions a word— "powertoni"—that the article's writer encountered during his conversation with members of the right-wing Hindu group, the Shiv Sena. We come across this word after reading the stories that the three SS workers tell the visiting journalist about the Hindu-Muslim riots in Mumbai.

The writer had asked one of the members, "What does a man look like when he's on fire?" The answer had come in a matter-of-fact manner. "A man on fire gets up, falls, runs for his life, falls, gets up, runs. It

is horror. Oil drips from his body, his eyes become huge, huge, the white shows, white, white . . ."

When asked about how they can murder with impunity, they respond: "The ministers are ours. . . . If anything happens to me, the minister calls. . . . We have *powertoni.*" The interviewer realizes suddenly that this seemingly incomprehensible word is a contraction of the term "power of attorney" and here refers to "the ability to act on someone else's behalf" or to kill people, minorities, trade unionists, Communists under a system of extra-legal protection.

As I contemplate the new words, rather, the new distorted realities, that are being born on the streets of the cities in India, I begin to question the fantasy of impotence that might lie behind my interest in language. The preoccupation with fragmentary words, especially against the backdrop of the absence of wider social connections, seems to presume that postcolonial identities form and march only under the banner of innovations in writing. And in making that assumption I am only mimicking the defunct role of the exiled Western modernist writer. Even the cruel fate of Salman Rushdie takes on the appearance of a Third-World parody of that First-World farce. What alternatives, then, do I have?

In this note, written as a travel warning, the question of words and silences and loneliness takes me back to the term I started with: *ghadar,* or "rebellion, revolt." Those immigrants who formed the Ghadar Party in 1913 were not simply registering a victory against the racism reflected in a 1910 U.S. immigration commission report that Indians were almost "universally regarded as the least desirable race of immigrants thus far admitted to the United States." Rather, they were part of a well organized diasporic effort to combat imperialism in India.

"To forge" has among its meanings the sense of "forming, making, shaping." In the heat of history, solidarities take shape. In an act of historical appropriation, the Forum of Indian Leftists launches *Ghadar* in 1997, linking its North American newsletter to the Ghadar Party. The past thereby becomes a post. Workers Awaaz organizes low-wage South Asian immigrant workers in New York City, bringing Calcutta and Chittagong closer in Queens. The home meets the world in a college classroom devoted to postcolonial theory. This too is not without its ironies. As a teacher, I find myself discussing the poetry of insurgency in India with affluent American students when the people for whom it was written are illiterate and, hence, unable to read.

A documentary film, *New World Border,* begins with this press release from the offices of the Immigration and Naturalization Service: "The

1997 INS budget allocates $3.1 billion for its activities, including more than $400 million for border control and the addition of 1,000 new border patrol agents and automated surveillance technology."

The transformation of the U.S.-Mexican border into a high-tech, highly militarized, low-intensity war zone demands a public discussion on immigration that has not yet taken place in this country. There have been occasions for fierce editorializing. For example, the fulminations of the presidential candidate Pat Buchanan, or the passage of Proposition 187 in California, which denies social services and medical aid to undocumented immigrants. Yet the American public remains either unaware of, or simply uninterested in, the kind of argument put forward by Nikki Fortunato Bas of the Political Ecology Group when interviewed for *New World Border*: "In terms of immigration, I think one of the things people aren't really grasping is that the U.S. plays a really large role in forcing people into migration. You know, NAFTA alone has displaced, I think, 300,000 Mexican farm-workers. The GATT has also played a role in destabilizing local economies and forcing people into migration. So, when the U.S. starts scapegoating immigrants for our problems, they have to really look and see what is driving people to come to this country."

What are the links between the shift of U.S. industries into the *maquiladoras* of Mexico and the growing impoverishment of the Mexican populace? The huge profits reaped by the U.S. companies, says Ruben Solis of the Southwest Public Workers Union, show that it is the Mexican workers who are in fact subsidizing those industries by taking low wages. "So, who is subsidizing who?" asks Solis. Such subsidizing is taking place even when a worker, legal or illegal, enters the borders. "It takes about $45,000 to raise a child with all the human and social services needed . . . to get them to a productive age. The United States doesn't pay one cent to produce those workers who come [here] and join the workforce. So, they save about $45,000 per worker in social services. Many of those workers pay income tax and social security and they never get that back."

As I write these lines, I hear on the radio that there has been a right-wing rally against foreigners in Germany. Not a week passes, the reporter on National Public Radio tells us, without an attack on immigrants there. We have been reading similar reports from France. An Indian newspaper brings news of attacks on Indian doctors by skinheads in Russia. In the U.S., the stories of brutality against immigrants, whether from the Mexican border or the sweatshops in New York or California, are not as unremitting or overwhelming only because they focus the dominant

culture's deepest fears and rage on the African American rather than the foreigner.

I gather together these stories and images in the hope that my students, and also perhaps other readers of this book, when faced with passport photos that fix identities, will search for other stories. Where identikit images diminish histories and trap us in narrow accounts, I would want these readers to supply different, proliferating narratives. Although this book is not about any of them, that image *could* be of a young African American male on an unfamiliar street, a child with Down's Syndrome at the next table in the restaurant, a young woman alone in a bar, or a foreigner asking for directions. It could also be an illegal immigrant. I would like the reader to allow, as Richard Rodriguez does, that "illegals are an outrage to suburbanites in San Diego who each night see the Third World running through their rose garden." And, at the same time, I would like them to insist, as Rodriguez also does when he writes, that "before professors in business schools were talking about global economics, illegals knew all about it. . . . The illegal immigrant is the bravest among us. The most modern among us. The prophet. . . . The peasant knows the reality of our world decades before the Californian suburbanite will ever get the point."

Passport Photos

Introduction **The Shame of Arrival**

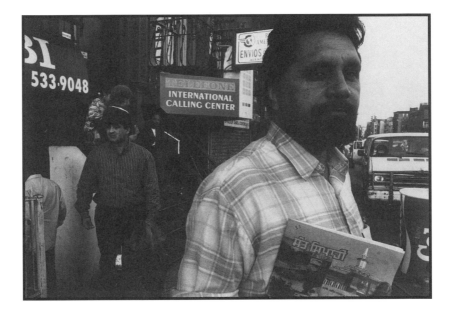

A book is a kind of passport.

Salman Rushdie

If it can be allowed that the passport is a kind of book, then the immigration officer, holding a passport in his hand, is also a reader. Like someone in a library or even, in the course of a pleasant afternoon, on a bench beneath a tree. Under the fluorescent lights, he reads the entries made in an unfamiliar hand under categories that are all too familiar. He examines the seals, the stamps, and the signatures on them.

He looks up. He reads the immigrant's responses to his questions, the clothes, the accent. The officer's eyes return to the passport. He appears to be reading it more carefully. He frowns. Suddenly he turns around and tries to catch a colleague's eye. It is nothing, he wants more coffee.

You notice all this if you are an immigrant.

Let us for a moment pretend you are not. Imagine you are drinking your coffee in the café close to your place of work. You notice that the woman who is picking up the cups and then stooping to wipe the floor is someone you have never seen before. She is dark but dressed cleanly in the gray and pink uniform of the employees here. You smile at her and ask if you could please have some more cream. She looks at you but doesn't seem to understand you. You realize she doesn't speak English. Oddly, or perhaps not so oddly, the first thought that crosses your mind is that she is an illegal immigrant in your country. But you don't say anything, you get up and ask someone else for the cream. You smile at her, as if to say, See, nothing to be afraid of here. She probably doesn't smile back. It might or might not occur to you that she doesn't know how to read your smile.

Standing in front of the immigration officer, the new arrival from Somalia, El Salvador, or Bangladesh is also a reader. When looking at the American in the café who addresses her—asking her, perhaps, if she wants to have coffee with him—the immigrant reads an unwelcome threat.

If we allow that the passport is a kind of book, we might see the immigrant as a very different kind of reader than the officer seated at his desk with a gleaming badge on his uniform. The immigrant's reading of that book refers to an outside world that is more real. The officer is paid to make a connection only between the book and the person standing in front of him.

The immigrant has a scar on his forehead at the very place his passport says that he does. For the officer this probably means that the man is not a fraud. For the immigrant, that scar is a reminder of his childhood friend in the village, the one whose younger sister he married last May. Or it is

likely he doesn't even notice the officer's glance. He is conscious only of a dark weariness behind his eyes because he has not slept for three days.

The officer reads the name of the new arrival's place of birth. He has never heard of it. The immigrant has spent all of the thirty-one years of his life in that village. This difference in itself is quite ordinary. But for some reason that he does not understand, the immigrant is filled with shame.

My attempt, as an immigrant writer, to describe that shame is a part of a historical process.

Part of that process is the history of decolonization and the presence, through migration, of formerly colonized populations in the metropolitan centers of the West. What has accompanied this demographic change is the arrival of writers and intellectuals from, say, India or Pakistan, who are giving voice to experiences and identities that Western readers do not encounter in the writings of Saul Bellow or John Updike.

But a crucial part of this narrative and its self-interrogation is the emergence of the discipline that can loosely be called postcolonial studies. Based most prominently in literary and cultural studies, but often engaged in conversations with older projects in the disciplines of history or anthropology, postcolonial scholars have made their task the study of the politics of representing the Other. This has meant, to put it in very reductive terms, not simply that there are more of those people speaking and writing today who are a part of the populations that were formerly solely the object of study by Europeans; it also has meant that a fundamental questioning of the privilege and politics of knowledge has made any representation problematic. There is now no escaping the questions "who is speaking here, and who is being silenced?"

A recent book by an anthropologist, T. M. Luhrmann's *The Good Parsi*, notes these two aspects, though its general discourse holds the hint of a reluctance to accept the wide-ranging implications of these changes for anthropology, a discipline that had been, after all, given shape within the broader history of imperialistic control of other societies:

> Throughout the human and social sciences, in the writing of fiction and history and music, there is anger about those who speak for others. In the academy women are hired to teach about women, African-Americans are hired to teach about African-Americans. Hispanics about Hispanics. Names like Prakash, Suleri, Mani, Bhabha, not to mention Appadurai, Narayan, Tambiah, Obeyesekere, now dominate where names like Cohn, Singer, Bailey, and Dumont once held sway. Gayatri Spivak denounces the principle that only

like can speak on like; knowledge, she says, emerges through difference. But her answer to the question "can men theorize feminism, can whites theorize racism, can the bourgeois theorize revolution?" is "yes but": "it is crucial that members of these groups must be kept vigilant about their assigned subject positions . . ." Her "must be kept vigilant" is ambiguous but has an ominous ring.

It would be a truism to state that these changes are not purely academic. Indeed, even in the more everyday world of travel, the writer who registers outrage or shame is different from the one of the days of yore. This difference is clear even when the one who has taken the place of the imperial traveler is a writer like V. S. Naipaul—renamed "V. S. Nightfall" by the Caribbean poet Derek Walcott—whose often contemptuous espousal of the bourgeois Euro-American viewpoint has been severely critiqued by numerous writers. In Naipaul's narrative, exceeding his expression of personal anger or shame in his last book on India is the attempt to delineate the silence of those who have suffered under—and, in fact, have been erased by—the sentence of imperial history.

In *India: A Million Mutinies Now,* Naipaul recounts the experience of reading in the Indian city of Lucknow a book by William Howard Russell, a British correspondent for the *Times.* The book is entitled *My Diary in India in the Year 1858–59.* Written during the Indian Mutiny, the book reeks of death and plunder. Among the details of the burning bodies of the sepoys in their cotton tunics are the retellings of the looting at the hands of the British soldiers. From the sacking of Kaiserbagh in Lucknow, Russell himself got a piece of the loot ("a nose-ring of small rubies and pearls, with a single stone diamond drop"), though he lost the chance of acquiring an armlet of emeralds and diamonds and pearls because he did not have on his person the 100 rupees in ready cash demanded by a soldier ("Russell's money was with his Indian Christian servant," and he "heard later that a jeweller . . . had bought the armlet from an officer for £7,500"). Naipaul writes that these details "enraged" his Indian companion, Rashid, an inhabitant of Lucknow. But Naipaul also notices that Rashid and he are not identical readers of the historical text: they are positioned in different historics. Russell's book delivers divergent tales to its two present-day readers.

Russell had described Lucknow before its destruction as "more extensive than Paris and more brilliant. . . . Not Rome, not Athens, not Constantinople, not any city I have ever seen appears to me so striking and beautiful as this." Today, in the place of the gardens of the past, are

hotel buildings and the embankments shared by black buffalo and the colored garments laid out to dry. When Naipaul distinguishes Rashid's nostalgia and pain from his own, he identifies with those who, rather than being displaced from their moment of glory, actually passed from a kind of silent ignominy to unnoticed oblivion:

> Rashid grieved for the wholeness of the Lucknow world he had been born into, the world before partition. This world would have had elements of old Muslim glory: the glory of the Kings or Nawabs of Oude, and before them the glory of the Moguls. There was no such glory in my past. Russell's journey from Calcutta to Lucknow lay in part through the districts from which, about 20 to 25 years later, my ancestors migrated to Trinidad, to work on the plantations there.

The India that forms the core of Naipaul's concern is described by him as "the lesser India." This was the India "only glancingly referred to, [and] always assumed." Those who made up the lesser India "went on working during this time of war, working in the fields, constructing fortifications, clearing away corpses, looking for positions as servants: an India engaged without ever knowing it, in subduing itself."

I do not want to see in that kind of unknowing the definite traces of the barely explicable shame that I attributed to the immigrant face-to-face with the customs officer. But I do want to posit as one of the concerns of postcolonial writers the desire to address in their writing, and not without a measure of self-reflexivity, instead of the pride of the victors, the less readily readable structure of feeling of those who did not deliver commands to history. Here I echo, with the distortion implicit in all echoes, Ashis Nandy's question to modern Indians who have mimicked the imperialist's respect for the martial Indians but not the "effeminate" ones: "Why have they felt proud of those who fought and lost, and not of those who lost out and fought?"

I was living in a part of Brooklyn populated by Arab migrants when the Oklahoma City bombing in April 1995 provided the U.S. media an occasion to point all its accusing fingers at "Middle Eastern terrorists." While "experts" provided biased and also baseless opinion (the one at CNN averred, "It's clear, I think, that there must almost certainly have been a foreign origin to this, and probably one in the Middle East, although, of course, I have no facts to confirm that yet"), Arabs were conspicuously absent from the media panels on the bombing. (An enterprising

ABC reporter decided to correct this imbalance by interviewing a British citizen who spoke of the effects of an IRA bombing threat: "Loss of innocence, loss of flexibility, loss of comfort, loss of trust more than anything else." Loss of trust in what, I wondered. In the fighting machine called the British security system? Or, by any leap of imagination, in the prejudice preserved as faith that the Irish are either getting drunk in bars or blowing them up?)

A few days after the Oklahoma bombing, I walked into a store near my apartment to buy bread. The Yemeni store owner had pasted on the wall behind him a photograph from a recent front page of the *New York Times*. The photograph showed Hillary Rodham Clinton and her daughter, Chelsea, smiling, seated together in front of the Taj Mahal in Agra, India. I asked the Yemeni man why he had pasted up that picture. He began to answer me: "I wanted to show how proud people feel when they're not Muslim . . ." Then his voice choked with emotion, anger overwhelmed him, and he stopped. He fell silent.

What was he trying to tell me? That the Taj, which could of course be described as an example of Islamic architecture, was here being appreciated by folks who didn't hesitate to kill a million Muslims in Iraq? I cannot say for sure. But whatever name we give to that emotion, I could see that it was a pain mixed with rage that made the store owner silent. Maybe it was the fact that the women in the photograph, sitting in front of a mausoleum and with a mosque to the left, looked so happy? And so very different from that pregnant Arab woman who, hiding alone in her bathroom, suffered a miscarriage because a mob in a midwestern American town surrounded and threw stones at her home? All because someone of her faith had been quickly assumed to be the one who had planted the bomb in Oklahoma City?

To conduct postcolonial studies in the American imperium we should be able to take note of, sometimes even to question, but nevertheless *to take seriously* the rage that makes an immigrant speak and, on occasion, turn to silence. (Or, as in the case of Colin Ferguson, the gunman on the Long Island Railroad, to killing.) In that case, what Nandy says of a necessary reading of colonial history also holds true for the postcolonial one: "While the economic, political and moral results of colonialism have been discussed, its emotional and cognitive costs have been ignored. And as Freud reminds us in this century, what we choose to forget has a tendency to come back to haunt us in 'history.'"

Let me return then to the image of shame. The figure of abjection I choose

is again the surrogate Other, the writer-intellectual, a reader of the post-colonial condition, projecting on the screen of history a sense of the Self.

V. S. Nightfall is perhaps not inapt as a name or a description because there is a sense in which the Caribbean writer's presentation of the post-colonial realities is never quite able to extricate itself from the darkness.

Even in *India: A Million Mutinies Now,* where we get a "kinder, gentler Naipaul" (the phrase is Rob Nixon's), the depression, this time born supposedly out of empathy rather than repulsion, casts its tall shadows. "It is hard for an Indian not to feel humiliated by Russell's book," writes Naipaul after he finally finishes reading *My Diary in India in the Year 1858–59.* What brings on this sorrow for the modern-day travel writer retracing the steps of the imperial traveler is the realization that during the years of the revolt there were Indians who were utterly without an idea of a wider fellowship:

> Just days away from the comfort of Calcutta, he [Russell] is among people to whom the wider world is unknown; who are without the means of understanding this world; people who after centuries of foreign invasions still cannot protect or defend themselves; people who—Pandy or Sikh, porter or camp-following Hindu merchant—run with high delight to aid the foreigner to overcome his brethren. That idea of "brethren"—an idea so simple to Russell that the word is used by him with clear irony—is very far from the people to whom he applies it.

To compound his sense of distress, Naipaul—here identifying himself it would seem as an Indian—writes that the "ambiguity" that the Indian must experience is a part of that feeling of humiliation. After all, had it not been for British rule and the changes it introduced through its institutions of learning, commerce, and government, Indians would not have acquired "a larger idea of human association . . . the ideas of country and pride and historical self-analysis."

Pride? If pride was indeed acquired by the Indians, even if we believe Naipaul's story, why does his prose still remain so abject? But that is hardly even the main issue. The scandal of this experience of shame is that it has no sense of irony. To begin with, Naipaul identifies himself with the British traveler and feels the whiplash of the latter's appraisal. Not for a single moment does his ahistorical self-analysis ever admit another reader of the colonial text. Thus bereft of the presence of the colonized as sentient beings, our writer feels utterly secure in construing the indigenous subject as empty of will, stratagems, subterfuge, or even innocence. Ignorant— if not also disinterested—in the articulations and agency of the subaltern

colonized subject, our postcolonial writer takes the unsurprising step of welcoming, in the very next paragraph, the imperial conqueror.

Disgusted as Naipaul is by the spectacle recorded by Russell, Indians "run[ning] with high delight" on the road behind the invading army, he remains insensitive to the ironical fact that he himself has no trouble in following, with great enthusiasm, the British on their civilizing mission. Naipaul congratulates the British for their success at building roads, railways, and, of course, instilling among Indians a sense of country, pride, and historical self-analysis. It becomes clear that when he castigates Indians for their ambiguous responses to the British, the imagined Indian is only an imaginary figure on whose body our writer can peg his own ambivalence. And so it is that what I had earlier called an interest in illuminating the darkness created by colonialism turns out, in the end, to be nothing more than a brandishing of the lamp of Enlightenment, with a bit of pathos thrown in.

Naipaul's brief excavation of history is also an example of what historians have called "elite historiography." It remains self-satisfied in its dismissive writing-out of those subjects of history whose narratives are not congruent with either the imperial history or the history written by the nationalist leadership. It is hardly surprising that a few pages after his paean to Russell, Naipaul is providing an eager ear to an Indian man in his seventies who declares that "Gandhi made us a nation. We were like rats. He made men out of us." (As Bertolt Brecht would say: "Caesar beat the Gauls. Was there not even a cook in his army?") In this deification of Gandhi, and its rapid suppression of what Shahid Amin calls the "many-sided response of the masses to current events and their cultural, moral and political concerns," we witness the repetition of the same reading code: history being given shape by the unified and singular subject, first the British, and then the Indian leadership intellectually formed by the British and, hence, very nearly identical to it. What falls out of the equation completely is precisely what Naipaul had earlier called "the lesser India."

The emotion that Naipaul experiences takes lucid form here, and, certainly, the sense of humiliation he betrays is sincere. Yet he is a bad reader of history. His model reader is still the one who is reading over the shoulder of the imperialist *and in his language*. The shame that he claims to see in the Indian is a generalization from his own specific class- and culture-based sense of inferiority against a victorious political and ideological system that now claims him as one of its own. (Or so our writer would like to believe.)

I need to revisit and revise the scene at the customs desk. The new arrival responds to the questions asked by the immigration officer. The postcolonial writer, male, middle-class, skilled in the uses of English, is standing nearby and wants to follow the exchange between the officer and the immigrant. Perhaps he wants to help, perhaps he is interested in this conversation only for professional reasons (or both). But for some reason that he does not understand, that he *cannot* understand, the writer is filled with shame.

The postcolonial writers who are read in the West are mostly migrants. They have traveled to the cities of the West—often for economic reasons, and sometimes for political ones, though it could be argued, of course, that all economic reasons are political too—and in the books they write they undertake more travels.

What makes even a figure like Naipaul engaging for me is that—perhaps because of what he calls his "depressive's exaggeration, or a faraway colonial's exaggeration"—his writing retains the intense appraisal of emotional costs that analysts like Nandy have found missing from studies of the colonial experience. (Of course, I've also been arguing that in Naipaul's case this engagement turns out to mask an identification with the victorious West or with the West as victor.) And it is precisely where the postcolonial writers make their own experiences as migrants and travelers intersect with and reflect on a broader, shared condition of displacement and loss—"the migrant is, perhaps, the central or defining figure of the twentieth century"—that their writing reaches its finest critical potential. It is also, inevitably, precisely at those points that it reveals its limits.

In Amitav Ghosh's *In An Antique Land,* the writer is a young Indian student in rural Egypt doing research in social anthropology. The book follows Ghosh's archival search for a twelfth-century relationship between a Middle Eastern Jewish trader in India, Abraham Ben Yiju, and his toddy-drinking Indian slave, Bomma. These details are interwoven with the more contemporary relationship that develops between the Indian intellectual and the friends he makes in the Egyptian villages not too far from the Cairo synagogue where for a very long time the papers of Ben Yiju were housed.

Ghosh was only twenty-two when he traveled in 1980 to Egypt. One day, while making tea for two young men in his rented room in the village, he is caught short by an observation made by one of his visitors,

Nabeel: "It must make you think of all the people you left at home . . . when you put that kettle on the stove with just enough water for yourself."

This comment, Ghosh notes, stayed in his mind. "I was never able to forget it, for it was the first time that anyone in Lataifa or Nashawy had attempted an enterprise similar to mine—to enter my imagination and look at my situation as it might appear to me." Ghosh, the traveler, appreciates the travel undertaken by his friend, Nabeel, in his imagination. That effort brings Nabeel closer to that place where Ghosh himself has traveled—which is not so much Egypt as much as a place away from home, or from that which could be called the familiar. To be where one is not, or where one is not expected to be, and sometimes not even welcome . . . to travel to that place and write about it becomes the credo of the postcolonial writer.

This movement is not always possible. People are held down where they are, or there are intransigent barriers between them. A shared language is an impossibility. In one of the episodes that Ghosh describes with instructive wit, some older Egyptian men at a wedding in the village want to know what is done with the dead in India, whether it is really true that they are cremated, and whether women are "purified" ("you mean you let the clitoris just grow and grow?"), and boys, are they not "purified" either, and you, doctor, are you? Our writer is unable to respond and flees the scene. The trauma of a childhood memory merges with a shared trauma of a public memory and ties his tongue. Ghosh broods over memories of Hindu-Muslim riots in the Indian subcontinent (present in the narrative of his earlier novel *The Shadow Lines*):

> The stories of those riots are always the same: tales that grow out of an explosive barrier of symbols—of cities going up in flames because of a cow found dead in a temple or a pig in a mosque; of people killed for wearing a lungi or a dhoti, depending on where they find themselves; of women disembowelled for wearing veils or vermilion, of men dismembered for the state of their foreskins.
>
> But I was never able to explain very much of this to Nabeel or anyone else in Nashawy. The fact was that despite the occasional storms and turbulence their country had seen, despite even the wars that some of them had fought in, theirs was a world that was far gentler, far less violent, very much more humane and innocent than mine.
>
> I could not have expected them to understand an Indian's terror of symbols.

The name that Ghosh gives to the reality—or, at least, the possibility—of travel and historical understanding is "a world of accommodation."

When the young writer and a village Imam get into a fight about the West and its advanced status in terms of "guns and tanks and bombs," and then both make claims about India's and Egypt's respective prowess in this regard, Ghosh confesses that he feels crushed because their heated exchange has most indelibly announced an end to that world of accommodation:

> [I]t seemed to me that the Imam and I had participated in our own final defeat, in the dissolution of the centuries of dialogue that had linked us: we had demonstrated the irreversible triumph of the language that has usurped all the others in which people once discussed their differences. We had acknowledged that it was no longer possible to speak, as Ben Yiju or his Slave, or any of the thousands of travellers who had crossed the Indian Ocean in the Middle Ages might have done.

But the postcolonial writer need not blame himself here. It is not his debate with the Imam but the might of U.S. armed forces supported by most of the Western nations that rubs out, at the end of Ghosh's narrative, his friend Nabeel—lost among the countless migrant workers in Iraq from countries like Egypt and India, displaced in the desert because of the sudden onset of the Persian Gulf War.

In this scenario, the immigrant does not ever appear before the customs officer in the airport of a Western metropolis. As driver, carpenter, servant, or nanny, the immigrant from countries of South and South-East Asia provides service in the Gulf states of the Middle East and Libya. In some of their cases the passport is a missing book.

Lacking proper documents, and much more vulnerable to exploitation and abuse, those immigrants are given the name "contract labor" in the zones of shifting, global capital. In the 1950s and 1960s U.S. capital first attracted foreign labor in the Middle East and today, benefiting from investments of the rentier oil-rich Arab states, still profits from the labor of migrants. And when Western capital's profits were threatened, it was the lives of such migrants, and not only those who were employed in Iraq, that the Gulf War threw into devastating crisis. The postcolonial writer speaking of the migrant worker during the war is doing something rather simple. He is reminding us that the man who said to the foreign visitor in his room one evening, "It must make you think of all the people you left at home . . . when you put that kettle on the stove with just enough water for yourself," is alone now in a distant city threatened with destruction. And that man, when not seen in the footage of the epic exodus shown on television, is then assumed to have "vanished into the anonymity of History."

. . .

The migrant laborer might have "vanished into the anonymity of History," but the postcolonial writer clearly has not. By presenting those contrasting conditions, I am making a statement here about class, but besides that fairly obvious fact, what do I say about *writing*?

To ask a question about writing, especially postcolonial writing, perhaps we need to reverse our reading of the passport as a book and, instead, examine the formulation put forward by Rushdie, "A book is a kind of passport." Rushdie's point is on surface a fairly general one. For aspiring writers—"would-be migrants from the World to the Book"— certain books provide permission to travel. Recounting the history of his own formation, Rushdie pays homage, among others, to Günter Grass's *Tin Drum*. Grass's great novel, Rushdie writes, served as a passport to the world of writing. But even when writing of the book as a passport in a *metaphorical* sense, Rushdie is writing about a book—*The Tin Drum*—that is in a *specific* way about migrancy and a migrant's sense of place and language.

That is not a universal trait among writers. The trope of migrancy does not exist as a material fact, in either a metaphorical or literal sense, in the writings of Norman Mailer or John Grisham. But it emerges as an obsession in the pages of a writer like Rushdie. For him, in fact, "the very word *metaphor*, with its roots in the Greek words for *bearing across*, describes a sort of migration, the migration of ideas into images." Rather than oppose the metaphorical to the literal, it is the idea of the metaphorical itself that Rushdie renders literal and equates with a universal condition: "Migrants—borne-across humans—are metaphorical beings in their very essence; and migration, seen as a metaphor, is everywhere around us. We all cross frontiers; in that sense, we are all migrant peoples."

There is a danger here in migrancy becoming everything and nothing. Aijaz Ahmad points out that exile is a particular fetish of European High Modernism and in Rushdie's case becomes simply ontological rootlessness. And, Ahmad argues, novels like *Shame* display a form of "unbelonging" and an absence of any "existing community of praxis." If we agree with Ahmad and see the obsessive celebration of migrancy in Rushdie as a mere repetition of the desolation experienced by the modernist writer in exile, we might also sense that the inexplicable shame that permeates the postcolonial writer is only that of being taken as a representative by the West but having no one, in any real sense, to represent.

That is a real, hard-to-shake-off, nagging shame. And what complicates it further is that the writer is aware that while the migrant worker has "vanished into the anonymity of History," the writer himself or herself hasn't. But why has the writer escaped that destiny? We can be reductive and attribute the appeal of a writer like Rushdie or Ghosh only to Western tokenism, and indeed much can be said about the subject even without being reductive. But books written by immigrants or writers of immigrant origins are not merely hollow receptacles for the will of the West. This book that you are holding in your hands has been written in the belief that words matter. Words from an alien language. But also words in a familiar language that attest to different realities: words are our defense against invisibility.

I'd like to imagine the immigration officer as a curious reader of my book. But the officer should not assume that this passport doesn't have any missing pages; indeed, he would be wise to be skeptical even of his own interest. I am reminded of the wary response of Mahasweta Devi, an Indian writer who has earned high recognition for her work among the aboriginal or tribal populations in Bihar and Bengal: "Why should American readers want to know from me about Indian tribals, when they have present-day America? How was it built? Only in the names of places the Native American legacy survives." I take Devi's words as a provocation to present in this book, interspersed with my images from India and other places, the photographs that I have also taken in the United States. (The Other shoots back.) In which case, why only quote Devi? In order to go on with this mapping of a mixed, postcolonial space, I would like to frame these images with a line borrowed from the black hip-hop artist Rakim: "It ain't where you're from, it's where you're at."

This is where I'm at: in the spaces claimed or established by these images. These photographs—please see the notes as well as the list of illustrations for more information on them—detail a different kind of immigrant experience. What these images offer cannot be described as "illustrating" any kind of argument; in the image of a woman holding a rubber Miss Liberty, for example, it is for the viewer to construct a story that binds or divides the three female figures in their distinct moments of emergence as objects or subjects. The recording of the difference that I am calling "immigrant experience" also has partly to do with labor and protest. Hence the images of workers and, in some cases, their organized protest, on the streets of New Delhi and New York City. The accompanying narratives, and oftentimes the photographs themselves, raise the

question about how these images are to be seen. And from where. As a way of announcing that difference, let me offer at the beginning of this book a photograph that sets itself against the photo of the White House taken by the visiting tourist. This is the photograph of the First House from the viewpoint of the homeless sleeping outside its walls one Christmas Eve.

Language

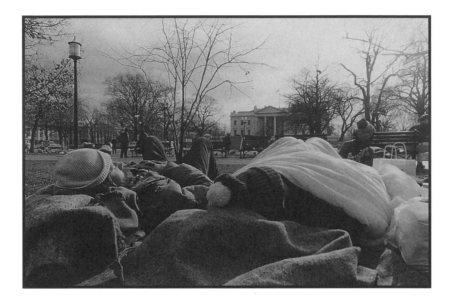

Everytime I think I have forgotten,
I think I have lost the mother tongue,
it blossoms out of my mouth.
Days I try to think in English:
I look up,
paylo kallo kagdo
oodto oodto jai, huhvay jzaday pohchay
ainee chanchma kaeek chay
the crow has something in his beak.

Sujata Bhatt

Name
Place of Birth
Date of Birth
Profession
Nationality
Sex
Identifying Marks

My passport provides no information about my language. It simply presumes I have one.

If the immigration officer asks me a question—his voice, if he's speaking English, deliberately slow, and louder than usual—I do not, of course, expect him to be terribly concerned about the nature of language and its entanglement with the very roots of my being. And yet it is in language that all immigrants are defined and in which we all struggle for an identity. That is how I understand the postcolonial writer's declaration about the use of a language like English that came to us from the colonizer:

> Those of us who do use English do so in spite of our ambiguity towards it, or perhaps because of that, perhaps because we can find in that linguistic struggle a reflection of other struggles taking place in the real world, struggles between the cultures within ourselves and the influences at work upon our societies. To conquer English may be to complete the process of making ourselves free.

I also do not expect the immigration officer to be very aware of the fact that it is in that country called language that immigrants are reviled. I'd like to know what his thoughts were when he first heard the Guns N' Roses song:

> Immigrants
> and faggots
> They make no sense to me
> They come to our country—
> And think they'll do as they please
> Like start some mini-Iran
> Or spread some fuckin' disease.

It is between different words that immigrants must choose to suggest who they are. And if these words, and their meanings, belong to others, then it is in a broken language that we must find refuge. Consider this example.

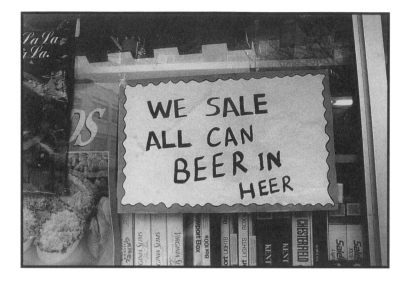

I took this photograph while standing outside an Arab grocery store in Brooklyn. While pressing the shutter I was aware of another grocery store, in the film *Falling Down*, where the following exchange took place between a white American male, played by Michael Douglas, and a Korean grocer:

> MR. LEE: Drink eighty-five cent. You pay or go.
>
> FOSTER: This "fie," I don't understand a "fie." There's a "v" in the word. It's "fie-vah." You don't got "v's" in China?
>
> MR. LEE: Not Chinese. I'm Korean.
>
> FOSTER: Whatever. You come to my country, you take my money, you don't even have the grace to learn my language?

What Foster doesn't realize is that not only is it not his country alone, it is also not his language anymore. (That should be obvious to the ordinary American viewer, except that it *wasn't* obvious to every one. And it isn't.) But what I'm interested in asking is this: what is it that Mr. Lee is saying?

In saying "Not Chinese. I'm Korean," Mr. Lee is talking about difference. He is trying to tell another story. His story. Except that Foster won't listen. He is more interested in taking apart Mr. Lee's store with a baseball bat—the same way that, as Rita Chaudhry Sethi reminds us, others destroyed Japanese cars before Vincent Chin died. Vincent Chin

was a young Chinese American who was murdered, also with a baseball bat, by two white autoworkers in Detroit. Chin was called a "Jap" and told "It's because of you motherfuckers that we're out of work." When I say Mr. Lee is talking about differences, I don't simply mean the difference between someone who is Chinese and someone else who is Korean. Instead, by difference I mean a sense of where it is a person is coming from. Both in terms of a location in place and in history.

Vincent Chin was an American of Chinese origin. The year he was killed marked the hundred-year anniversary of the Chinese Exclusion Act; in the year 1882, lynch mobs had murdered Chinese workers who were working on the West Coast.

Chin's murderers, Ronald Ebens and Michael Nitz, were autoworkers in Detroit, the city that entered the annals of early U.S. industrialism through its success in manufacturing cars. Ebens and Nitz did not know the difference between a worker and a capitalist. They were kept ignorant of the world of transnational capitalism, their very own world in which "General Motors owns 34 percent of Isuzu (which builds the Buick Opel), Ford 25 percent of Mazda (which makes transmissions for the Escort), and Chrysler 15 percent of Mitsubishi (which produces the Colt and the Charger)." Chin's killers did not spend a single night in prison and were fined $3,780 each. A Chinese American protesting the scant sentence is reported to have said, "Three thousand dollars can't even buy a good used car these days."

What does the word "Jap" mean? What is the difference between a Japanese and a Chinese American? What is the difference between a Chinese American and a used car? How does language mean and why does it matter?

As the Swiss linguist Ferdinand de Saussure argued very early in this century, language is a system of signs. And any sign consists of a signifier (the sound or written form) and a signified (the concept). As the two parts of the sign are linked or inseparable (the word "camera," for instance, accompanies the concept "camera" and remains quite distinct in our minds from the concept "car"), what is prompted is the illusion that language is transparent. The relationship between the signifier and the signified, and hence language itself, is assumed to be natural.

When we use the word "alien" it seems to stick rather unproblematically and unquestioningly to something or someone, and it is only by a conscious, critical act that we think of something different. Several years ago, in a public speech, Reverend Jesse Jackson seemed to be question-

ing the fixed and arbitrary assumptions in the dominant ideology when he reminded his audience that undocumented Mexicans were not aliens, they were *migrant workers*.

E.T., Jackson said emphatically, was an *alien*.

That is also the point made, albeit with more special effects than political ones, by the opening sequence of the film *Men in Black*.

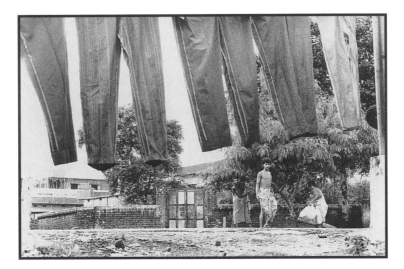

The empty legs of the trousers hung up to dry in my birthplace, Ara, can be seen as just that, empty, lacking the fullness of meaning. But the image of the trousers—or the *signifier*—can also, however, be imaginatively joined to the concept of the bourgeoisie—or the *signified*—in whose service the half-clad washermen, not to mention the washerwoman with her back turned to us, labor in the river. These men who are poor do not wear the trousers they wash. The critical reader can fill the empty legs of these trousers with another meaning, the meaning born of a class and caste analysis of contemporary Indian society.

If you have been patient with my exposition so far, we might ask the same question of the object called the passport. How do we understand it as a term of language?

Let me, somewhat polemically, establish its meaning precisely by foregrounding a difference. For those who live in affluent countries, the passport is of use for international travel in connection with business or vacations. In poorer nations of the world, its necessity is tied to the need for finding employment, mainly in the West.

Once the process of acquiring a passport is over, you are reminded by friends and relatives that the real hurdle is getting the visa to enter that country that has now become this real place in your dreams. The passport is without any value if it does not have the visa. In other words, it is meaningless as a passport.

Abraham Verghese, writing in the *New Yorker,* had this report from the U.S. consulate in his home city of Madras, India:

> One morning, the visa officer turned down six consecutive doctors and told the seventh, who happened to be a friend of mine, and whom I'll call Vadivel, "Spare me the crap about coming back with specialized knowledge to serve your country. Why do you really want to go?" Vadivel, who had held on to his American dream for so long that he could speak with the passion of a visionary, said, "Sir, craving your indulgence, I want to train in a decent, ten-story hospital where the lifts are actually working. I want to pass board-certification exams by my own merit and not through pull or bribes. I want to become a wonderful doctor, practice real medicine, pay taxes, make a good living, drive a big car on decent roads, and eventually live in the Ansel Adams section of New Mexico and never come back to this wretched town, where the doctors are as numerous as fleas and practice is cutthroat, and where the air outside is not even fit to breathe." The consul gave him a visa. The eighth applicant, forewarned, tried the same tactic but was turned down.

If, on the one hand, the meanings of words like passport and visa are tied to dreams and fantasies, they are also, on the other, inextricably woven into the fabric of power and social prejudice. Americans learned recently of what one commentator called the "State Department visa 'profiles' of foreign applicants based on skin color, ethnicity, looks, speech—and remarkably enough—fashion sense." A Federal District Court judge had questioned the legality of State Department manuals that, apart from encouraging "special handling" of blacks, Arabs, and others, provide a list of abbreviations to help sort applicants: "RK=rich kid, LP=looks poor, TP=talks poor, LR=looks rough, TC=take care." In the case in which the judge had provided his ruling, among the evidence submitted were rejected applications with notations like "slimy looking," "Wears jacket on shoulders w/earring" and "No way . . . poor, poor, poor."

A fictional tale that takes place against the background of the humiliating drama of getting a visa is Salman Rushdie's marvelous short story "Good Advice Is Rarer than Rubies." It is also a tale about an old man's falling in love with a young woman who is a stranger. The beautiful Miss Rehana, whose "eyes were large and black and bright enough not to need the help of antimony," arrives at the gates of the British Consulate to ap-

ply for a visa. As we learn later in the story, she is about to go to what she calls "Bradford, London" to join a man who she had been engaged to as a child. She is approached outside the gates by Muhammad Ali who specialized in wheedling money from unsuspecting, illiterate women who had no skills in the language of the state.

The old man is struck by Miss Rehana's singular charm. "Her innocence made him shiver with fear for her." He is bewitched by her beauty, and he finds himself moving beyond the set speech in which he would warn applicants of the kinds of questions the British authorities would ask. "Muhammad Ali spoke brutally, on purpose, to lessen the shock she would feel when it, or something like it, actually happened."

"The oldest fools are bewitched by the youngest girls," writes Rushdie. And Muhammad Ali offers Miss Rehana, almost helplessly, a forged British passport, gratis.

But Miss Rehana does not accept Muhammad Ali's gift; it is only his advice she wants, for, as she says, "good advice is rarer than rubies." As she turns away from him, Muhammad Ali says to Miss Rehana, "Bibi, I am a poor fellow, and I have offered this prize because you are so beautiful. Do not spit on my generosity. Take the thing. Or else, don't take, go home, forget England, only do not go into that building and lose your dignity."

I do not think that what would cause Miss Rehana to lose her dignity is only the violence of a particular inquiry by immigration agents, say about her virginity, a subject of inquiry vehemently protested in the 1980s; instead, it is also the violence of the immense erasure of differences, historical particularities, and the individual humanity that is at the heart of Muhammad Ali's fears for her.

You start with an inquiry into the meaning of a word and you enter a world of difference. What are the answers to the question of an Indian woman's identity? Similar to the point about difference raised in the context of the Korean grocer, Mr. Lee, this question, too, finds an answer only in the form of more questions—at least in this brief fragment from an epic poem "Aay Wha' Kinda Indian Arr U?" written by a Sri Lankan-Canadian poet, Krisantha Sri Bhaggiyadatta:

> am i the Indian wearing salwar or a sari, a turban or a pottu
> on the subway platform at 10 p.m.
> am i the mother awaiting the scalpel-wielding
> C-section surgeon at Scarborough hospital?
> am i the baby who puts off being born
> from June to October to February to June
> awaiting a Jullundur Spring

am i the self-sacrificing monogamous Sita
　　or am i the strong-willed and passionate
　　revengeful polyandrous Draupadi
　　(& her five Pandavas),
　　or am i the "we shoulda met earlier" Usha of Urvashi
am i the Indian who must submit to virginity tests
　　from immigration's con/insultants?
am i the sponsored Indian whose husband owns her
　　for ten years or else . . .
　　thanks again, to the immigration department's
　　department of familiar values
am i the Indian who is kept 5 oceans apart from her lover?
am i the Indian hiding in a women's shelter
　　from her "til death do us apart" husband. . . .

The questions asked by the poet are important not only because they are so heterogeneous. They also hold a special appeal for their ability to return us to language as the terrain on which difference is constructed or resisted. That is what I see, for example, in the poet's novel splitting of the word "con/insultants." Or in this anthropological account from 1924 about an early Sikh migrant in the U.S., which is cited by the Asian American scholar Ronald Takaki: "In one of the camps [for migrant workers in California], an Asian Indian told a visiting lady: 'We eat no meat, that is, no beef—the cow is sacred.' 'But you drink milk?' she snapped skeptically. 'And your cow gives you the milk!' 'Yes,' he countered, 'we drink our mother's milk also, but we do not eat her!'"

When you turn to me in the bus or the plane and talk to me—*if* you talk to me—you might comment, trying to be kind, "Your English is very good."

If I am feeling relaxed, and the burden of the permanent chip on my shoulder seems light, I will smile and say, "Thank you" (I never add, "So is yours"). Perhaps I will say, "Unfortunately, the credit goes to imperialism. The British, you know . . ." (Once, a fellow traveler widened her eyes and asked, "The British still rule over *India*?").

It was the British who, in the first half of the nineteenth century, under the imperative of Lord Macaulay, introduced the systematic teaching of English in India in order to produce a class of clerks. In Rushdie's novel *The Moor's Last Sigh,* a painter by the name of Vasco Miranda drunkenly upbraids the upper-class Indians as "Bleddy Macaulay's Minutemen. . . . Bunch of English-Medium misfits, the lot of you. . . . Even your bleddy dreams grow from foreign roots." Much later in the novel,

the protagonist, Moor Zogoiby, reflects on Macaulay's legacy as he is leaving for the last time the city of his birth, Bombay:

> *To form a class*, Macaulay wrote in the 1835 Minute on Education, . . . *of persons, Indian in blood and colour, but English in opinions, in morals, and in intellect.* And why, pray? O, to be *interpreters between us and millions whom we govern.* How grateful such a class of persons should, and must, be! For in India the dialects were *poor and rude, and a single shelf of a good European library was worth the whole native literature.* History, science, medicine, astronomy, geography, religion were likewise derided. *Would disgrace an English farrier . . . would move laughter in girls at an English boarding-school.*

This historical reverie is an occasion for Zogoiby to declare retrospective judgment on the drunken Miranda, to assure the reader and posterity that "We were not, had never been, that class. The best, and worst, were in us, and fought in us, as they fought in the land at large. In some of us, the worst triumphed; but still we could say—and truthfully—that we had loved the best."

But what is it that was judged the best—in English?

The answer to that question can be sought in the pages of another Third-World writer, Michelle Cliff, who in writing about a Jamaican childhood describes how the schoolteacher's manual, shipped year after year from the London offices, directed the teacher

> to see that all in the school memorized the "Daffodils" poem by William Wordsworth. . . . The manual also contained a pullout drawing of a daffodil, which the pupils were "encouraged to examine" as they recited the verse. [Cliff rightly adds,] No doubt the same manuals were shipped to villages in Nigeria, schools in Hong Kong, even settlements in Northwest Territory— anywhere that "the sun never set". . . . Probably there were a million children who could recite "Daffodils," and a million more who had actually never seen the flower, only the drawing, and so did not know why the poet had been stunned.

I was one of those children, though I cannot remember being shown even a drawing of the flower! And this in an independent nation, still unable to shrug off, when it comes to education in English, its colonial heritage. I can, therefore, understand the critique of that education lying at the heart of the Jamaican cultural theorist Stuart Hall's observation: "When I first got to England in 1951, I looked out and there were Wordsworth's daffodils. Of course, what else would you expect to find? That's what I knew about. That is what trees and flowers meant. *I didn't know the names of the flowers I had left behind in Jamaica.*" In some

ways, admittedly, we cannot speak of the postcolonial experience as only limited to the idea of the absent daffodil. A more adequate representation of that experience would encompass, at the same time, that moment when the Indian child thinks of the daffodil as a bright marigold—or when, as in Cliff's novel, a student in the Caribbean colors it "a deep red like a hibiscus. The red of a flame." In that instant, which I can only call one of creative appropriation, language does not remain an instrument of cultural domination. It is transformed, knowingly or unknowingly, into a weapon of protest.

But let me return to that particular moment when, as his plane banks over the smoky landscape of Bombay, Moor Zogoiby finds himself thinking of the doings of the Indian elite in the past ("In some of us, the worst triumphed; but still we could say—and truthfully—that we had loved the best"). His thought can also be seen as a protest. His Bombay was a Bombay that is no longer. For his Bombay was, as he says, "a city of mixed-up, mongrel joy." That vision of the city is in direct conflict with the Bombay, or Mumbai as it has now been renamed, of the right-wing, Hindu rule of the Shiv Sena in Maharashtra. The Shiv Sena's vision of Mumbai is essentially a purist one. It is intolerant of those that fall outside its own, arbitrary, even atavistic, frame of reference. What Zogoiby seems to be savoring in his past, as he leaves his city behind him with no companion other than a stuffed mutt by the name of Jawaharlal, is the kind of modern liberal democratic vision we associate with an earlier India led by Nehru. "Unlike many other nationalists who had come to a sense of their Indianness through the detour of the West," Sunil Khilnani points out, "there is no trace in Nehru of that inwardly turned rage of an Aurobindo or Vivekananda, political intellectuals who strove to purge themselves of what they came to regard as a defiling encounter with the modern West—an encounter that had first planted in them the urge to be Indian." Against the memory of Jawaharlal Nehru, the mongrel visionary, we have the reality of the Shiv Sena supremo, Bal Thackeray, who lists Hitler among his models.

And yet there is one detail that deserves commentary. The Shiv Sena leader's own name owes its origins to his Hindu father's admiration for the English novelist William Makepeace Thackeray. I recall that detail not in order to point out that the Shiv Sena leader is hypocritical—though he might be that, and he can certainly be accused of much else—but to point out that, in the postcolonial condition, contradictions are inescapable.

To begin *to see* the contradictions is to become aware of history and, therefore, of another relation that this history has with the present. And to think of these contradictions *as inescapable* is to abandon a naive and dangerous view of history that inevitably harbors in its heart murderous longing.

Let's take the fairly banal example of the name of the street on which I passed most of my youth in India. My parents' house in Patna was on a street that is still called "Hardinge Road" by the city's mail carriers, the ricksha pullers, and a wide variety of the city's citizenry. The road was named by the British after Charles Hardinge, the viceroy in India around 1914. In the 1980s, forty years after independence, the provincial government renamed the street "1942 Kranti Marg" (literally, 1942 Revolution Street). This was in honor of the high school students who, while participating in the 1942 Quit India movement, had fallen to British guns. For as long as I can remember, their historic statues have stood at the mouth of the street.

For me, this renaming wasn't without significance: it attached me to a history of nationalist struggle and its local roots. It made more real and meaningfully concrete what otherwise remain grand and empty proclamations of patriotism. However, at the same time, while indeed calling that street "1942 Kranti Marg," I cannot ever forget that there are in use in that town, and in the country as a whole, other names that are, if not English, at least *in English*. To deny that would be once again to deny our history. It would be to succumb, perhaps as hypocritically as the Shiv Sena chief does, to a purism that, at least in his case, has no role other than sanctifying the persecution of those that are relegated to the role of Others in his history. They are the Muslims, the untouchables, Communists, progressive women . . .

Which is not to say that any defense of the use of English should be uncritical. In a fine, witty novel, *English, August*, written by Upamanyu Chatterjee, the narrator's amusement at the use of English in small-town India is designed to mock the pretensions and the complacencies of the petty bourgeoisie. The narrator, while certainly very much an elitist, does not remove himself from the circle of critique. Take his own name, for example. He was named Agastya after a famous sage in the Hindu vedas. While in school, he told his friends he had wished he was a part of Westernized "Anglo-India, that he had Keith or Alan for a name, that he spoke English with their accent." From that day, he had been given among other names—which included "last Englishman" or just "English"—the name that stuck, "August." In the novel, even while baring his own repressed

Anglo-envy or expressing his enjoyment at the spicy masala mix of his tongue, August does not fail to lampoon the affectations of his friend, a member of the metropolitan Americanized bourgeoisie in India:

> "Amazing mix, the English we speak. Hazaar fucked. Urdu and American," Agastya laughed, "a thousand fucked, really fucked. I'm sure nowhere else could languages be mixed *and* spoken with such ease." The slurred sounds of the comfortable tiredness of intoxication, "'You look hazaar fucked, Marmaduke dear.' 'Yes Dorothea, I'm afraid I do feel hazaar fucked'—see, doesn't work. And our accents are Indian, but we prefer August to Agastya. When I say our accents, I, of course, exclude yours, which is unique in its fucked mongrelness—you even say 'Have a nice day' to those horny women at your telephones when you pass by with your briefcase, and when you agree with your horrendous boss, which is all the time, you say 'yeah, great' and 'uh-uh.'"

The one named August is "hazaar fucked," the other, if I may hazard a guess, "plainly fucked." It is for the latter, from the position, perhaps of the former, that I had coined an (im)proper name, a name for a dog that is, and yet isn't, a cousin to the mongrel we encountered beside Zogoiby's legs:

LORD MACAULAY'S TAIL

TheEnglishlanguage was the second name
of Lord Macaulay's pet dog.
So we became its tail.

The mistake was
that we believed this tail
actually wagged the dog.

Now the condition is such
that on that side the teeth of the dog might well be
devouring someone

but on this side
we keep wagging the tail vigorously.

Those of Lord Macaulay's breed occupy the missionary position in relation to Indian education in the English medium. They are the ones who receive their training in convents from Christian priests described by the writer Shashi Tharoor as those "who serve their foreign Lord by teaching the children of the Indian lordly." Those priests might not be the ones, however, who teach in schools with names like Bright Future English School—a name noticed by Pankaj Mishra during his travels through small towns in India, narrated in his book *Butter Chicken in*

Ludhiana. Or even in institutions with names more like St. Joseph's Cross School—a name that, with the word "cross," has connotations not only of Christ but also of an unstable hybridity or mixing. The name draws Mishra on this speculative path:

> St. Joseph's Cross School? Even the name sounded dubious. I couldn't recall a school with that name in Meerut. It was probably very recent, cleverly exploitative of the Indian regard, not entirely misplaced, for Christian schools and English-medium education. Scores of such schools, more than half of them fraudulent, had come up all over small-town India, some with incomplete buildings that frequently collapsed and left in their stead a turbid dust of recriminations and denials hanging over buried bodies.

In this contemporary rewriting of the colonial project of missionary education, new fraudulent acts forge the consciousness of small-town India in the name of older, more legitimized, acts of moral uplift and business as usual. Mishra imagines only the pile of collapsing rubble on children's bodies, but in the decades that followed Indian independence there were many deaths as a part of what was called "language riots." In the demand of various groups for separate states under the federal Indian government, one bone of contention quite often was the existence of "English-medium" schools. If India was now free, did we need to have schools that prided themselves on teaching only English?

Among my earliest memories of going to school is of a rainy day when I was perhaps five. The car taking us to school suddenly stopped. Men, shouting slogans and waving their arms, smeared the license plate with tar. The driver turned the car around and brought my sisters and me back home. We were off from school; and, though not entirely unshaken by the event, I remember being very happy at the prospect of playing with paper boats.

Those men, although I did not know at that time, were part of the "Hindi Only" movement that considered the use of English in India a throwback to the imperialist era of the British. In *Midnight's Children* Rushdie's hero, the boy Saleem Sinai, finds himself crashing on his bicycle into one of the protest marches. The narrative is unable to hide the fact that grave issues of class identity gave intensity to what would be described as a merely cultural demand for a "linguistic state":

> Hands grabbing handlebars as I slow down in the impassioned throng. Smiles filled with good teeth surround me. They are not friendly smiles. "Look look, a little laad-sahib comes down to join us from the big rich hill!" In Marathi which I hardly understand, it's my worst subject at school, and the smiles asking, "You want to join S.M.S. [*Samyukta Maharashtra Samiti,* or United Ma-

harashtra Party], little princeling?" And I, just knowing what's being said, but dazed into telling the truth, shake my head No. And the smiles, "Oho! The young nawab does not like our tongue! What does he like?"

Sinai, in Rushdie's novel, makes his escape from his predicament by giving to the crowd a nonsense rhyme in Gujarati, the language of the crowd's opponents.

> *Soo ché? Saru ché!*
> *Danda lé ké maru ché!*

A nonsense rhyme—"How are you? I am well! / I'll take a stick and thrash you to hell!"—and cleverly designed to mock the rhythms of Gujarati, it gets adopted as a slogan, a war cry, an insult. Soon the first language riot is under way, leaving fifteen killed and over three hundred wounded.

When I was a schoolboy and confronted by the faces outside the windows of the car taking us to school, I was unable, lacking the prescience of Saleem Sinai, to read in those faces, in their words and gestures, the signs of social disenfranchisement and anger. Nor was I involved with those people in exchanges that would impress me with premonitory messages about the power of words. But a somewhat jagged line joins that event with the more immediate reality in which I find myself: an immigrant speaking a language that, even when it is the one that my listeners speak, still *sounds* different from theirs. As I stand in front of a classroom filled with English-speaking, mostly white-skinned, students—we could be engaged in a discussion about a writer, the sounds of whose name are utterly alien and distant not only to my illiterate grandparents but also, it sometimes seems, to my own lips—I might be composing my own nonsense rhyme to give those I see ringed around me.

> I leave the door open
> when I teach. And turn back
> to spell on the board the word
> they said they "didn't get."
> "Oh that!" they say, moving
> quickly to the next point. Sometimes
> I apologize. They understand
> I don't have to. "No big deal."
> "Doesn't bother me." We agree
> to hide our embarrassment.
> And put everything within
> quotes (like "they" and "I")
> to keep things manageable.

I turn from the board: black
wall with weak ribs of chalk.
My voice rises, fills the room
and moves out of the door.
It dances in the corridor, tripping
with its foreign accent
those calmly walking past.

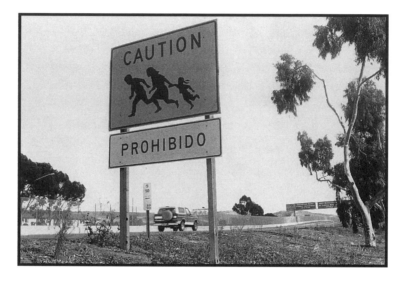

I took this photograph very close to the U.S.-Mexico border, somewhere between San Diego and Tijuana. There was a tear in the fence; I climbed under it and came up close to the highway to get a better shot. When I went back to the place in the fence, I was startled out of my skin by a Border Patrol van that was very slowly driving past. The officer did not see me, however, and I was soon back in the bar next to my motel.

While sipping my beer, I imagined a conversation with the border patrol officer who had only narrowly missed catching me.

OFFICER: I saw you photographing that sign. That was good, an excellent idea. What do you think about the sign though?

ME: Mmm. I don't know. It's just that— this is the first time I saw that sign. In my country, we have family-planning signs with figures like that. Father, mother, kid. The Health Ministry has a slogan painted beneath it, One or Two Kids. Then Stop.

OFFICER: That's very interesting. This is what I like about multicul-
turalism. You get to learn about cultural difference.

ME: You really think so? Yes, that's great. What can I learn
from *this* sign?

OFFICER: Well, you've gotta get into the semiotics of it, you know
what I'm saying?

ME: Uh-huh.

OFFICER: I'll be damned if language is transparent. That's the bottom
line here. Just look at that sign—in English it's Caution, but
in Spanish, it's *Prohibido*. You don't think those two words
mean the same thing, do you?

ME: I don't know. I don't know Spanish.

OFFICER: Okay, well, I'll be patient with you. The sign in English is
for folks who drive. They're being cautioned. Now, the sign
in Spanish—

ME: Yes, yes, I see what you're driving at! The *Prohibido* sign is
for the Spanish speaker—

OFFICER: There you go! Bingo! Bull's eye! They don't have the word
Caución there. It's plain Prohibited: pure and simple. The
picture, the image—it splits, right before your eyes!

ME: The scales have fallen . . .

OFFICER: Well, but you gotta stay alert. 'Cause culture is a moving
thing, meanings change. Or sometimes, just get plain run
over. All the time.

ME: Yes, yes.

OFFICER: What work do you do?

ME: I teach English.

OFFICER: No kidding! See, this is America! You teaching *English* to
our kids, I love it. Say, did you ever watch *Saturday Night
Live* when it first came on?

ME: No, I don't think so.

OFFICER: Michael O'Donoghue played a language instructor. He was

teaching this confused immigrant played by John Belushi. You know the sentence that O'Donoghue used to introduce the language?

ME: What was it?

OFFICER: I will feed your fingers to the wolverines.

We could have gone on, the officer and I. If we were swapping stories today, I'd have mentioned the news report that the telephone company Sprint, in its billing letter in Spanish, threatens customers with phone cutoff unless their check is received by the end of the month. According to the news report, the Anti-Defamation League and the National Council of La Raza have filed complaints. Why? Because the billing letter in English is somewhat differently worded: "As a customer you are Sprint's number one priority. We . . . look forward to serving your communication needs for many years to come."

And, if the officer had had more time, we might have arrived at an understanding that language, especially English, has been used as a racial weapon in immigration.

To cite a historical example: in 1896 a colonial official argued against the restrictions imposed on the entry of Indians in South Africa, adding that this would be "most painful" for Queen Victoria to approve. At the same time, he sanctioned a European literacy test that would automatically exclude Indians while preserving the facade of racial equality.

Almost a hundred years later a Texas judge ordered the mother of a five-year-old to stop speaking in Spanish to her child. Judge Samuel Kiser reminded the mother that her daughter was a "full-blooded American." "Now, get this straight. You start speaking English to this child because if she doesn't do good in school, then I can remove her because it's not in her best interest to be ignorant. The child will only hear English."

Who is permitted to proceed beyond the gates into the mansion of full citizenship? And on what terms? These are the questions that the episode in the Texas courthouse raises. Apart from the issue of gross paternalism and an entirely injudicious jingoism, what comes into play here is the class bias in North American society that promotes bilingualism in the upper class but frowns on it when it becomes an aspect of lower-class life.

More revealing of the ties between language and U.S. immigration is the following newspaper report: "School and city officials expressed out-

rage this week over the Border Patrol's arrest of three Hispanic students outside an English as Second Language class."

For the Chicano poet Alfred Arteaga, the above story about arrest and deportation has a double irony: "irony, not only that 'officials expressed outrage' at so typical an INS action, but irony also, that the story made it into print in the first place." Arteaga knows too well that what Chicanos say and do in their own language is rarely found worthy of printing.

I think it is equally significant to remark on the fact that the officers who conducted the arrest were patrolling the borders of the dominant language to pick up the illegals. They are ably assisted by the likes of the California state assemblyman William J. Knight, who distributed among his fellow legislators a poem, "I Love America." That poem begins with the words "I come for visit, get treated regal, / So I stay, who care illegal." This little ditty makes its way through the slime of a racist fantasy. Its landscape is filled with greedy swindlers and dishonest migrant workers. The breeding subhumans speak in a broken syntax and mispronounce the name Chevy, the heartbeat of America, as (call the National Guard, please!) Chebby. The poem ends with a call that emanates like a howl from the guts of the Ku Klux Klan:

> We think America damn good place,
> Too damn good for white man's race.
> If they no like us, they can go,
> Got lots of room in Mexico.

If the immigration officer were to ask me about my language, what would I say? That any precious life-giving sense of language loses all form in this arid landscape of Buchanan-speak? Perhaps. That any answer I could possibly give is nothing more defined than a blur moving on the infrared scopes of those guarding the borders of fixed identity.

Homi Bhabha writes: "The enchantment of art lies in looking in a glass darkly—a wall, stone, a screen, paper, canvas, steel—that turns suddenly into the almost unbearable lightness of being." But where is this buoyancy, the refulgence, the mix of new life and new art? As the case of Fauziya Kasinga reminds us—the young woman who fled Togo to avoid genital mutilation and was held for long in detention by the U.S. Immigration authorities—grim reality so often persists in its unenchanting rudeness.

In such conditions to speak is only to declare any speech a station of loss.

I brought two bags from home, but there was a third that I left behind.
In this new country, apart from the struggles that made me a stranger,
were your needs, of the ones who bid me goodbye, those I left behind.
Among the papers I collected, you had put a small bag of sweets, I left
 behind.
There were divisions at home, there were other possibilities;
there were communities in my town, there were communities where I came;
I found a job, called it a struggle for survival, everything else I left behind.
I didn't want to forget my traditions, the tradition of forgetting I left
 behind.
Bags, passport, my shoes crossed the yellow lines, something was left
 behind.
Here I am, a sum of different parts; travel agents everywhere are selling ads
for the parts that were left behind.

And yet, while speaking of the patrolling of the borders of dominant
identity, I must note the presence of one who is still eluding arrest: a bor-
der-artist/poet-performer/hoarder-of-hyphens/warrior-for-Gringostroika.
Officer, meet Guillermo Gómez-Peña. You have been looking for him not
only because Gómez-Peña declares "I speak in English therefore you lis-
ten / I speak in English therefore I hate you." But also because, like a
"Pablo Neruda gone punk," this "border brujo" threatens mainstream
America with the swaggering banditry of language, demanding as ran-
som a pure reality-reversal:

What if the U.S. was Mexico?
What if 200,000 Anglo-Saxicans
Were to cross the border each month
to work as gardeners, waiters
3rd chair musicians, movie extras
bouncers, babysitters, chauffeurs
syndicated cartoons, feather-weight boxers, fruit-pickers
and anonymous poets?
What if they were called Waspanos
Waspitos, Wasperos or Waspbacks?
What if literature was life, eh?

Photograph

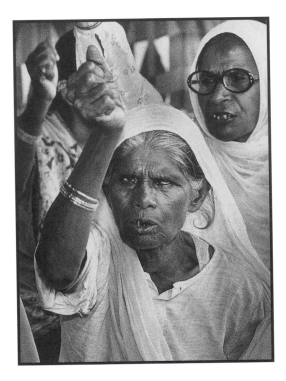

Wait a minute! The face of the middle-aged man was known to him! It was the face of his cousin, Sundararaya. He had a photographic studio in Hunsur. How did this picture come to be in this book? How did this man come to be here?

A. K. Ramanujan

The woman in these images is a protester from Bhopal. Which one more closely resembles a passport photo? Why?

I read of the February 23, 1997, shooting at the Empire State Building in the newspapers the next day and wondered how I could talk about this with my students.

Once again, truth became a matter not to be sought from books or the words teachers write with chalk on the blackboard. This time we were to study the lines of chalk drawn around dead bodies.

In the United States during the previous year 20,000 people died in homicides and 30,000 in suicides.

A friend said to me, "Talk about killers killing themselves. Killers turning their weapons—which make them feel powerful, but only momentarily—vengefully on themselves."

In my mind, the title of a book of poems written by an Egyptian Jew in exile—*A Foreigner Carrying in the Crook of His Arm a Tiny Book*—gives way to another horrible image: a foreigner who carries in the crook of his arm a tiny gun.

There is a terrible solitude that surrounds the dead; it is only enhanced when the dead is also a killer.

I have looked at the newspaper photographs of the gunman, a Palestinian English teacher, Ali Abu Kamal. In one of the photographs his young son, sitting between his grief-stricken mother and sister, holds a large framed picture of his father.

Printed beneath that photograph is a blowup of Abu Kamal's face from the same picture, the only mug shot we will now see of the dead man.

In the second photograph Abu Kamal is no longer a father or a husband.

We no longer see him against the cheap backdrop of a Third-World studio photographer's imagination: a canvas curtain with flowerbeds painted on them, simulating a large garden outside one's home or, perhaps, the romance of easy, unrestrained travel to faraway places.

Our vision has fled that land about which Yehuda Amichai once wrote:

Sometimes pus
Sometimes a poem.
Something always bursts out.
And always pain.

If we are so inclined, we might already see in that close-up of his photograph the face that was described by one of Abu Kamal's victims, "He looked crazy, just a mad old man."

Amichai could find only this terrible, moving consolation for his own pain.

> But through the wound on my chest
> God peers into the world.
> I am the door
> to his apartment.

What color are God's eyes? I ask because I also read in that newspaper report about the wife of a "recent immigrant" who was also badly injured in the Sunday shooting. "She's got the reddest eyes I've ever seen," a hospital worker said of the grieving Mrs. Carmona.

In Abu Kamal's violent end and in the grief of the Carmonas, like the shadow of the negatives that persist in the black and white images we see, we are confronted with immigrant histories.

"Despair is still my star," bemoans the Syrian writer Adonis. And I'm ready to see—quickly, urgently—how it comes to be that a single man's sense of unremitting loss draws on another buried, often denied, narrative of collective injury inflicted in an unequal world.

It is a recognition of that which should turn this story of Ali Abu Kamal into the history of the grief of entire nations.

Or, if you prefer, rewrite the symbol of the Empire State Building, from the Hollywood romance of a single man sleepless in Seattle into the nightmare of millions living life as a waking sleep.

And it is in writing, I would like to tell my students, that one works against death. That one protests against annihilation. Against the failure of memory.

A ruse that works as a revenge against the collective forgetting of other deaths.

It was perhaps this that Amiri Baraka had in mind when he wrote in his play *The Dutchman and the Slave* that Charlie Parker would have played not a note of music if he could have walked up the East 67th Street and killed the first ten white people he saw. Not a note!

• • •

I did not know Ali Abu Kamal, nor do I know him any more now. While looking at his face framed in the pages of the *Times*, I was reminded of Claudine K. Brown's essay "Mug Shot: Suspicious Person." My own essay, submitted to the *Times* but not published there, was inspired by Brown's experience of seeing a mug shot in a train station of H. Rap Brown, activist and spokesperson for the Student Nonviolent Coordinating Committee:

> I had just recently heard H. Rap Brown speak at Long Island University. The audience was enthralled by his passion for the civil rights movements and his straightforward no-nonsense delivery. He had the long graceful fingers of a basketball player and the irreverent wit of many of the young men in my neighborhood. His mug shot made him an anonymous stranger. He was no one's son, no one's lover, and danger to all who might encounter him.

In writing in similar terms about Abu Kamal, I was also doing something else, however. In claiming to speak for him and, in fact, in speaking of those that I so generally call immigrants, I was, and am, claiming an identity for myself. Then and now, this is a framing of myself in a world of my own choosing.

To the immigration officer, examining my passport photograph, I might be saying "You do not know me." Obviously, that performative gesture is being carried out in the frame of a text and in a practice called writing. A writing that at its furthest limits calls attention to the same nightmare of millions living life as a waking sleep. But more immediately, one that invites some thinking on the purpose served by those photographs that serve the purpose of the state. What kind are the images produced by the state?

INS unveils high-tech fraud-resistant "green card" with a new official name, announced the recent front page of a newspaper in the U.S. ethnic press. Inside, the reader learned that the Immigration and Naturalization Service had begun mailing to 50,000 new legal immigrants what the INS believed was "one of the most sophisticated, counterfeit-resistant documents produced by the Federal government."

The report also said, "The new $38-million high-tech wonder uses holograms, embedded photographs, thumbprints, and a wealth of electronic data to make it easier for employers and law enforcement officers to tell whether an immigrant is entitled to live and work in the United States."

(The "green card" is not really of that color. It once was, on the eve of World War II when it grew out of the Alien Registration Act that re-

quired all foreigners to register with the government. But the card changed color in 1964. And now once again it is green, at least in part. My own card, acquired not too long ago, is actually a shade of pink, and my countenance inscribed therein bears a startling resemblance to one of those convicted of blowing up the World Trade Center. To my mind, and I do not say so in jest, this fact attests to a technology that turns aliens—those convicted in the bombing case included—into lawbreakers, if not also terrorists.)

There are two features about the new green card that are deserving of comment. The first, of course, is its emphasis on countering counterfeiting (with embedded digital images, multifaceted holograms, laser etching, etc.). Hence its use of "an optical stripe on the back of the card that contain[s] the holder's digitally encoded photo, fingerprints and biographical information, which can be read only by a special INS scanner." The second feature, one that is not given much attention in the INS statement, is that the new card identifies the nationality of the green-card holder instead of merely carrying a number as all the previous versions did. As immigrants-rights groups have rightly charged, this latter feature makes it easier for employers to practice discrimination. What is important to find here, of course, is that these two features reinforce the principal ideological reasoning behind passports and alien cards—and also, for that matter, the INS, which Chandra Talpade Mohanty describes as "one of the central disciplinary arms of the U.S. State."

The political theorist Benedict Anderson notes that "the huge volume of passport forgeries and the high prices they command show that in our age, when everyone is supposed to belong to some one of the United Nations, these documents have high truth-claims." If the high-quality fake green card can easily fetch a price of $15,000, then the variety of high-tech investments in the production of the genuine article—including "the 'microprinting' of the country's 42 presidents plus the flags of the 50 states"—go a long way in defining and preserving the faith in irreproducibility and well-guarded "reality."

But what of the second feature that the new card possesses, of identifying the holder in terms of nationality? Anderson's comments on the nature of the passport are once again useful here in our understanding of the new green card. He argues that while our passports have "high truth-claims," they are at the same time "counterfeits." Our passports "are also counterfeit in the sense that they are less and less attestations of citizenship, let alone of loyalty to a protective nation-state, than of

passports as economic status [handwritten annotation]

claims to participation in labor markets." The immigrants-rights groups' protests over the new card's feature carrying information about the holder's nationality finds resonance in Anderson's following remark: "Portuguese and Bangladeshi passports, even when genuine, tell us little about loyalties or habitus, but they tell us a great deal about the relative likelihood of their holders being permitted to seek jobs in Milan or Copenhagen. The segregated queues that all of us experience at airport immigration barricades mark economic status far more than any political attachments. In effect, they figure differential tariffs on human labor."

This is what we must conclude then: the digitally encoded photograph on my card produces a fixed, tamper-proof identity for me in the eyes of the state. And the only reality that counts in the state's view is my rank in the labor hierarchy. That digitally encoded photograph of the legal immigrant is a familial descendant of all those other photographs about which John Tagg writes in his analysis of the emergence of photography as a means of surveillance by the police in prisons. Of course, as Tagg points out, photography didn't remain limited to those institutions: "From the mid-nineteenth century on, photography had its role to play in the workings of the factory, the hospital, the asylum, the reformatory and the school, as it did in the army, the family and the press, in the Improvement Trust, the Ordnance Survey and the expeditionary force." And, to add the obvious, the Immigration and Naturalization Service.

When I wrote earlier of the technology of the state that produces all aliens as threatening undesirables, I was in part drawing on a critique of the panoptic photographic practice made by a writer like Tagg. He writes of a nineteenth-century practice of photography for a publicity campaign for a "Home for Destitute Lads": "We have begun to see a repetitive pattern: the body isolated; the narrow space; the subjection to an unreturnable gaze; the scrutiny of gestures, faces, and features; the clarity of illumination and sharpness of focus; the names and the number boards."

You, dear reader, will perhaps reflect immediately on the experience of having a photograph taken for a driver's license at the Department of Motor Vehicles. Or, if you have been more adventurous, the flashback to the eye-level mug shot taken at the police station. For me, to recall the arts of state portraiture is not to say "Please, this is humiliating for an immigrant." Nor is it an aesthetic response that protests "Look, a critic is being beaten by the discourse of brute realism!" Rather, it is to highlight the more serious issue: where do the resources of another practice lie? Especially when dealing with the varied, and often

invisible, complexities of immigrant lives, how might we struggle against the poor economy of the photographs taken by the state or the racist, dominant media?

In Réda Bensmaïa's *The Year of Passages* the narrator, a novelist of North African descent living in the U.S., is impatient with the state's demand for his photographs. His complaint to the honorable "Mr. Ambassador" clarifies that he's not piqued by the high rates demanded by the consulates of the countries of "the Fir$t World"; instead, it's the fact that he can't stand having shots taken of his mug ("A mania for photos!"). Bensmaïa writes:

> Because it requires me to see my own mug, I have to see all the *distortions and wrinkles* that the pure passing of time has inflicted on my pure face, *all without rectification!* Every time I get a new visa I've got to get a new visage. *In the word visage there is the word visa*, Elya notes.

This impatience is not a matter of vanity, though indeed that is how it seems. Instead our novelist is actually railing against the fact that "everybody thinks they can buy our face cheaper than anyone else." When spoken by an Algerian, particularly when we recall the role of Algerian labor in current markets of a European power like France, these words refer not only to the market but also to the political economy of identity itself:

> Everybody thinks Algerian faces are a dime a dozen! Everybody thinks they can *spot an Arab Algerian's* face. Now I think that's wrong. . . . I, well, think they've raked our faces over, that they take our *good Algerian faces* for granted. . . . In black and white it's all the same mug of an old dried-up mummy. With or without colors it's all the same look of men wanted dead or alive! . . . They've glued on us a face that looks like a mug shot.

The condition that Bensmaïa's narrator is describing becomes particularly menacing when we think of the dominant Western media's quick frame-up of an imagined Arab involvement after the Oklahoma City bombing in 1995. As Jim Naureckas of the newswatch group FAIR pointed out, the media in this country blindly assumed that the explosion had been caused by (to quote the CBS broadcast) "Middle East terrorists." A columnist for the *Chicago Tribune*, Georgie Anne Geyer, wrote, "It has every single earmark of the Islamic car-bombers of the Middle East." The *New York Times'* A. M. Rosenthal weighed in after the attack, "Whatever we are doing to destroy Mideast terrorism, the chief terrorist threat against Americans, has not been working."

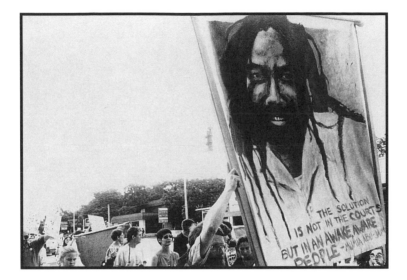

What is striking about Geyer's and Rosenthal's columns is that they were filed *after* the FBI released sketches of two suspects who, as Naureckas caustically points out, "looked more like Midwestern frat boys than mujahideen." This goes a bit beyond what Bensmaïa's narrator was telling us. It isn't simply that every Arab face is reduced to a mug shot: it's also that any other mug shot will *also* be assumed to be that of an Arab. What does it mean to reduce someone's visage, his or her history, to a mug shot?

Soon after the Oklahoma bombing, a nationwide mobilization was underfoot among progressive groups to stop the Pennsylvania execution of the Peabody Award–winning radio-journalist Mumia Abu-Jamal. It was widely contended that Abu-Jamal, who is African American and an active critic of the racist deadly attacks engineered by the police on Philadelphia's MOVE community, had been denied a fair trial and was about to be condemned to a modern-day lynching. Speaking at a public event organized by a local committee that had been set up to help mobilize the defense of the prisoner, I could not but attempt to contextualize Abu-Jamal's case by referring to the Oklahoma bombing.

As Naureckas states in his report after the bombing, "Out of the 171 people indicted in the U.S. for terrorism and related activities in the 1980s, only 11 were connected to Arab groups—6 percent of the total." Terrorist acts, in the view of the dominant media, were those acts committed by others, particularly Palestinians, but not those conducted by cit-

izens of the U.S. or those backed by the government of this country. (It should also be pointed out that "Middle Eastern terrorists" is a blanket term used for all Arabs, but never as a reference to Israelis.) To quote Naureckas: "When the bombing suspects are conservative white men from Middle America—who look like 'us,' as the media decision-makers define 'us'—then there must be a search for understanding."

If of the six major previous bombings in the U.S., all except one were the work of Americans, and still Tim McVeigh's sketch did not retard the wholesale condemnation of the Arab peoples, then should we not understand in a similar way Mumia Abu-Jamal's conviction by the justice system and by the dominant media? Here was an African American male in prison, a part of a racial population that—a mere 11 percent of the national population—today makes up for a full 40 percent of the death row population in this country!

That was the context in which we needed to look at the large image of Mumia Abu-Jamal, for some only a man in dreadlocks, looking back at us.

Victor Burgin, writing on photography, comments: "More than any other textual system, the photograph presents itself as 'an offer you can't refuse.'" This is so because the viewer is seldom asked or expected to be a critical reader of a photograph. Under a way of seeing things that can be described as realist, we are not, as readers, expected to ask *how* this reality, or this image, came to be. Or, to put it in slightly more theoretical terms, where the signifier is thought to be identical to a preexisting signified, there is hardly any interrogation of the *process* through which signification takes place. As John Tagg states, "In realism, the process of production of a signified through the action of a signifying chain is not seen. It is the product that is stressed, and production that is repressed."

How to emphasize production over product? It is in *writing*, the German cultural critic Walter Benjamin believed, that one worked against the death of meaning that resulted from the practice of photography. Benjamin had this to say about writing: "What we must demand from the photographer is the ability to put such a caption beneath his picture as will rescue it from the ravages of modishness and confer upon it a revolutionary use value."

Photographs are so often assumed to be unambiguous in their meaning, and hence transparent. Because of their assumed transparency, photos should be accompanied by an untiring contextualization. Or perhaps I should say recontextualization, because nothing comes without its con-

text; the point is to confront the reader or the viewer with the context that foregrounds the process of making meaning. Everything that appears natural, or what we might consider "present" or "verifiable" in the case of a photograph, is denaturalized. That word evokes, not the least for Benjamin when he was calling for a different consumption of photography, the "epic theater" of the great German playwright of the left, Bertolt Brecht. For me, it evokes even the more mundane activities of Brecht as a writer, for example, of taking a pair of scissors and cutting out a photo from a newspaper and writing a poem beside it—making the picture into a site, and also a stake, of meaning-making—and reminding us that Brecht was turning himself into less of a consumer and more of a producer of culture.

AMITAVA KUMAR, THE *STAR TRIBUNE*, JUNE 27, 1993

Even though he's not the most photogenic of this nation's senators, Sam Nunn didn't let that thought stop him from sending from his brief vacation on the naval submarines a postcard to the American people with his own picture on it.

You probably received it too, in your morning newspaper on May 11. The photo shows Nunn (wearing glasses) crouching with his colleague Sen. John Warner in front of three sailors who are lying on their bunks. On May 16, in another article appearing beneath the same picture, someone was quoted as saying that this photograph taken aboard the submarine *Montpelier* had done more to retain the ban on gays in the military than "a thousand generals testifying against it."

Now, why is that so? I do not believe that the power of this image is that it brought home to the land-locked public of the U.S. the first image of close living in the subs and ships. Instead the photograph's presumed power lies in its presentation: in the unusual image of the senators squatting in the cramped quarters on the front lines of this debate. The story's headline declares with absolute and unchallenged finality: "Senators board ships, told gay ban must remain." The equally tendentious sub-headline, ignoring the contrary views of other sailors, offers the words of a Petty Officer: "I will refuse to serve."

The photo could just as easily be read as a pretext for arguing that the bunks gave so little space for maneuvering it would be impossible to have sex with another person—male or female. But what I want to do is appropriate briefly the sailor's place and voice another complaint: why do we so drastically reduce the immense complexity of reality, its wide heterogeneity and scope of dissent, by what we so quickly accept as the singular truth presented in the shallow frame of an image?

Susan Sontag has written: "Photographs furnish instant history, instant sociology, instant participation." Instead of critically building diverse contexts for a photograph with words and other images, every morning we allow news-

papers to stir a spoonful of information in a cup and slide it beneath our nose. But that's not how we are going to wake up.

Take a look at the woman in the photograph below that was taken by me at a bus stop in my homeland, India, one August afternoon two years ago. We could fix the meaning of this photograph in the static reproduction of a stereotype: Indian poverty. The viewer stares into the starving mouth of an entire nation and its unchanging history in the Western psyche.

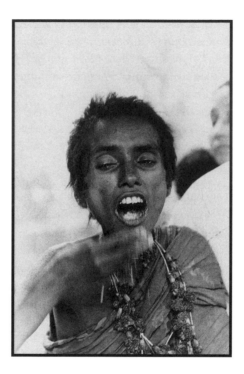

Alternatively, however, we can build another practice of receiving and understanding images. As a photographer presenting this image to North American viewers, for example, it might make sense to juxtapose this image with the following caption: "Alice Walker has written of the poet Jean Toomer's journey in the early 1920s into the American Deep South where he encountered black women with work-worn, sexually abused bodies and an intense, almost unconscious, spirituality. 'These crazy Saints stared out at the world, wildly, like lunatics—or quietly, like suicides; and the "God" that was in their gaze was as mute as great stone.' I have looked at the faces of some of the men and women in India, the land of my birth, and found only evacuation zones, abandoned, cleared even of memories. For me these are not nameless sites, however; in them I recognize the political geography of postcolonial histories and well-remembered struggles."

Free speech is only another name for advertising unless it involves inter-
pretation. We need to interrupt received narratives and draw new relations
between different realities. I would have very much liked to have seen beside
the reports of the senators' impassioned concern about people living and work-
ing in proximity, other images from the sweatshops and the tenement houses
showing folks stifled in claustrophobic conditions and eliciting never a word
from these few good men. The sexist and homophobic sections of the U.S.
army might already have won the mother of all battles here, at home, if Sam
Nunn's campaign brochure was so gullibly consumed as a documentary re-
port from the front.

It would be a cliché to assert that we live in a world in which we are sur-
rounded by images. These images, some of them in any event, are in-
formative; but the information they give us is devoid of all lived experi-
ence. Photographers are complicit in this. In a compelling critique of the
contemporary practice of photography, Sontag upbraids photographers
for their surrealist indulgence: "Reality is summed up in an array of ca-
sual fragments—an endlessly alluring, poignantly reductive way of deal-
ing with the world." In an essay dedicated to Sontag, the Marxist critic
John Berger constructs a tableau where the photographer is a shadowy
figure in a scene of larger absences:

> If the public photograph contributes to a memory, it is the memory of an un-
> knowable and total stranger. The violence is expressed in that strangeness. It
> records an instant sight about which this stranger has shouted: Look!
> Who is this stranger? One might answer: the photographer.

The work of memory, this urgent beating back of the ghosts of alien-
ation, is to be carried out by restoring the value of meaning to a photo-
graph. And this meaning, Berger believes, cannot be of a singular nature:
it must be several things at once. He writes: "A radial system has to be
constructed around the photograph so that it may be seen in terms which
are simultaneously personal, political, economic, dramatic, everyday and
historic."

As photographers and viewers, we need to make an image work like
memory, crisscrossed by dreams and detours. A critical reading practice
that adopts that goal cannot be satisfied with a "straight-reporting"
model of documentary; especially in a postcolonial context, an image
will have to be seen as surrounded by other images, other words, and al-
ways, other worlds. Such a practice cannot be unilinear in yet another
sense: it cannot flow from the photographer to the viewer. In a new, al-

tered mode of reception, there is no finished photograph. An image can only be a part of a continually changing narrative, interrupting the authoritative discourse of a lecture on a distant history.

BURIED BENEATH THE BIBLE: A POSTCOLONIAL DETOUR

Highway 55 is a searing strip of heat during this August afternoon. I cross the first of the signs that ask me to Prepare to Meet God. A jet almost surgically slices the sky in half, leaving a white scar dissolving inside my brain. I have been driving for two days, having started at St. Paul, Minnesota; in Jackson, Mississippi, I'll swing east to Florida.

I'm going to be teaching university students in Florida about postcolonial literatures; on the seat beside me, propping my tape player, for example, I have a book that offers the oral narratives of Asian American immigrants. During lunch, while I ate fried catfish that I had bought from two black women who had set up a stall, I read the account of a Chinese boy growing up in segregated Mississippi. "We thought of buying a house in 1966, but it didn't work out. It was a white neighborhood, and the day before closing, we received a telephone call. Someone said, 'If you buy that house, we will burn it.'"

The highway is lined with pines, the monotony of that stretch broken by the hand-painted boards that shriek warnings to the sinful. The previous evening, I had stopped and taken pictures of the stiff, plaster-of-

paris statue of Mark Twain looming beside the highway near Hannibal, frozen in an attitude of ill humor and bad health. I have no doubt at all that I'd prefer the sort of banality I have left behind me rather than the hate and narrow moralism that seem to await me at the end of this day's journey. Even the dumb Garrison Keillor story on the radio that is being broadcast by the WMAV station at the University at Oxford, Miss., about two midwestern brothers having trouble sharing a coat because they don't want to touch each other, takes on a threatening and ominous tone. After all, if I'm to believe the holy truths of the roadside signs, it wouldn't be tolerated if a man put his arms around and loved another man.

On another station, one that described itself as "a Christian radio to fuel the holy fire," I had earlier heard a bunch of guys commenting on the killing of Michael Jordan's father. Someone from an institution actually named the National Center for Fathering opined that the way Jordan was going to deal with his tragedy was "going to make him a man, because he's now the head of the clan." For a good ten minutes, grown-up boys who are usually called men, perhaps insecure about retaining control over everything they had taken for granted, stressed the importance of love and respect for fathers.

Hell Is No Joke, Pray For Your Sins, and Adultery Aids Kill. It is exhausting to weather this machinery of condemnation that makes sinful deviants and unfit minorities from those who fall outside the tight ideology of the Christian family. I turn with relief to my unused tape player and happily allow Lou Reed's astringent vision to guide me through the entangled paths of hypocritical pieties and universalist assumptions of right-wing zealots. "Give me your hungry, your tired, your poor, I'll piss on 'em. That is what the Statue of Bigotry says. Your poor, huddled masses, let's club 'em to death. Get it over with, and just dump 'em on the boulevard."

A short distance before I drive into Wilmer, Alabama, I spot a sign that simply says Palestinian Gardens Next Paved Left. I immediately decide to quit the highway. My scholarship and writing—my life—in this country are intimately wrapped around the question of transplanted populations, their cultures, the hybrid identities they produce and preserve. As I turn on the thin road lined with pine needles, my mind is caught in the fantasies of the transported love of migrants; I imagine Palestinians, denied a nation and sometimes it seems even a destiny, bringing to this remote part of this faraway land, some plants from their native soil. I'm reminded of the story that the Israeli Arab writer Anton Shammas tells

of a man he calls Abu-Khalil, bringing to San Francisco from his West Bank homeland the flora and fauna dear to him, including seven birds— the duri, the hassoun, the sununu, the shahrur, the bulbul, the summan, and the hudhud, small-talk companion to King Solomon himself.

My Budget van passes the type of territory I associate with the photographs of Eugene Richards in his book *Below the Line: Living Poor in America*. There are ramshackle one-story houses and mobile homes, interspersed with a few others set more at a distance and clearly belonging to those who are more affluent. I see two white women with wan faces and then pass a shaggy dog guarding a deerhide stretched on a wooden frame. At last, I arrive at the Palestinian Gardens.

There are only pinewood benches facing a wooden lectern, behind which I see a pond covered with lotus leaves and dominated, at the far end, by a large white cross. Large frogs plop into the water as I walk past. Then, I see the Palestine of the Bible Belt. It is not the Palestine of a people held under Israeli military occupation. Instead it is a small colony of two-feet-high concrete structures built to resemble primitive desert dwellings of the Middle East. Large white nameplates distinguish otherwise identical structures: one part is called Jerusalem, another Samaria . . . A piece of ground to the right bears the sign, Mound of Temptation.

In the name of a past, namely the biblical past, history in terms of the urgencies and suffering of the present is buried completely. This place is not a symbol of a land that is daily, brutally, denied its right to existence; it is emblematic only of the contradiction between the lives of Others and the law of Christianity in this land. While writing of Palestinian lives, Edward Said discusses the compulsions of repetition: same food, same rituals, the reenactment of a familiar way of being. It is perhaps an attempt at compensation through excess. And still, he notes, "something is always missing by virtue of the excess." Here, in Alabama, I am caught in a narrower tautological circle: there is something missing only because of the excess of its missing. I cannot hope to hear in these gardens the voices of Sabreen, the Palestinian Musical Ensemble, singing:

> They drove him away from every port
> Took his young sweetheart
> You with bloodshot eyes and bloody hands
> Night is short-lived
> The detention-room lasts not forever
> Nor the links of chain.

All I hear among these pinewood benches, even though there's no one around, is a single, rather recognizable, voice telling his own story that is not mine, guarding his privileges that I do not share, and passing terrible injunctions that I fear and can only resist.

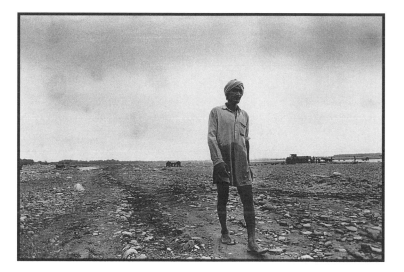

The postcolonial critic Gayatri Chakravorty Spivak writes: "When I speak of art specifically, away from the scene of crisis, my take is a school-teacher's take: art and literature and music for me are audio-visual teaching aids in the construction of cases." Paying heed, I use the photographs I've taken in various parts of the world, but most certainly in India, to provoke my students to think not only about the invisible worlds within the world they live in but also about the connections between those worlds.

Although the result would be to produce a sense of globality, it is still very much a local practice; in other words, it springs from the particular histories you inhabit and the kinds of questions you bring to your reading of a photograph. In that sense, the active meanings and uses of the images in this book are going to be of your own making.

Martha Rosler, who has been influential in critiquing the claims of moralizing, documentary photography, or the ways in which such photography is unproblematically received, suggests: "[C]onsider a photo book on the teeming masses of India—how different is looking through it from

going to an Indian restaurant or wearing an Indian shirt or sari? We consume the world through images, through shopping, through eating."

Can I insulate the presentation of these photographs from that impulse? I cannot say with any certainty. Can you?

These two images—one above, one below—are of landless workers. They are photographs of men who migrate in the summer months from my ancestral village in Bihar to labor in the rock quarries of Punjab (like the quarry worker in the above shot taken near Dumtal in 1994). When the land dries up, leaving them no chance of earning wages, these men move west to work and succeed in drawing out a living, like water from those rocks.

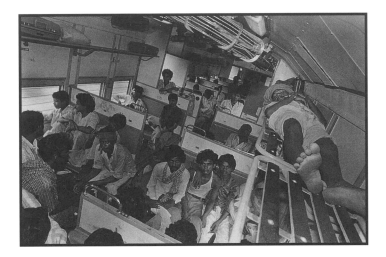

After walking a few miles from the village, the workers take a bus that brings them to the town from which they can catch a train going west. The entire journey to the quarries takes about three days. There are no women from the village on this journey; the two women I met were migrant workers from Bangladesh, going to work in Mughalsarai on the banks of the river Ganges.

The migrant laborers sometimes spend up to five months at the quarries. There are some, however, who cannot "adjust" and leave—"sometimes without even collecting pay." Eight or nine workers live in a room about 20 feet by 12 feet built on top of the warehouses or the offices of the construction company. One out of a small group of four prepares food for the others in a rotation of once every four days. Everyone eats rice in the morning around eight, and the diet at night is mostly *roti*, or

flattened bread. Some nights the men get a ride on one of the trucks going to town. Once there they sit in the small cinema theater and watch a Hindi film.

Nagendra Paswan, a twenty-four-year-old from the village adjoining mine, said he is the one who writes five to ten letters home for his co-workers each week. There are "a few main things" in all the letters so that the relatives of the other workers in the village also get the news of their people. In most letters, he writes, "I am better now, I'm sending you money."

The "you" in the letters are the wives, sisters, blind or sick mothers, and children who continue to do all the work that remains to be done.

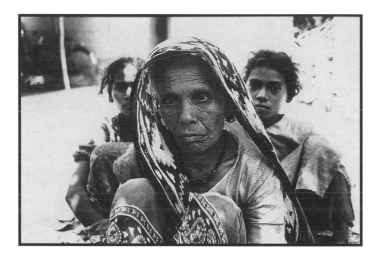

The work of the Brazilian photographer Sebastião Salgado is an enduring tribute to the magnificent labor of those who work with their hands. This is how he describes women's labor in the construction of a dam in the state of Gujarat in India:

> A large number of women are working on the dam. They represent a majority of all the workers. And, as ever, in India, Bangladesh, and Pakistan, they do the hardest work. Men only do hard work when sheer physical strength is needed. Then the men become human bulldozers, tearing at the earth with their shoulders, legs and hands. But the women carry the earth away.
>
> They do this for six days a week, carrying soil, stone, mud, tubes, pipes, removing the desert that they are helping to transform. On the seventh day, they do not work at the dam but they do not rest: they stay home preparing food for the week ahead. Then they return to the desert for six more days of building life, shelter, and bread.

For the French critic Roland Barthes, pictures are received in a divided universe, split between the public and the private: "on one side the Images, on the other my photographs; on one side, unconcern, shifting, noise, the inessential (even if I am abusively deafened by it), on the other the burning, the wounded."

Let's take the case of the immigrant. I imagine a figure standing in a street. Her eyes are dazed by the glitter of Times Square or maybe it's only the flash from the camera used to take her picture for the green card. She sees an image, her eyes begin to focus even as she battles with recognition. It is a large poster in a travel agency, showing a woman of her age from her own country. Does she regard it as an irrelevant splash of commerce, or does she feel the laceration of keen memory?

Is it necessarily one or the other?

Let us arrive at this question via a short journey. In his riveting account of migrant workers in Europe, *A Seventh Man*, John Berger presents a novel tale about the use of photographs. When smugglers accepted money to help illegal immigrants cross into Spain and France, poor Portuguese peasants often ended up getting cheated of their money. They were likely to be abandoned, and they either died of starvation or returned home poorer by a year's wages. Then the migrants devised a system to protect themselves. This is how Berger describes it:

> Before leaving they had their photographs taken. They tore the photograph in half, giving one half to their "guide" and keeping the other themselves. When they reached France they sent their half of the photograph back to their family in Portugal to show that they had been safely escorted across the frontiers; the "guide" came to the family to prove that it was he who had escorted them, and it was only then that the family paid the $350.

The photograph serves as a site for a certain kind of closure. When the "guide" brings his half of the photograph, the completed portrait assures the members of a family of a simple fact, that their son, or husband, or brother, has crossed the frontier, is safe, and likely to return home a richer man someday. In contrast, the photograph stuck on the immigrant worker's identity card in the factory where he will find work, while carrying a kind of assurance, has no similar consoling power for him or for his family. In fact, that photograph only fixes him in the hierarchy of the state that assigns him temporary residence as a second-class citizen. This cannot be about completeness; it can only assure him of how far he has come now, and there is no going back, at least for a while.

(A seventh man, a son or husband or brother—that was Berger writing in the 1960s. Today, the workers being smuggled across national borders are no longer overwhelmingly male. Indeed, the immigrant population is almost uniformly gendered female in certain parts of the world. But why only speak of the world as if it were far away? As Andrew Ross informs us in *No Sweat*, "A recent GAO report estimates that over a third of New York's 6,500 shops are sweated, as are 4,500 of L.A.'s 5,000 shops, 400 out of 500 in Miami, and many others in Portland, New Orleans, Chicago, San Antonio, and Philadelphia. In the L.A. basin, $1 an hour is not an uncommon wage in Orange County's Little Saigon, while the New York City wage floor hovers around $2 an hour in Sunset Park's Chinatown." The exploitation of immigrants in sweatshops, first documented by pioneer photographers like Jacob Riis, continues in the heart of most major American cities today. Ross adds: "Women still make up the majority of sweated labor, their sewing skills traditionally undervalued and their homework sustaining the most underground sector of the industry.")

Now I return to my earlier question. Does the woman in the Manhattan street regard the poster as an irrelevant splash of commerce, or does she feel the laceration of keen memory? And is it necessarily one or the other?

Choosing a language different from Barthes, I want to say that the immigrant's experience of looking at an image like that, or often any other, is that of *negotiating* between two poles, one of them anthropological and the other autobiographical. The former is distancing, it imposes on the immigrant the flat weight of being an object of a knowledge exercise, it renders the object powerless. The latter works to help the viewer situate herself in a narrative, it is enabling, and it is self-transformative. It is meaningful because it carries the weight of memory for those not most distant from the event or face being recorded but the ones who are the closest and most intimate.

This division I have imposed between the anthropological and autobiographical is far too simple, I know. Binaries often collapse and there are always third spaces. Consider Richard Wright's *Twelve Million Black Voices*. As a writer, Wright mixes the two modes. The book begins: "Each day when you see us black folk upon the dusty land of the farm or upon the hard pavement of the city streets, you usually take us for granted and think you know us, but our history is far stranger than you suspect, and we are not what we seem." The anthropological as a way of producing scientific data takes on the passion and poetry of the

personal claim to subvert objective knowledge ("we are not what we seem"). At the same time, the autobiographical as the story of a self, narrow and subjective, assumes the force of collaboration and collective identity ("us black folk . . . we . . . our") precisely through documentary.

When Wright writes of different black lives, in an "uneasily tied knot of pain and hope whose snarled strands converge from many points of time and space," he provides a vivid image both for lived history and for writing or photography.

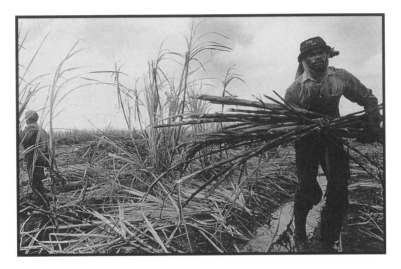

This is a photograph of a Trinidadian Indian peasant whose ancestors were brought to Trinidad from the region around my village in India in the previous century to cut cane. In taking this picture, in beginning to tell a story about the detours of history in the story of postcolonialism, I am producing my own brand of anthropology and autobiography too. The story is not simply limited to one or the other. In addition, it is told here in parts. It doesn't drive to a single conclusion or even claim authority. It arrives at a series of related points from all directions, like people coming to board a train that will take them away. I sit among them, but the journey is not mine alone.

Name

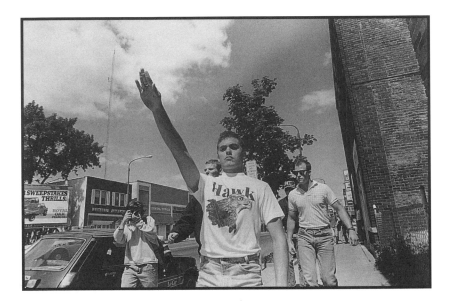

Púchho tó, kiská hai yeh shav?
Rohitáshva ká?
Nahin, nahin,
Har shav Rohitáshva nahin ho saktá

Ask, whose corpse is this?
Is it Rohitáshva's?
No, no,
Every corpse cannot be Rohitáshva

Shrikant Verma

During a recent visit to Trinidad, sitting in a roadside bar near rural Mayaro one morning, seduced by the sign in the heat outside that said Guinness Is Good for You, I asked the woman at the counter whether the man on her poster, the long-haired, bare-waisted singer Chris Garcia, was Indian.

Yes, she said.

More than a hundred and fifty years ago, after the abolition of slavery in the Caribbean, about 134,000 Indian laborers were brought to Trinidad as indentureds. Today, nearly half of the population of Trinidad is identified as being of Indian origin.

In the bar that morning in Trinidad, however, the singer's name presented a new challenge to me. How did he come to have a name like Chris Garcia?

I asked the bar owner about it, but she didn't know. It was several days later, by pure chance, that I read in the Trinidadian Indian writer V. S. Naipaul's fragmentary autobiography, *Finding the Center*, the details of the accidents of a syncretic history that is another name for the postcolonial diaspora.

During Naipaul's childhood Trinidad was poor, even with the American bases, and many poor Trinidadians made their illegal passage to nearby Venezuela. Naipaul writes, "Some acquired Venezuelan birth certificates; so it happened that men whose grandfathers had come from India sank into the personalities, randomly issued by the migration brokers, of Spanish mulattoes named Morales or Garcia or Ybarra."

At once more and less than the story of a straightforward Anglicization—the fate of many of the early immigrants to the West—the name Chris Garcia suggests a detour. Or, for people who had after all journeyed to the Caribbean on ships, it calls for the metaphor of a casting away of what had till then been their vessel, their home, and making for the shore clad only in the skin in which they were being reborn.

Such details of naming resonate with other histories. In the Chinese American writer Fae Myenne Ng's excellent novel, *Bone*, we learn very early on about two Chinese men, on a ship, giving form to their "paper histories." Leon and You Thin Toy carried false papers to get past immigration. Once on shore, You Thin quickly changed back to his real name, but Leon never did. Ng tells us: "Leon liked to repeat what he told You Thin: 'In this country, paper is more precious than blood.'" Leon does not even give anyone the same birthdate twice. He reasons that if

you don't tell the truth you'll never get caught in a lie. In a place where his truth doesn't count, not on its own terms, he produces his own truth as he goes along.

And yet Leon is bound to his own law of preserving the memory of these unstable details of his life. In a moving chapter later in the novel, we see him looking for the bones of his "paper father," Grandpa Leong. Leon is unable to find peace till he can fulfill his promise to send the bones back to China. Leon even has the habit of saving every scrap of paper, including the letters of rejection he has received, in a suitcase. Lei, who is the novel's narrator and Leon's stepdaughter, agrees with him: "For a paper son, paper is blood." She too is like her father. "I never forget. I'm the stepdaughter of a paper son and I've inherited this suitcase of lies. All of it is mine. All I have are those memories, and I want to remember them all."

More than the fact of history's detours or the attempt at memory is a mundane fact: the issue of power, its differential, that leads to that institutional condition of fear which overdetermines, sometimes, even a name. This is what an early sociologist, Paul C. P. Siu, wrote in his pioneering work on San Francisco's Chinese laundry workers:

> In China, it would be regarded as a disgrace to change one's surname. But to change or to assume an "immigration name" in America is justified as a necessity and protection. Obviously, a psychology of fear has developed among the Chinese in this country—fear of exposure of fixed immigration status, and, in fact, a sentiment has developed that the disclosure of another immigration matter is an evil act, and morally condemned as *Hai-chun-tse-ma* [*Haiqun Zima*] (Trojan horse).

And yet the immigration officer, pausing to look at the writing beside the section marked "Name," might do well, if not perhaps better, to reflect on the histories of the names closer to hand. Consider the name of one of America's best-known universities, Yale.

The university is named after a high-ranking functionary of the British East India Company, Elihu Yale. As the governor of the province of Madras, Yale amassed huge wealth along with notoriety. He parted with a portion of that wealth, as Gauri Viswanathan explains, both to support Protestantism in the U.S. and to perpetuate his name.

"Yale College, as surrogate heir to the childless but wealthy English merchant," Viswanathan writes, "inherited a patrimony that united the destinies of American higher education with the fruits of England's em-

pire-building." To recall this history is to go beyond simply reminding ourselves that higher education in America is linked to the plunderings of mercantile capital. For Elihu Yale's gesture was hardly an isolated act: the colonizers gave their names to the streets, buildings, and whole towns in the lands they ruled. How might we better understand that common practice? In Viswanathan's analysis of this process, especially in the case of the heirless Yale, the rulers were able to "bestow their paternity on the colonial landscapes as a gesture of ultimate conquest."

Edward Said traces the process of filiation and affiliation that provides the cultural ideology to accommodate the shifts from the structure of the family to other social contexts in high modernism. Viswanathan gives that insight a more specific charge in the colonial setting. "'Naming' is the link between the two states of filiation and affiliation: a real historical breakthrough occurs when a patronym can be passed down as easily from a man to an institution as from a father to his sons or daughters, circumventing almost entirely the role of the woman in the reproductive process."

To accept the full measure of Viswanathan's argument is to understand names and the process of naming as inextricably tied to structures of patriarchal compensation as well as systematic elisions of gendered agency—not to mention the repressed history of ruthless taxation and exploitation of the colonized population that provides the foundation for the noble pursuit of education in this country.

To link the proper name to those other things improper is also to contest the reading of my passport by the state—it doesn't matter which state, they all follow the same law of the proper—in terms of the name on it, singular, affiliated to the name of the father. And the country of citizenship, only another name for the name of the father, because *especially* as "the motherland," it substitutes through this affiliation, the role of the mother.

How to track and understand the politics of naming, and its representation in colonial history? Gayatri Chakravorty Spivak examines this question by looking at a passage from the writings of Edward Thompson who, in a 1928 study entitled *Suttee*, had written about the then prevalent practice of widow burning (when the surviving widow ascended the funeral pyre of her dead husband and perished in the flames, she became a *sati*). Here, first, is Thompson commenting on one General Charles Hervey's previous writings on the subject:

Hervey has a passage which brings out the pity of a system which looked only for prettiness and constancy in woman. He obtained the names of satis who had died on the pyres of the Bikaner Rajas; they were such names as: "Ray Queen, Sun-Ray, Love's Delight, Garland, Virtue Found, Echo, Soft Eye, Comfort, Moonbeam, Love-lorn, Dear Heart, Eye-Play, Arbour-Born, Smile, Love-bud, Glad Omen, Mist-clad, or Cloud-Sprung—the last a favorite name."

What might be deduced from these names that Hervey translated with such authoritative literalness and utterly presumptive ease? In responding to Hervey below, Spivak foregrounds the difficulty of translation. Hence, her deliberation on the different possible sources for the translated names, and the ways in which they carry intertwined connotations of European fantasy being. Spivak's pointed query here is about the uncertain location of India in Hervey's discourse and, in a closely related way, about the silent woman purportedly being saved by the beneficent Western scholar-administrator:

> What, for instance, might "Comfort" have been? Was it "Shanti"? Readers are reminded of the last line of T. S. Eliot's *Waste Land*. There the word bears the mark of one kind of stereotyping of India—the grandeur of the ecumenical Upanishads. Or was it "Swasti"? Readers are reminded of the *swastika*, the Brahmanic ritual mark of domestic comfort (as in "God Bless Our Home") stereotyped into a criminal parody of Aryan hegemony. Between these two appropriations, where is our constant and burnt widow?

The proper name, turned into a common noun in Hervey's translation, is appropriated for use as a sociological chart by Thompson. Spivak's query about the "constant and burnt widow" also carries with it the reminder that the aura of these proper names owes a lot to the "translating" work of Edward FitzGerald. He was the one who, after all, through *The Rubaiyyat of Omar Khayyam,* presented in the imagination of the West "a certain picture of the Oriental woman through the supposed 'objectivity' of translation" rather than through "sociological exactitude." For those who would read from this kind of "translation" the philosophical maps of a culture, Spivak provides a deft critique: "[T]he translated proper names of a random collection of contemporary French philosophers or boards of directors of prestigious southern U.S. corporations would give evidence of a ferocious investment in an archangelic and hagiocentric theocracy."

When I come across the mention of the fact that early sea captains brought indentured Indians to the United States in the eighteenth century, and when I see the names of these first Indian immigrants to North

America—James Dunn, John Ballay, Joseph Green, George Jimor, Thomas Robinson—I take my cue from Spivak and reflect on the massive, institutional rewriting of peoples and their identities in history. There is no easy access to the identity of James Dunn, indentured in Calcutta and brought to Georgia. I read that at his master's death, the seals were taken off his indenture and hidden in a towel; but Dunn did not burn his papers and sought freedom through the courts. His dark skin, however, was taken as a condition for the denial of civil rights. He was punished for his attempts and sold into slavery. Who was James Dunn? How did he come to acquire that name? How, in asking these questions, can I not help repeating the gestures that Spivak critiques in Hervey?

For let us remember that Spivak's goal here is close to Derrida's, who provided through his critical examination of Lévi-Strauss's anthropological discourse on the Nambikwara, a commentary on what he called "the conjoint intrusion of violence and writing." To write is to participate in that violence, and yet . . . And yet Spivak is also asking a different, more specific, political question: what of the ones who are being thus (mis)named, what of *their* voices?

Rather than providing here a litany of presumed, "authentic" voices, let me answer that question by examining in the texts of postcolonial fiction the drama of names and protest.

The reader opens the pages of Hanif Kureishi's *Buddha of Suburbia* and with the first few lines learns that the narrator is a Londoner by the name of Karim Amir, "an Englishman born and bred, almost." Later in the book, wanting to land a job as an actor, Karim visits a director by the name of Shadwell. Shadwell is to direct Kipling's *Jungle Book* and at one point proceeds to speak to Karim in words that are from Punjabi or Urdu. Shadwell soon learns that Karim doesn't speak "the language." Karim is asked if he has been "there." "Where?" he asks. Shadwell's reply is steeped in authority and authenticity: "You know where. Bombay, Delhi, Madras, Bangalore, Hyderabad, Trivandrum, Goa, the Punjab. You've never had that dust in your nostrils?"

When Karim disappoints him, Shadwell laughs ("a series of short barks in his throat") and says:

> What a breed of people two hundred years of imperialism has given birth to. If the pioneers from the East India Company could see you. What puzzlement there'd be. Everyone looks at you, I'm sure, and thinks: an Indian boy, how exotic, how interesting, what stories of aunties and elephants we'll hear now from him. And you're from Orpington.

And when Karim coolly assents to this, Shadwell rounds off his ruminations grandly by concluding, "Oh God, what a strange world. The immigrant is the Everyman of the twentieth century. Yes?" Well, it depends, Mr. Shadwell. How exactly do you mean? That is the dialogue I'd like to draw this man of the theater into—and I can't.

The immigrant in Shadwell's discourse is one who should be markedly different. Except that he turns out to be, as far as Shadwell is concerned, a disappointment. In my reading of his words, it is precisely the immigrant's capacity to disappoint, to be no different than what he actually always was—plainly ordinary—that makes him "the Everyman of the twentieth century." Except that for Shadwell this ordinariness is a diminished condition. Its presence disappoints him, yes, but it is also what, in the end, allows him to proclaim his mastery over the immigrant. If Karim had suddenly appeared to Shadwell as nothing but a Mowgli in a loincloth, he would have been charmed by the little savage. But Karim turns out to be a letdown, he's never had that dust in his nostrils, and because of that, Shadwell can finally feel comfortable with his little Mowgli.

At the end of Michael Ondaatje's novel *The English Patient*, the reader stands face-to-face with the Indian sapper who has heard on the radio the news of the bombing of Hiroshima and Nagasaki. We see the sapper, a soldier in the British army, unable to eat or drink anything, stripping his tent of all military objects and his uniform of all insignia. He is clad in nothing but a *kurta*, his "body alive in its sleeplessness, standing on the edge of a great valley of Europe."

His alienation is complete. We witness the collision of the phenomenon of Europe and the name that identifies him as its Other: "His name is Kirpal Singh and he does not know what he is doing here."

Indeed, what is a Kirpal Singh doing in Europe or Canada or America? To answer the question behind the riddles of the names like Kirpal Singh, Karim Amir, James Dunn, "Comfort," Leon, and Chris Garcia, is to produce a modern narrative of imperialism and neoimperialism. But in the margins beside the question about what Kirpal Singh is doing in Europe is another one that puts the whole matter in reverse: what are the Kennedys doing in India?

In my high school, on the banks of the Ganges, there were two brothers, their skin as brown as mine, and their parents had named them John F. and Robert F. Kennedy. Two middle-class kids in India, in the 1970s, named after the president and the attorney general of the United States. Although it is now impossible for me to determine the reason for the

names, I wonder why I didn't pause in my childhood to wonder whether these names had their origin in the presence of Roman Catholic missionaries in that part of the world (though even that connection, as Spivak points out in an interview, could be complicated: many of the teachers in the missionary schools were Indian tribals—so called aboriginals—who had converted to Christianity, that is, who "had dehegemonized Christianity in order to occupy a space where they could teach social superiors"). Or whether it'd be better to read in the naming of my schoolmates the "success" of the U.S.-sponsored Green Revolution in India, a revolution driven by the use of capital-intensive techniques that made the rich richer and the poor poorer and, in addition, played havoc with the ecosystem.

Was this naming a precursor of the conditions that I recognized in my better-informed youth when I saw a cartoon in an Indian newspaper in the 1980s showing a little girl with a pot balanced on her head who walks to the well past a large billboard that says "Drink Pepsi"? Ten years later, with the increased migration to the United States of both skilled and unskilled workers from India, it also doesn't seem too out of place to speculate through hindsight whether the parents wanted to mark with those names their sons who might one day travel from that zone of agricultural backwardness to what they saw as the land of distant promise that had succeeded in sending man to the moon.

Or perhaps the Kennedys in India were a part of that greater reality in which religious conversions or, even without them, the mere names were expected to transport the disenfranchised into another social zone. Shashi Tharoor has written an engaging account of a boy called Charlis from an untouchable caste in the southern Indian state of Kerala. (Incidentally, it is the group of Parayan untouchables from Kerala who have given the English language the name for an outcast, "pariah.") Charlis was named after the Prince of Wales. This name is a source of mockery in the upper-caste family in which Tharoor's narration is based:

> Do they have any culture, any traditions? One of them, that cobbler fellow, Mandan, named his sons Mahatma Gandhi and Jawaharlal Nehru. Can you imagine? The fellow didn't even know that "Mahatma" was a title and "Nehru" a family surname. . . . So of course when this upstart scavenger shopkeeper has to name *his* offspring, he went one better. Forget nationalism, he turned to the British royal family. So what if they had Christian names? So what if they couldn't pronounce them? You think Charlis is bad enough? He has two sisters, Elizabeth and Anne. Of course everyone in the village calls them Eli and Ana.

Eli and Ana, as Tharoor's narrator informs us, meant "rat" and "elephant" in Malayalam. So that the appeal to royalty didn't really, in the end, secure a release for the sisters from the ways in which their names had been inscribed in the social system right from birth.

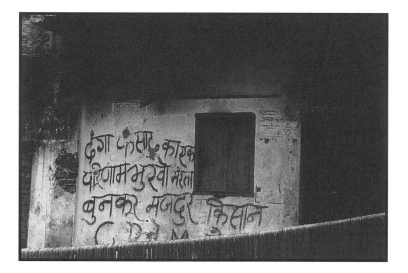

Riots in India are fought in the name of god.

It is in the name of the poor and those hardest hit by this violence that resistance is organized against those riots by Left parties.

The slogan painted on this gutted wall of a store in Bhagalpur—witness to some of the worst Hindu-Muslim riots since 1947—in Bihar, India, reads *Danga fasad ke ek parinam / Bhookho marta bunkar, majdoor, kisan* (In this alone the results of riots lie / From hunger weavers and peasants die).

In the days immediately following the riots in 1989, this slogan represented a part of the measures taken by various individuals and groups to begin clarifying the politics of such religious or, in the terminology common in India, "communal riots." The People's Union for Democratic Rights brought out a comprehensive report on the Bhagalpur riots after the killings were over. It was necessary, explained the union's Professor Uma Chakravarty, to see how protest and class solidarity were being deliberately blocked through vertical mobilization along religious lines.

This writing on the wall participates in the agenda spelled out by Chakravarty. Graffiti like this, reflecting the history of struggles in and

across religious communities, among the working class for instance, forge an alternative sense of community. Among the impoverished weavers of Bhagalpur, for instance, it is common to describe the relationship of the Hindus and Muslims by using the metaphor of the warp and the woof in weaving. A metaphor like this acquires a lot of resilience at certain moments of historical importance as when, four months after the riots, Hindu and Muslim weavers observed *shaheedi diwas* (martyrdom day) to commemorate the day in 1987 on which two weavers, one Hindu and the other Muslim, Shashi Kumar and Jahangir, were killed "by a single bullet" from the police who fired on the weavers' demonstration against the government.

The two names, inscribed together, produce the name for a united community. Rushdie's *Midnight's Children* recognizes the importance of names in India but also the limits of this fact: "Our names contain our fates; living as we do in a place where names have not acquired the meaninglessness of the West, and are still more than mere sounds, we are also the victims of our titles."

My own parents named me after Gautama the Buddha (one of the titles for his wisdom was the "One of Endless Light," *Amit-abha*) who found enlightenment at a place a few hours drive from my own hometown, Patna. Patna is the capital of the state of Bihar where names tell their own story. (Or perhaps I should say, these are stories that remain to be told. Who in Scotland tells the story, I wonder, of one of their towns named Patna because of the fortune made in colonial times from Patna rice?) The poorest in Bihar are known by the caste name of *Musahar*— rat-eaters. The refuse of a moribund semifeudal society, this caste has indeed subsisted on field mice and agricultural waste. "A common name among Musahars is Bhukhan (*hungry*)," writes the commentator Arvind N. Das. Das notes the cruel irony that "hungry Musahars have been given the surname 'Rishidev,' after the sages of yore who voluntarily starved themselves."

Even the name of my home state is drawn from the Buddhist monasteries—*viharas*—that were built when an institutionalized Buddhism reorganized itself in the region as a set of fiefdoms. But that historical memory is hardly alive today and is rarely acknowledged. And yet the memory of Buddhism leads me to raise a question of contemporary relevance. Popular lore suggests that the sight of a beggar, a sick man, a corpse, and a sannyasi who had renounced the world moved the Bud-

dha to give up his princedom and seek the meaning of life. If I follow the logic of Rushdie's writing on names and their limits, one question emerges forcefully: if the sight of the poor and the destitute, the dead and the dying, is all that it takes, why aren't there a million Buddhas in India?

The question is rhetorical. Not because it doesn't require a response but in the sense that it calls for an effort of understanding. We must ask: in what form, in what places, in whose name, does the question appear?

In the name of the poor and the unemployed—because the name of the poor is open for use both by their representatives and by the rich—the government of India instituted in the 1990s the New Economic Policy (NEP) sponsored by the World Bank and the International Monetary Fund (IMF). The long-term goals of this plan involve the opening of the doors of internal and external markets to competition, largely through the increase of foreign direct investment and privatization. While the supporters of the NEP have touted its successes in terms of increased foreign investment, the new policy will have—is already having—deleterious effects on working-class households.

In the representation of the NEP by the rulers or the dominant media, the subaltern classes and groups do not have a voice. That resistance is articulated in more marginalized forms or not at all.

One example of a site of resistance is *Aadhi Zameen* (literally, "half the earth"), a magazine that is now the journal of the AIPWA (All-India Progressive Women's Association).

Aadhi Zameen was launched in 1991 in opposition to the other magazines for women in India that were, according to the editor, Meena Tewari, "catering to the bourgeois needs of providing women information about making pickles and using cosmetics." The publication of this journal is a protest against the narrowness of that part of the feminist movement that struggles only against patriarchy, that believes "the policeman rapes only because he is a male and not because he is also a part of the state"; at the same time, this journal also attempts to correct the gender blindness of the peasant-workers' movements that have ignored questions of "gender-equal distribution of wages and gender-equal representation in the organizations of the movement."

I invoke this feminist magazine in the present context because I was witness, in August 1994, to the huge protest organized by the women associated with AIPWA against the NEP. Drawing attention to the connection of multinational capitalism and the exploitation of working-class

women, the August rebellion (scheduled—indeed *named*—to coincide with the commemoration of the "Quit India" movement launched against the British in August 1942) also made clear that the organized resistance by such women is under way in India and that those fighting against exploitation everywhere share solidarity in such struggles.

Of course, it is not only in the history books that people are named one way or the other, as actors or as bystanders. The process of naming goes on in films, in speeches, in classrooms, in novels, in conversations. There are other ways in which women—and even men—are being named in India also in the matrimonial columns of the national newspapers. In fact, it is not only the people but India itself that is being named.

Dear sirs and madams, it is in the matrimonial columns where the history of my country is being written. In proper relation, of course, to the rest of the world: hence, the constant appeal to the West, and the Non-Resident Indian, the N.R.I.

"Beautiful Fair Convented Preferably Professional Match for Kayastha fair handsome 30/172/65 B.E. (Elec) M.S. (Computers) working multinational USA status family. Write Box 82319."

"Parents of Rajput boy with British citizenship Post Graduate 27/181 belonging to affluent, traditional business family invite matrimonial correspondence from parents of slim beautiful tall educated homely girl from cultured family. Boy and family visiting India in September. Write Box 3594."

"Engineer, Doctor, C.A., from status family settled abroad preferably US citizen/Green Card holder for slim wheatish-complexioned religious-minded Sunni Pathan girl, 22/176. GRADUATE WITH DIPLOMA IN COMPUTER SERVICES MANAGEMENT. FLUENT IN ENGLISH. Send biodata and photo to Box L-22319."

"Academically brilliant boy for Jan 1964 born girl/156 IIT-M graduate Indiana University Ph.D. Willing to settle abroad. Early marriage preferred. Contact Ms. S., 9th Cross, 5th Main, Mysore."

"Bengali parents settled in Bombay invite correspondence with photograph only from N.R.I.s soft-spoken vegetarian settled in USA, Canada or Australia for Brahmin (Sandilya) virgin girl, 5'5"/23 yrs. Language no bar. Write Box 92096."

Rishte hi rishte, mil to lein. Lots of relations, try at least. This is the language of the literate classes. In these sentences you find the vocabulary of the dreams of those who own apartments in the New Economic Policy. Shame: No Bar. Daughters are dressed up in the language of the privileged; sons are made to reveal in the most naked form their access to privilege. In their unpunctuated rhythms, these words convey the desperate seeking of one of their own kind before the gravitational pull of poverty or mischance drags them under. Gone, *khatam!*

Country. Seeking financial tourists to invest. Divorced after first marriage to Britain. Well-behaved countless English-speaking issues and hostile siblings. If having taste for adventure, land aflame with struggles. All to be curbed by police danda-stick, and the police to be curbed by proper fixed-price hafta bribe. IMF-World Bank affiliates preferred. Others welcome to apply with proper payment.

In this commercial language, only names matter. And hence, they don't matter at all. You could be named Pal, or Kal, or Dalal. And you could be flying British Airways, Lufthansa, or Air France—it doesn't matter at all.

Your name is Pal, or Kal, or Dalal. You've lunched at
 Delhi's Ashoka Hotel
with the Trade Secretary today, tonight you will meet the
 Finance Minister.
The Mercedes you've hired will take you to the
 Minister's home, your driver
will discreetly follow you with the gifts in the bags
 marked Tax-Free.
You will shake the Minister's hand, he will barely glance
 at the bags,
you will have a polite exchange for ten, maybe fifteen,
 minutes.
The next day, you who are named Pal, or Kal, or Dalal,
 will get a call
from the minister's secretary. Your papers have been
 signed. It is cool inside
the hotel now. You wait for the Industry Secretary. He's
 a dignified man,
he studied Indian history at Cambridge and tells you the
 dates of the years
the Hindu king after whom the hotel has been named
 occupied the throne.
He's very precise in his use of English. Yes, he will have
 wine during lunch.
He admits that he smokes and you leave your fresh
 packet of Rothman's
near his elbow with a Cartier lighter beside it. Please
 don't shame me,
this is what you say when the Secretary returns your new
 lighter.
You are eager to hear what he has to say about Western
 development,

and why India remains so poor, even though we have
 everything.
Again, with an economy that is enviable, the Secretary
 says Everything,
and he gestures at the remains of the meal, the saag
 cooked in butter, lamb,
the Peshawari pulao that the chef, an old refugee,
 prepared for you.
You feel good about being the frontman for Pepsi or
 AT&T or John Deere
in India. You who are named Pal, or Kal, or Dalal,
 follow the Secretary's gaze
as he looks at the well-dressed men around you, a
 woman in a blue silk sari
is laughing, her head tilted back, black hair falling
 behind her cane armchair.
You nod when he says, The rightists are backward, and
 the leftists wrong.
Tomorrow you will catch your plane to New York City.
 You will fly Air India,
you always do, because you're loyal to your country,
 though you're at home,
of course, also in the elite cabins of British Airways,
 Lufthansa, or Air France.

Among the Pals, or Kals, or Dalals, as an Indian immigrant in the
United States, I feel caught between two histories: an earlier one, in the
beginning days of this century, when Indians on the West Coast were
called "ragheads" or "the filth of Asia," and a more recent history, in
which a privileged, middle-class, often rather conservative presence of
fellow Indians has earned us the narrow status of a "model minority."

In choosing between the two impossibles, I set myself the task of de-
scribing the process of naming. And of finding, returning here to Said's
terminology, another set of affiliations, and announcing solidarities with
others misnamed. It means resisting the fear as well as the narrow class-
alliances of the mother, in Hanif Kureishi's short story "We're Not Jews,"
about whom her son says: "But Mother always denied that they were
'like that.' She refused to allow the word 'immigrant' to be used about
Father, since in her eyes it applied only to illiterate tiny men with down-
cast eyes and mismatched clothes." It also means aligning myself with
the kind of activism envisioned by Chandra Talpade Mohanty when she
writes: "Having always kept my distance from conservative, upwardly
mobile Indian immigrants for whom the South Asian world was divided

into green-card holders and non-green-card holders, the only South Asian links I allowed and cultivated were with Indians with whom I shared a political vision."

This task brings me and other immigrants, as both Kureishi and Mohanty would also insist, to a space of common ground where we can explore our similar histories. I turn, once again therefore, to other names.

In his meditation on the naming of Mexican immigrants in the U.S., the French philosopher Jean-Luc Nancy writes: "You are called *Chicanos*. This name shortens your name, Mexicanos, in the language that was once yours but has not remained the language of each one of you. Your name was given back to you, cut."

Nancy traces the turns within the language of naming. "*Gringo*, the name you use for the white American (who claims to be white), derived from *Griego*, the Greek, who was in the past, the typical foreigner. The same foreigner that made you foreigners on your own land, on the land that everybody and nobody owns."

The word that is produced from a cut—Chicano—cannot leave everything else intact. It cuts into all other meanings, all claims of purity and, I'd add, claims of innocence. A new, shared difference is produced. Nancy names that third term of difference: "'Chicano' breaks into my identity as a 'gringo.' It cuts into and re-composes it. It makes us all *mestizo*."

As Native Americans protest the appropriation of their tribes' names, what they are raising their voices against is not the emergence of a mestizo culture: they're telling mainstream America that when a people serve to provide names for corporate commodity culture, what is being produced is a wretched culture.

In the town of Gainesville, Florida, where I teach, what makes another man my brother is that we root for the same football squad and piss warm beer on the other team named after a Native American tribe that doesn't today even have a truck named after it.

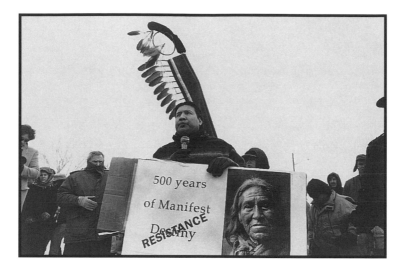

I took this photo outside the Superdome in Minneapolis where the members of the American Indian Movement were protesting the name of one of the teams—Washington Redskins—playing in the Superbowl that day.

This is a culture that even turned Sitting Bull and his revolt into a bit-part in a traveling circus run by a guy who called himself Buffalo Bill.

Of course, I'm aware of the critical warning that "multiculturalist diasporists"—that would include me—are actually like that in-between figure Buffalo Bill Cody. In the same way that Buffalo Bill acquired the freedom of Wounded Knee participants so that he could put on display the show called Wounded Knee, diasporic intellectuals stage "culture" in First-World multiculturalism. Perhaps.

When I ask myself or readers of this book the critical question "Who is given the name 'immigrant'?" I am indeed "staging" culture. But what this staging enacts is, in some measure, the mechanism of our social ideology. The critic is saying, "Watch me reveal myself, reveal you . . ." Now show me . . .

The picture conjured in my mind by the word "immigrant" need not have anything to do with a real newspaper report about a Mexican couple being clubbed by two white Riverside sheriffs on a highway in El Monte, California.

The ordinary signifiers linked to racial or national identities need not have fixed, solid referents. Often, they are anchored in the zones of our collective fantasies.

For example, I could be lying in bed—as I was only half an hour ago—reading a poem whose opening lines are:

> Today you are wearing a white body marked vertically and
> horizontally with the stripes of underwear, garter belt,
> stockings. You move unsteadily on the two black bars of your heels.

The poem is written by a poet whose name is Evelyn Lau. It appears in an anthology of Asian American poetry. In the poem, a bald man sits on the side of the bed playing with spoons and baking powder and cocaine.

Is he white? She clearly isn't, I tell myself. I work through a small, scattered drama of sexuality and power that burns close over the words and gathers like smoke. I inhale. I quickly decide that the narrator "wearing the white body" is a woman of Asian origin. The bald male, the client, is white.

> Through brown slits he watches you
> open your legs. Wider, he says. You gather one breast
> up in two hands and place your own nipple into your mouth.
> Good girl, he says.

To be white is to be able to say "Good girl" when a woman puts a nipple in her mouth.

That man has a beach towel under him to protect his sheet when he comes. But I'm not taking any precautions at all. By the time I reach the end of the page, I can hear the loud noise of helicopter blades that are actually in another poem three pages away.

The sum of my responses to Lau's poem reminds me that encounters with race, characteristically clichéd or not, and whether or not they are faithful to seemingly obvious facts, are often colored by fantasy. In those dark chambers, what is revealed always hides something else. These experiences, given the power of the patriarchal dominant, are also always irreducibly gendered. Unavoidably, they engage a whole variety of complicities and contradictions of identities: racial, class, sexual, and assorted others.

In language, specifically in the field of writing, I have discovered road maps to immigrant conditions. In memoirs and daily journalism, in the fictive space of novels by writers of immigrant origin, in poems written to celebrate or condemn hybrid existences, the construction and critique of dominant white racism go on. In a space beyond scholarly discussions, using codes other those of academic political correctness, in the routine flows of everyday language, identities stall—or stumble. And often, with

a dull and somewhat tiresome brutality, racism extracts a terrible price
from those most unaware of having been drawn into an exchange of mis-
taken identities.

In a suburban, American home standing on a Kashmiri
 carpet
that has been brought from India the last time relatives
 came here to visit,
as you offer these riddles to flavor the dinner of tandoori
 and saffron-colored biryani,
your host sips his scotch which back home he would buy
 for nine hundred rupees
on the black market, and then he feels secure enough to
 say that you are right,
the Indians call all Nepalis Bahadurs as if they had no
 other names, and that's
mistaken identity, but you have to admit that every time
 an American shakes my hand,
he or she has to pledge their love for Indian food and I
 can't even say I thank you
—on behalf of Indian food. The repeated joke carries
 away his indignation
and as his wife waits to serve him the food she has
 cooked, your host provides
you space to note around him the wide measure of his
 Indian identity: the classical
music of Pandit Jasraj, the distinguished books of
 literature, Tagore's fabulous art
—in their wealth irreducible to a plate of food, however
 rich.

In London the visiting Korean and Japanese businessmen
 buy silk lingerie
in the shops behind Globe Theatre but you read recently
 that the Indians and Pakistanis
there have been paying thirty pounds a head to watch
 the lesbian double-act
of two Muslim girls, Zarina and Qumar, and what sort
 of mistaken identity is it
that makes you connect all that to the stories of
 transported loves
of a friend whose hands are small and brown like your
 mother's
telling you in a bar in New York that her current
 American boyfriend just asked her
when she'd get over her difference, she could not use her
 being Indian as an excuse,

he said, the way people keep blaming the fact that their
 parents were alcoholics,
when in fact in trying to save her he is forgetting so
 much, just like those Asian
butchers who hacked a Muslim prostitute in Southall
 halal-style, letting her bleed to death,
and in any case it's excuse enough for your friend to
 declare her distance
from her love for this man who was pledging Sigma Chi
 in Michigan
while she was eating bhelpuri in Bombay.

Mistaken identity is not, however, a name that you can
 pin on
to the face of the anonymous killer on the notices put
 out by the police.
Instead, it is like a new line you might draw on a map to
 link two places
in a relation that is yours. It is like snatching away the
 mask that the President
of this country wears when he plays golf and moulding it
 into a toy for a child,
a shelter for the homeless, a fresh slogan for change or a
 poem about the future.
Naming only fixes you as one or the other, the substance
 or the shadow.
It is not enough to say that the worker who was killed
 was called Jeevan.
It is not enough to say that Jeevan was a worker at the
 Modi metal factory.
The point about mistaken identity is in a sense not about
 names at all:
it's just about declaring that it is never enough. For if it
 were enough . . .

In present-day U.S., it is not difficult to find sympathetic ears—and a
publishing house—for a language of unqualified racism against recent,
which is to say dark-skinned, immigrants.

Very early on in *Alien Nation*, in what he flatters himself is an exposé
of the immigrant conditions in the U.S., Peter Brimelow, its author and
a writer for *Forbes* magazine, confronts the horror of the Third World
in the heart of darkness that is New York City:

> Just as when you leave Park Avenue and descend into the subway, when you
> enter the INS waiting rooms you find yourself in an underworld that is not
> just teeming but is almost entirely colored.

After bemoaning that in 1990 only 8 percent of the legal immigrants to the U.S. were from Europe, Brimelow addresses what he supposes are his like-minded readers: "You have to be totally incurious not to wonder: where do all these people get off and come to the surface?"

Brimelow, an Englishman who is now a naturalized American citizen, froths at the mouth when witnessing the demographic changes in his adopted country because he believes that "the American nation has always had a specific ethnic core. And that core has been white." This race enthusiasm pushes Brimelow to proffer bigoted advise to his ordinarily conservative colleagues when they happen to disagree with him. For instance, A. M. Rosenthal from the *New York Times* wrote that "this country should have the moral elegance to accept neighbors who flee countries where life is terror and hunger, and are run by murderous gangs left over from dictatorships we ourselves maintained and cosseted." To Rosenthal's conclusion, "If that were a qualification for entry into our golden land, the Haitians should be welcomed with song, embrace and memories," Brimelow responds. "Be careful about those embraces, Mr. Rosenthal, sir. Some 3 percent of the Haitian refugees at Guantanamo tested HIV-positive."

From George Washington who said, during a phase of the Revolutionary War, "Put none but Americans on guard tonight" to Theodore Roosevelt who declared, "There is no room in this country for hyphenated Americans," Peter Brimelow finds loose examples for inspiring racial prejudice. And in a text that's nearly three hundred pages long, he spews contempt for "all those endless newspaper columns about Vietnamese valedictorians and the delights of ethnic cuisine." The reality, of course, is that more newspaper columns get written about immigration as a *problem* threatening the North from the South—rather than a global issue engendered by the very structure of capitalism whose principal beneficiaries live in the North.

In *Alien Nation* Brimelow goes on to suggest that dogs be set on people trying to illegally cross the U.S. border to find work. (To be fair to Brimelow, he is not entirely insensitive. He points out that "the dogs don't have to *eat* the illegals.")

At one point, Brimelow quotes Raoul Lowery Contreras, a columnist writing for a Sacramento weekly paper, *El Hispano*. Contreras was contesting a point raised by George Will, who in turn was using Brimelow's critique of the 1965 Immigration Act that allowed foreigners, including people of color, to emigrate to the United States. George Will wanted im-

migration supporters to "explain why they wish to transform the American nation as it had evolved by 1965."

Here's the lengthy quote from Contreras, answering Will, that Brimelow cites:

> In their precious 1965, I was 24 years old and, though I was a veteran of six years service in the American armed forces and a life-long U.S. citizen, I could not vote in some Texas counties. Fellow Marines, black Marines, couldn't vote in at least ten states of the land of the brave and of the free.
>
> . . . In 1965, black children were murdered by white males in many ways, in many places, in the South. Black male adults were beaten, killed and castrated in Mississippi, Alabama, Arkansas and other Southern states for the crime of having a black skin. . . . In 1965, though a veteran, college graduate and political professional, a bartender refused to serve me a drink in a Texas bar because, he said, "We don't serve foreigners."
>
> That was Brimelow's and Will's 1965 America. Unfortunately, it was my 1965 America also. *That's the America that needed to be transformed and that's exactly what's happening*, Brimelow, Will and Metzger [leader of the White Aryan Resistance, a neo-Nazi group] notwithstanding.

To all this, Brimelow can only say in bold defiance, "Even at the height of Jim Crow Era, the United States was not Hitler's Third Reich." He then goes on to fault Raoul Contreras for "his profound alienation from America—and his conscious support of immigration as a way of striking back." More than a hundred and fifty pages later, Contreras's name comes up again. This time it is in the context of Brimelow's suggestion that racial intermarriage might be a good way to ensure assimilation of aliens into the shared, national fold. And Contreras, he notes, is part Anglo, the child of a mixed marriage. The conclusion a reader is to draw from this information? "Intermarriage cannot guarantee social harmony. That can only be done by an American majority that is confident and strong."

Welcome to the United States of Amerikkka. Give me *all* your tired, your poor, your huddled masses and I will join them under one race, one nation, and one father.

In Brimelow's prose we are treading the fantasy landscape of whiteness. Lawlessness and disease are, for Brimelow, immigration's chief gifts to the U.S.; to top them, there is, he claims, "increased mismatching with the U.S. Labor market." Here, as in almost all other aspects of Brimelow's arguments, it is important to recognize that commonsensical assumptions (rather, racist prejudices) form the basis of a predetermined conclusion. For a dissenting view, we might refer to the economist Julian Simon. In

his book *The Economic Consequences of Immigration*, Simon writes that "even throughout the early history of the U.S., immigrants did not arrive with less education than natives had—contrary to popular belief and contrary to the famous poem by Emma Lazarus at the base of the Statue of Liberty."

> Give me your tired, your poor,
> Your huddled masses yearning to breathe free,
> The wretched refuse of your teeming shore,
> Send these, the homeless, tempest-tossed, to me:
> I lift my lamp beside the golden door.

Simon goes on to provide in his book the results of his (and Stephen Moore's) survey of the economists who had been past presidents of the American Economic Association as well as those who had been members of the president's Council of Economic Advisors:

> In answer to the question "On balance, what effect has twentieth-century immigration had on the nation's economic growth?" 81 percent answered "Very favorable," and 19 percent answered "Slightly favorable." None of these top economists said that immigration was "slightly" or "very unfavorable," or felt that he or she did not know enough to answer. This extraordinary consensus belies the public picture of the economic profession as being on both sides of all important matters.

In fact, the gap between what is commonly believed and what is the reality seems to be at once more basic and more pervasive. It is perhaps best expressed by these facts cited in an article in the *New York Times*:

Percentage of the United States population that white Americans think is Hispanic: 14.7.

Percentage that is Hispanic: 9.5.

Percentage that white Americans think is Asian: 10.8.

Percentage that is Asian: 3.1.

Percentage that white Americans think is black: 23.8.

Percentage that is black: 11.8.

Percentage that white Americans think is white: 49.9.

Percentage that is white: 74.

In the end, this is what it comes down to. The poverty of the immigrant conditions is that truths are doled out to us in a parsimonious economy of numbers. And to produce other, richer, more complex narratives

is to perform the task of the culture mugger. I say that not cynically, but with a certain delight. For the reality of postcolonial names offers ready evidence of the way that the language text of history itself resists not only the poverty of statistics but, more important, the reductiveness of dominant namings.

Farrukh Dhondy offers an object lesson in his novel *Bombay Duck* about the names of food items in Indian restaurants in England:

> Bombay Duck is not a duck at all. In fact it should be spelt Bombay Dak. What it is, is dried fish (known in Bombay as Bombil) and when the British introduced the railway system to western India under their Raj, it started going in wagonloads to the interior from Bombay. The crates stank of dried fish, like stale penises. They were marked "Bombay Dak" literally "Bombay Mail." At the time the railway was run by whiteys. The English may call a spade a spade, but they don't call "stinking fish" by that name. They referred to it euphemistically as "Bombay Dak," the Bombay Mail.

Place of Birth

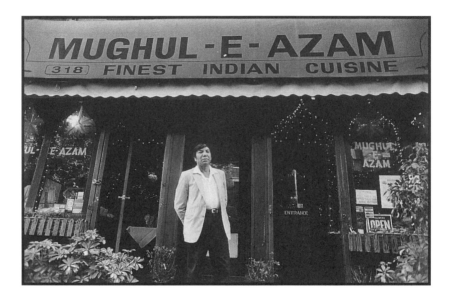

Hamaar gaon hai ala babua, hamaar gaon hai ala
Beta hai bandook uthaulé, baap japé hai mala

My village is unique, little sir, my village is unique
The son has taken up arms, the father counts his rosary

Mathura Prasad Navin

One morning during the Persian Gulf War, I had a strange thought, as if in a dream.

The Americans had turned each home in Baghdad into an oven and waited for the Iraqis to turn up as cooks in the U.S.

Like the Vietnamese before them.

If immigrant realities in the U.S. were only about ethnic food, then my place of birth, for most Americans, would be an Indian restaurant. That's a bit extreme, perhaps. And yet—imagine this happening over and over again: when a stranger asks you where you are from and you say "India," he blows air as if to cool his mouth. Then he grins and says "Curry!"

The immigration officer turns over the passport in his hand, his eyes traveling over the name of my place of birth. Does he recognize that, to some extent, immigrant savvy determines our origins? And as a result that our origins are not quite fixed. That instead they're simply locations for certain narratives we spin about culture, ours or theirs. Take the Indian restaurant, for instance. Naheed Islam writes that Bangladeshi businesses call themselves "Indian," choosing this name as a more recognizable, marketable identifier:

> Older Bangladeshi restaurants bear names such as "Tandoori Nights," or "Gate of India," for they reach out to a clientele who can not, or does not, distinguish between peoples of different South Asian nations and commonly mis-identifies most of them as Indian. Bangladeshis play on such mistaken identities but at the same time—as in the case of the restaurant "Gate of India," where a Bangladeshi artist has painted a mural of a "typical" scene in Bangladesh—they find ways to assert their own construction of identity.

The man who grins and says "Curry!" as if he has said it all is very different from Salman Rushdie who says of India "we were not so much sub-continent as sub-condiment." I see Rushdie wittily claiming a history, while my hypothetical interlocutor is only unwittingly erasing it. What is the history, you might ask, behind "curry"?

"Whenever Indian food is mentioned," writes Shashi Tharoor, "the non-Indian says with a knowing nod, 'Ah yes, curry.' Unfortunately, though, there is no such dish." Tharoor goes on to say that curry, essentially, is "any dish with a gravy" and, of course, there are countless dishes like that in every major style of Indian cuisine. In a sense, then, the non-Indian's use of the word "curry" is catachrestic (the *OED* defines catachresis thus: "Improper use of words, application of a term to a thing which it does not properly denote, abuse or perversion of trope or

metaphor"). In the writings of Gayatri Chakravorty Spivak, the idea of
a catachresis as a metaphor without an adequate literal referent becomes
a model for all metaphors, all names. For Spivak, this concept allows her
to essay descriptions of subjects and processes that occupy as yet un-
namable spaces. My own aim, in linking "curry" with "catachresis," is
to ask a slightly different question. If the word "curry" doesn't have a
stable referent or a fixed origin, how can its changing use by postcolo-
nials be seen as a sign of resistance?

In Ziauddin Sardar's playful presentation, we learn that "curry" has
enjoyed many recuperative uses at the hands of subcontinental immi-
grants. In the 1960s, Indian restaurants straightforwardly catered to Raj
nostalgia with names like "Last Days of the Raj"; during the next phase,
there was a reclamation of an indigenous history, and thus it also be-
came common to see names like "Taj Mahal" and "Red Fort"; during
the third stage, the restaurants' names like "Bombay Brasserie" repre-
sented the infusion of new ethnicities and also a certain self-confidence;
and now, in the most recent phase, the names quietly advertise the likes
of "Café Laziz" in order to indicate authenticity of expression.

In this journey from a working-class food to the most popular cuisine
in England, "curry" as the catachrestic origin has shown a unique, trans-
formative potential. Like Marcel Duchamp, who introduced the urinal
into the art museum, the Indian restaurateur has added the *balti* (bucket)
into the elite category of cordon bleu pots. Those terms that had been
considered static markers of origin have been open to change, and, equally
important, Sardar writes, they have transformed the British culture. Ac-
cording to Sardar, the Indian restaurant "has cosmopolitanized and hu-
manized a very parochial and sanitized people."

As he turns the passport over in his hand, I want the immigration of-
ficer to look up and grin. He should say to me, "Now that you have come,
Bollywood will come to Hollywood, and curry will be eaten in a hurry."

The place where I come from

Is the weary arm of the woman
that has been grinding corn
since the light of the stars

began to fade over the temple
where the priests will receive
the flour from the woman's master.

The place where I come from

Is the brown back
of the untouchable that can shift
so easily the weight of the sack

of the moneylender's wheat from
the twentieth vertebra to the twenty-
first on an empty stomach.

The place where I come from

Is the tongue of the mad
fakir that summons stories
of fever and chaos

which make strange sense
to some who are now possessed
and imagine redemption.

Far away from this desk in a white-walled room where I sit writing
this for you is a river that flows in our native land.

Invisible to the person standing on the roof of the tallest skyscraper
in front of me, lost in sounds that are so unlike the nearby noise of fast
cars passing on roads that loop in the air, buried among banks that hide
the salt of darker skins, that river, Kuano, still flows years after the death
of the poet Sarveshwar, who had his home on its banks. He once wrote:

Kuano nadi, sankri, neeli, shaant
Jaane kab hogi aachitij, laal, uddhaam,
bahút gareeb hai yeh dharti
jahaan yeh bahti hai.

Kuano river, thin, blue, calm,
when will it spread to the horizon,
turn red, turn turbulent,
very poor is this land where it flows.

I raise my head and smell the air. Beside me is the open window. I
suddenly imagine a tea shop near a familiar village path beside which
there are quiet explosions of red *gul-mohar* flowers. And I hear coming
from that space, rising in strength, the words of "the people's poet,"
Nagarjuna:

Yahi dhuaan main dhoond raha tha
yahi aag main khoj rahaa tha
yahi gandh thi mujhé chaahiyé
baroodi charré ki khushboo!

This was the smoke I was seeking
This the fire I was looking for
This was the smell I wanted
the scent of gunpowder shells!

Beside the words "Place of Birth" in my passport is scribbled the single word "Ara." But my passport, quite understandably, holds none of the words that the poet Nagarjuna wrote about the place. Ara is a small district town; the district's name is Bhojpur, and that is the title of Nagarjuna's poem.

In the poem, Nagarjuna implores a small boy not to allow the poet to leave Bhojpur for Patna or Delhi. He wants to be allowed to fill his nostrils with the scent of gunpowder. He wants too the acrid taste of police brutality on his tongue. He wants to write, he says, about the battle maneuvers of the sons of the soil.

In Bhojpur, our poet declares, you find the mausoleum of non-violence, here too is the parliament's grave. Why does he feel this undefeatable rage? More crucial, what is the reason behind his joy?

In 1986 a detailed document was published under the title *Report from the Flaming Fields of Bihar*. The organization responsible for the publication of this report was the Communist Party of India (Marxist-Leninist). This was the same party that had been responsible for the peasant uprisings in the late 1960s and early 1970s under the label of the Naxalite Movement, named after the village in West Bengal where the first rebellion for land rights took place in May 1967. Twenty years later, the movement had become dissociated with its origin and was identified entirely with newer struggles elsewhere in India, most prominently Bhojpur in Bihar.

Bihar, where Gandhi had launched his satyagraha movement earlier in the century, had emerged as the crucible for a new kind of struggle and consciousness. In a region of chronic poverty and caste-class exploitation, the CPI (ML) document presented a changed world, a world of ill-fed and ill-clad people up in arms, flinging a challenge to an oppressive agrarian order: *Joté boyé katé dhaan, khét kaa maalik wahí kisaan* (those who till and sow and harvest, only they are the owners of the land). Srikakulam and Telengana, which had been legendary names associated with popular struggles in the earlier decades in other parts of India, were reinvented in a fresh period of struggle just when their invocation had begun to seem an act of empty nostalgia.

These peasant struggles contest the way in which we tend to inscribe time and its passage under the sign of Western hegemony. As the CPI (ML) leader Vinod Mishra commented after the collapse of the Soviet Union, "There was a time when the specter of communism haunted Europe and now the specter of Europe is haunting communism everywhere." The question that Bihar's struggles force on us is whether the Third World and its peoples have a future different from Europe's. It seems that Western analysts, in declaring capitalism the chosen path for the Third World, are unprepared to grant the Third World any legitimate identity, an identity that need not be yoked to Europe's triumphs and failures.

As I teach my seminars in the classrooms of the U.S. universities, I sometimes need to stop and remind myself of the distance in time and space from that scenario in my birthplace where conditions are such that even the Public Works Department of the government of Bihar has a special Naxalite cell. The cell has been entrusted with the task of constructing roads in the areas where peasants are rebellious. Those who do not have access to roads that will take them to schools or hospitals finally get roads so that the police and the army can take swift action if the property of the landlords is in any way threatened.

Another way to remind myself of that other world, the world I've left behind, the world linked to this one only by hidden lines of capital and exchange, is to translate its writings. For some time now I have been translating the poetry of Alokdhanwa, who lives and works in Patna. Alok has been a poet of the revolution and a partisan in peasant struggles. He sees the appearance of his own poetry among the traditional aesthetes as the intrusion of a shepherd in the museum of poetry, as unexpected as the sight "in Sahu Jain's fish-tank / instead of the fishes, afloat, the corpse of Gajanan Madhav / Muktibodh." The image of the revolutionary poet dead in the fish tank of India's best-known capitalist patron of writing speaks powerfully of the place that protest poetry is consigned to in the institutions of the arts. Determined to struggle in the domain of poetry in Bihar, Alok maneuvers his critiques against those poets, including those on the left, who "show themselves again and again the serfs of that one face / the map of whose bathroom is bigger than the map of my village."

In my classroom in the U.S., however, in a seminar I'm teaching on writing and politics, I'm brought up short by the following words in a book on poetry in the age of media: "The real controller of the game is

hidden from us, the inaccessible system core that goes under the name of Read Only Memory (ROM), that's neither hardware that you can touch nor software that you can change but 'firmware'. . . . We live in a computer age in which the systems that control the formats that determine the genres of our everyday life are inaccessible to us."

True enough. But Alok's poetry? Who will build roads to, or for that matter, plug computer terminals into the huts of the people he writes about? And, just how inaccessible *are* they to us? To counter the sanctioned ignorance that makes him invisible Alok delivers an object lesson—and provides a map of the place of my birth.

ALOKDHANWA, OPEN FIRE POSTER

This is the twentieth April of Nineteen Seventy-Four or
a professional assassin's right
hand or the leather glove
of a detective or a spot stuck on the binoculars
of an attacker?

Whatever it be—I cannot call it just another day!

Where I am writing—this is a very old place,
here even today more than words it is tobacco
that is used.
The sky here—is only as high as
a pig.

Here the tongue gets used
the least,
here the eye gets used
the least,
here the ear gets used
the least,
here the nose gets used
the least.

Here you have only teeth and the belly,
and hands buried in mud
there is no man
only a dark hollow
that keeps begging for grain—
from one day of downpours to another day of downpours.
This woman is my mother or
a five foot iron stick—
on which hang two pieces of dry bread—

like dead birds.
Now between my daughter and my strike
there is not even a hair-breadth's difference
when the constitution is on its own terms breaking
my strike and my daughter

After these sudden elections
should I stop thinking about gunpowder?

Can I after Nineteen Seventy-Four's twentieth April
live
like a father with my children?
Like an ink-pot filled with ink, like a ball,
can I with my children
be like a green, grassy field?

If those people ever grant me entry into their poems
it is only to blindfold me
and to use me
and then leave me outside the borders
they never let me
reach the capital.
I am grabbed
by the time I begin to reach the district towns.

It is not the government—it is this country's
cheapest cigarette that has kept me company.

Growing all around my sister's feet
like yellow plants
was my childhood—
that was eaten by the police *daroga*'s water-buffalo.
To keep a sense of humanity alive
if the *daroga* has a right to shoot
then why don't I
have the same right?
The earth on which I sit writing
the earth on which I walk,
the earth which I plough,
the earth in which I sow seeds and
from which I gather grains and
load them in *godowns*—
for that earth do I have a right to shoot
or do those eunuch landlords—
who have turned this entire nation into a moneylender's dog?

This is not a poem
this is a call to open fire
that all those who use the pen
are getting from all those who work the plough.

. . .

A recent travelogue ends with a visit to Bihar. The writer's preliminary observations leave little doubt about what is to follow later: "It was my first hour in Bihar—I had never been there previously in all my travels across India—and already it was exceeding all my dread-laden expectations." (About another town in Bihar, the Lonely Planet Publications guidebook *India: A Travel Survival Kit* says: "Muzzafarpur is of no real interest. This is a poverty-ridden and agriculturally backward area.") In the more recent travelogue, we learn a new name for the state, the "Fourth World." Just a couple of pages later, we read: "Different standards of human conduct prevailed in Bihar, and the visitor could never know what to expect."

Where is catachresis when you need it?

Yet what this visitor was saying is usually said many times by many Biharis every day. And that too without the weariness of not having anything novel to say. In my late adolescence, however, I remember coming across a travelogue that repeated the clichés and yet helped me understand how to situate this received wisdom in a historical context.

"There is no denying that Patna is poor and filthy," the Swedish writer Jan Myrdal began about my hometown in his book *India Waits*. But, he asked, "What is so strange about that?"

> The reason Indian cities are old-fashioned in this respect is that colonialism and foreign domination interrupted and distorted Indian development. The fact that European journalists often suffer culture-shock while in India and begin writing about Indian excrement and Indian spirituality only shows that they are lacking in a sense of history.

Jan Myrdal's father, Gunnar, was Sweden's former ambassador to India and a Nobel laureate. The sense of history that Myrdal is talking about is crucial, and it is sometimes entirely absent from the understanding of European *and* Indian journalists. That history, for Myrdal, is symbolized by an odd-looking, giant building in Patna, the Golghar. Built in 1786, resembling in its form a copular beehive, the Golghar was intended by the British to serve as a giant granary and prevent recurrent famines in the region. But the building was never used—and even if it had been used, Walter Hamilton noted in *East-India Gazeteer* in 1828, it wouldn't have provided "the province with even a single day's consumption."

The contradiction between a surreal building and all too real famines was made clear to Myrdal by his Bihari companion, Ashok:

The famine of 1770 was the first British famine in India, although it wasn't until later, in the nineteenth century, that Indian famines became a topic of conversation in Europe. The number of victims has been a subject of controversy. It is possible that ten million people perished. One third of the fields lay fallow. Children were offered up for sale, but there were few buyers to be found. Cannibalism occurred. Nevertheless, the East India Company continued its tax-gathering. There was a qualitative change in the nature of the famines after the arrival of the British. One can say that the famines during British rule were a function of British efficiency in tax-gathering and administration. The last famine, which struck Bengal and Orissa in 1943, caused the death of about 3,500,000 people. Golghar is an administrative fantasy. A dream-building.

The encounter with imperialism led to Bihar's massive exploitation with no beneficial changes to offset it. The destruction of industry and the stagnation of agriculture through ruinous revenue policies continued unabated. While the British reaped ill-gained profits from the opium and indigo that they had cultivated in Bihar, the region itself received nothing. Even the soil of northern Bihar, containing saltpeter needed for gunpowder, was taken to distant Europe. By the end of the eighteenth century, the British had gained a monopoly over saltpeter, and the French under Napoleon had lost access to it. Arvind N. Das, commenting on this fact, writes: "The battle of Waterloo may have been won on the playing fields of Eton but to some extent at least it was lost on the chaur fields of Bihar which yielded the raw material for the gunpowder."

A materialist accounting of how Bihar was underdeveloped allowed me to see my surrounding poverty as well as the complicities of a semi-feudal dominant order in another light. And yet Myrdal's words took me by surprise when he offered the following eulogy to Patna: "To Patna—but hardly to Stockholm—one might travel to meet a Berzelius [an early nineteenth-century Swedish chemist]. Even if Stockholm has become more hygienic since Egron Lundgren's [a Swedish artist who visited India in 1858, to draw and paint for Queen Victoria] time, it is still a cultural backwater compared to Patna." I was more prepared to believe that, if he was sincere, Myrdal had been overwhelmed by the mere presence of resistance and ideological consciousness amidst the grinding poverty. It is also very much likely that Myrdal was impressed by the ongoing peasant struggles in and around my place of birth, Ara, in Bhojpur. These were the struggles that a left intellectual, Chandrabhushan, long politically active in that region, describes as "putting Kafka on his head." In a reversal of the story of Gregor Samsa, according to Chan-

drabhushan, poor peasants in Bhojpur have awakened from a night of bad dreams and seen that they have changed from insects into human beings.

This change, a result of organized and militant peasant movements in the region dating back at least to 1929, is also related to another kind of movement, migration. According to Kalyan Mukherjee and Manju Kala, there have been two noticeable trends:

> One, a slow but steady migration of the rural proletariat to the other States in the country. The porters who jostle in and out of trains that touch Howrah Station in Calcutta, send money orders to impoverished parents in the God-forsaken villages of Bhojpur. The sinewy coal-cutter who descends every day into the bowels of the mines in Dhanbad-Jharia-Raniganj is more often than not a Bhojpuri. Bhikari Thakur, eminent folk-singer from Bhojpuri-speaking Saran district, has woven this predicament of the separation of the fathers from their sons and husbands from their wives into the moving *bidesia* ballads that are sung till this day. [And second,] large numbers of villagers are conscripted into the defence forces every year. Both these trends—of human displacement—have left behind in the hearts of the population a streak of reckless, hard-swearing machismo. *Ara Zila Ghar ba, kis baat ka dar ba?* (Ara district is our home, why then any fear?)

In reality, the "human displacement" from Bhojpur has a still longer history. Devastated by famines, and caught in a worsening situation after the revolt of 1857 against the British rulers, indigent men and women of the Bhojpuri peasantry were among those who undertook a difficult journey across the ocean's *kala paani*, "the black waters," to Trinidad.

The Trinidadian Indian writer V. S. Naipaul famously described India as an "area of darkness." His younger brother, Shiva, came to Bihar and diagnosed it "a dying state." Bihar "has become a byword for all that is most helpless and terrible about the Indian condition," he wrote. It was from what the younger Naipaul called "the subcontinent's heart of darkness" that many of the 134,000 Indian laborers came, brought to Trinidad as indentured laborers after the abolition of slavery in the British Caribbean.

Bhuruth

Sookra

Dookhee

These are the names that appear on top of the list of the 220 Indians who arrived on board the *Fatel Rozack* in May 1845. I turn the page over and read some of the names of the women.

Bhooseya

Gungeeya

Aublokhyeea

Etwareeya

Samareeya

Mungree

None of these names, not one of them, will be found among the Indian immigrants in London's Southall or in New York's Jackson Heights. The dust of the Gangetic plains covers the letters of these names. They are the names that belong to those migrant workers in India that today board the trains in Bihar or eastern Uttar Pradesh. They go looking for work in the rock quarries and fields of Punjab or to labor in the small industries in the towns around Delhi. Many find work as servants and gardeners in the posh urban houses in the capital.

The landless laborer from Bhojpur who has come to Delhi or Punjab reinvents himself in some measure. So does a middle-class Indian like me who comes to the United States for an education and possibly a job. Yet there is an enormous difference between these two reinventions of new, mixed selves.

The New York–based Indian software engineer who can mix an Oxford accent, a Tamil meal of rice and *rasam,* and a high-fidelity music system from Hong Kong represents hybridity that is in an uncomplicated sense privileged—and very different from the masala mix of a Hindi-speaking Bihari migrant ricksha puller in Punjab who has a fondness for Bruce Lee shirts and the six or seven words of English he has picked up on the streets of what he regards as a foreign city.

The *Time* magazine writer Pico Iyer, who learned to walk in the city of Bombay, once wrote: "I have a wardrobe of selves from which to choose and I savor the luxury of being able to be an Indian in Cuba or an American in Thailand; to be an Englishman in New York." The fairly obvious point I am making by returning to the history of migration to

Trinidad is that the worker from Bhojpur today has more in common with those workers than he or she has with Iyer and me. They do not have the privilege of owning wardrobes, literal or metaphorical, and their identities, in the lines in front of the immigration officer, would be well nigh unnegotiable.

He grew up in Patna, Bihar's capital city, famous for its corruption, crushing poverty, and delicious mangoes.

Sitting in a classroom in Bihar, he wanted to travel first to Delhi, then to America, and then, naturally, the moon. Now, teaching in a classroom in America, he talks about his photographs of the workers from Bihar, his sisters, his trip to Trinidad.

He uses this strange family album to talk, sometimes at great length, about himself.

For a child who grew up in India, the name West Indies meant cricket. Every few years the West Indians would travel to India or vice versa. The early crossings of indentured laborers from India to the Caribbean never found mention among his family or friends.

He believes they are the heirs of Columbus; they have repeated his mistakes. A dark-skinned cousin in India is called a "West Indian" by his family in Patna. In a racist joke, they confuse the cousin with the great black captain of the West Indian team, Clive Lloyd.

He remembers wondering as a boy how an Indian with a name like Kallicharan was playing on a team of black West Indians with names like Roberts and Richards. Then he also happened to hear that one of his boyhood heroes, the Indian cricketing great Sunil Gavaskar, had named his son after Rohan Kanhai, the renowned batsman of yesteryear from British Guyana. More than a decade would pass before he read the following introduction by the Marxist writer C. L. R. James to an article that James had written about Kanhai:

> I take Kanhai as a high peak of West Indian cricketing development. West Indian cricket had reached such a stage that a fine cricketer could be adventuresome, and Kanhai was adventuresome; I try to relate that adventuresomeness to the type of cricketer he was at that particular time. People felt that it was more than a mere description of how he batted: it was significant of something characteristic of us as cricketers. They felt it was not only a cricket question, because Kanhai was an East Indian, and East Indians were still somewhat looked down upon by other people in the Caribbean.

He knew from experience that Biharis are looked down upon in India; and this was true it seemed in the West Indies too. He learned that

East Indians have been called the "coolie people" by others in the West Indies. Those who named them thus were saying that the East Indians had their place of birth in a "cowshed."

In any case, the decoding of the mystery of that one name in the team of eleven cricketers was a reminder, he concluded with a pedagogical flourish, that the route to his place of birth always involved a detour through the pages of history.

In some sense, he mused poetically, your place of birth is always a state of mind. In fact, he tells himself, thinking a bit more clearly, that his place of birth is sometimes a place only in the mind of a writer from the West.

I am a figure in your dream, he soliloquizes.

When the sun rises over the skyscrapers of New York City, darkness has already fallen in the land of my birth, Bihar. In that area of darkness, the head of the New Delhi bureau of the *New York Times* discovers the face of otherness that offers the comfort of absolute difference. "Shackled by Past, Racked by Unrest, India Lurches Toward Uncertain Future" is the title of a story filed by Edward R. Gargan.

(Mr. Gargan also provides a photograph. A mangy dog, forgetting his duties, stares mournfully at his paws in the immediate foreground. In the background, a woman squats on the ground and faces the camera. To her right are two boys. Behind them are the clay walls of a hut and the open hearths. Printed beneath the dog's tail are the words: "In Pawna, a village in Bihar State . . .")

From that remote wasteland of meaning, the journalistic Indiana Jones files his report on his reading of the runes of frozen time. "More than 70 percent of India's people live in villages, where their habits, customs and traditions have changed little over the centuries, even as economic, religious and political forces have changed around them."

The report is lengthy (hence, authoritative) and undeniably human (hence, believable). The changes it announces, however, seem all the more illusory because the article returns us so relentlessly to the unchanging condition. By the article's end, it has become able to psychologize current struggles and fit them into a vision of the eternal, fixed psyche. The concluding quote reads: "The Indian temperament is not democratic enough."

Let me engage in a bit of psychologizing myself. In this article, we are back in the nightmare space of an American childhood memory during the 1950s or 1960s. It is dinnertime in a white middle-class American home. The child, who is refusing to finish the food on the plate, is re-

monstrated by the mother, "Eat your food, Billy. There are children in India going to bed hungry!" (Never mind the fact that India does produce enough grain to feed its entire population. Never mind that still there is widespread hunger. Never mind that prosperity under the auspices of the U.S.-guided Green Revolution was designed to block a Red Revolution and managed to make the rich richer and the poor more desperate. Never mind that there is something called contradiction, and that its complex attritions have nothing to do with the monumentalization of stasis.)

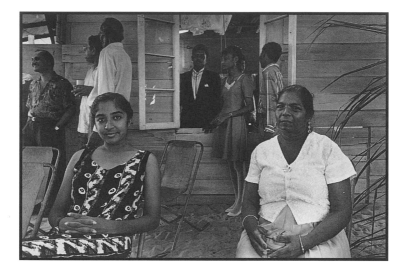

Charlieville, Trinidad.

One afternoon I was at the home of Ken and Roslyn Parmasad. The heat was intense and unbearable till it began to rain. As I watched the raindrops fill up the broken bottles embedded in the wall outside, I read the introduction Ken provided to his 1993 dissertation, which was written at New Delhi's Jawaharlal Nehru University:

> My research in India and the eventual production of this thesis was a process which was marked by occasional moments of exciting discovery, periods of intense frustration, bouts of frantic urgency and a nagging sense of historical hurt which I had brought with me from Trinidad.
>
> [I recalled] the years of my boyhood as I was growing up on the St. Joseph estate in Mayaro. I have never been able to forget the distant and pained longing in the eyes of the ex-indentured laborers who lived in the estate barracks. Their long spells of silence spoke more loudly than words and, more so than most other children, I found myself usually attracted to them. When I

touched Indian soil for the first time, images of Murgan, Tambi and other ex-indentureds, from a far away Trinidad of my boyhood came flooding before my eyes.

I asked Ken and Roslyn to tell me more about this "historical hurt" that Ken talks about in his dissertation.

ROSLYN: That's what lots of Indians [in Trinidad] feel.

KEN: [*Pauses*] That is what somebody like Naipaul went to India to work out. What am I doing here? This place [India] draws you. . . . It's very difficult. It comes from a feeling of rootedness. It has more to do with the violence of a rupture. Blacks in the new world suffer that too—it's about existence in these fabricated societies. Native populations wiped out, and people were brought out on denuded lands. You are placed there without a past that is indigenous to you.

ROSLYN: Indians in India have monuments, we [in Trinidad] are creating monuments. There is so much taken for granted [in India], we are in the process of rooting ourselves. Walcott talks of putting fragments together—

KEN: Walcott is in fact talking about that historical hurt. [*Deliberates*] We have had to assemble fragments, which turn out to be a different whole. That is why I tell [people from India], "Look at Trinidadians with new eyes. You aren't going to understand us with Indian categories." It's a hurt that shapes one's being . . .

Ken and Roslyn's daughters sing a song they have prepared for the festival of lights, *Divali*, about Lord Rama's return to his kingdom of Ayodhya after fourteen years in exile. I see the Indians in Trinidad turning the ancient Hindu epic *Ramayana* to a story about exile and transplanted religion: "We have to come to tell the story of the children of Ram. . . . / Every day we see your *leela* in this land, / we the children of indenture / building here our own Ayodhya."

The Ramleela that is performed in my village in India on a makeshift stage is not very different from the performance put up at a thousand venues in Trinidad.

It is one of these performances at Felicity in the Caroni Plains of Trinidad that Derek Walcott was talking about at the beginning of his Nobel Prize acceptance speech in 1992.

Based on the Indian epic, the *Ramayana*, these performances that go for several days glorify the ancient king of Ayodhya, Ram, "the lord of Raghu's race, whose limbs are delicate and dark as the dark-blue lotus, who has Sita enthroned on his left side, and who holds in his hands infallible arrows and a graceful bow."

"Here in Trinidad," said Walcott, "I had discovered that one of the greatest epics of the world was seasonally performed, not with the desperate resignation of preserving a culture, but with an openness of belief that was as steady as the wind bending the cane lances of the Caroni plain."

In India the television version of the epic, shown week after week on Sunday mornings, held the entire nation captive. As a tinsel production with shoddy performances, the fascination that this mega-series exercised on India's millions is revealing.

In India, history has been reduced to the meaninglessness of Gandhi smiling at you from his official portrait while the clerk at his desk brazenly demands five hundred rupees as a bribe before passing a file. This is what freedom in post-independence India has meant: gods reduced to god-men, and politicians emerging as demigods. In a world made alien by television you've come back full circle when television made gods real.

And with the *Ramayana* it is not just the gods, it is the return of the familiar narrative . . . the narrative that has names carrying the intimacy of sounds you've heard since childhood. When L. K. Advani, the leader of the Hindu ultranationalist party in India, has his Toyota van decked out as the chariot of Lord Ram, he is exploiting this appeal of the epic.

The right-wing leader is aware too that the ritual of the entire nation watching this program—to the extent that, as the members of my own family discovered, even the crematorium was shut down till the show was over—itself contributes to the sense of being a nation. That the message inscribed in the ritual is also very clearly a Hindu one is illustrative of the way in which the dominant ideology has successfully yoked a sense of origin for the people to an exclusivist narrative. The fact that all versions of Hinduism do not promote this sense or that the ultranationalist's mythology is highly contradictory are all fair objections but hardly relevant given the way in which the masses receive the message.

The Hindu ultranationalist's use of the epic is some distance indeed from the concept of the epic put forward by the Marxist playwright Bertolt Brecht. The epic form, Brecht reasoned, would free socially conditioned phenomena from that air of familiarity that protects them from the grasp of our understanding. Rather than promote empathy and identification, the epic theater would produce interruption and alienation.

What does this project of defamiliarization entail for, say, the people in Trinidad who see in a particular vision of India their origin, their place of birth?

In a very clear sense, the place of birth is a site, of memory, desire, what you will. It also becomes a site always already under construction, seeking scrutiny and revision. In the case of Trinidad, it is the "children of indenture" who are calling themselves "the children of Ram": for them Ram's triumphant return to Ayodhya after fourteen years becomes the condition fulfilling the experience of exile.

But there are also other questions, because there's always an *elsewhere*. That elsewhere recalls what has not been named and is, sometimes, unnameable. Again, in the case of Trinidad, it means an alertness to the fact that the "children of indenture" are of all religions, and such identities need not, and cannot, be articulated solely as a Hindu one. Thus *Ram Rajya* (the rule of Ram) becomes a catachrestic condition. It names what still isn't: a fair and just order for followers of all—and no—religion.

The Brechtian intellectual, disguised as a traveling narrator or *sutradhar*, raises the question of critically imagined communities and offers a travel advisory.

> Among those who traveled from India to the Caribbean we had our own mad Columbus.
>
> He was the one who, I'm told, stricken with homesickness threw himself in the sea to swim back home.
>
> Mad Columbus hurt me into poetry. In trying to swim back to Calcutta from Guyana, he offered a lesson about the perilous gesture of return.
>
> *The Daily Chronicle* also tells us that our hapless swimmer was quickly rescued and jailed for 14 days for indecent exposure.
>
> Would-be travelers to imaginary homelands, stay warned!

On December 6, 1992, Hindu fundamentalists demolished a mosque in present-day Ayodhya in India.

What was the pure homeland—before history—to which those zealots were traveling?

What warnings can anyone bring to those Indians abroad who donated gold bricks for that violent undertaking?

Date of Birth

The summer of 1947 was not like other Indian summers.

Khushwant Singh

It's late at night, some time after midnight. What is born at that hour is a restless loneliness.

The reruns of old Hollywood movies don't interest you. Not even the one where a white man with black grease rubbed on his face plays an arrogant maharaja in British India.

You keep switching channels. You won't for a moment let Rush dribble on you. You change the channel when you see knives being sold with lifetime guarantees for only $19.99. You stop when you see an Indian face. Of course, it's the Discovery channel. The camera pans over a river. Will they show crocodiles? No, tonight, it's tigers . . .

At the river's edge, the fishermen wash the boat's bow and pray. It reminds your British journalist-commentator of the difference between these parts and the rest of the world. A few minutes later, wandering in the mangroves of the Sunderbans, the commentator remarks that 437 people have been killed by tigers there in the last 21 years.

That gesture toward time or history is a passing one: it is eternity, vast and ahistorical, that interests your urbane TV philosopher-guide. "The tiger has a part to play in the order of things: that's the legacy of Hinduism."

You listen to this tale of beauty and terror, courtesy BBC. You, too, are interested in both time and the legacy of Hinduism, but that poses a precise *political* problem for you. You are not held by eternity, you feel history's calculated pressure on your nerves. The politics that lies beyond the reach of BBC is exactly where you find *your* approach to the meaning of Hinduism. In the question of caste, for instance. And in this approach, time is a clear site of uneven social contradictions juxtaposed in an historical frame.

ARITHMETIC

The road from the two-story high

Gita
mandir

to the huts of Jagjiwannagar
is three
miles
long.

The yellow building of the Police Station
faces the Gita mandir.

Now, here is the question.

How long
will it take the police
to reach
the bespectacled statue of Babasaheb Ambedkar
at the entrance of Jagjiwannagar?

That is the pure problem.

The constables are perhaps at that moment
assembled in the mandir
participating in a kirtan.
Drops of sweat
hang like pearls from their sacred threads.
The wireless message
disturbs this pleasant communion
with the gods.
It is not the re-birth of Krishna
that is announced
but a riot.

Four men today laid their hands
on a lower-caste woman
on the premises of Bharat Tannery.
The woman was raped
perhaps only by mistake.
It must have been so.
After all, how could these upper-caste
men touch an untouchable?

The strike-call by the D-S 4
is perhaps an example
only of political opportunism.
And the bomb-explosion during the meeting
in Jagjiwannagar ten minutes ago
is a crude demand for attention.
Perhaps.

Given these conditions, how long
will it take the police
to reach
the bespectacled statue of Babasaheb Ambedkar
at the entrance of Jagjiwannagar?

Some examples might help.
It took twenty years
after Independence
and not until Naxalbari and Srikakulam

that the rest of India woke up
to the rural reality.
It took less than thirty minutes
for the Prime Minister
to fly over his constituency
to lay the foundation-stone
of a watch factory.
It took the British
two hundred years to learn
that India was not their property.
And, in case these things interest you,
in America, it takes perhaps less than three seconds
for President Bush to sign an order
for the bombing of towns and villages
in any given country
in Central and South America.

India was born fifty years ago, in a blood-stained partition. The "midnight's children" who were Salman Rushdie's focus are now middle-aged: India's politicians, administrators, teachers, doctors, farmers, and writers repeating with a different poignance the lines of Faiz Ahmed Faiz who wrote half a century ago:

Yeh daagh daagh ujaala, yeh shab-guzeeda sahar
Woh intezaar tha jis ka, yeh woh sahar to nahin
yeh woh sahar to nahin, jis ki arzoo lekar
chale tthe yaar, ke mil jaayegi kahin na kahin.

These tarnished rays, this night-smudged light—
This is not that Dawn for which, ravished with freedom,
we had set out in sheer longing.

Anand Patwardhan is a well known Indian documentary filmmaker. In a well-received article published on January 25, 1997—a day before the Republic Day—Patwardhan mocked the following day's enactment of a nationalist ritual:

> The Republic Day Parade, perhaps understandable when undertaken by a newly liberated nation, is for a country that is 50 years old hardly a sign of security or maturity. That we have become increasingly dependent on vulgar displays of militaristic jingoism and "patriotic" fervour is inversely proportionate to the actual loss, both of freedom and of idealism since the heady days of 1942 and 1947.

Entitled "Republic Day Charade," Patwardhan's article was a severe indictment of a condition where the burning of foreign cloth during the early days of the anti-imperialist freedom struggle has given way to the craze for imported designer tags and "phoren" goods. What Patwardhan was expressing was not nostalgia but anger at the celebration of inequality: "It is no longer considered to be bad taste to flaunt your wealth in a country where the average monthly wage is less than the price of an executive's lunch." After the recent nuclear tests by the ultra-nationalist Bharatiya Janata Party government in power in New Delhi, it has become more urgent to emphasize the huge social inequalities that BJP's jingoistic displays can barely hide. As a commentator pointed out soon after the tests were carried out in Pokhran, "226 million Indians are without safe drinking water; 640 million without basic sanitation; 291 million are illiterate; 44 percent of the population (one third of the world's poor) lives in absolute poverty."

In Patwardhan's piece, the portrait painted of India was a scathing one. India was a place where questions left unanswered take on the guise of questions left unasked—questions even of the order of who exactly are they who benefit from a Western-oriented economic policy that converted a self-sufficient rural population into the reviled slum dwellers of some heartless metropolis. Patwardhan read in this passivity the signs of a growing culture of dependency on our rulers. In fact, going further, he saw in the mobilization of narrow nationalism in India a reaction to the inhabitants' dependency and also helplessness in the face of the mounting power of the distant and invisible global powers:

> Not surprisingly, the more dependent we become, the more we must sustain the illusion and gesture of independence, the illusion of nation, the illusion of culture and religion, indeed, the illusion of any sort of identity that can

bring us some comfort in an age where corporations rule anonymously over a population that has no name. So revivalism, communalism and fundamentalism become the order of the day for they protect us with the familiarity of the known. And the most legitimate form of uniting the known "us" against the unknown "they" is nationalism.

Marking out his own distance from "the suave owners and spineless editors of newspapers that pay handsome tribute to 50 years of independence and at the same time carry loving paeans on the birthday of their favourite fascist," Patwardhan stated clearly that this year when the tanks rolled down and the parade got under way, he would "not be cheering." And that if he bought a paper tricolor when the festive parade passed, it wouldn't be because he was proud but because he "didn't have the heart to rob an urchin of his one legitimate job for the day."

That concluding sentiment in Patwardhan's piece calls attention to those we might call "midnight's grandchildren." The South Asian Coalition on Child Servitude estimates that there are 55 million children under 14 forced to work in India. Look at my 1991 photograph of a young bird-seller arranging his cages in a middle-class apartment-building complex in Patna. The youth's extraordinarily thin limbs tell the story—and local medical practitioners often cite the statistics and circumstances behind them—of cramped quarters and the rampant presence of tuberculosis. People in the West (supporters of the Harkin Bill in the U.S., for example) can ease their conscience by proposing a ban on goods manufactured by children in the Third World. Yet that by itself accomplishes very little. The question that remains is this: what has been done to alter the structural conditions that will ensure an end to poverty as well as the inequality of wealth? Senator Howard Metzenbaum from Ohio starkly proclaimed, "Buy an oriental rug and you have a good chance of walking on the labor of an Indian child." But does he have an answer to the charge that, in the absence of any efforts to rehabilitate these children or organize them to fight for their rights, such moral pieties might only serve First-World manufacturing interests? As a pamphlet by the Forum of Indian Leftists points out, the Harkin Bill seems to defend First-World business interests that do not want to see their products displaced by cheaper, child-labor-subsidized goods from the Third World.

The broader point is that it's not enough to lament that, fifty years after independence, children in India are starving and exploited. Rather than fix the time of independence in a gloomy frame of unchanging oppression, we need to see this time as one of changes where the employ-

ment of child labor has reflected national and global shifts. As the International Labor Organization also recognizes, it is the logic of late capitalism, and its global search for an unorganized, temporary, and flexible workforce, that has led to an increase in child servitude worldwide.

In the case of India, according to the FOIL publication, after the postindependence decline, child labor emerges as a growing phenomenon only in the late 1970s and the 1980s. This was the time of the shift in the Indian economy to a model of export-oriented growth—a model that has been most forcefully pushed by the IMF and World Bank in most of the Third World. The priorities stressed by these programs, including internal austerity and economic liberalization, have spawned not only the reign of unregulated hyperexploitive capital. They have also caused the acute hemorrhaging of resources from social services like universal education for children. A child charred to death in a match-making factory in Sivakasi is not in some crude sense an emblem of India's current backwardness; it is as much a symptom of India's entry into the regime of advanced capital, and that death signifies the global future of millions under the rule of transnational corporations.

LETTER TO INDIA ABROAD

On the occasion of India's 50th Anniversary of Independence,
and in memory of Faiz Ahmed Faiz

I.

Washington—Convinced she was about to win the National
Spelling Bee, 13-year-old Rebecca Sealfon from Brooklyn,
N.Y., shouted each letter of her last word into the microphone
"e-u-o-n-y-m" and raised her arms high. She beat out Prem
Murthy Trivedi, 11, of Howell, N.J. Prem lost after he added
an extra "l" to the word "cortile," a courtyard.
Sudheer Potru, 13, of Beverly Hills, Mich., came third.

Associated Press

I need to look up the word "euonym" in my d-i-c-t-i-o-n-a-r-y.
"Euonymous: Well or felicitously named, as in, The Peace Society
 and its euonymous president, Mr. Pease."
Prem Murthy Trivedi from Howell, N.J., and Sudheer Potru, of
 Beverly Hills, Mich.,
and there must be many others,
Deepa Rao, 12, from Jacksonville, Fl., and Renuka Ghosh Michaels,
 14, of San Diego, Calif.,
these are the born-again Indians of pages 45 or 47 of next week's
 India Abroad.

One Mr. T. V. Raghavan from Houston will write that this is the best
 news he has heard
since Vishwanthan Anand beat the computers 4–2 in the Dutch
 tourney,
"including the one named Genius which had already beaten Kasparov
 previously in rapid chess."

There is Senator Jesse Helms on page 16 of my last *India Abroad.*
Sen. Helms responded to an invitation by the Indian American Forum
 for Political Education and its euonymous president-elect, Swadesh
 Chatterjee, to help celebrate India's 50th anniversary of independence.
On way to the bold type, the exclamation marks, the box with the
 word URGENT screwed on it, I reach at last the Classifieds, past the want
 ads for motel help, computer programmers, drivers, tandoori cooks,
 curry cooks, live-in housekeepers, typists fluent in English, till I am
 seeking with the rest of independent India one beautiful girl, convent-
 educated, tall, slim, fair, charming, caring, humble, from respectable
 family, open-minded with traditional Indian values. Two columns to the
 left of "Restaurant for Sale under $60,000" and right next to "Photo
 Lab Must Sell Due to Health" is one that reads:

"24 and 29, handsome, tall, citizens with mixed blessing of
eastern and western cultures are seeking women, 22–28. Contact:
boys@desilink.com."

Dear Editor, Prem Murthy Trivedi, Sudheer Potru, Deepa Rao, Renuka
 Ghosh-Michaels, T. V. Raghavan, Swadesh Chatterjee, and citizens
 of mixed blessing, a.k.a. boys@desilink.com:

You have in your possession
words

to spell and to sell
tell me

how many "l's" are there in "loneliness"?
Why have these words become meaningless to me

Ma ghar aaunga
to tumhare liye kyaa launga?
When I come home
what will I bring for you, Ma?

You invite Jesse Helms, the euonymous head of the Foreign
 Relations Committee,
to tell you about your independence
and he does
praising you for the opening of the market
of "the world's largest democracy" to the U.S.
and you who print news reports
of your sons and daughters winning quizzes
with the correct names of fossils and the T-Rex
why didn't you ask Jesse Helms if he knew the difference
between Bhagat Singh and Manmohan Singh?

What link do I have anyway to the world's
largest democracy
that is ever worth more than a 49-cent-per-minute calling card?

That is why
I sit here turning the pages of my *India Abroad*.
Like the women's magazines published in Nagpur and Lucknow
still firm in the belief that what Indian women need most of all
are new recipes for pickles and mango chutney,
here is a newspaper that offers me
one cup of India-brand nostalgia
mixed with a half cup
of thinly disguised comfort at having finally left its shores
and another tablespoon
of envy for those other Indians who have really made it here,
the CEOs, independent entrepreneurs, and research scientists.

And should any of this give me indigestion,
there is a generous sprinkling of ads for astrologers:
"Are you frustrated in love or marriage?
Is somebody giving you hard time?"

2.
While I've been talking, dear editor, a corner of my brain has
 turned black like the night
but it could be also be a screen in a dark theater
cut diagonally in two by the roaring of
the empty train in which lies the lone traveler. It is an August
 night in 1947.
K. L. Saigal with a voice that sang anthems to pain, Saigal mad for
 more liquor and the cool hills of Simla, hums a tune near the
 window while the train's wheels strike a steady beat.
Or it is 1997. That traveler could be a woman of dark skin,
 beneath the sepia shawl, Kuppa.
A Gulf-Air flight brought her from a white house in Oman with five
 cars parked in the front.
Kuppa is returning with thirteen thousand rupees after six months
 in the desert with an Arab family for whom she cooked and cleaned.
The man she worked for never laid a hand on her. In a film, here
 the reel breaks with a snap, the men in the theater whistle
 and shout information that they're privy to about the
 projectionist's mother.
When the whistle blows, the sleeping figure in the train feels
 sparks fall on her half-opened eye.
Then feels the lurch as the train cuts, passes over, whatever it
 was that was lying on the rails.

It's India's Independence Day. What will the West give us as a
 present?
A younger, fitter Mother Teresa who'll preach the virtues of the
 poor.
India will give the world maid-servants
who'll teach the world to be humble and to pray.

The train comes to a stop at a platform. I want to read a review
 of the film they're shooting *The Nation at Fifty: The*
 Railways.
There are two bearded men with a camera and a tripod on the
 platform outside. A woman in a red sari and bright jewelry
 makes repeated appearances at the train's door. She breaks
 into a smile and speaks.
A train passes in the opposite direction.
In the middle months of 1947, trains in the north went back and
 forth across the border laden with the bodies of the raped
 and murdered passengers.

In November 1984 the rumor spread through the streets of Delhi
 that trains from Amritsar were arriving filled with corpses.
So, the streets of Delhi were filled with corpses.
Tonight too
trains will snake out of stations
like whispers passing between places in the dark.

> *Tu kisi rail-si guzarti hai,*
> *Main kisi pul-sa thurthurata hoon.*
> You pass by like a train,
> I shudder like a bridge.
>
> *Dushyant Kumar*

Like any other self-respecting
progeny of Bombay films
I cannot stop myself from incongruously bursting into song
with the nightingale of post-independence India, Lata Mangeshkar
fresh from a concert at the Royal Albert Hall:
Tum na jaane kis jahaan mein kho gaye,
Hum bhari duniya mein tanaha ho gaye
You got lost in another world unknown,
I was left in this whole world alone.

In the textile strike that started in 1982 in Bombay
there were 250,000 workers.
You got lost in another world unknown,
I was left in this one alone
with an obituary to a murdered trade unionist
in the pages of *India Abroad*.

This is not a song, nor is it an anthem.
This is only a letter.
This is a letter in search of the name
of the taxidriver from Queens
who calls each week to talk to his school-going daughter in Ambala.

This is a letter in search of the name
of the seventy-year-old *naani* who strains her eyes through glasses
to stitch garments for hours in an apartment in Bensonhurst.
The students in Pittsburgh, burdened with their own studies,
who printed pamphlets to fight those
who from this distance dream of destroying old mosques.

In search of the name
of the young bride
from Rajkot who searches silently for the names
of other women who will help her in New Jersey.

This is a letter in search of the names
of the ones who will teach the sons and daughters
of Indians now settled in New York and Los Angeles
the poems of Nirala and Faiz.
Of the ones who hold literacy classes so that women can fill out forms
in English and ask a stranger for directions
to a train station when they need.

In search of the names
of the ones who did not write letters home
except to ask "how are you"
for fear that if they said more they would reveal
what had happened to their American dream.
Of the ones who wrote letters and then saved them
in the hopes of using them
to cover the cracks
that kept appearing in their mirrors when they looked at themselves.

Time is the train, all its lights out in the night, passing through the barren landscape of Punjab with its load of silent refugees.

The train travels through other zones of memory. It returns. Its return always changes the landscape. In that sense, time is also like a letter that crosses different paths and, when returned to the sender, changes the sender forever. When the letter marked UNKNOWN AT THIS ADDRESS returns to the one who had sent it, that person no longer remains in any successful sense a sender. There is no one to send letters to anymore.

In the year prior to 1947 when India gained independence, an insurrectionary peasant movement began in Telengana. Led by inspired Communists, this movement would last at least till 1951. For the countless peasants who participated in this struggle, the arrival of Indian independence must have been a dead letter. For them, it was their own struggle, not the national one led by their masters, that would bring to its knees the feudal powers that had governed their lives for so long.

But here, too, time is partitioned differently for the different actors in the drama. A remarkable document entitled "That Magic Time: Women in the Telengana People's Struggle" brings us face-to-face with the fact that women in the movement were placed in a very different relation to the *time called history* than the men:

> In spite of the nostalgia and warmth with which they relive those magic times there is a note of pain, of a vision betrayed. Kamlamma left one child behind and joined a squad. She delivered another child in the forest and was ordered to give away the six month old child as the safety of the squad was at stake. She was told she would *be making history*, that her name would go down in history if she sacrificed the child for the movement. She begged for a few days time to wait for her husband before giving away the child. She felt deeply wounded when accused of not having the correct proletarian consciousness.

This woman's sense of betrayal and bitterness—is it the region of the "post"? Yes. But in saying this I'm not arguing that pessimism forms the horizon of the "post." Rather I'm underlining the sense of possibility and difference that allowed the women of Telengana to create "those magic times" (postindependence). To be receptive to their critique is to see the time after 1947 as also a split field—split by gendered inequality and these women's struggles for a greater equality both within the home and outside. Within that breach of time I see not only the shattering of its monotonous oppressiveness but also the open agenda of insisting on difference, the difference of landless peasants from the nationalist bourgeoisie and of peasant women from peasant men. They, and I, demand a reading of time that fractures its identification with a singular dominant meaning.

As I study the "post-" within the concept of the postcolonial, I want to stress that among its users are those who have traveled to the West, those who write letters home, those whose time and place of being force them to recognize that they're always only posting their reality, or, to put it awkwardly, they're always between their realities writing broken lines.

People often protest at this usage. If "post-" refers to a break, they charge, are you saying that now everything is different? Is India, for example, free of foreign dominance of all kinds now? When was post-colonialism?

I understand, even accept, the critical force of that question, but my appeal is beside the point: to write letters is to indeed say that it is never any different, that we need to keep *writing* letters, that we keep writing letters even when the readers are stillborn.

> The term *postcolonial* is increasingly used to describe that form of social criticism that bears witness to those unequal and uneven processes of representation by which the historical experience of the once-colonized Third World comes to be framed in the West. . . . As a mode of analysis, it disavows any nationalist or nativist pedagogy that sets up the relations of Third World and First World in a binary structure of opposition, recognizing that the social boundaries between First World and Third Worlds are far more complex.
>
> *Homi Bhabha*

LIMIT POEM

You do not live your life
in this poem.
These lines are, however,
among those that define your spaces.
This poem is the limit
traversing several habitations.
 Neither of us
stands at the center of this map.
These are lines of the border country
where you and I might meet.

The smoke from Jaffna scatters
over the vast subcontinent.
The story that is being told
is from messages intercepted in the forests
where armies fight to be called
 enemies.
The smoke over there tells a tale
but an inadequate one. And
yet it guides movements of platoons
and migrant populations.

How many times do my letters
say the same things?
My words break at familiar places
and there are cracks

where you might rather easily feel
 the roughness
that is so disconcerting.
The Americans go on
about Third-World debt
in the same way as our leaders
go on speaking about development.
Then, they switch roles:
the Vice President of the World Bank
says a word about India's progress
and our Prime Minister declares that corruption
is a pan-Indian phenomenon.

Where the white moon hangs closest
to the white fields
where the waters of the pond
are for all castes
where the women drawn in a circle
spin a tale of courage and revenge
where the road ends
in a prison or the free country
where red oleanders bloom
or within four walls
small sacrifices give sustenance
to daily life . . .
you and I will have to choose a point
from which to speak.

There are no addresses
in the border country.
Rather, there are only wrong addresses.

There are lands evacuated
even of memories. Things change
even when surrounded by barbed wire.
In less warlike conditions,
people change houses.
The letters come back
to the sender's address
looking different.

The letters that are returned
to me will bear the inventory of the changes
in you. I too am not stone
or without history. I might not receive
what is returned to me.
That history
will be as incomplete as this one.

The Bangladeshis bitterly blame the Indians
for the floods in Dacca. The people
are living on the highways.
Imagine, for a moment, the postman
waving a U.S. air letter
on a road where cholera is beginning
to spread.
Or even the helicopters
we will send or, a fortnight later,
the stuff from the U.S. bases.
I mean, talk about wrong addresses!

But we keep writing letters.
The burning of Lancashire fabrics
in 1905, for example.
Though that didn't necessarily
save the industries of Murshidabad
or the weavers whose bones
an Englishman wrote
were already bleaching the plains of India.
And today, too, it's the same.

The refugee trekking across Ethiopia
has been left in no condition
to protest about IMF policies!
But we keep writing letters
even when the readers are stillborn.

The problem of time. In India, it means that the country's date of birth is also the date of its partition. The trauma of 1947 partitions time, but not into a before and after. The trauma does not split all sense of history—though it does that too, in the psyches of the survivors.

Rather, what I'm trying to argue for is a different process of remembering. Instead of locating the trauma and fetishizing it—monumentalizing it—in a singular, painful event, we need to remember time as always already partitioned. In that remembering, time and its tensions persist in a whole series of events, often repeated.

In the celebration of the fiftieth anniversary of Indian independence— a memory that even ads for AT&T marketed in the pages of Indian newspapers in the diaspora—to think about this time differently means recalling the reality of the partition into India and Pakistan. Ten million people were displaced in that event and almost a million people died or maybe more. But where are their memories now? Urvashi Butalia writes, "The suffering and grief of Partition are not memorialized at the border,

nor, publicly, anywhere else in India, Pakistan and Bangladesh. A million may have died but they have no monuments."

Against forgetfulness, against even monumentalization, I'd add, there can be the persistence of memory that admits time and its tensions by resisting easy closures. Butalia writes of a long-cherished meeting of Indians and Pakistanis at the border, at Wagah, on the night of August 14, 1996. The plan for this meeting was that well-intentioned citizens on either side of the Indo-Pak border would face one another and sing songs of peace. "But they came back disappointed. The border was more complicated than they thought—there is middle ground—and also grander. The Indian side has an arch lit with neon lights and, in large letters, the inscription MERA BHARAT MAHAN—India, my country, is supreme. The Pakistani side has a similar neon-lit arch with the words PAKISTAN ZINDABAD—Long Live Pakistan. People bring picnics here and eat and drink and enjoy themselves." What intervenes is precisely the monumentalization of another history, a history that projects into eternity the name of the nation; and it is this thwarting that we need to recall too if we are to resist the grand appeals of the narrow nationalist discourse.

More significant, however, in my opinion at least, is the *repetition* of the scene of the partition in postcolonial India. I'm referring to the repeated outbreaks of Hindu-Muslim communal riots that target, in the euphemistic language of Indian journalism, the "minority community" and subject them to horrifying pogroms. It is this fact more than anything else that we need to recall in order to ensure a process of remembering that is other than the grand monumentalization of the nationalist advertisers.

Writing about the days following the partition, the short-story writer Saadat Hasan Manto, then employed in the Bombay film industry, noted in his memoirs: "I found it impossible to decide which of the two countries was now my homeland—India or Pakistan? . . . Now that we were free, had subjection ceased to exist? Who would be our slaves? When we were colonial subjects, we could dream of freedom, but now that we were free, what would our dreams be? Were we even free? Thousands of Hindus and Muslims were dying all around us. Why were they dying?"

The pathos of having to make the impossible choice between two countries was most memorably captured by Manto in his short story "Toba Tek Singh," in which the lunatics in an asylum need to be assigned to the two different countries. In that story the inmate Bishan Singh dies, unable to sort out in his mind where his village, Toba Tek Singh, might be located: "There, behind barbed wire, on one side, lay India and be-

hind more barbed wire, on the other side, lay Pakistan. In between, on a bit of earth which had no name, lay Toba Tek Singh."

In a recent piece in *The New Yorker*, Salman Rushdie wrote about "Toba Tek Singh": "The lunacies in the asylum become, in this savagely funny story, a perfect metaphor for the greater insanity of history." I cannot disagree, yet I feel, quite strongly, that in contemporary times the pathos of the human being unable to choose between two nation-states has been overwhelmed by another, new kind of feeling. This feeling is the abjection of the postcolonial citizen whose problem is not so much being unable to choose between two homelands as being expected to choose only one.

It is against this false choice that Ajai Singh, a journalist and Hindi poet living in Lucknow, protests:

I am half Hindu
Half Muslim
I am the whole of India.

Singh's protest is also against the threat made to Indian Muslims during a riot when, in the words of one slogan especially popular among bigots, they are asked to choose not between India and Pakistan but between Pakistan and *kabristan* (graveyard).

There can be no mocking of the Enlightenment discourses of rationality in relation to this narrative. For against all the complacent assumptions of greatness, and with all the anthems of national achievement in the past fifty years, we are left with these accounts of the workings of the modern Indian nation-state:

In several places like Vijaynagar, Pandesara, Hidayatnagar, etc., people complained that the likely BJP [the right-wing Hindu party, which has built its popularity by demonizing the Muslim minority] candidates for the forthcoming municipal corporation elections collected information about Muslim families with promises of renewing ration cards. This information was used to identify Muslim families and their homes for burning and looting.

We are forced to ask: when was the partition? When is it not?

In response to this violence, it is not only our conception of time and history that has to change but also our writing of it. Responding to the demolition of the Babri Masjid in Ayodhya, the historian Gyanendra Pandey pondered the question of a "lumpenised India" and its vicious propaganda. A history written from below, Pandey felt, could not simply "sanitise" violence and thereby "make bland and rather more palatable what is intensely ugly and disorienting." Pandey's remarks—his "de-

fence of the fragment"—are taken further by the cultural theorist Rustom Bharucha, who wants us to begin "by 'quoting' violence, inserting one's position in relation to it, devising multiple frames within which violence can be examined through multiple angles rather than a unitary position, and by examining the moment of violence not so much in all its visceral immediacy but its residue and signs through which it is possible to think of its wider implications."

The problem of violence, of viewing it, of *seeing* it, is also a problem of time. If I understand Rustom Bharucha correctly, to see violence in a way other than in its "visceral immediacy" is to see it in another time. Framed by another mode of intelligibility, surrounded by other words or images. To see anything in its "visceral immediacy" is to view it merely as a part of what Benjamin would have called "the continuum of history"; to see it otherwise, to see it in a way that is dialectical, according to Benjamin, is to experience it as an irruption in the empty, homogeneous time. The difference is visible too in Benjamin's insistence that instead of a relationship to an "'eternal' image of the past," the historical materialist must establish "a unique experience with the past."

Can there be a postcolonial writing that exists without challenging our conception of the place and time in which the "post-" is inscribed? And, equally important, in its exchange of letters, even in its breakdowns of communication, can it afford *not* to signal very strongly the time lag that at once holds together the elements of our social lives and keeps them separate—keeping public hours from private, for example, or Third World of inequality and poverty from Fourth World of sexual or gendered oppression?

CHANGES

(For Daya Pawar and Ramji Rai)

In a letter from Los Angeles
written by an upper-caste chemist,
the untouchable poet in India
learns that Indians in the United States
are treated like dogs.
This, I imagine, is in the fifties,
before Ravi Shankar played
with the Beatles
or Hollywood had sold Gandhi
with popcorn to millions.

Beside a dusty rose bush near Bombay,
the news being read on the radio nearby,
our poet looks at the long letter.
His joy makes him cry.
That afternoon, he will sit down
to write. He wants to be honest.
I felt so damn good, he will write.
Now, you've had a taste
of what we've suffered in this country
for far too long.

The poet's Indian upper-caste friend
in Los Angeles has a son
in college now, I imagine. I do not know.
But, if this is true, then how
sure would you be that he doesn't call
Mexicans "tonks" because that's
the sound a flashlight makes
on their heads when cops hit them
at the border?
 Because I suspect
he has read volumes of computer
manuals but not the poem his father
got in a letter from Bombay, the smart son,
I believe, rails against affirmative action
for Blacks, Asians, and Latinos
whom he calls only by other names.

I don't allow niggers in my cab.
The Pakistani driver looks so small
inside his rearview mirror.
An Indian was stabbed in the neck
in Queens the other day. I don't even
sleep with them. He spits and pulls out
a cigarette. You? I don't smoke, I say.
No, who do you sleep with? I shake
my head, and look out of the window.
The drizzle is very thin by now.
Never sleep with Americans. No sense
of family or respect. I like Germans.
Once I had an Italian girlfriend,
very nice. These words press around me.
I sit still in my corner, more than
voiceless, as if I have lost my identity,
wanting to be back in the movie theater
where I had been only five minutes ago,
my arm thrown around my lover's American shoulders.

Mehdi Hassan is singing for us
giving the evening sky its color
which is red like the eyes of a rohu fish
pulled fresh out of water. I'm back
in India after three years and my sister
sitting on our roof with the kites
flying above our heads wants to know more
about my divorce. I keep rewinding
the tape to listen to the same ghazal
about the smoke rising in the sad air.
There is so much patience in my sister's voice,
such persistence. We have been talking
for an hour before I say, No, that's true,
touching her hand, but I also don't know
how you'll figure out in this calculus
the outrage of love's imbalance,
or, for that matter, the reasons then
for all that abides which we do call love.
Her remark floats still like a kite.
You are a man, she had begun, and to add to that,
a man living in America.
I don't think we're meeting on equal
terms at all. We withdraw into silence.
In the pale twilight, there's between us the song
about the smoke rising in the sad air.

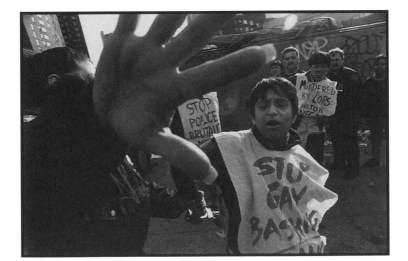

A FINAL NOTE ON TIME: A CRITIQUE OF PROGRESS

In my ancestral village in India, my distant cousin Lallan Bhaiya built a small dike for the water in his paddy field and then sat down, his feet still caked with mud, to ask me about Gainesville. "Tell me about that world," he said.

I was reading Al Franken's *Rush Limbaugh Is a Big Fat Idiot,* and plainly enjoying myself. I replied carelessly, "It was voted the best place to live in America."

I should have known this would pique his interest. He didn't trouble me then, but later, when everyone had returned from the fields, people sat around asking questions. My grandmother is now eighty years old, and every time I go back people in the village begin conversations by saying, "She's very old now. You should come back."

"How long does it take to make the journey?" somebody inevitably asks after that, perhaps because they are thinking of funerals. I make my answer easy by saying that the place where I live is on the other side of the globe.

"Right now, the sun is coming up there. When we wake up tomorrow, in Florida night will already have fallen."

"Oh, our own country is so much better then," my father's first cousin exclaimed at that. I was pondering the logic at work there when Lallan Bhaiya announced to the assembled crowd, "Our brother lives in the best town in America."

I was clearly expected to go on and lend substance to that assertion. But I didn't. And it's not because I couldn't say much that was good about this city or its communities.

Instead, to offer the cheapest bit of ethnographic detail seems sometimes merely to sensationalize and misrepresent lives. On both sides.

Yet it seems necessary to make the effort to perform the task of informing people, divided by differences, about the ways in which our lives are unfolding in relation to each other.

I would have liked to tell Lallan Bhaiya that the America that he imagined as being so distant is already within reach. The city of Delhi had been for me a city where activists staged street plays, where my friends worked as journalists and teachers, where young girls were harassed by men in the city buses, where workers from my home state were badly exploited and underpaid in the giant construction projects, where the monsoon sky was held aloft in the month of August by thousands of colorful kites.

Neither the beauty nor the filth had vanished. However, I witnessed a massive change this time. On the night of my arrival I saw the city, quite literally, in a new light. It was illuminated by the bright lights shining on huge billboards for Citibank, Pepsi, Coke, Toyota, Sony, General Motors.

What people across the world think of when they think of America will soon have covered the Indian countryside.

Gainesville might be the best place to live in America, but what kind of a place is America?

Two years after the North American Free Trade Agreement went into effect, jobs have been disappearing and benefits declining—not only in one but in all the three countries involved in the pact. According to researchers at the Institute for Policy Studies, NAFTA has given corporations increased power to drive down wages and working conditions.

The Xerox plant in Webster, New York, recently threatened to shift production to Mexico unless workers agreed to concessions, including the reduction of the base pay rate by 50 percent for all new employees.

We learn from Graef S. Crystal's book *In Search of Excess*, that the ratio of pay of a typical worker to that of a typical CEO is 1:16 in Japan and 1:21 in Germany. That ratio is an astonishing 1:120 in the U.S.

This frightening inequality can be confirmed by looking at figures presented by the Economic Policy Institute. The richest 10 percent of Americans own 89 percent of total stock assets; the poorest 90 percent of the people of this country can boast of owning a meager 11 percent of that wealth.

Should Lallan Bhaiya in my village in India be happy that America is not quite half a world away anymore?

Profession

Two books had recently appeared on the subject in Delhi, and had caused much debate and controversy in the tiny world of English departments.

Pankaj Mishra

In Khushwant Singh's famous novel about India's partition, *A Train to Pakistan*, one of the characters is a pedantic Communist social worker called Iqbal. He comes to the village of Mano Majra to "divert the kill-and-grab instinct from communal channels and turn it against the propertied class"; instead, the villagers recognize in him a member of the educated elite, and even the village ruffian Jugga, the novel's real hero, seeks a very particular lesson from Iqbal. "Teach me some 'git mit' like 'good morning.' Will you, Babuji-sahib?" Till then, Jugga's knowledge of English had been limited to bits of "little verse" in half English and half Hindustani: "Pigeon—*kabootar, oodan*—fly / Look—*dekho, usman*—sky."

By the novel's end, we have been witnesses to the fact that Iqbal's access to the language of power has led only to futile fantasies of self-aggrandizement. "If only he could get out to Delhi and to civilization! He would report on his arrest; the party paper would frontpage the news with his photograph: ANGLO-AMERICAN CAPITALIST CONSPIRACY TO CREATE CHAOS (lovely alliteration). COMRADE IQBAL IMPRISONED ON BORDER. It would all go to make him a hero." Against this bold claim to a privileged place in history is Jugga's small, immediate concern about the safety of his beloved Nooran, a Muslim, probably a passenger on the doomed train to Pakistan. All of Iqbal's words, especially all his words in English, are unable to explain or alter Nooran's fate.

To recognize in Iqbal a model of the nationalist revolutionary is to commit an injustice to those who struggled not only for independence from the British but also continued that struggle in postcolonial India. But what of Iqbal as a model for the teacher of English, in the sense of occupying a position, whether self-important or not, of utter marginality? Let's consider the case of India. Gauri Viswanathan succinctly sums up not only the way in which teachers of English are peripheral in the postcolonial context but also how, at the same time, they are complicitous in the perpetuation of an elite order:

> [T]he literacy percentage in India, in all languages, has crawled at the rate of less than one point per year since independence. At a time when three out of five students drop out before they reach the fifth standard, when another fifteen per cent fail to reach the high school stage, and when more than fifty per cent of those who do manage to go to secondary schools fail to matriculate, the declining literacy rates is cause for considerable alarm. Furthermore, the decline has to be set against the mushrooming growth of schools offering an ed-

ucation in English language and literature. Far from encouraging the spread of literacy, the growth of such schools has virtually stymied it. This it has done by promoting a restrictive meaning of literacy as the passive acquisition of the mechanics of language and structured ways of thinking. The filter-down effect has diluted whatever creative potency literacy programmes in other Indian languages might have.

At the same time, as Viswanathan would readily allow, the ideological and institutional power of English in a society like India makes it necessary to think through the ways in which it can be changed and appropriated rather than simply rejected as a political option. What needs to be understood is the socio-cultural context in which English and its teaching is given meaning. Indeed, Viswanathan recounts a meeting with a young woman near a construction site in Madras, an exchange that underlines the power that students and teachers of English are supposed to possess. She reports the young worker's words: "She then excitedly asked, 'Can you teach me English? Can you teach me how to read nice books like the ones you're holding?' This time I was visibly astonished and asked her why she wanted to learn English so badly. Her answer shook me up then, and continues to do so even now when I recall it: 'Because I want to live in these houses rather than build them.'"

Viswanathan's essay appears in a volume entitled *The Lie of the Land: English Literary Studies in India*; most of the contributors to the volume stress that to recognize the colonial provenance of English education is a necessary step. Still, none of these teachers and theorists are prepared to give in, and I think very rightly, to a chauvinistic, ultra-nationalist demand to banish English from the Indian curriculum. Their attempt to produce a more meaningful pedagogic practice lies in articulating a need to relate what is taught in the classroom with the world outside it—a strict departure from the colonial charters and the continued dominance of that conservative agenda in postcolonial universities even today.

Does Khushwant Singh's Iqbal serve as an approximation of the postcolonial teacher of English in the *Western* academy? Unlike Singh's Iqbal, the postcolonial intellectual cannot, of course, be seen as the harbinger of modernity in the rural backwaters; but, as a bearer of a privileged knowledge that has its origins in faraway lands, the postcolonial intellectual does indeed resemble Iqbal. This status is consolidated very often by the claims of a theoretical practice that frequently, like Iqbal's own modus operandi of inferring boldly from Marxist classics, functions formulaically and with little concern for public consequences.

And yet here too we must contend with the other side of the coin. I have in mind the argument that, even within the dominant liberal regime, it is not only possible but also necessary to introduce oppositional knowledge in the classroom. It is through this deployment of, for example, anti-imperialist knowledge that many postcolonial teachers of literature and theory have made their singular mark in the Western academy.

I can come to class on the first day and show the slide of a postcard from a decade or more ago. It shows a billboard with a corporate logo and a child kneeling beside a dirt road in the Central American countryside. Above the child's head, the advertisement reads "He knows only three words of English: Boy, George, Uniroyal." A line of black paint cuts across the last three words, and, thanks to the ingenuity of a graffiti artist, the new message reads "He knows only three words of English: Go Home Yankee."

When I show my students this, I want to teach them that multicultural education in the U.S. might be nothing more than propaganda—or worse, advertising—if it doesn't hear, and amplify, those voices all over the world who talk back to power.

And yet what does this really mean? After all, the child beside the dirt road didn't put the words on the billboard. It is less easy in my classroom—and I'd imagine in many others like mine—to draw attention to the words of other students, in other worlds. In the silence that attends the absence of those voices, is it surprising that teachers like me often find themselves raising their voices? So that these raised voices, in quieter moments, sound so much like resounding slogans—or even, at times, like lessons learned by rote in school and repeated aloud.

How many times in these pages do I raise my voice at the figure I describe as the immigration officer? He is the one who stands in the shadows even as I, in the pages that follow, talk of other experiences, for example, of my teaching in a North American classroom. What is it that I would like to teach the immigration officer?

There is another question. If he is the Other with whom I am united precisely because I so very consistently choose him as my interlocutor, does he in any significant way remain Other? I have a good reason to ask this. I remember that the immigration officer is the one who, unlike anyone else, held my passport in his hand. Or, imagine the visa officer in the American embassy in Delhi. He also probably felt my fear. Or my father's humiliation. Perhaps he registered my sister's confusion when he asked her a question. On occasion he steps out of the embassy into the streets of my city. And stops to consider the honest remark of a tailor, a cobbler, or a child, who feels in no way beholden to him. The visa officer cannot *not* know who I am and what place he holds in my thoughts. And I in his.

Ashis Nandy argues that the "White sahib" need not always be seen as the "conspiratorial dedicated oppressor." Instead, Nandy advances the view of the colonizer as "a self-destructive co-victim with a reified life style and parochial culture, caught in the hinges of the history he swears by." Nandy's argument is simple: "All theories of salvation, secular or non-secular, which fail to understand this degradation of the colonizer are theories which indirectly admit the superiority of the oppressors and collaborate with them."

In each of the encounters that I describe above, there are moments that are pedagogical. There is teaching going on in those experiences. Of course. The rest of this chapter also gives voice to those experiences and points toward what is at stake in mobilizing those oppositional experiences in the Western academy. But, using Nandy, I also hope to make a different point. My teaching, in marking its otherness, remains caught only in the terms of opposition. A more responsive teaching practice might go further and comment on the process through which difference, instead of being fixed, itself changes. Not only because of recognizable historical shifts but also, more subtly, as a result of the ways in which the interrogating officer becomes, inevitably, the one he interrogates.

• • •

While I'm listening to a rector's talk
here in the university
(grey cops are at every door
contributing to the culture),
nauseous till I'm pale, I remember
the sad peace of my native poverty,
the sweet sluggishness with which
everything dies in my town.

Roque Dalton

One night my father telephoned me from India to give me the news of Maheshwar's death. Maheshwar was the commander of the new cultural struggle inaugurated by the Indian People's Front; a singer, poet, editor, and organizer, he had turned his illness into an occasion to mount another critique of life under capitalism, calling for a radically new culture. Lying on his hospital bed in Chandigarh, he wrote:

My friends do not want to stick by my side
beyond the ritual exchanges about our well-being.
It is right at this point of time
that my loneliness descends
and like the dusk spreading in the sky
fills the corners and the insides of my brain.
This loneliness alone is my strength
in its womb
takes birth my desire to live . . .

You will be finished—
you will be killed
because—
when did you learn in life
the politics of sharing with someone
someone's loneliness.

Maheshwar led multiple, varied assaults on the conditions that limit all aspects of our lived experience: his thinking touched and transformed the lives of both literate and illiterate folk within the Indian People's Front. Poetry as much as the parliament was for him a zone of struggle and a site for building an inventory as well as a new history. Where his comrades had given attention exclusively to debates about peasant-industrial workers alliances, Maheshwar widened his canvas to include questions about, for example, love and commodification: "After all how can anyone be in love / if in your heart vast as the sea there isn't space enough

for a Kelvinator fridge?" That is why, in the obituary I wrote for him, I referred to the teaching I practice here:

> And yes, in the end, I must express a resolve. Do you recall those words of Maheshwar when he says: "I understand that inside the politics of bourgeois democracy, those people that we send inside the bourgeois institutions, should be tried and tested Communists, the most experienced, the most selfless." Here I am in America, in what Che Guevara called "the belly of the beast." The U.S. academic institution is a bourgeois institution *par excellence*. Maheshwar forces me to ask how am I going to be the alert, active intellectual who will undertake the initiatives to expose the Western bourgeois hegemony. Dear Maheshwar, I am not being the least bit sentimental when I say that when next I pick up a piece of chalk and begin to teach, I'll think of you . . . and I promise you that my pedagogy will be a bullet that stops the oppressor in his tracks, it will be a song that will add its note to the many songs that you left in our midst.

I quote my promise to Maheshwar because the debates in this country, especially those surrounding the teaching of postcolonial theory, have nothing to do with criticism that searches for constituencies or discloses a community, national and international.

If this profession is to have a different, and broader, significance, we must break from a practice of writing that serves predetermined rationality and forms of predefined criticism. We can turn to what Ashis Nandy calls "mythographies" wherein we expose the "real" history as a fable and extravagantly proclaim alternative myths:

HISTORY

(For Divya Singh)

They caught the peasant
walking home from the field.
On the dark road
they gagged him
and cut off his nose.
This they took to the museum
and stuck to the king's
noseless statue.

Thus was born the history
that is taught in schools.

The writing that seeks to build communities will, I hope, work unabashedly, even urgently, as an appeal and, quite literally, as a call. In that spirit, I offer a poem that takes up and examines three letters.

Reaching across global divisions and distance, we need to form coalitions to contest those unholy alliances that have developed between repressive regimes at home and the privileged elite abroad. My desire to produce new, rebellious songs linking expatriate lives with oppositional possibilities in the homelands we have left also counters those popular Hindi film hits that celebrate nostalgia as a static condition demanding nothing more than sighs for the moon tugging at the branches of the *neem* tree in the courtyard of the village home. The next poem struggles with the meaning in "N.R.I."—a nominational type that was invented by the government of India to lure the capital of affluent Indians living abroad, mostly in the U.S. and the U.K. These Non-Resident Indians get tax privileges and other help, including cheaper, refundable airline tickets when they are on a visit "home."

N.R.I.

(For Chandrabhushan)

Look up at the name I have given
this poem. If it were to fly off this page
and pass through my right cheek
and keep heading eastwards
in the direction of the deepest darkness
that will surely give way to light
—who is there in this city
who will tell me how many miles
these three letters with my blood on them
will need to travel before dropping
resoundingly on the roof of your house
where you live among friends?

I know you well. If this were to happen
even though these are only letters
you would settle down to ask them
questions like did your eyes meet
the eyes of those Indian women who linger
outside the toilets in Heathrow airport
with their brushes and brooms?
What do they think of Prince Charles
conducting virginity tests
on the bodies of immigrant women?
*Hum to hain pardes mein, des mein
nikla hoga chaand re.* This talk of the moon
back home in the village tugging
at the branches. Is this all only nostalgia?

You might even send these letters
back to me so that I may go on
with this poem. Far away from this desk
in a white-walled room where I sit
writing this poem for you is a river
that flows in our native land.
Invisible to the person standing
on the roof of the tallest skyscraper
in front of me, lost in sounds that are so unlike
the nearby noise of fast cars passing on roads
that loop in the air, buried
among banks that hide the salt of darker skins,
that river, Kuano, still flows years after
the poet Sarveshwar with his home
on its banks died, once having written:
"Kuano river, thin, blue, calm,
when will it spread to the horizon,
turn red, turn turbulent,
very poor is this land where it flows."

Tomorrow when you drink your tea
in sight of the workers who make thin cotton
mattresses you will be putting together
two more words for a poem
whose rhymes might not translate well
in English. Your poem is about a town
that's spread around a small railway yard
where a guard who lost his legs to a train
helps little children fly kites.
You won't be happy till there's the sudden smell
of hot mustard and cumin fried in ghee
over a blazing fire, and the laughter of women
who have dark coal-dust buried beneath their nails.
Little news comes there, except
about births or deaths, dates of festivals
and marriages. In this world of your poems
you and I open another book,
a fat ledger of names of people
whose foreign cars are wider than the roads
of your village, whose words are three
or thirty times weightier than yours.
This ledger is marked N.R.I.

No poems about them in your book
yet. But they are growing in number,
these men who eat *paan* folded in dollar bills
and spit out the red juice

which gives that strange color to the buildings
in New Delhi. They would've been our landlords
had we been born in the last century.
Now the absentee landlords
have names of firms on Wall Street.
I've seen these men in my dreams: chicken
feathers clinging to their bloated faces,
watching Hindi film-videos
in their bedrooms in London and Washington D.C.,
their beds afloat in a sea of Scotch.
Their cousins in Calcutta and Bombay
conduct the same base business they always have
but translate it into English these days.
That one-eyed boy from your village
who used to sit all day on the lowest branch
of the mango tree is now their servant.
They have given him a guard's uniform
to keep out of their sight people like you.
Ask that boy, he will tell you. Indian ministers
visit these homes, and big officers are given
perfume for their wives and mistresses.
Priests find their Himalayas here,
among the tall, American skyscrapers.
These holy men feel that heaven
is to be enjoyed wherever it can be found.

In their journey back to me, these letters
cross a sleeping *basti*, a dark city
above which rise terrifying sounds.
There are lorries parked in silent rows
with pictures of our heroes on their side
—Bhagat Singh with a hat, Azad twirling
his moustache, a smiling Gandhi
though someone has scratched out his eyes.
An owl guards the government post-office.
There are new phone-booths to talk to people
all over the world, even as our whole world
is being lost to us.
 Under half a dozen guns
trained on them from faded movie posters
there are bundles sleeping fitfully on the streets.
While they sleep, fifty million others in the city
are lighting fires, waiting in lines, setting machines
into motion. I want you to write and tell me
what are their thoughts.

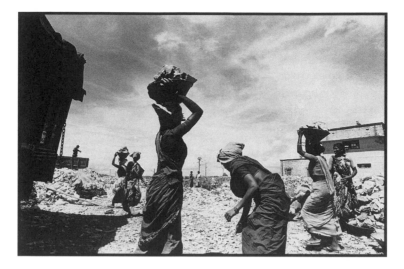

A pedagogy that chooses to perform on the border of the U.S./Them divide exists neither in the light of cocky arrogance nor in the darkness of quietism. It reminds us, as in the work of Guillermo Gómez-Peña, that this world is an irretrievably mixed-up place. The genuinely new world border will be inevitably *mestizo*—but even so, we can't forget that it is the poor, the colored, and, in a very literal sense, the border crossers, who pay the price of "purity" and monoculturalism.

This border pedagogy is performative: it is active, and it enacts or *stages* the contradictions that condition it. It is effective, affective, and certainly excessive. When Susan Buck-Morss elaborates her understanding of what she calls Benjamin's "war of demolition," we get a sense of what performance might undertake in opposition to the natural, linear, wholly conventional or stable pedagogy:

> But it the conceptual platform that was exploded, not the material elements. When these were "blasted out of the continuum of history," blown free of the codifying structures which entrapped them, it was necessary to catch them up again in a new cognitive net before they disappeared in history completely. Here was the constructive moment of the dialectic.

AMITAVA KUMAR, THE *GAINESVILLE IGUANA*, DECEMBER 1993

You too, dear cultural subject, it doesn't matter in what corner of this planet you went to bed, are probably just waking up and sipping your cappuccino in America's multicultural morning where the sun shines on

Benneton ads that show racist L.A. cops kissing Rodney King's ass and Americans of all races putting all their differences aside to sing happy jingles pledging allegiance to the flag of unchecked consumerism.

Guillermo Gómez-Peña, Mexico-born cultural-criticism hustler now unsettled in Los Angeles, slips into this scenario with the rudeness of a pirate-radio hack, bringing in news from across the border of mainstream propaganda and understanding. The other night at the Harn Museum in Gainesville, Florida—a town otherwise famous for serial murders and tourist killings—I watched Gómez-Peña present *The New World Border,* a show that broadcast in a mixed tongue the presence of the Other amidst us in a world that can no longer sing the anthem of love for family, country, and white-bread values. Citizens of lard-white, securely male and middle-class, complacently heterosexual America, in Gómez-Peña's hilariously hyperbolic prophetic announcements, appeared as illegal aliens in a reinvented universe, the "wasp-backs" in a culture where the museums would conceivably be overflowing with the rotting bodies of purists and puritans, exoticizing anthropologists, elitists, supremacists, palefaced custodians of privileged knowledge and (it's the same thing) bad taste.

Gómez-Peña scripted this *New World Border* and presented it in collaboration with Roberto Sifuentes. Their electric, bizarre performance closely resembled the new world it announced: reality that looks and feels "like a cyberpunk film directed by José Martí and Ted Turner on acid." Gómez-Peña and Sifuentes appeared on stage as exuberant, irreverent graffiti artists, impatient as much with the patronizing liberalism of the Right as with the solemn pieties of the Left. This wasn't intended to be a show that dished out the "We are the World" theme song of the Coke commercial; neither was it prepared to mime the tame puppetry of Public Television. Instead, it asked us: when Gringostroika happens, who will still be dictating the terms of the debate?

This question fell into the lap of the audience, quite literally, like a dead chicken. The performance had proceeded with two dead chickens hanging at the front of the stage. At one point Gómez-Peña hit one of the chickens with his gloved fist and then, in a ritual where he intoned the words "chicken/Chicano," drawing attention to the racist name for Mexican migrant workers in Texas, he severed the chicken's head. The few members of the audience who protested what they felt was an abuse of animal rights were asked by Gómez-Peña why they hadn't asked any questions about the human skeleton that had also hung from the ceiling. Unlike the chickens, that question remained hanging after the perfor-

mance was over. Yes, under a pretext of a specious universalism that equates all forms of life, why is it that animals take precedence over humans—especially when those humans happen to be of another color? (Guess what? It's called liberalism. Look into it.)

Post-performance, when this multicultural self stepped out of the Harn, I thought I had walked into another theater. In the parking lot, all the cars had pink sheets on their windshields. "Need Insurance?" was the question on top. Printed beneath was a phone number and the assuring message "Se Hablas [*sic*] Español." So, what did the folks at Sleazeball Insurance think? Probably that they'd find a captive audience of ethnics at this performance. I'd like to think that capitalism, savvy and sordidly multicultural, got tripped here. It was not migrant workers who needed Gómez-Peña in their midst that night. Rather, it is those with two houses, two cars, two dogs, probably also two insurance policies, but only one language, who should have come out to find pink slips that asked, with the crassness that only capitalism can manage, "Need a Multicultural Education?"

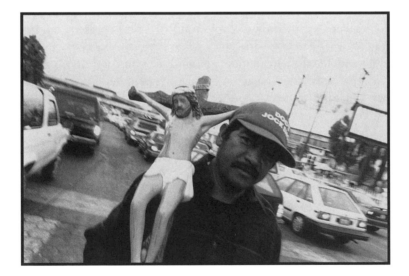

In an act reminiscent of George Bush's 1988 campaign in which he shamelessly scapegoated an entire race by fixing it in the stereotype of a singular image of Willie Horton, in late October 1994 Susan Smith, the South Carolina mother who was charged with the killing of her two sons, lied to the police that her children had been kidnapped by a young black man in a knit cap. This identikit image was something that had, the police later claimed, introduced doubt in the picture Smith had been painting. As we all know, Smith confessed to the crime after failing two lie-detector tests. But what are we to make of the suspicions aroused in the mind of Sheriff Howard Wells in the town of Union, South Carolina, regarding the stereotyping of blacks?

Not too much. Because it was not only the policemen but also the broader citizenry in California who, only a week after the Smith case hit the press, fell to the ploy of seeing in the dark-faced stranger the scapegoat for their ills. In the 1994 elections the Californians voted by a margin of 59 percent over 41 percent in favor of the Proposition 187 that will deny public services to the undocumented workers who, it is presumed, will continue to cook, baby-sit, and provide cheap labor without having any access to health care and education for their own children.

The face projected by the ominous threats of Proposition 187 is that of a stereotype. It is an anonymity that can be affixed to descriptions like "the nanny from Tijuana" or "the farmworker from Rosamorada"; it applies equally indiscriminately to "the waitress born and raised in San Diego" or "the non-English speaking, green-card holder from San Salvador." The body of the debased Other is stigmatized even while—rather, *because*—it serves, through its labor, the ends of progress and the preservation of the status quo for the affluent mainstream.

This stereotypical quotation is not limited to African Americans or Mexican Americans. "It is only a slight overstatement to say that Muslims and Arabs are essentially covered, discussed, apprehended, either as oil suppliers or as potential terrorists," wrote Edward Said in *Covering Islam*, commenting on the media attention to the Middle East after the end of the Teheran hostage crisis.

In Said's translation, the Western media's narrative about the Islamic world is shown to be interestedly narrow and stereotypical. As "[v]ery little of the detail, the human density, the passion of Arab-Muslim life has entered the awareness of even those people whose profession it is to report the Islamic world," Said's counternarrative demands the elaboration of other rather particular stories in opposition to what he rightly

sees as only "crude, essentialized caricatures." This demand is most explicitly formulated by Said in the following passage:

> To dispel the myths and stereotypes of Orientalism, the world as a whole has to be given an opportunity, by the media and by Muslims themselves, to see Muslims and Orientals producing and, more important, diffusing a different form of history, a new kind of sociology, a new cultural awareness: in short, Muslims need to emphasize the goal of living a new form of history, investigating what Marshall Hodgson has called the Islamicate world and its many different societies with such seriousness of purpose and urgency as also to communicate the results outside the Muslim world.

The need to produce different histories and new writings—a demand renewed by Said after the bombing of the World Trade Center in New York and repeated by others after the presumptuous racist attacks on Arab American families following the Oklahoma bombing—burdens cultural workers and intellectuals with the task of providing alternative readings, supplying critical contexts for the consumption of cultural texts as well as events, in short, translating what would be available as natural or incontestably plain into that which is political and has different consequences.

The construction of such an inventory is so necessary and at the same time so utterly absent that it is impossible, it seems to me, not to take a *pedagogical* stance—toward both the individual self and the surrounding culture, particularly inside the dominant ranks of understanding in the West, marked by what Gayatri Chakravorty Spivak terms "the sanctioned ignorance that every critic of imperialism must chart."

PRIMARY LESSONS IN POLITICAL ECONOMY

For every ten bushels of paddy she harvests
 the landless laborer takes home one.

This woman, whose name is Hiria, would have to starve
 for three days to buy a liter of milk.

If she were to check her hunger and not eat
 for a month she could buy a book of poems.

And if Hiria, who works endlessly, could starve
 endlessly, in ten years she could buy that piece

Of land on which during short winter evenings
 the landlord's son plays badminton.

This politics of professing postcolonialism lies in its drawing of equations between disparate realities. But, even in drawing equations, it dispels any sense of balance or equality. More thoroughly, there is a dispelling of any sense of stability. Everything is revealed as framed by the language of ideology, and, even the simplest elements of mechanics are always irreducibly political in that sense.

I can already hear the clamor of right-wing conservatives who shout that this is a brand of teaching that politicizes everything and doesn't respect individual differences. But they are wrong. Sometimes, some difference is no difference at all. As the Indian sapper Kip in Ondaatje's *English Patient* protests when he's told that the national identity of the one he accuses is not British: "American, French, I don't care. When you start bombing the brown races of the world, you're an Englishman." And at other times, some differences do not constitute a real difference. In Ondaatje's novel the Italian, Caravaggio, corroborates Kip's feelings about the bombing of Hiroshima and Nagasaki: "He knows the young soldier is right. They would never have dropped such a bomb on a white nation."

Against those who exoticize, erase, demonize, or just plainly incarcerate those who are genuinely different, this brand of pedagogy proclaims a community of sameness, a coalition of the marginalized, a broad unity of the oppressed against the oppressors. It engages the exuberant logic of Subcomandante Marcos's response to a question about his identity:

Marcos is gay in San Francisco, black in South Africa, an Asian in Europe, a Chicano in San Ysidro, an anarchist in Spain, a Palestinian in Israel, a Mayan Indian in the streets of San Cristóbal, a gang member in Neza, a rocker in the National University, a Jew in Germany, an Ombudsman in the Defense Ministry, a Communist in the post-Cold War era, an artist without gallery or portfolio, a pacifist in Bosnia, a housewife alone on a Saturday night in any neighborhood in any city in Mexico, a reporter writing filler stories for the back pages, a single woman on the subway at 10 P.M., a peasant without land, an unemployed worker, a dissident amid free-market economics, a writer without books or readers, and, of course, a Zapatista in the mountains of southeast Mexico.

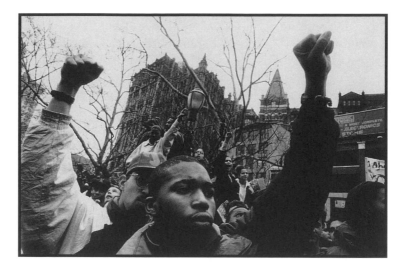

THE MLA PRESIDENT'S COLUMN

I was headed for the Omni Park Central Hotel in New York City at nine in the morning. The Pakistani cabbie suddenly became solemn when I confided to him in Urdu that he was transporting a candidate for a job interview at the Modern Language Association Annual Meeting. "Do you have a green card?" the driver asked me. "No, but I'll apply for one if I get a job." "In this mother-fucking country," he opined, "you only get jobs when you know something about cars."

For my first interview, I was given the empty seat by the window. From that vantage point I took in the sight of the ten University of Pennsylvania professors impressively arrayed around me. Houston Baker was preparing himself a cup of tea, and when I admitted that this indeed was my first interview of the day, he smiled broadly and said, "Well, we'll put you in good shape for the others." Or words to that effect. I wasn't yet beginning to hear words as words: it was more like being at a foreign airport and following the signs that meant Bags but could also mean Bus.

That year—I'm speaking of 1992—Baker, who now sat sipping tea, was the president of the MLA. I had read his rap on race only months after my arrival in this country in 1986, a fresh immigrant in the land of theoryspeak, utterly ignorant of the world that now confronted me with its divisions between the signifier and the signified. But six years later, in this hotel suite, I entertained a different feeling of closeness with

Baker. I felt it'd be worth talking to Baker not because I had become acculturated and had truly internalized the social mores of our profession but more because I had been reading the "President's Column" that he wrote in the MLA *Newsletter*. In each of his columns, drawing on an autobiographical voice that joined itself to the interests of minorities, women, and even graduate students, Baker came across to me as someone who was very seriously taking his position at the top to announce that decisive changes *below* had put him there.

In the fall *Newsletter*, Baker wrote about "a common fund of apprenticeship experiences and memories"—like anthropologists' ethnographic accounts of their travels to other lands—that "constitutes what I would call fieldwork in our disciplines." In each of his columns and, as I was to witness later on the day that I had my interview with him, in the course of his presidential address, Baker would skillfully use his personal experiences as an African American student as well as teacher of literature to present telling details of the changes that have become a part of our profession. Everywhere, he conveyed a sense of participating in an energetic defense of what June Jordan calls "the multifoliate, overwhelming, and ultimately inescapable actual life that our myriad and disparate histories imply."

Thus, speaking that night as the president of the MLA, Baker would remark on the different look the annual convention bore back in 1968 (Baker's first MLA meeting) when he saw only one other person of color at his hotel. "The most unsettling moment came when I stepped off the hotel elevator on the second morning. I felt a hand on my shoulder and turned to encounter a ruddy-faced giant who drawled, 'Excuse me. Do you know where I can find any good Negro boys to teach at my school?' I balked, sputtered, and felt goose bumps rising but managed to respond that he might have more luck if he tried looking for black *men*. His companion guffawed, and I hastened to escape."

I am less willing than Baker to grant the MLA the multicultural virtues he so easily bestowed on it (in his final column he wrote that "the Modern Language Association is not just a room but truly a building we feel is *our* own"). I choose to put more emphasis on Daphne Patai's assertion that "as for African Americans, their scant presence on university faculties is a national disgrace." However, I am accepting of the pride that Baker claimed unabashedly for himself and others who are "proud and civil directors of buildings such as the Center for the Study of Black Literature and Culture at the University of Pennsylvania" and similar centers at Harvard, UCLA, Cornell, and Ann Arbor. More than mere

pride, I had also come to expect a struttin' defiance, recalling that exchange cited by Frantz Fanon: "'Look how handsome that Negro is! . . .' 'Kiss the handsome Negro's ass, madame!'"

I myself had understood, with Baker, that my "skin is, in fact, what the West Indian novelist George Lamming metaphorically claims it is— a castle of one's own." Not too long before my interview, in a diary that I had published in a scholarly journal, I had quoted my poem that addressed the reality of my foreign body in the classroom of the U.S. academy. That poem ended with the words:

> I turn from the board: black
> wall with weak ribs of chalk.
> My voice rises, fills the room
> and moves out of the door.
> It dances in the corridor, tripping
> with its foreign accent
> those calmly walking past.

And, again with Baker, I realized that the field of pedagogy is a place where the personal and the public meet to give rise to a provocative kind of politics. Baker rightly claimed a certain pride in announcing the establishment of multicultural programs; I had displayed my share of defiance in spelling out an activist, anti-imperialist agenda. In the diary that I had published, I found a militant pleasure in describing the role of one of my students, Melinda, in a rally to protest the assassination of six Jesuit priests under the death-squad Arena government in El Salvador. A law firm that did the public relations work for that government and secured U.S. aid for the military was holding a banquet in Minneapolis. Allow me to quote a part of my entry for that night:

> We're outside in the cold chanting: "One, Two, Three, Four—U.S. Out of Salvador" and "Hannan-O'Connor you can't hide!—We charge you with genocide." Policemen are protecting the city's elite, whom we can see through the glass walls. We keep up the chanting while Hannan and O'Connor's guests drink wine and converse amidst lighted candles. Then, someone says we should move and stand outside a door in another part of the building. We knock, no response. A minute later, the door opened. It's Melinda who, I learned later, had hid in the bathroom earlier in the day to let us in. . . . The banquet is disrupted and the local television stations present our protest on the nightly news. The law firm has been clearly embarrassed and the reality of civilian killings brought out in a manner that will be impossible to hide for any public relations firm.

My job interview, at least the one that I began this narrative with, was a lengthy one and involved engaging discussions with several people in the room. (I didn't get the job at Penn, however, and I'm reasonably certain that my ignorance about cars wasn't a factor in that decision.) As far as my professional chat with Houston Baker is concerned, what we argued over has pertinence for this text. During the interview, I had begun explaining my work as an attempt to speak in divided tongues, hoping to produce a global hybrid discourse that would correct and critique the mystifying divisions and disjunctures under late capitalism. At each point, I was politely contested by Baker. The idea of following a mode of global pedagogy that linked the shoes one was wearing with the labor of postcolonial workers did not seem to impress Baker beyond a point. To paraphrase his vigorous queries: but how would you understand a local pedagogy? It is all very well to attend to workers in Indonesia, but what about the here and now? How do you respond to the needs and anxieties of students that need to be addressed in their own specific contexts?

Unknown to me then, Baker was to deliver that evening his presidential address entitled "Local Pedagogy; or, How I Redeemed My Spring Semester." By the end of that talk, which brought the staid MLA audience to its feet, Baker had moved from mere autobiography to a more particular performance: he had tapped into the idea of a confession to provide a narrative of redemption for himself and, miraculously, for the profession he was representing as a leader that night. Baker's main story, in a large nutshell, was the following one. A black female undergraduate in his class on Black Women's Writing asked Baker why they weren't discussing Phillis Wheatley's poetry in relation to the black community per se. Baker's response had been that the class was going to concentrate on conventions and reading skills. The semester was generally a failure, and during the evening's lecture, Baker was redeeming that past by acknowledging that instead of falling prey to some abstract generalizing rhetoric about shared democratic interests he should have respected the concrete, local geography of concerns through which the student's question had made its way. The suppression of blackness and of female agency was a foolishly censoring act. A more responsible pedagogy would be one that did not flinch from being what conservatives might call "narrow" or even "partisan."

In my estimation, the turns of this argument represented a consummate political skill. The mode of the confession ushered into the ranks of the professionals, who still might hold dear something called "the lit-

erary," a sense of local concerns that gave meaning and weight to politics; at the same time, for those who might grandly and even routinely invoke the categories of race, class, or gender, Baker was serving a reminder that all that talk meant nothing if you couldn't deal with immediate realities like the kind of hostile social spaces that women and minorities traversed on their way to their class. And yet I found this performance, even with its strategic strengths, curiously lacking. The experience was doubly dissatisfying for me because I felt that in my discussion with Baker that morning I had failed to advance a more compelling account of pedagogy as well as of performance that transcended the barren binary of "local/global."

So let me mimic Baker and attempt a revision of my own. I do not expect redemption because this is not intended as a confession. The self-reflexivity of a confession is a rather limited one: you failed once, and after you have confessed, you and even your listeners who pardon you can now be absolved. I want to enact a less triumphalist gesture, and the contradictions I want to keep alive are not unrelated to the tension between the local and the global that Baker in his lecture rather quickly foreclosed.

Where is Indonesia, Professor Baker, other than in sole of your shoe? As a local line of query, this question allows us to begin with what your students have on their person, both as object and as ideology. As a global mode of questioning, it refers to the task of making visible those relations that are effaced by the workings of late capitalism, in this case, the invisible labor of the Indonesian who made your Nike shoes. Nothing, in other words, makes my question inherently local or global. Moreover, a moment of reflection suggests that, as a pedagogical strategy, it'd require a great deal of hard work and imagination to actually remain in any one mode of intellectual operation. In that case, the more productive move is that of recognizing that the real labor of critical pedagogy lies in doing the dialectical dance between the two terms. We have to produce the effective kinetic motion on the floor of history that opens the space of one to the other. In that motion, genuine dialogic interaction—of modes of knowledge, of forms, and of people—lies. To return to Baker's classroom, the choice shouldn't be between questions of conventions and issues of communities. Rather, the histories that make unstable the divisions between those two different modes of inquiry should become an active part of the course.

As we know, Fanon wrote with lyrical power against Sartre's assertion that the idea of race is concrete and particular and that the idea of

class is universal and abstract. Fanon's foe was a deracinated socialism. An overly localized understanding of blackness in Baker poses the same problem from the other end—even when it is invested in strategy or the demands of rhetoric. And this of course is not an argument that needs to be advanced only against Professor Baker. When Charles Barkley defends his aggressiveness against Angolan players at an Olympic game by saying "It's a ghetto thing, you won't understand," he needs to be heard. At the same time, Barkley needs to understand too that there are ways of broaching historical links with the Angolans that would help explain what put him in the ghetto in the first place. Or, dammit, just help explain why the folks King Charles grew up with remain in the ghetto while he is a star selling his powerful body and a brand of cologne on TV.

The personal voice, in Houston Baker's columns as well as his other reflections, achieves the greatest critical purchase when it expresses a complexity that would otherwise remain beyond the reach of the traditionally academic commentary. It encompasses rage and longing, gives voice to memories as well as to the experience of reason making sense of those memories, putting the brutality and the beauty of the past in perspective. Sometimes, it also touches on the sensibility of silence, when there is no possibility of redemption and only the chance of finding a brief reprieve. In solidarity with the more enabling use of the personal voice in Baker's writing, I offer my poems for the INS and set them in the U.S. embassy in New Delhi, a site of the local that is always already also a marker of the global:

I.
The cigarette smoke lingered
in the blue Minnesota chill
as my friend said, "I'd like to talk
to you of other things.
Not politics again but things like
whether you are lonely."

"What could be more political
than the fact that I'm lonely,
that I am so far away
from everything I've known?"

But, the consular here has other queries.
Do you have property in India?
Land? Relatives? Anything?

"Write down, officer:
The yellow of mustard blossoms

stretching to the blue horizon.
My grandmother's tears
when she asks me what good is your learning
when it steals you from my embrace.
In our old house, with its dampness,
the music of my sister's laughter.
Four friends who bring news
of a new canal that has been dug by the villagers.
The bend in the river
near the tall trees where the spirits
of my ancestors are consecrated.
Women's voices from across the waters
that I have been hearing since my childhood.
The smell of hot pepper being roasted over a naked fire."

All of this from that one brief hour in November
during which my friend had asked her question.

II.
"And how do I know
you are going to come back
—that you aren't going
to stay there in the States?"
The officer is young, wearing a tie.
He turns my passport around
till he has my picture upside down,
the loose change for my bus-ticket
rolling out of my shirt-pocket
 into his lap.

III.
A Marine walks around us, his attention cocked.
What does he want me to do?
"Rambo, Rambo." I shout exultantly.
But, that's too recent, let me mine
the archetypes. "Hey Charlie,
Give me a Lucky Strike. Some gum?
Want a good fuck? Very cheap. Dirty magazine?"
I do nothing, I say nothing.
In the garden outside the peacocks call.
I sip the coffee and plot my moves.
Now am I doing what he wants me to do?

IV.
"Do you intend to overthrow
the government of the United States
by force or fraud?"

An old man who wants to visit
a son in New Jersey
wants me to help him
with this question on the form.
A friend tells me later of someone
who believing it was an either/or question
tried to play it safe and opted
for the overthrow of the government
by fraud.

V.
"You can't trust them," one officer says.
I'm prepared to bet he is from Brooklyn.
There is no response from the other one. He is not angry,
just sad that I now work in his country.
This quiet American has pasted a sheet with Hindi alphabets
on his left, on his right there is a proverb from Punjab.
"You just can't trust them," the first one repeats,
shaking his wrist to loosen his heavy watch.
The one sitting down now raises his weary eyes.
"Did you, the first time you went there,
intend to come back?"
 "Wait a minute," I say, "did you get a visa
when you first went to the moon? Fuck the moon,
tell me about Vietnam. Just how precise
were your plans there, you asshole?
And did you when you went to Panama the first time
know that you'd come back, guns blazing, a century later?
And this," I fist my cock when I say this, "and this
is what I think of your trust. Do you understand
that every time a doctor, teacher, engineer, or scholar
comes to the United States from India
you save more on bills
that what you and Charlie here
would be able to pay
till the year two thousand and four?
So that your saying that we can't be trusted
is like the owner shouting his worker's lazy
after he has stripped his skin and taken his soul.
He's sold . . . do you hear me?
 Hear me
because I want this fact to be stored
like a bullet in your heart."

Maybe I did say all of this, and it was fear
that I saw in the officer's eyes
when in response to my shrug
he slowly turned the pages of my passport and stamped it.

Nationality

Our tryst with destiny is complete. Everyone
feels nationalistic. Pass out the barfis. It could
be a hockey match. A Tendulkar century. A riot
or a nuclear blast. We are happy.

Shiv Vishvanathan

There are nations within the nation. I am not speaking of separatist groups; nor am I speaking of consenting federations.

I speak of the divisions between the home and the world. Traditionally, women have been bound to their homes. If the nation is divided between the home and the world, then multinational capitalism reproduces that division on a larger scale. Capital travels to zones of non-unionized, fixed employment where women in large numbers provide low-paid labor.

The Third-World nation is a differentiated space. Feudal slavery might coexist with high-tech exploitation. In either form, these modes of oppression call into question the coherence of the fiction given the name Nation.

At the end of "Douloti the Bountiful," a powerful short story by the Indian writer Mahasweta Devi, the putrefied corpse of Douloti, the "kamiya-whore," the bonded sex slave, lies sprawled all over the map of India that the schoolchildren had outlined in the ground and marked with chalk. In the story, the schoolteacher is unable to plant the standard of the independence flag. "What will Mohan do now? Douloti is all over India."

Yes. I think that in the year of the fiftieth anniversary of the Indian independence he can only turn away from Douloti and garland the pockmarked, stone statues of the founding fathers (like those leaders in the photo above; they preside over a new college whose collapsed walls are visible in the background).

Even when the nations within the nation refer to separatist struggles, as in the case of Kashmir in India, it is the women who bear the most violent scars of these divisions.

The Committee for Initiative on Kashmir, a human rights group of prominent civil liberties personalities in India, sent a team of four women to investigate "the impact of militarization of the Kashmir Valley on the lives of the people there, especially the women." On the opening page of their report, the committee states: "The security forces were looked upon as 'brute animals worse than the troops of Chenghiz Khan.' In Kashmir where even eve teasing [harassment of women] was rare every instance of molestation and rape sends shock waves through out the valley. It cuts against the ethos of the Kashmiri society. Of all the atrocities committed by the security forces, the treatment of the Kashmiri women has embittered the people of the valley the most."

The report was published at the beginning of the uprising and the imposition of military rule in Kashmir. In the past eight years, according to some estimates, 20,000 have died in the past struggles between the Indian armed forces and various separatist militant groups. The dead, of course, have included civilians, sometimes caught in the cross fire but also, oftentimes, the victims of counterterrorist tactics of the army.

Recently, parliamentary and state elections were held under heavy military presence, and some semblance of normalcy in the government returned. I visited Kashmir in July 1994 as an investigative photojournalist and was told repeatedly about the instances of rape and torture at the hands of the *jawans* of the Indian Border Security Force. (Many of the people, some of them illiterate, would pause and use the English word "rape"—they pronounced it "wrap" and during those few days that enunciation stuck in my mind, the sudden intrusion of the foreign word, of the violent behavior that, in this form at least, was foreign to the society.) Defying the curfew orders imposed by the military, I went with three men from the JKLF (Jammu and Kashmir Liberation Front) to the Shaheed Murgazar (the martyrs' graveyard).

Abdul Aziz Lone, 70-year-old keeper of the graveyard and the mosque there, removed the sheet of blue tarpaulin covering the fresh grave of his son. Abdul Hamid, 17, had been shot during the Noor Bagh police firing only three days previously. The grieving father sat silently beside the grave, not saying anything. This was his second son who had died during the troubles.

The entire graveyard had a new look about it. There is no other way of saying this. It was as if someone had brought in a fleet of new graves to a giant parking lot and put flower pots between them. On looking closer, I saw that the gravestones were actually made of plywood and had fresh, cheap paint on them. My companions spoke of "mass killings." Abdul Aziz opened a box at the far end of the graveyard and laid out photographs of young men and a few women. My guides repeatedly referred to them as "martyrs."

Dominating the graveyard on that side was the *qabr* (grave) of Mohammad Maqbool Butt, the man who is considered the most prominent separatist leader of the Kashmiris. Butt had been hanged by the Indian government in February 1984, apparently in retaliation for the murder of the Indian diplomat Ravin Mhatre by JKLF activists in Birmingham, England. (Interestingly, the JKLF itself was formed in 1976 and based in the United Kingdom—some would say *perversely* repeating a history

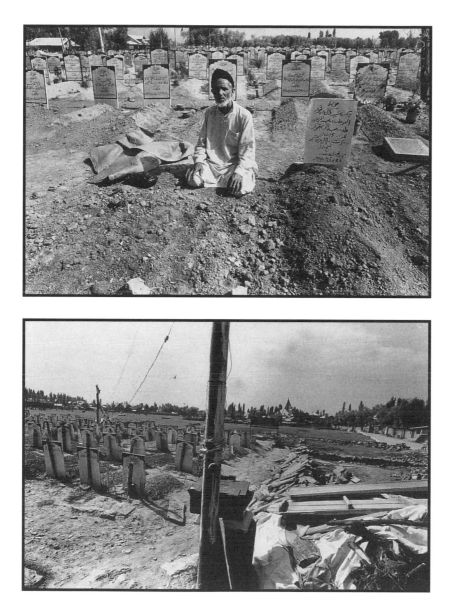

familiar to the subcontinent, the fomenting of nationalist struggles by expatriate intellectuals and leaders in the West—the nation rewritten from outside the nation.) Butt had earlier been in Indian and Pakistani jails— he had killed an intelligence officer in Kashmir and escaped from prison; in Pakistan, he had masterminded the hijacking and then the bombing of an Indian Airlines plane in Lahore—but had finally been arrested after a failed bank heist.

Standing by his grave, however, I was thinking of a remark of his, quoted in a woman's letter that had been published in the report of the Committee for Initiative on Kashmir: "Martyr Maqbool Bhatt [*sic*], in his interview, just before climbing to the gallows, had specified among other issues, 'I do not support any differences on the basis of sex, for the establishment of a society based on equality and harmony the role of the woman is as important as of the man. I am not in favor of the prevalent practice of burqa [the veil] in Muslim society because it confines women within the four walls of the home.'"

Whatever Butt's views on women's rights might have been, the JKLF, according to the committee's report, has been "more or less silent" on that issue. If, on the one hand, the security forces have unleashed their terror in the space where normal institutions of governance are absent, then, on the other, fundamentalist Islamic organizations have stepped into the void felt in the society. Women have been left with increasingly little space for maneuver. To quote from the committee's report once again: "There is a continuous pressure from the various fundamentalist groups on the common Kashmiri to become more Islamic. In the absence of organized democratic and secular forces to resist such pressures, the Muslim women are slowly giving in to the fundamentalist intimidation."

There can be no concept of the nation without inalienable fundamental rights for everyone—even, or particularly, for the rebel. This ordinary lesson imparted to schoolchildren is daily contradicted in the acts of an army carrying a war against its own people. "Independence" and "freedom" are words used as coins to introduce individuals into the political economy of fear and humiliation: "The army, after conducting the search operations, collected all the women and stripped a young man naked. When the women put their eyes down they beat the boy and asked him to request the women to look at him. When he did so an officer said 'is se le lo apni azadi' (go and take your independence from him)."

• • •

The Hazratbal mosque stands a little outside the main city of Kashmir's capital, Srinagar. In *East, West*, Salman Rushdie's collection of short stories, there is one entitled "The Prophet's Hair" that describes in the manner of magical realism the tale of a relic being removed and then returned, through treacherous turns of irony, to its proper place of belonging, the Hazratbal mosque. The relic in question is "a cylinder of tinted glass cased in exquisitely wrought silver, and . . . within its walls a silver pendant bearing a single strand of silver hair." That sacred relic is believed to be the hair of Prophet Muhammad himself. Today the mosque continues to be home to the relic. And recently, the mosque, it must be added, has also been a site of fierce contention between separatist militants who have taken refuge there and the Indian army that, for a period of time, laid a siege outside its walls. During my visit to the mosque in 1994, young children arrayed in front of me, when prompted by an adult to tell the visiting journalist what it is they most desired, pumped their fists in the air and shouted *Azaadi!* (freedom!).

There is another work of fiction in English by an Indian writer that deals with the relic. Amitav Ghosh, in his novel *Shadow Lines*, describes the historical details surrounding the mysterious disappearance of the relic, the Mu-i-Mubarak, from the Hazratbal mosque on December 27, 1963. In Ghosh's narrative, a more materialist accounting of an important social fact occupies the place that fierce, polemical irony takes in Rushdie's story (the entire episode and the community's sorrow, the occasion for the expression of grief but also solidarity, fade into backdrop for a tale of petty theft in Rushdie's narrative). In the days following the theft of the Mu-i-Mubarak, there were demonstrations of sorrow and protest "in which Muslims, Sikhs and Hindus alike took part." There were some incidents of rioting too, and a curfew was declared by the government. Ghosh's novel goes on to reveal that amidst all the grieving and demonstrations, "in the whole of the valley there was not one single recorded incident of animosity between Kashmiri Muslims, Hindus and Sikhs. There is a note of surprise—so thin is our belief in the power of syncretic civilizations—in the newspaper reports which tell us that the theft of the relic had brought together the people of Kashmir as never before."

The relic was recovered a few days later by the officers of the Central Bureau of Intelligence. There were no explanations offered, and the event remains shrouded in mystery. The recovery led to spontaneous celebrations among all the communities in Srinagar. Ghosh's prescient prose

records the following: "For the first, and almost certainly the last, time the celebratory slogan 'Central Intelligence zindabad!' [Long live Central Intelligence!] rang out on the streets of an Indian city."

In 1996 the film *Maachis* (Matches), directed by the popular Hindi mainstream director Gulzar, was released from Bombay. Unlike an earlier Indian film, Mani Ratnam's *Roja*, which had used the separatist struggles in Kashmir as a backdrop for a narrowly nationalist romantic thriller, Gulzar's *Maachis* found it necessary to condemn the police atrocities and human rights violations against innocent civilians in the Indian state of Punjab. The bombings and killings in Punjab, for several years preceding the eruption of full-scale violence in Kashmir, had commanded attention on both the national and global stage. *Maachis* wasn't a condemnation of the use of state violence, nor was it a critique of the duplicities of the leaders of the bourgeois nation-state. Even less was it a call for open and democratic political negotiations. Instead the film got its humanist appeal from showing how brutal violence at the hands of the armed forces turned ordinary, laughing, hockey-playing citizens into armed terrorists who were vulnerable to the seductions of the terrorists' rhetoric.

But what was the rhetoric of those presented as terrorists in the film? During one sequence in the film in which the main character is initiated into the ideology of the militants, the leader who appears to be the weapons and detonations expert (played with characteristic power by the veteran actor Om Puri) engages in a long discourse that is eloquent in expressing postcolonial disenchantment: "The country hasn't become self-sufficient. Yes, some people have. Electricity, water, housing, health care, education. What has become available to the common man? Sixty percent of the people still live below the poverty line. And they're not only poor, they're also unfortunate. It's been more than forty years since we got our independence. *Half a century* . . . how long are we to wait? . . . I want my fair share, and that too in my own lifetime, *right now*."

This rationalization of the present was coupled with a reframing of the past. In a country where mainstream dogma still adheres to a broad nationalist ideology that freedom from the British was won by nonviolent means, the leader in *Maachis* articulates his entry into the space of the nation-state in an originary moment of violence, the moment of India's partition and the displacement of vast populations: "Our parents and grandparents died. Our homes were destroyed. . . . Our parents had come, dying and broken. In our own country. When they came, what

name was given them? Refugees. 'They have come to take refuge.' Those mother————! *Arre, we were the ones who brought freedom with us for these people!* Lost our lives on the way . . . what have these people done? They have only been signing papers, that's all."

In the 1997 elections in Punjab, *Maachis* became a weapon in the hands of political parties who wanted to talk about police and army excesses. It also, however, represented a general sign of a search for justice as well as a resolve to address the issues long left unexamined. There were other repercussions. In May 1997 a district police chief threw himself under an oncoming train because he was being prosecuted for his brutal actions against suspected terrorists. People show a new willingness to talk in public about human rights violations and also discuss legal actions against the terror tactics of the police largely because they no longer see the nation as being under any threat from that quarter. According to an Associated Press report of July 4, 1997, the demands for justice were in fact what the retired police chief of Punjab, K. P. S. Gill, held to be "anti-national" and the work, quite literally, of foreign agents:

> Gill again has gone on the offensive, this time against human rights organizations, which he accuses of being front organizations for pro-separatist groups in the United States, Germany and Britain. "There are large numbers of interest groups abroad which do not like India to be strong, which are bent upon exploiting the basic conflicts which exist in our society," said Gill, who retired as director-general of police 18 months ago.

What is certainly lost in this drama of recriminations is the charge made by the leader of the militants in the film *Maachis*, a charge that establishes the basic questions outside the frame of a single party or the conduct of any particular part of the government: "There's no party of ours. I'm not fighting on behalf of a faith or a nation. I'm fighting a war against my own needs and desperation. This system wants to prove me impotent, but I am not impotent."

And beyond this are the other questions, taken up neither in the film nor in the recent debate over the role of the police in Punjab. Those questions are about the struggles in the nation where the people *are* fighting for a party *and being killed for it.* In order to unearth that truth, we need only look at the history of peasant revolts in India and the long struggle of the Communist movements in rural India. And the history of bloody repression against them, sometimes even by other Communists in power . . . in the name of the nation.

· · ·

Even those who would seek to limit the history of the emergence of the Indian nation to the single figure of Mahatma Gandhi often do the small duty of recalling that Gandhi's satyagraha movement began in 1917 as a part of the movement of agrarian protest in Champaran, in Bihar.

Contemporary historians have shown adequate disdain for the "sponsored histories" whose bourgeois nationalist authors offer only hagiographic accounts of Gandhi at the expense of the independent initiatives and organizational prowess of ordinary peasants. Arvind N. Das, who has also contributed to what has been called "subaltern history," comments: "The first lot of historians writing about the movement too were no better than panegyrists for whom the individual role of Gandhi far surpassed that of any group." What is equally lacking in the elite nationalist accounts is a sense of balance that would restore attention to the whole of the history of peasant struggles rather than, say, the one in which Gandhi made his inaugural appearance as a leader in the independence movement. To quote Das again, "More literature exists about the Champaran Satyagraha than about much bigger and more significant agrarian movements like Telengana and Tebhaga or even the Kisan Sabha in Bihar."

This longer history not only precedes the appearance of Gandhi but also continues past the year of Indian independence right to the present moment. More than the recent separatist movements in India, it is the history of sustained peasant protest that provokes the most serious interrogation of the Indian claim to democratic nationhood. Most striking in this regard, as its history spans the coming of Indian independence in 1947, was the Communist Party–led Telengana uprising that took place between 1946 and 1951. The Telengana region in southern India witnessed, in the words of the historian Sumit Sarkar, "the biggest peasant guerrilla movement war so far of modern Indian history, affecting at its height about 3,000 villages spread over 16,000 square miles and with a population of three million."

Today the struggle of the poor peasants and tribals in and around the Telengana region continues. The postcolonial struggle of such peasant groups came to a head in the early 1970s, under the leadership of the newly formed Communist Party of India (Marxist Leninist), or CPI (ML). It was met with brutal repression. Whether it was in the state of Andhra Pradesh, or the city of Calcutta and the surrounding districts in West Bengal, or the rural areas of the adjoining state of Bihar, the significant movement of young, urban, educated youth among a radicalized peasantry also signified an attempt to close another huge gap in the Indian

nation, that between the city and the country—accompanied, in some complex ways, by the divisions of class between the middle class and the peasantry. What is it that lasts today beyond the memory of the terror that left thousands dead on the streets and imprisoned in Indian jails?

The peasant movement has shifted and transformed itself in different parts of the country, most notably in Bihar and Andhra Pradesh. If it hasn't been able to challenge, much less to transform, the conditions in contemporary India, then the persistence of its protest as well as the brutality unleashed against it from time to time *do* manage to underline those conditions that make such protest necessary. On July 11, 1996, for instance, in the hamlet of Bathani Tola in Bihar, between 100 to 150 armed goons of a landlord army massacred 20 villagers—10 of them women and 9 children—and used kerosene to set their houses on fire. The members of the upper-caste landlord army, Ranveer Sena, were delivering a lesson to the lower castes, the untouchables, and the Muslim villagers who had recently organized under the CPI (ML). These deaths didn't go unmourned but did not achieve anything by way of institutional changes in the government or its stance toward the poor. This is because, for landlords, as Arun Sinha writes, "democracy" has meant "the services of an obsequious police force in the local *thana*" that spreads terror.

Thus we come back to Alokdhanwa's portrait of a divided polity and his angry charge against the landlords "who have turned this entire nation into a moneylender's dog."

· · ·

I saw them bury a dead child
 in a cardboard box
(This is true, and I don't forget it)
On the box there was a stamp.
"General Electric Company
Progress is our best product"

Louis Alfredo Arrago

Of 13,400 abortions conducted
at a Delhi clinic in 1992–93,
13,398 were of female fetuses.

Shashi Tharoor

Lest it be assumed that it is only the repressive might of the postcolonial nation-state that is responsible for all the deaths in the Third World, we need to look a bit more carefully at the global context in which the imperatives of the nation-state not only collude with but also are so often scripted by the profit motive of international, primarily Western, capital.

In a report published in *Sanskriti*, a newsletter of progressive diasporic Indians, Mir Ali Raza draws into close relationship the profits of General Electric Company (GE) and increased female feticide in India. In 1993 GE announced new investment initiatives in Third-World countries, including India, taking the international component of its total turnover to over 50 percent of its annual revenues (estimated in 1997 at over $60 billion per annum). According to Raza, "One of the major industries targeted for expansion in India was that of diagnostic imaging equipment, a market valued at $16 million and estimated to be growing at 20% per annum (over twice the level of average industry growth in India)." Among the modern marvels introduced was an easily portable 20-lb. ultrasound scanner equipped with the remarkable capacity of predicting the sex of the fetus by the middle of the first trimester of pregnancy.

In January 1996 a law went into effect in India banning sex determination tests. The government of India was responding to alarming reports about falling sex ratios and the role of sonographic tests in selective feticide. In spite of the government's correct response to this horrendous coupling of modern science and entrenched patriarchy, and regardless of the GE management's contention that sex tests are only a limited part of the range of uses to which the ultrasound equipment can be put, it should be noted that the government has not banned the production or sale of such equipment, and, indeed, it clearly regards GE's investments in India as a major boon and a matter of pride. The consequence we see here, then, is this: in a single city like Jaipur, there have been reports of over 60,000 sex determinations, and the foreign investment in India has increased from $100 million in 1991–92 to over $5 billion in 1994–95. Further, as Raza rightly points out, "By refusing to acknowledge the explicit links between technology, capitalism and patriarchy, the governmental efforts at curbing feticidal practices end up furthering them through the very laws it sets up to prevent them." These consequences include the possibilities of curtailment of abortion rights as well as the chances that women will end up being penalized in courts while doctors and manufacturers are not even cited as defendants in the litigatory process.

Examples of the might of foreign capital riding rough-shod over Indian people's interests—if not also their wishes—can be found in other domains too. The struggle in the Narmada valley to oppose the construction of the World Bank–funded dam that would have uprooted one million people has received widespread attention in recent times. Against the elite nation represented by the Indian comprador bourgeoisie in the government and trading communities, utterly complicitous with Euro-American capital, there has been an impressive mobilization of *the other*, subaltern nation represented by indigenous peoples, environmentalists, and progressive grassroots activists. One of the most effective leaders in this mobilization has been Medha Patkar, who, after the first massive rally at Harsud, articulated the split in the nation thus:

> To evict the people now, the Government of India will have to declare war on its own people. Sixty thousand people of the Narmada valley and from other projects around India gathered at Harsud, with support from human rights groups, social activists, scientists and environmentalists because we have determined collectively to save India and its people from the clutches of a few avaricious fanatics.
>
> At Harsud the seeds of a unique unity have been sown. A unity which asks for a new developmental model. The fruit of our endeavor, we hope, will reach the far corners of India and the world. What we are saying to the world is, "Stop the destruction of our natural resources immediately. Look back at the path we have taken and take stock of all our losses and gains. Learn from mistakes made and redress injustices inflicted upon the indigenous people, who have more to teach us about sustainable land use than all the professors and experts in the world. Reduce consumption and allow for a more fair distribution of limited resources."

Patkar's appeal is not so much in terms of preventing another Bhopal—though that too would be wholly valid (a poisonous leak in 1984 from the Union Carbide multinational company's factory in Bhopal killed, according to official sources, over 6,000 people, though the true figure is over 15,000. About half a million survivors continue to suffer from the consequences of the leak). Instead Patkar's fight is against the devastating logic of corporate greed. In asserting the need for justice for all and a fair distribution of gains, she is opposing the practices of latter-day imperialism.

A quick picture of the way in which global capitalism works, even when it clothes itself in the rhetoric of "development" and "aid," is provided by Edward Goldsmith. He recalls the incident a few years ago when the British government threatened that it would cut off aid to India if it

did not buy 21 large helicopters, costing about £60 million sterling, from a British corporation called Westland. Goldsmith writes: "This is but a more sophisticated method of achieving what Britain achieved in the previous century when it went to war with China so as to force that country to buy opium from British merchants in India." He adds:

> In general terms, aid cannot be of use to the poor of the Third World because they necessarily depend on the local economy for their sustenance, and the local economy does not require the vast highways, the big dams, or for that matter the hybrid seeds, fertilizers and pesticides of the Green Revolution, any more than it does the fleet of helicopters that the British government imposed on India. These are only of use to the global economy, which can only expand at the expense of the local economy, whose environment it degrades, whose communities it destroys and whose resources (land, forests, water and labor) it systematically appropriates for its own use.

More recently, taking strength from the struggles of Patkar and others, grassroots activists in Nepal successfully blocked the World Bank-IMF plan to build the Arun III dam. In a report written by Gopal Siwakoti, a human rights lawyer and one of those involved in that struggle, we learn about the "expensive and apparently irrational" modus operandi of the bank. An Italian company, Cogefars, had been contracted although, for a fraction of the cost, local engineers and laborers would have performed that task.

The governing logic of such large projects, argues Siwakoti, is primarily to "provide markets for the products and services of transnational corporations." The funds are paid directly to the corporations involved, which means that the entire project is not only "more expensive and wasteful, it also results in the target country never developing its own capacity to become self-sufficient." The invidious ways in which aid functions to put Third-World nations under the thumb of corporate capitalism is once again revealed by the accompanying conditions for receiving such "help." Siwakoti carefully explains:

> The bilateral portions of the aid also had strings attached. For example, the German portion of the aid, the largest grant ever yet given for a development project, depended on the purchase of turbines from a German company. Similarly the Finnish aid depended on the purchase of Finnish multi-fuel plants. This is typical of World Bank loans; often, developing countries end up paying more to industrialized countries for goods and services tied to Bank loans than they actually receive as net disbursements.
> The banker's lending terms or conditionalities appeared to be even more deleterious and mounted a serious challenge to Nepal's sovereignty. Nepal

was getting a loan of US $630 million to pay for first world contractors at first world prices. But it would have had to pay the Bank interest of over $300 million in the first 10 years of construction alone, and the rest over 40 years, increasing the net cost of the dam to more than $1 billion. In order to safeguard its investment the Bank thought it perfectly reasonable to argue that the existing National Electricity Authority be dissolved and that the Bank be allowed to set the electricity tariff for the State of Nepal. Nepal could not plan any rural electrification or even plan any future hydroelectric projects of over 10 MW without specific permission from the Bank. And, of course, the Bank would also need veto power over any social projects that might cut into the money available to repay the Bank. Not only would these conditions have imposed a debt burden of more than twice Nepal's annual development budget but they would also have compromised the country's sovereignty and made it impossible for the country to invest in any programs promoting economic justice, health and social welfare.

Third-World peoples' struggles and the analyses that emerge from their midst point out that the nation, if we are to understand it in terms of the vast majority of working people, is struggling against the elite members of its society and their collusion with the development-and-aid regime of the capitalist First World. In some ordinary undeniable way this scenario positions most of the poorer nations in the world in a relationship of opposition to the North, most prominently to the United States. And proof of this is forthcoming not necessarily from our close examination of the statements of the ideologues of the Third-World struggles; instead, we need only pay heed to the words of the masters of the game here, in the heart of the First World. Consider, for example, the words of an erstwhile president of the World Bank, Eugene Black: "[O]ur foreign aid programs constitute a distinct benefit to American business." Or, for that matter, the blunt pronouncements of the former U.S. president Richard Nixon, "Let us remember that the main purpose of aid is not to help other nations but to help ourselves."

In opposition to what the World Bank does, we have the example not only of people's protests in India or Nepal but also the work that people from those nations do in the West. According to the UN Population Fund: "Ratio of funds sent home by migrant workers worldwide [in 1993] to total foreign aid distributed by government: 3:2." But as vital as the money itself is the *ideological* work such migrants do. How do those outside the nation—especially the members of a radicalized diaspora—go about rewriting the nation?

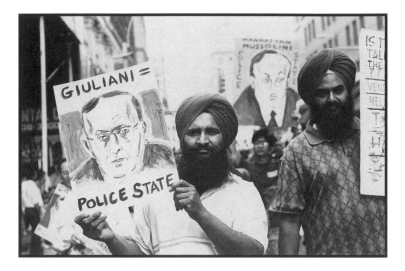

For each group
I have become a lost part

Of some other
they

My home is a prison of time
the world my exile

They both spurn me
they both disperse me

One is security
the other a scattering

One is a prison
then the other a straying

I run away from both
I come close to the two

Because my home is in exile
and I'm in exile at home

 Ved Prakash Vatuk

These words that I offer here in translation come from a contemporary Hindi poet who lives in Berkeley, California. The existential dilemmas of his diasporic existence might appear to keep the poet isolated. Yet elsewhere, as in his poem addressed to the U.S. president Clinton, we find the outsider in America speaking the truth to power on the behalf of the rest of the world. In that poem, Vatuk questions Clinton's

need to remain silent for one hundred and sixty seconds to mourn the dead in Oklahoma. "What am I to do," our poet says, "for me / have died, are dying / from the terrorism that bears your seal of approval / on each patch of this earth / young-old, men-women." Recalling Vietnam, the deaths in Iraq, the history of slavery, the dead in Palestine, Lebanon, Cuba and Congo, the bloodshed in his own Punjab and Kashmir, the bloodshed in Bangladesh, he asks: "Those weapons / whose were they / is there a continent / where your bloody claws / have not reached / where has not been established / your official terrorism."

This different kind of remembering is consonant with what I see as Vatuk's important contribution to the life of South Asians, particularly Indians—among them, his efforts since the 1960s, along with other activists like Kartar Dhillon, to revive the Ghadar Memorial Hall in San Francisco. The hall is dedicated to the memory of those working-class Indian settlers on the West Coast in the U.S., members of the Hindustan Ghadar Party, who had gone back to India after the First World War to fight against the British.

A poem written by Vatuk in memory of the Ghadar Party martyrs reads in part:

Whenever
you see each Ram in exile
selling out for a few coins

in that night of doubt
remind yourself then
again and again
of that half-clad, half-fed, half-literate
helpless, lost, that laboring, peasant team who
in this land that at every step
stung
on this friendless, hard, stony ground
in this jungle
of beastly culture
with its unending assaults
had the courage to fight
and who had
sacrificed their all
so that all of us
could like free people
become human. And live.

This poem foregrounds quite starkly the condition of the earliest Indian immigrants to North America. It is also a condition that is difficult

to imagine in current times given the overwhelming perception, largely accurate, of South Asians in the diaspora as a highly educated, middle-class workforce. Consider a report in Singapore's *Business Times* on the Indian Global Entrepreneurs Conference being held there in June 1996:

> Prof C. K. Prahalad, who holds a prestigious chair in the business administration faculty at University of Michigan, said it would be a mistake for India to view non-resident Indians (NRIs) only as a potential source of funds. They also constitute a significant "brain-bank," he said. He estimated that there are at least 300,000 highly qualified and highly skilled Indian professionals scattered around the world, many of whom are distinguished in their respective fields. The potential contribution they can make to India is arguably more important than NRI investors. He estimated this to be equivalent to a $50 billion technology transfer.

Vatuk would be the first to agree that this is not quite the freedom that the members of the Hindustan Ghadar Party had in mind. The people that his poem describes do not very easily find representation in the writings of canonized diasporic writers, and they certainly do not encounter their own voices and selves in the popular forums—except as dumb, laughing-stock figures like Sirajul and Mujibur on the Dave Letterman show or the cartoon character Abu on *The Simpsons*.

The Indian as cabdriver, in Hollywood films and television dramas, brings the touch of the comical and the exotic. Call it the brown man's burden. In such an environment, one recent work that marks an important intervention is Vivek Renjen Bald's documentary video *Taxi-vala/Auto-biography*. In this 1993 video, distinguished by its honest engagement as well as its self-reflexivity, Bald interweaves his voice-overs and critical reflections with interviews that he conducts with South Asian cabbies in New York City.

Watching Bald's film, the audience gets to watch and listen to an immigrant worker's struggle with the American dream:

> IRFAN: We used to think that when we go over there, we will make enough money. So we don't have to worry—we just need to go to America and then everything will be okay. We just work eight hours and every day we will get $100 or something like that. And we were happy that we're gonna make more and more money. . . . [But] when I came here and it was a recession period—and still it is—many people were jobless, and I was also jobless. I had a lot of wishes that I will do this and that, but after three months I did nothing—I stayed at home or just roamed around. I couldn't get any job. . . . Then I realized it's very hard to live in America.

In another instance, we learn about the college-going cabdriver's encounters with cultural stereotyping, the insensitivity to cultural difference, and the contempt with which a dominant culture regards labor, especially the labor that it itself does not perform and leaves for the less privileged:

> In my college, there is this fraternity, I think it's HKN or whatever, and whenever you become a member in that, like one of the brothers, you're assigned a brother and whatever he says to you, you gotta do it. That's like, part of joining. And one of my friends, when he joined this group, he was asked to wear a turban for a week. I mean they can tell you anything they want, they can tell you that you have to wear your shorts over your pants or you have to wear the pants the other way around or whatever. But he was asked to wear a turban. He's from Pakistan. He's never worn a turban in his life. But he was asked to wear a turban and a T-shirt saying, "Cab Driver."

Apart from these interviews, however, is the self-critical and highly self-reflexive discourse of the filmmaker himself. Bald keeps returning very painstakingly to issues of racial and class privilege as well as repressed issues of gender and sexuality. In doing this, he provides his viewers a very vivid sense of how, in the diaspora too, replicated models of the nation exist alongside possibilities for their reconstitution—or not. Let me cite a longer fragment of his voice-over to make this point clear; it involves a situation that most South Asian males who have traveled in the cabs in New York City might be quite familiar with:

> As I begin to shoot and edit, talking to more drivers and cutting interviews into neat little segments, the absence running through the video becomes obvious.
> Among taxi drivers, I'm in an all-male part of the community. And off camera, time after time, I'm remaining silent, avoiding discussions and confrontations that might jeopardize my own inclusion.
> One night a driver turns to me and asks: Do you have a girlfriend? Is she Indian? Is she American? Do you live together? I could answer plainly: "Yes, I have a girlfriend. No, she's not Indian, she's African American, Italian American, Native American and Chinese American. Yes we plan to live together." But instead of answering, I'm uncomfortable, I evade the questions. Is this a desire for privacy or a fear of judgment?
> Then he continues, complaining that American women are too promiscuous, that in America South Asian women become spoiled, and they need to be restricted. And through all of this I don't say a thing—not a word of argument, not a word of protest. In my silence, I'm thinking about my girlfriend and other close friends, my feminist Indian American mother, and my grandmother from Lahore who used to rise each morning against her husband's wishes to go sing protest songs in front of British colonial jails. But still I don't speak a word.

So with each new interview, I try to bring the issues on camera, asking drivers questions: Why is it only men who come here on their own, I ask. Why can young men do what they please, go where they please, work and grow up here, but young women are restricted? I ask: Don't we have a chance, in our generation, to criticize and change what's given to us? But my simplistic questions fall flat—they fail to say anything about the complexities of South Asian or U.S. sexisms. They shift attention away from my own silences and exclusions; and, at worst, they make the drivers look foolish in front of American eyes, while I hide conveniently behind the camera.

Taxi-vala/Auto-biography is an example of the kind of artistic labor that extends the work of Edward Said's *Orientalism* within the Western academic setting. Works like these also draw on the work of a variety of postcolonial theorists, including Spivak and Bhabha. They convey, with intelligence and political wit, the experience of immigration, its pain as well as its silences and contradictions. These graphic presentations of what Raymond Williams called "structures of feeling" produce new maps of the shifting, changing nation. When you listen to the members of the British band Asian Dub Foundation declare that they are "massive not passive," when you hear their sounds or read of their work among Indian, Pakistani, and Bangladeshi immigrants in London's Tower hamlets, you also understand that this kind of cultural production is less easy to parody than the writings satirized in Rushdie's novel *The Moor's Last Sigh*. Its narrator, Moor, describes the work of an art theorist on the oeuvre of Aurora Zogoiby, his mother:

> Dr. Vakil at once set about compiling an exhaustive catalogue, and began work, too, on an accompanying critical appreciation, *Imperso-Nation and Dis/Semi/Nation: Dialogics of Eclecticism and Interrogations of Authenticity in A.Z.*, which gave the Moor sequence—including the previously unseen late pictures—its rightful, central place in the corpus, and would do much to fix Aurora's place in the ranks of the immortals.

In the debates that have occupied center stage in postcolonial theory, the issue of immigrants—more particularly their popular culture—refashioning the space of the nation remains unexamined. Subtle, and often powerful, pursuits have been mounted of "the Other question" in the reading of Western colonial texts. But relatively little has been written on the quotidian lives and the struggles that animate such existence. To make it worse, a reading of most special issues devoted to postcolonial conditions would convince you that the 3.2 million poor in Chiapas or Calcutta hunger to read in the pages of the scholarly journals the debates between the elite of New York and New Delhi. And yet I hesitate

to admit Kwame Anthony Appiah's critique of postcolonial intellectuals where he derides such intellectuals as "Otherness machines" with the manufacture of alterity as their principal role. In the shifting drama of demographics and profitable businesses, even if we admit the *relevance* of Appiah's critique, we need to assert a fundamental truth: Proposition 187 was not written and framed by postcolonial intellectuals. We are—to alter a phrase coined by one such intellectual— "Outside in the Otherness Machine."

Nevertheless, the overwhelming feeling I have from my particular vantage point in the field of postcolonial theory is that intellectuals appear locked in a palace warfare, their shouts strangely masking the clamor in the open streets outside. And these streets, I want to emphasize very clearly, are the streets of the Western metropole . . . and they are alive with the movement of immigrants' feet.

New York City, 1995. At a protest organized by the Committee Against Anti-Asian Violence (CAAAV), a woman is shouting "Get these cops off me" as she is pinned down on a car. One policeman has his legs pressed against her, pushing her down. The protesters there that afternoon, stopping traffic at the mouth of the Manhattan Bridge, are telling those who are held up in their cars, some of them honking and angry, that they will do anything to draw attention to a history of police brutality against Asian Americans. The legal observers and a handful of journalists present at the civil disobedience action take the role of witnesses to prevent the use of what officialese describes as "excessive violence."

Later, the committee organized effective support to win legal justice for a South Asian cabdriver and activist, Saleem Osman, who was dragged from his car by NYPD officers. The cops warned him, "There's no black mayor any more. You better watch out." They also said, "Go back to your own country."

The CAAAV protest is an instance of diasporists' clamor in the open streets outside. Even as I put the finishing touches on this book, a variety of South Asian and Caribbean groups in New York City are organizing to protest the violent assault on Rishi Maharaj, a young American of Trinidadian-Indian origin. His assailants in the largely Irish and Italian neighborhood in Queens, according to the police, wanted to attack an "Indian."

When arguing for the need to recognize the Indian nation's various rewritings outside its own physical boundaries, in the diaspora, I am talking about strikes and protests, new songs and new beats, and popular,

challenging coalitions of dissent. Take, for example, the 1978 Grunwick's strike in Britain, during which, as Kalpana Wilson reports, "Asian women workers at a photo-processing factory attracted mass support from black and white workers; thousands of demonstrators clashed with the police outside the factory for months on end." Although the strike was foiled by the leadership's decision to withdraw support for mass action under the pressure of government threats, "the militancy of Asian workers had been proved and the Western myth of the passivity and submissiveness of Asian women was shattered." Another example, this from the domain of what she calls "sex and solidarity," comes from Gayatri Gopinath: "We know what a high it can be to walk into a bhangra party and revel in the sight of queer brown folks doing their thing; or to participate in conferences like *Desh Pradesh* that draw progressive South Asians together from all over the globe. Many of us are also a part of more informal networks of friends and lovers that traverse various diasporic locations. These are but a few of the multiple and proliferating sites—both formal and informal—upon which a South Asian diasporic queerness is being articulated." And, to return to *Taxivala/Auto-biography,* here is the testimony of a driver describing his reality: "I'll tell you the truth—the cab driving, it wrecks your nerves, first of all. And you don't have the time to think about anything, I mean think about anything else. And you get like some kind of dangerous fumes—from the engine, since the air comes through the engine. That's what I feel, you know, it's bad for the memory. It affects the nerves."

In the split-screen world of postcolonial writing, populated by its proponents and quite certainly its detractors, it is the heterogeneous articulations of struggles and compromises that are so very often left out of sight. And yet in these diasporic articulations—in radical poetry or the mixed beats of *desi* musical groups, reports of workers' strikes or queer struggles for HIV education among working-class South Asian groups, summer schools for youth run by progressive groups, or pamphlets distributed by those who run shelters for battered women—in these often fragmentary ways, the nation is being reinvented. Not only outside its borders but also with a new name or meaning.

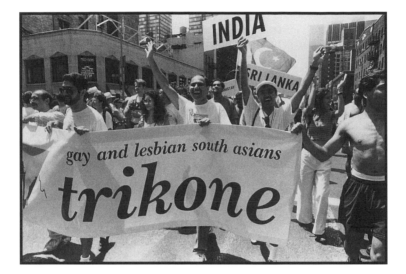

An insistent question: what remains of a nation after it has exploded a nuclear bomb?

In May 1998 the government of India conducted nuclear tests. In quick retaliation, Pakistan did the same. In both countries there was widespread jubilation. Each country experienced an outbreak of fervent nationalism. It was as if, from the radioactive ash, the reborn nation had emerged whole.

Yet what kind of an emergence was this?

In India a right-wing leader, responsible for many deaths in anti-Muslim riots, declared that we were not eunuchs anymore. In Pakistan, before it exploded its own bombs, the opposition leader, a woman herself, taunted the premier with the remark that he should wear bangles. The space of the resurgent nation was masculinist and patriarchal. It turned its gaze at its minorities and wanted to find them fixed in the gesture of saluting the flag. Or else . . .

When the nuclear tests took place in May, I was finishing this book. A scene in Michael Ondaatje's *English Patient* occurred to me, one I mentioned in an earlier chapter. At the end of that novel we find the Indian sapper, a soldier in the British army, stripping his uniform of all insignia. He has heard on the radio the news of the bombing of Hiroshima and Nagasaki. Ondaatje writes: "His name is Kirpal Singh and he does not know what he is doing here." Standing at the edge of a valley in Europe, Singh's alienation is complete.

From my place on the margin of North American society, I felt the need to declare my total alienation—from the acts of my own government that had chosen to take these steps down a path that was so dangerously carved out by the West. The anger that this alienation limns is finely articulated by the late poet of Punjab Avtar Singh Pash, who ends one of his poems with these words: "If this is how the security of a nation is served / That by crushing each strike a sacrifice is offered to peace / That an act of courage just means dying at the nation's borders / The flower called culture adorns only the king's casement / That by being yoked to power's fruitless well can the fields ever find water / If labor will always have to become a knock on the ruler's doors / Then we are in danger from this nation's security."

But to *whom* could I most clearly express this feeling of alienation? To the immigration officer in the pages of my book? No. In front of the immigration officer, I could only repeat the words of Arundhati Roy, the recent Booker Prize winner:

> But let us pause to give credit where it's due. Whom must we thank for all this?
> The Men who made it happen. The Masters of the Universe. Ladies and gentlemen, the United States of America! Come on up here, folks, stand up and take a bow. Thank you for doing this to the world. Thank you for making a difference. Thank you for showing us the way. Thank you for altering the very meaning of life.

And with others, in India and Pakistan, I would want to point to Roy's other words, those that insist that "for India to demand the status of a Superpower is as ridiculous as demanding to play in the World Cup finals simply because we have a ball." The reason Roy wants to underline this fact is pretty simple:

> We are a nation of nearly a billion people. In development terms we rank No. 138 out of 175 countries listed in the UNDP's Human Development Index. More than 400 million of our people are illiterate and live in absolute poverty, over 600 million lack even basic sanitation and about 200 million have no safe drinking water.
> A nuclear bomb isn't going to improve any of this.

And what of my feeling of alienation? Would expressing this feeling of isolation, for example, be enough? I remember Rushdie who, expressing the relation of the writer to the nation, is quite categorical about the opposition: "The nation requires anthems, flags. The poet offers discord. Rags." In her own essay Roy unfurls her banner of writerly protest:

"If protesting against having a nuclear bomb implanted in my brain is anti-Hindu and anti-national, then I secede. I hereby declare myself an independent, mobile republic."

A writer can do this. Declare that she is nation unto herself! Even invite others. We're now open to immigration! The reason these bold declarations don't diminish my sense of alienation, and, in fact, only enhance it, is the quick realization that I'm not utterly mobile in history. There are miles of barbed wire. Of all sorts. And this becomes clear most of all when Roy rightly says: "However many garlands we heap on our scientists, however many medals we pin to their chests, the truth is that it's far easier to make a bomb than to educate four hundred million people." If I secede, if Roy secedes, we secede also from that difficulty. To put it directly, to secede is as easy as to make a bomb.

The real task, even for those who as diasporics think of seceding, is to contemplate that difficulty. Of how in our minds we allow ourselves to believe that it was ever possible to find a space of withdrawal. It is also, inevitably, the problem of a collectivity, far beyond individual issues or even nations. Neither writers nor scientists can save the world by themselves. Or escape it entirely. That is the plain truth of the nuclear bomb. When it explodes, it finishes us wherever we reside in our mobile republic.

Sex

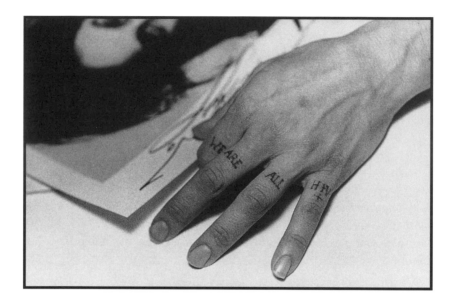

When a lion emerges from the forest, no one bothers to ask whether it is male or female.

Nizammudin Auliya

Sex. The very word induces in my mind a confusion, which I might or might not be able to dispel. Not only the confusion of genders. Male? Female? But the inevitable, accompanying questions. What does it mean to be male? Or female? To be neither, or both? And present among these more obvious questions, like a whiff of other meanings, the fact of sexuality itself. The fantasy of sexual acts and affect.

Are these the questions in the immigration officer's mind too? Should I imagine that these questions come to his mind—and why do I always imagine the officer is male—when he holds my passport in his hand?

Maybe the officer has heard about the *Kama Sutra*, the ancient Indian text of sexual arts. He has probably seen Richard Attenborough's film *Gandhi* and is reminded of his ascetic adventures. My engagement here with the question of sexuality is not wholly removed from the consideration of the immigration officer's awareness. I am in some ways preoccupied with the issue of what my sexuality, or that of my sister, means in the Western imagination.

A few summers ago I read Sudhir Kakar's psychoanalytic report on "Indian sexuality." One story in the book remains in my memory: an account of a relationship between Mahatma Gandhi and a British woman in her thirties, Madeline Slade, an admiral's daughter who had joined the venerable Indian leader in the national struggles.

Gandhi gave her the Indian name Mira, after the sixteenth-century saint who was infatuated with the god Krishna. Mira's presence unsettled Gandhi, and he sent her away to various other ashrams. Once, in 1927, Mira visited Gandhi to help him and he sent her back. Then he immediately wrote to her: "I could not restrain myself from sending you a love message on reaching here. I felt very sad after letting you go. I have been very severe with you, but I could not do otherwise." He wrote again the next day. And later from prison.

"Have I not expressed my love, often in storms than in gentle soothing showers of affection?"

In another letter, "You are on the brain. I look about me, and miss you. I open the *charkha* [spinning wheel] and miss you."

Madeline Slade continued to live in India till 1958, a whole decade after Gandhi had been shot to death.

The Indian psychoanalyst I was reading visited Slade in 1964 at her home in the forests near Vienna, where she lived with a dog and an old Indian servant. She was "reserved," the scholar writes. Slade told him that Gandhi didn't interest her anymore. Now she'd returned to her first love, Beethoven.

When the psychoanalyst was leaving the farmhouse, Slade's servant ran after him and begged to be taken home to India. The old man was left standing on the grassy meadow as the visitor drove away.

I cannot exactly say why the story remained with me. Nonetheless, I think it had something to do with the old servant rather than Gandhi or Mira. Slade's own narrative, about her own exploration and her finding fulfillment with Beethoven's music, furthers the psychoanalyst's musing on sexual relations. Of course, Gandhi's obsession with sublimation as well as his lifelong attempts to espouse maternal-feminine principles is also instructive. Indeed, Gandhi and Slade's story may relate to the state and sexuality in complex ways. Yet the servant, who gets left out of that narrative, is a reminder of another kind of loneliness in history. The yearning of one utterly homesick. But one who also leaves a question in our minds: did he not love?

What kind of feeling or entity finds its articulation in terms of the following elements: a menstruating woman, a dead cow, meat, sex?

In 1973, nearly three decades after India achieved independence from British rule, Namdeo Dhasal published his book of poems, *Golpitha*. A year earlier, along with Raja Dhale, Dhasal had helped found the Dalit Panthers, a protest organization that sought to fight for those who have for centuries been brutally exploited and regarded as untouchables by the Brahmanic hegemony.

Dalit literally means "downtrodden." It is used as a name to refer to the untouchable castes within the Hindu hierarchy. This name "Dalit" stands in opposition not only to the former title of untouchables but also to that of Harijan—literally, "children of God"—a name given to them by Mohandas Gandhi and considered patronizing by most Dalits.

In the poems that appear in the collection *Golpitha*, Dhasal takes on the identities of poet and prophet, repudiating in a new language the whole of the familiar past and, through this negation, creating a future.

In most of Dhasal's poems it is the body of the woman that becomes the figure subjected to brutality and exploitation. In fact, Dhasal's book takes its name from that street in Mumbai in a district that is notorious for its poverty and traffic in contraband. Prostitutes there wait in what are literally called "cages" for the clients who stroll down Golpitha. In a poem addressed to "Mandakini Patil," he writes:

Manda
Your mind is neither ash nor marble
I feel that your hair, your clothes, your fingernails, your breasts
Are all me and they blast off revelations within me
Colonies of the dead. Hunchbacks on deathbeds.
Sandwiches. The milk of a bitch that has just given birth.

The condition that Dhasal maps here is one that does not necessarily exclude him; he articulates the horror also from a position of identity. Thus, even though the poem keeps "woman" an "other" as muse, its mode of address leads to a statement about a shared condition.

Until this time you and I were unrelated
And no greetings burrowed holes into one from the other
This time is as long as 10 miles, as short as 10 seconds
Its movement spans
You: Me: Seeds: A common splinter of glass cutting into us both
And further splintering and piercing through thousands of conditions
 of our being

What seems to me rather carefully plotted here is the eruption, rather disruption, into history and the recognition of a thousand painful discontinuities and unities. A different kind of discontinuity as well as unity emerges in V. S. Naipaul's account of his efforts at meeting Dhasal—because what inflects the story, even in Naipaul's words, is the assertion of a woman's voice. This voice belongs to Mallika, Dhasal's Muslim wife, who published a best-selling autobiography in Marathi, *I Want to Destroy Myself*. This is what Naipaul writes of her book: "Mallika's book was a story not only of love, but also of disillusion and pain. . . . She had suffered. She had been introduced to shocking things. Namdeo had a venereal disease; he continued to go with women from the brothel area. . . . She was passionate about the freedom of women; but in her own life, because of her love for Namdeo, she found that she had lost some of her autonomy. After 10 years of love and torment she had written her book."

Intertwined, however, with his wife's story is Dhasal's own, of nervous breakdowns, his own and his mother's. We are told that every time his mother heard the radio, she expected to be told that her son had been killed. Dhasal also explains to the visiting famous writer the origin of the reason why the people in his caste, that of Mahars, are the only one among the untouchables who are allowed to own land. The tale is of interest in this context because its saga of domination carries a full charge of the sexual:

Once upon a time, there was a *raja* of Bidar. He wanted to send his daughter to a certain place. The Mahars were the people who traditionally carried the palanquins, and the raja ordered the local Mahars to carry his daughter to where she had to go. The Mahars understood the seriousness of what they had been asked to do; as a precaution, to avoid accident or misunderstanding, they castrated themselves before setting out. The raja's enemies started to spread a story that the raja's daughter had been carnally used by the Mahars. The raja summoned the Mahars and questioned them. They displayed themselves to him, and said they had castrated themselves before taking the princess. The raja was so pleased he gave the Mahars land. That was how the Mahars became the only scheduled caste [within the government schedule of "backward" castes] in the area to own land.

This tale is extraordinary for its articulation of self-castration and also for its simple suppression of the violence entailed in its self-telling. In other words, what is left unsaid is the psychic mutilation untouchable men and women, Dhasal and his mother as well as his wife, undergo just in order to be able to survive. Or to be allowed to write.

Yet this precarious condition that could be the precursor to a genuine dialogue disappears when the poem makes "woman" the site of either degradation or redemption—for men. One of Dhasal's poems, "What Grade Are You in, What Grade?" asks the reader whether "he" has "done that":

Fucked a menstruating woman? Fucked her?
Dragged around the dead cattle? The dead cow?
Rubbed the grindstone? The grindstone?
Known what *hayale* is? Cow gut?
Saved stale bread? Ate it?
Sucked the marrow? The marrow?
Fried the giblets? The giblets?

In this poem, almost in a ritual manner Dhasal very powerfully details what the Brahmanic Hindus consider defiling: a menstruating woman, a dead cow, meat, sex. This poem also serves to document what had been the duty of the Dalits, the pariah castes condemned to the outskirts of Hindu life, performing the tasks of the traditional scavengers.

Have you fondled breasts? Breasts?
Kissed? Kissed?
Filled the hole? The hole?
Made your penis swell? Your penis?
Knocked anyone up? Knocked her up?
Done it from the back? The back? Done it twice in one night? Twice?

You have lots of gaps

What grade are you in?
What grade?

What is disturbing about the poem—beyond the banality of its sexuality—is that the speaker and the one the poem addresses are both clearly male and patriarchal. The woman in this supposedly oppositional discourse remains the passive subject who is merely the submissive instrument of degradation. While men, depending on their caste and their defilement, belong in different grades, women are clearly not even permitted institutional access.

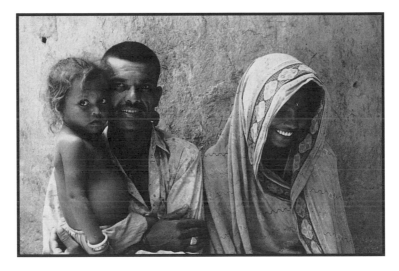

My argument here should not be reduced to that which illustrates the phenomenon of non-Dalit men trying to rescue Dalit women from Dalit men. Instead this critique is aimed at the relations between men that rely on but nevertheless exclude women.

We can look at the poem's violence somewhat differently. Dhasal's refusal to describe alternative, rather utopian, sexual relations could also very much be an argument for systemic change. In his view, the poison of Brahmanic dominance and hypocrisy taints the entire universe of human existence; hence his poem for Mandakini Patil rejects the possibility of a more meaningful sexual relationship by critiquing the system that Brahmanism, as an ideology, protects:

The loved woman is a sanctified harlot
The lover a purified pimp

Women are the printed prostitutes of men
Men are the pimp of women
The connection of man and woman
A handful of harlots, a handful of pimps,
a few disposable toothbrushes
To be spat out after use and then to gargle
with the water of holy Ganga.

In this universe, all the parts tell the same story: for Dhasal, the untouchable does not have access to any adequate language of opposition. The significance of this recognition for him is that mild doses of pleasure and palliatives won't do; the need is for the complete reversal of the Brahmanic system. People as well as the gods themselves must be changed. In this sense, in the face of the pervasive exploitation and brutality that the untouchable poet registers, Dhasal would share with the critical theorist Gayatri Chakravorty Spivak the understanding that "the subaltern is the name of the place which is so displaced from what made me and the organized resister, that to have it speak is like Godot arriving on a bus."

And yet, as Spivak also insists, we want the end of "subaltern" as a name or as a category. In the struggle to get rid of the condition of subalternity, we must remember that the subaltern agent often militates against the singular history of dominance and, too, that there is always the waiting for Godot.

While acknowledging the mobilization of a goddess-centered religion in the Devi movement of 1922–23, Spivak writes that, in contrast, "In the current Indian context, neither religion nor femininity shows emergent potential of this kind." I prefer to read Spivak's plangent declaration as a call for a political agenda that is able to tap the possibility of a religious or female identity for progressive social change. It is necessary to take note of those changes afoot in India that aim to realize precisely that potentiality. These changes need not refer only to organized mass movements; often, they are present in the daily lived practices of the people.

Let's take the case of Mira, the sixteenth-century princess whom Gandhi associated with an upper-class Englishwoman. Mirabai took up the life of an itinerant singer. She adopted as her guru Raidas, a cobbler by caste. While the ruling class in Rajasthan has tried to erase Mira's name from its history, the subalterns have tried to preserve Mira's memory through her *bhajans,* her religious songs. There are two very important points that Parita Mukta makes in her arguments about how the

memory of Mira serves as the locus of gender, religion, class, and caste conflict. First, Mira's legend "has been retained in a sphere over which the rulers could not wield direct power—the sphere of religious expression, of bhakti and bhajan singing, into which the rulers did not intrude"— and second, "the singing of Mira becomes a political act when it is sung, as it is in Mewar, by the subordinate sections, of peasant and artisan origin, who understand that to sing Mira is to flout Rajput authority." This second point becomes clearer, I think, from what Mukta goes on to report:

> Huki Kodra Patel, a 60-year-old widow who lived on her own, tilling nine bighas of unirrigated land in the village of Pahara near Kherwara, said at a bhajan gathering held in her house: "They sing only of their warriors and their battles," pointing in the general direction of Udaipur, "We sing Mira."

Was Gandhi thinking of the people's Mira when he gave Madeline Slade that name? I do not know. But the name and Mira's hymns are a reminder of how the question of sex, being male or female, is of enormous significance and intelligible only as a part of a systemic understanding, that is, in relation to other vectors of social being like class, caste, and, as every immigration officer knows, nationality.

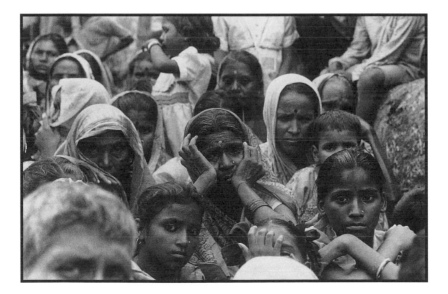

TEN STEPS TO BURNING INDIAN WOMEN ABROAD

> In such cases, she asks provocatively, what defines the insider as
> opposed to the outsider? Skin color? . . . Language? . . . Nation?
> Political affinity? What about those with hyphenated identities and
> hybrid realities?
>
> *Robert Stam, on the filmmaking of Trinh T. Minh-ha*

> I notice in your questions a kind of warning which, pared down to
> essentials, is: don't talk at us, you are in a different position. I
> would think again, since this is the kind of thing I meditate on, of
> what the other person defines me as in order to define herself. You
> might want to think and meditate on your own desires in that
> matter.
>
> *Gayatri Chakravorty Spivak, in an interview
> with Indian feminist scholars in New Delhi*

Step 1

Sex: female. But beyond that? The figure of the Indian woman, as an ap-
proximation or as a name, inhabits the space of representation. A space
overdetermined primarily by patriarchy, capitalism, and technology. To
confront the construction of femininity in that place is to simultaneously
engage with the protocols of reading such a space.

Indu Krishnan's 1990 documentary, *Knowing Her Place*, is about a
woman named Vasu who finds that having to negotiate between India
and the United States is "like moving in two directions at once, or like
being in two places at once." Krishnan's film usefully documents the
struggle that Vasu undergoes, in India where she was sent after she at-
tained puberty, and then, more dramatically, in the U.S. where she has
been living with her family. The film is especially effective because it shows
Vasu overcoming the systematic devaluation of her experiences by her
husband and two sons. *Knowing Her Place*, however, in recording the
dualities that tear Vasu apart, reproduces in a very limiting way the stereo-
typical divisions between the two countries. At one point, Vasu says that
the American part of her wanted to ask questions while the Indian part
of her remained submissive—thereby dismissing the fact of ongoing gen-

dered oppression in the U.S. as well as the long history of a variety of women's struggles in India.

In her sensitive review of the film, the cultural theorist Lata Mani comments on the ways in which the film's material resists Krishnan's structuring dichotomies. Mani writes: "By contrast to its reductive binary framing of the problem of cultural identity, the film is refreshingly complex in its representation of women's agency." She notes, for example, how the film documents Vasu's search for her own voice and the ways in which she finds her own autonomous space, albeit aided by class privilege. And, then, Mani adds a caveat against producing what might be described as a dominant (as opposed to a resistant) reading of *Knowing Her Place*. I'd like to quote it at length because it is in her reading of the film as a space of representation that Mani provides what I had earlier called the protocols of reading such a space:

> It may be tempting to some to interpret *Knowing Her Place* as a caricature: life imitating modernization theory—"Encounter with America leads Indian woman to challenge Indian traditions. Ensuing internal conflict resolved through therapy and a career of her own." The "India vs. America" meta-narrative might prompt such a reading. To conclude thus, however, would be to advance a reductive tabloid interpretation that ignores the wealth and complexity of the material contained in the film—a complexity which consistently and compellingly exceeds any simplistic reading.

Under the deliberately simplistic rubric of "Ten Steps to Burning Indian Women Abroad" that I began above, I take up precisely those complexities that Mani writes of, in order to call into question the simplistic appeals to Western liberal consciousness by a few recent representations of Indian women.

What are the struggles being waged over gendered identities in a film like Deepa Mehta's *Fire*? Are films by diasporic women of Indian origin like Mehta or, for that matter, Mira Nair, whose last major film was *Kama Sutra*, also inevitably films about "India"? To the extent that the fact of Western viewership complicates any reception of a film about the gendered Indian subject, as in the case of, say, Shekhar Kapur's *Phoolan Devi*, how are diasporic Indians, especially Indian intellectuals, to intervene in the interests of promoting a secular, democratic, feminist, and anti-homophobic culture?

But why do I ask these questions, and from which specific location in culture? Let me address this prior question first.

Step 2

I work as the media coordinator on an electronic list for progressive, diasporic Indians. Early in 1998 I received a posting from a woman in Baltimore who wanted to vent her frustration with the coverage of the Indian general elections in the pages of the *New York Times*. John F. Burns, then the *Times* reporter in India, had been taking rather seriously his role as Lawrence of Arabia with a laptop. Pointing to the reporter's rhetoric, his reference to the "sinuous alleyways" of old Delhi that he imagined had existed unchanged for centuries, my Internet interlocutor remarked: "His language might be more appropriate to the tales from Arabian Nights—or do you think I'm overreacting?"

More than the Orientalizing fantasies of the reporter, it is my correspondent's concern with overreaction that engages my attention. A question like hers, in fact any question about a response to mainstream representation of Indians in the Western media, poses a dilemma. On the one hand, the condition of diasporic existence breeds a hunger for the images of what persists in our psyche as home; on the other hand, it cannot be denied that a feeling of acute exasperation develops rather quickly in response to the shallow and often misleading representations. It becomes necessary to protest. And, in the process, we always seem to be running the risk of fulfilling the dominant stereotype of Third-World Oliver Twists asking for more.

I do not raise this issue here simply to underline the pitfalls of oppositional critiques of the media. What is as important, it seems to me, is the more basic political recognition that, as diasporic Indians, we consume images of India in the representational theater of the West. In other words, to speak of Indian women's cinema, particularly when my correspondent or I—or other diasporic members of the audience—describe the experience of watching an Indian film in the United States, is always to register the fact of the dominant Other's powerful gaze. It is with this salient fact in mind that I first offer you two media critiques—one was published in the Indian newspaper with the largest circulation in the U.S., and the second appeared in a well-known leftist journal in India.

Step 3

Sitting in a Florida movie theater, I watched Mira Nair's *Kama Sutra: A Tale of Love* recently with an audience of aging hippies and other Non-Resident Indians.

Now, while it is true that I am Indian you should not assume that I have read the ancient text of courtship and love, *Kama Sutra*.

Although I did have in college a dorm mate whom everyone called Kama Sutra. For no apparent reason other than that his first name, Rama, rhymed with the title of the fourth-century text. And as far as I could tell, Rama had as much knowledge of sex, which is to say very little, as the rest of us. In fact, as much as the rest of the kids just out of high school in many other parts of the world.

While we are on the subject, although I'm from India, you should not assume that I recognize the India in Nair's *Kama Sutra*.

Although I should not necessarily mind it when filmmakers of Indian origin prove to Hollywood that if Hollywood can make a spectacle of India in films like *A Passage to India* and *City of Joy*, then we Indians can do it even better. Heck, we can also make a spectacle of ourselves.

Janet Maslin wrote in her *New York Times* review of the film that the sensual detail was so real she could "almost smell the incense wafting from the screen." Yes, next time, if either the filmmaker or the reviewer moves into things more current, Maslin will be able to almost taste the curry chicken.

What do I mean by more current? I certainly couldn't mean the evocation of the lushness, the languor, and the erotic in Maslin's review. That way of looking at the East is much, much older than—to use a standard Americans might recognize—even Strom Thurmond, the geriatric conservative senator. It is the centuries-old vision that set up the lure of imperialist conquests and legitimated control.

Except, now that I think of it, it seems to me that Nair's effort, while tired, is not without its own kind of fresh charm. Of course, this is the India of courtesans wearing outfits more beautiful and stylish than those being produced in the sweatshops of Kathie Lee Gifford. But consider the real question, what is this for?

Yes, Nair's effort is current, in spite of its being situated in the sixteenth century, because unlike her last film set in India, *Salaam Bombay*, her latest effort makes that part of the globe attractive once again to Americans.

In recent years American capital has been flowing to the opened markets of India under the guidance of the Washington-based World Bank and the International Monetary Fund. Now, with Nair's film, investors can relax.

Their money is going on a vacation. Their profits rendered more sensuous than mere Dow Jones averages. Their interests accompanied by

the call of peacocks and the jingle of women's dancing bells. Nair's film is set in the present precisely because it is set in the sixteenth century.

Now, although I am an Indian, you should not assume that I want the presence of doctors and computer scientists in a film to make it real.

I'm only arguing that, even if I do not recognize the India in Mira Nair's film, I think the film, in a perverse sense, is only too real.

Though, now that we are on the subject, I want to find out if there is a relationship between Nair and all those Indian doctors and computer scientists.

Just as America's super-technological revolution has benefited enormously from the cheaply produced intellectual capital imported from places like India, is Nair, I wonder, one of those who might be described as a part of the imported Third-World *cultural* capital, whose goal is to make the rest of the world more alluring for American finance? And vice versa?

If that is what the film *Kama Sutra* is about, then, we might ask, as Tina Turner did long ago, with emotions more powerful than this film can provoke, "what's love got to do with it?"

Step 4

While being served Nair's rich and utterly banal feast of tourist-catalogue emotions and action, I couldn't help but think of my last experience of sitting in a theater here watching an Indian film. On that occasion, the film had started not with a slow pan of stately ramparts and unfolding countryside but in a barred room with a woman who shouts *Main hoon Phoolan Devi, bahenchod, main hoon* (I am Phoolan Devi, sister-fucker, I am).

I had emerged from the dark of the theater on that occasion, after having seen Shekhar Kapur's *Bandit Queen*, feeling drained and disgusted.

Kama Sutra evoked a minor sense of disgust too, mostly at a film industry and its hawkers who sell tinsel. Who possess that spectacular Midas touch of capitalism that even when they lightly brush issues of importance, especially of the Third World, they turn them into commodities.

Bandit Queen was no tale of love: it returned again and again to the conditions that make love difficult. And it had nothing to do with how well the audience had read or understood an archaic and often oppressive fourth-century text. It had everything to do with the extant inequali-

ties of gender and class and caste that made any meaningful existence for someone outside the dominant order impossible.

A part of the pressure and the embarrassment of stepping out of the theater that night after the special screening of *Bandit Queen* was also the shame of being seen, as a male and as an Indian, as a part of a culture of oppression.

As I watched *Kama Sutra* in an audience, as I said earlier, of aging hippies and other N.R.I.s, I thought also of another account. In Pankaj Mishra's travelogue, *Butter Chicken in Ludhiana*, we come across a narrative offered by Sarah, an American woman who is visiting Varanasi: "I know my Indian women-friends get treated pretty badly, but the frequency and viciousness is much more if you are a white woman and have blonde hair. There has not been a day since I came here when I have gone out of my house and not been sexually harassed."

How about advertising this reality in a film being shown in the U.S. and in India? In a standard Bollywood film, the routine of "eve-teasing" (or sexual harassment) basically takes care of the let's-get-acquainted strategy. The villain might also have raping privileges, for which he is duly punished by the hero, but not before the audience has been solicited as acquiescent voyeur.

Sarah's experience in *Butter Chicken in Ludhiana* turns on her helplessness and rage when ten people just stand around and watch when a man at the Sankat Mochan temple walks up to her and squeezes her breasts. A few bystanders actually laugh.

While reading an account like this, I feel let down even by films like *Bandit Queen*. It is true that it refuses to follow the Bollywood routine of aestheticizing rape, but it is also true that its analysis remains broadly descriptive instead of incisive—and it finds consolation, cathartic no doubt, in the triumphalism of its conclusion where Phoolan Devi gets cheers from the masses and later finds amnesty.

There are ordinary details of struggles in history that the *Kama Sutra* cannot even imagine. And a film like *Bandit Queen* cannot embrace because it would have to move beyond the individual figure of Phoolan Devi and pay attention to the incoherence of disparate struggles, defeats and victories that do not respect the conveniences of a filmic narrative.

We await another film, or, perhaps more accurately, the film awaits another viewer.

Step 5

The viewers we get, not to mention the filmmakers, are often the kind that recall the words of the late Hindi poet Dushyant Kumar: *Dukan-daar to mélé mein lut gayé yaaron! / Tamaashbeen dukanein lagaaké baith gayé / Lahu-luhan nazaaron ka zikr aaya tó / shareef log uthé door jaaké baith gayé* (The shopkeepers were looted in the fair, friends! / The spectators set up shop and sat down / When the gory scenes were invoked / the polite folk walked away and sat down). But this world is not limited to film; film is a part of the global relations that make up the world under late capitalism.

I step inside my apartment, turning my back on a humid Florida night, and, switching on my TV, find an ad writer in Mumbai asking the question: "What does an Indian woman want?" This, it turns out, is a documentary being aired on PBS.

But the copywriter is not really speaking to me. He is speaking to those who are rich capital-holders in the West. When he spins the fantasy of a middle-class Indian housewife alone in her bathroom, daydreaming of a waterfall and her manly hero—a detail she recalls from the last Bollywood film, our ad man says, and all because she owns a bar of freshness soap—he is selling a vision of a financial market of hundreds of millions of Indian consumers.

I cannot envy the Mumbai man's knowledge of what the Indian woman wants. His confidence, one that he shares with his Western audience, is hardly surprising. It is a comfort that might very well indeed be premised on disavowals, not the least of which is the disavowal of the Indian woman herself. Where in this conversation is the Indian woman? Quite recently I read a news report about the harassment of women protesters opposed to the construction of a big dam in the Narmada valley. The National Commission of Women has been inquiring into the injustices, and the journalist wrote: "At a time when the government was preoccupied with propagating national pride over India's capacity to use weapons of mass destruction, I secretly felt proud of the institution these women represented. To have a national commission empowered to inquire into police brutality suffered by village women was no small achievement for a fifty-year-old republic." The resistance of women, the repression against the power they visibly represent, is not very new. Why does it not appear then in the answer that the Mumbai ad man provides to the world?

And where also is the recognition of class-based patriarchy, whose guilt and fear is forcefully imagined by the poet Alokdhanwa: "You! / who / keep your wives separate / from whores / and keep your lovers separate / from your wives / how you are struck with terror / when a woman wanders fearlessly / searching for her own self / together in whores and wives / and lovers!"

Step 6

Even liberal-leftist publications, aware of the conventions that keep wives separate from those paid to be lovers, circulate (consciously or unconsciously) the dominant motifs of an Orientalizing discourse. "India's Shame" screamed the title of the cover article in *The Nation* last summer, and inside, the writer Robert I. Friedman produced a Dickensian survey of horrors in Mumbai: prostitution, AIDS, and corruption. "When Mira, a sweet-faced virgin with golden brown skin," reads Friedman's prose, with voyeuristic avidity, "refused to have sex, she was dragged into a torture chamber in a dark alley." Our traveler foresees a country being pulled into "a black hole of despair," and this view is very easily reinforced when, as a collective letter published in the journal in the following weeks pointed out, the writer didn't bother "to consult grass-roots groups working on the issue of HIV/AIDS in India and other South Asian countries."

When writing of Mumbai as a "paradigm of urban decay" or the conditions in a health facility that were "as primitive as *Jurassic Park*," Friedman does not even make one single connection with the workings of global capital that contribute to Third-World poverty and its particularly devastating consequences on the lives of women and children.

Friedman's detailed reports, because of their relentless attention to the observable, physical aspects, appear all the more unquestionably real. They also make the idea of a different, more complicated, and even invisible kind of reality all the more difficult to imagine. But, and this is the reason why I bring up the case of Robert Friedman and his massaging of leftist-liberal condescension, even here in America, such views do not go uncontested, especially by Indian and South Asian women.

The storm of angry letters to *The Nation* did not demand easier standards of judgment or some kind of cultural relativism that would explain away what Friedman saw. Rather, the readers pointed out that Friedman saw too little. A reader wrote from Solvay, New York:

Your lead story should have been called "*The Nation's* Shame." To think, a progressive magazine publishing a racist article that openly pines for the days of colonialism. If I wanted to read voyeuristic and prurient descriptions of rape or offensive and irrelevant details of dirt—a standard trope of colonial and neocolonial writing about India—I could open the *New York Times*.

Friedman's article obscures the role of U.S.-backed leading agencies, the International Monetary Fund and the World Bank, which, under the name "structural adjustment," [have] forced the Indian government to reduce drastically its subsidized general health infrastructure in order to qualify for loans. In place of expanding the health care network, the World Bank supports token funding for AIDS and population control, as if those issues have no relation to India's general living conditions and economic stability. The shame of women's exploitation, poor health facilities and the spread of AIDS in India is not borne by one nation alone.

The attribution of shame by the West to the East hides a fundamental dishonesty. But it also very clearly suggests an unwillingness to listen. And in Friedman's case it is an unwillingness to listen to *women*. He not only ignores (or perhaps can't even find) those women who are a part of various organizations struggling, and in some measure succeeding, against those ills that he describes. More egregiously, he also chooses to ignore those women, both individuals as well as members of organizations, who wrote protesting his position. All that his report does—and here my own complaint would be against the standards of a progressive journal and hence, by implication, of progressive politics in this country— is dismiss the women and their criticisms with a nostrum: they should be back in India dispensing condoms. Yes, if you don't like what I write, why don't you go back where you came from.

Step 7

Why—or rather, *how*—are Indian women being burned in the West?

Let me describe very briefly an experience at a South Asian cultural festival in Canada. One evening a poet of Indian origin, collaborating with a female Bharatnatyam dancer, presented a work on bride burning in India. The previous night we had watched Mallika Sarabhai do something similar, and I, along with the audience, had liked it very much. The second night the poet was applauded too. But I was not too eager to clap my hands.

The poet read out a poem she had written about bride burning and told us, before she was interrupted by applause, that as long as any woman

was under threat of death we should protest. But I did not clap. Was the repetition of this theme on the second night inciting boredom in my heart? Had I found Sarabhai's protest more artistic? More authentic?

I raise these questions because diasporic Indians are also reading India from the West. And our writing, unless it is to reproduce the gaze of the West, must be interrupted by signs of dialogue with those about whom—and ideally, *with* whom—we write. On the one hand, I found Sarabhai's performance provocative because she didn't let Non-Resident Indians off the hook. The expatriate poet's protest, on the other hand, was meaningless to me in its passive sentimentalism. I found it exploitative. People often say of something they don't like that it was a tragedy being repeated as a farce. When tragedy is isolated as mere tragedy, as dead news, cut off utterly from the people it most affects, it becomes farce. Or, in the language of traditional Marxism, it becomes "reified" and hence turns into a "commodity."

And yet a week later, when writing a review for a Bay Area newspaper, all I could do was make cautionary noises: "This, however, is a culture that consumes difference—and also distress—as it does ethnic food. Even shock can only add spice to life. In such a scenario, the challenge for diasporic artists, especially if their art is produced primarily for those not native to that culture, is to produce an art that remains multivalenced and many-sided." Maybe I was the one who was burdened with politesse and hesitated to demand an art that was open to questioning by those it represented for others. Certainly the poet wasn't burdened with politesse. Rather, in her list of terrifying details about bride burning—and I have no other way of saying this—there was nothing she couldn't have bought along with her other purchases on a visit home: the brass figurines, the silk prints, the variety of mementos from the Central Cottage Emporium on Janpath—if such places do one day start retailing the horrors of our native land.

Step 8

I want to talk about Deepa Mehta's *Fire*. And its relation to the issues of gender and representation in what I earlier called "the theater of the West." But please be patient, gentle reader. A rather obvious point that needs to be made first is that a film does not emerge in a vacuum, that there are always other texts surrounding it, other films, other stories, and other conversations.

In a short story, "The Ultrasound," included in Chitra Banerjee Divakaruni's collection *Arranged Marriage*, the female narrator in California is thinking of her cousin in Calcutta. Both women are pregnant. The narrator's cousin has found out the sex of the fetus; it's a girl and the mother-in-law wants an abortion. In the story we read: "But already I know—how could I not have guessed earlier—what Runu is about to say. I remember the show some time back on '60 Minutes' about the increasing popularity of amniocenteses in India."

There is something peculiar, even disconcerting, about discovering my homeland through the kind offices of the U.S. television empires. That feeling of displacement is echoed in this double return of the repressed when, in the pages of a U.S.-based writer, I hear the echo of what in its inaugural moment had been no less troubling. What makes it worse is that in this later encounter, the short-story writer seems to have monumentalized the show. There is no gap for her—no other questions that appear—between one set of representations and another.

The *60 Minutes* report on CBS that Divakaruni's narrator remembers was broadcast more than a decade ago under the title "Till Death Us Do Part." It was a searing account of dowry deaths in Delhi where, as the commentator said, "a woman is burned every twelve hours." There can be very little to argue about the brutality and greed of patriarchy in such cases. But, in the same way as the CBS commentator informed us of the way in which a mother-in-law's grief was oftentimes unreal and that "crocodile tears are called mother-in-law tears" in India, I want to remain skeptical of the emotions displayed both by the television commentator and the short-story writer. The following, in brief, are my reasons.

The *60 Minutes* show ended with the words that India stands with "one foot in the space age, [and] with one foot in the Middle Age." What goes unremarked here is the complicity between the two—and I'm not commenting here simply on the ways in which we might easily see the current Indian government's use of nuclear power to mobilize medieval passions. Instead I'm referring to the U.S. media's complete and arrogant separation of India from the West as a place where women are mistreated. Among a host of other things, what I find appalling is the repression of the complicity between oppressive, dominant forces in India and the U.S. Let's ask, for example, how U.S. multinationals like General Electric, with their marketing of ultrasound devices, profited from the heinous social practices in India. But the pious head-shaking by the CBS commentator ignores such complexities.

The narrator in Divakaruni's story, wittingly or unwittingly, repeats this flawed separation or binary division between India and the U.S. She recalls her cousin's interest in becoming a traditional housewife and then begins to question the way in which she has now planted the seeds of opposition in the latter's mind. Thinking of her cousin's childhood images of red-bordered saris and the red marriage *bindi* (the cosmetic dot), the narrator asks: "Had I taken all of that away from her by my misplaced American notions of feminism and justice?"

Is feminism American? Did the narrator in Divakaruni's story, even if her knowledge of women in India was to be limited to the *60 Minutes* segment, have no knowledge of Indian feminists? Could she not have noticed the outspoken activism of Brinda Karat, the charismatic Communist leader of the women's organization Janwadi Mahila Samiti? *On that very show!*

What did Karat's brand of oppositional social consciousness mean to Divakaruni's narrator—or, for that matter, the American audience? Didn't it challenge not only their notions of Indian femininity but also their assumptions about what constituted the right social response? Let me pitch crassness against crassness: To make the connections I am seeking would jeopardize GE's advertising on future CBS shows, and, as far as our narrator is concerned, it'd rob her of the dream of having done the right thing. At least, without calling into question her own privilege in a society that rewards her precisely for not being Brinda Karat.

Divakaruni's narrator is not aware—perhaps she *cannot* be aware—that a group of five women made a film to protest the death, on September 4, 1987, of an eighteen-year-old woman, Roop Kanwar, on the funeral pyre that consumed her husband's corpse. I recall the work of this group, Mediastorm, because their film, *From the Burning Embers*, does not share Divakaruni's dream of a single woman's rescue by getting her a plane ticket to the U.S. Against such a solution that mixes deep class privilege and abject individualism, at the end of the Mediastorm film the words of Safdar Hashmi motivate us to think of a genuine alternative: *Aao ab milkar badhé, adhikar apné cheen lain, / Kafila ab chal pada hai, ab na roka jayéga* (Come let's advance together, let's take back our rights, / The procession is now afoot, now it cannot be stopped). The horrifying "social murder" of Roop Kanwar was also—as Anand Patwardhan rightly points out in his own 1995 documentary, *Father, Son, and Holy War*—connected in a straightforward way to the demolition, only a few years later, of the Babri mosque in Ayodhya. What we wit-

nessed in the right-wing mobilization around Roop Kanwar's death was the emergence of a nationalist-masculinist ideology that demonized the Muslim minority and turned women into submissive bearers of tradition. These are precisely the difficult connections missing from CBS's *60 Minutes* and the pages of fiction celebrated in the West.

It is certainly worth noting the names of the Mediastorm members who made *From the Burning Embers*—they are Ranjani Mazumdar, Shikha Jhingan, Charu Gargi, Sabeena Gadhihoke, and Sabina Kidwai—under severe conditions, including the threat of violence. The courage of such women, as well as the challenge of their work, trivializes the pious effusions of metropolitan writers like Divakaruni.

Step 9

"It is not only film images—filmic processes of looking—that need to be focused on, but also who is looking at the film," writes the film theorist E. Ann Kaplan in her book *Looking for the Other: Feminism, Film and the Imperial Gaze*. This rather straightforward insight provides a point of departure for my brief meditation on Deepa Mehta's *Fire*.

This film, its Indian-Canadian filmmaker said in an interview, "came out of that tug-of-war between traditional values and women's desire for independence." In another interview, Mehta repeats this point more vehemently.

> If you start making films with just the audiences in mind, whether Eastern or Western audiences, you're a dead duck. Your film might do well, but there's no integrity in the piece. I didn't think of an audience, I didn't even know whether I would have one! No, what I was trying to do was show the tug of war between tradition and the desire for a personal, independent voice.

Needless to say, what complicates this narrative are the questions of these women's identities, their class, the language they (and the film) speaks in, the trajectories through which the film depicts the women's emergence into a lesbian relationship.

I want to bracket those questions in order to address the point I started with: Who is the viewer of *Fire*? The film begins with a finely framed shot of the Taj Mahal, and the film's conclusion presents the image of a woman burning. These iconic images serve as bookends for an ideological text, and I find myself saying what I have already said about *Kama Sutra*—that this text might be best described as the neo-Orientalist West-

ern imaginary. Its framing sets up a very particular kind of viewing relationship; it promotes the idea of the West as the viewer. Its context is a global condition in which travel and tourism, not to mention the media, have secured a certain intimacy with the Third World and yet—in order to sustain the appeal of that Third World—must continue to produce it as different. The *difference* that *Fire* reproduces is the India familiar to the Western media-watching eye—the monumentalized, mythical past persisting as the image of the Taj and, as its underside the updated sati symbol, a woman on fire. The Western viewer consumes this difference without in any way feeling responsible for it. This is voyeurism. In spite of the richness of its evocations or the passion and wit with which it portrays the life of three women inside a middle-class, joint-family Indian home, *Fire* does not warn us to examine the limits and pitfalls of easy sympathy.

But let's return to step 1 and Lata Mani's remarks on the protocols of reading, especially reading the spaces of feminist representation. How might we read *Fire* otherwise? We get help from Spivak here: her analysis of Hanif Kureishi's *Sammy and Rosie Get Laid* offers a general approach to critical interpretation. Spivak writes that she wishes to emphasize "the formula of the new politics of reading: not to excuse, not to accuse, establish critical intimacy, use (or ab-use) the seeming weak moments for scrupulous ends." How can we use *Fire*'s "weak moment," its complicity with a neo-Orientalist paradigm of a woman on fire, to take our discussion elsewhere?

I think that can happen if we engage the question of viewership, by examining the idea that an audience in India would see the film very differently from a non-Indian audience in the West. Or that an immigrant's gaze would be unlike an immigration officer's. Let's return to my earlier observation about the way in which the two women relate to each other in *Fire*. The register of their relationship—in spite of the very problematic depiction of their lesbian identities as a result only of their dissatisfaction with their heterosexual marriages—gives us a clue about taking a different tack. Here's a portrayal of affective bonds between women in large families that calls into crisis the routinely superficial engagement with Indian arranged marriages. To underline this interpretation, Deepa Mehta tells Bapsi Sidhwa that one of the main influences driving her narrative is the importance of "arranged marriages":

> Growing up in a huge joint family. My aunts' and mother's arranged marriages. We lived in the city of Amritsar with my father's brothers and their

wives, and I saw this incredible bonding between sisters-in-law. . . . They got their emotional nurturing from each other more than their husbands, who were themselves in arranged marriages.

There is a way of pressing further with what, following Spivak, I exploit as the text's "weak moment" in order to produce a reading that works against the banal aesthetic (ten steps . . .) that the film might otherwise support. The split nature of the filmic text's reception, its divided locations and locutions, foregrounds the issue of who gets to speak for whom. If, in other words, we do not see the film simply performing for the Western gaze, then we can allow that in *Fire*, Deepa Mehta is able to performatively stage the play of gendered and sexual identities. In this reading, the filmmaker's position doesn't seek or demand authenticity. As more and more cultural production marked as "Indian" emerges from the diasporic nation that is largely constituted in the metropolitan centers of the West, our criteria of critical assessment will have to shift. The "weak moment" in the film, its susceptibility to the critique of being a product for the West, can also lead us to a more enabling discussion of the way the film helps us think through the issues of cultural production freed from narrower identity politics. Hence the epigraphs to this section of the chapter. Hence also this quote from Deepa Mehta in Ginu Kamani's interview with her: "I don't believe in cultural appropriation, and I don't believe in sexual appropriation. It's ridiculous. I don't have to be gay to do a gay film. I don't have to be straight to not do a gay film."

The consequences of this move, for me at least, are twofold. What we think of this film, but also, more generally, of the criticism that we write, is material for both substantive and formal revision. Arjun Appadurai notes that "India" is "a *site* for the examination of how locality emerges in a globalizing world, of how colonial processes underwrite contemporary politics, of how history and genealogy inflect one another, and of how global facts take local form." That necessary complexity eludes the narrow fixation on static identities or location while it preserves the critical charge of interrogating, assessing, speculating on the consequences of any cultural act. The formal revision of such conceptualizations includes the way we reimagine critique as the production of a critical montage. This is what I discern as the point Spivak makes when she says that *Sammy and Rosie Get Laid* gives us "a spectrum of the social text." She further writes: "One hopes that Kureishi's montage technique would have satisfied Adorno. It is much more concerned with negotiating a certain

kind of unease, a laughter tinged with unease and bafflement." It is not only that realism's principles are to be confounded. It also means that theory is mixed with journalism, and the theoretical critique of films is brought into dialogue with the concerns that linger in the private letters that we write home.

Step 10

Criticism is the screen on which we are forever projecting our desires.

With that in mind I ask a question of the ad man who had spoken of "the Indian woman": Where is "woman" in the nation called "India"? In fact, where is "India"? The imagined community in India, some would say, is entirely the stuff of movies. The Indian film industry, after all, puts out more than 800 films each year. The tinsel productions of Indian epics on television—which in India is a more recent medium but with a more explosive potential for a national viewing audience—can be described as having produced our national slogans.

There is some truth to the remark made by a prominent Bombay film-maker to a visitor: "The intelligence of the average moviegoer in India is that of an eleven-year-old." At the same time, even in areas where a regular supply of water and certainly health care is lacking, a government satellite can help viewers receive its signals on a small television set. In my sister's home, I watched a film made a few years ago about the work of the gods in the age of mechanical reproduction. The film, Utpalendu Chakravarty's *Deb Shishu* (God-child), was a progressive, class-based critique of the manipulation of the rural masses through superstition.

But what was more remarkable in the film was the transformation of the woman protagonist into the avenging goddess, Kali—not as a mystifying ascension into divinity but as a materialist-feminist dream of rebellion. The woman with the machete, even as a primal force, comes to the masses, let us not forget, as a mediatized event—as an image. Thus represented, she inhabits a certain contradictory moment where we encounter our impure real: the mix of the natural and the cultural, of the premodern and the postmodern, of passive acceptance and uninhibited revolt. Her rage and her resolve flicker on the screen where the present is only a moment of fluctuation. This moment's motivations are not entirely transparent, and all its consequences cannot be foretold.

Identifying Marks

A brown leaf on his black back. That
made the monsoons come on time.

Arundhati Roy

The feet of a landless worker never heal (it's not a field on the moon! these are the soles of my feet). Will this map of labor serve as a mark of identification in the customs offices of the First or even the Third World?

Saint Nihal Singh, one who was among the earliest immigrants from India, described his fellow newcomers as "picturesque." The identifying marks of his fellow Indians, whether picturesque or not, were certainly highly ideological; not only did he present each member of the new diasporic community as a "Hindoo," he placed them in the "Aryan" fold:

> All Hindoos who come to America have hair varying in hue from brownish-black to purplish or an intense raven-black. . . . The hide of the Hindoo varies from the dull, pale, sallow-brown of a Mexican to the extreme black of an African. The man who hails from the highlands of northwestern Hindustan is a shade darker than olive. A few coming from Kashmir have fair skins, light hair and blue eyes. Those who come from the low plains have darker complexions and an extremely sun-burnt appearance. . . . They have intelligent faces, keen eyes, compressed lips and determined chins. This type of countenance is distinctly Aryan, as all Hindoos who come to the land of the Stars and Stripes are descended from the same branch of the human family as the Anglo-Saxons.

Singh's need to represent Indians as Aryan might have been partially motivated by the need to contest racist exclusion. It didn't prove of much help. A 1917 congressional decree virtually barred immigration from India and other parts of Asia. In 1923, in the Bhagat Singh Thind case, which involved an Indian World War I veteran's appeal for American citizenship, the Supreme Court ruled that Indians were not "Caucasian" and hence not eligible for citizenship.

Using the work of the legal theorist Neil Gotanda, Lisa Lowe comments that "the sequence of laws in 1882, 1917, 1924, and 1934 that excluded immigrants from China, Japan, India, and the Philippines, combined with the series of repeal acts overturning these exclusions, construct a common racial categorization for Asians that depended on consistently racializing each national-origin group as 'non-white.'" The 1946 act repealed the exclusion of Indians, and the McCarran-Walter Act of 1952 abolished the 1917 "Asia Barred Zone." But it was not till the abolition of Asian quotas in 1965 that the main wave of Indian immigration took place, primarily of professionals like doctors and engineers. Only recently, with shifts in the economic needs as well as relations of both the U.S. and Indian economies, Indians from diverse classes, including working-class populations in larger numbers, have joined the lines of arrivals in cities like New York and Los Angeles.

Perhaps those among the recent Indian immigrants who want to describe themselves as "Aryan" have little desire to fight against racist exclusion. Their motive might lie more in the emergence of Hindu fundamentalism in the past decade in India, one of whose leaders, Bal Thackeray, praises Hitler as a hero. In this mythology of the "Aryan" nation, the concept of an ancient India populated by Aryans serves as an ideological site. Its purpose is to help consolidate a national identity that marginalizes its minorities, including aboriginal populations, as non-Aryans. In the U.S. context, however, this claim gathers other insidious intentions. The self-imagining of such Indians as "Caucasian" allows them to distinguish themselves from blacks and also Mexican and Latino immigrants. The Aryan continuum, in this manner, serves its exclusive function both in the Indian and American context—it is only that the identities of those dehumanized and deemed inferior change.

But what are the identifying marks of Indians in the white imaginary? In the early fall of 1986 the members of a gang in New Jersey called themselves Dotbusters—using the *bindi,* the cosmetic dot worn by Indian women, to name the community. The assaults on Indians, the murder of a 30-year-old banker, resulted from their racist resolve to drive Indians out of Jersey City. The dot, however, hasn't given Americans the only context for Indianness.

According to Ronald Takaki, in the middle of the nineteenth century "the Hawaiian Board of Immigration sent labor agent William Hillebrand to China to recruit laborers, instructing him to proceed from China to the East Indies to investigate the possibility of India as a labor source." Although Hillebrand was unable to fulfill his task, the Hawaiian planters looked to India as a source of labor. Takaki reports:

> "Where shall we look for the kind of immigrants we need to supply us with both a homogeneous population and labor?" asked the *Pacific Commercial Advertiser* in 1874. "We answer, to the East Indies. From the teeming millions of Bengals and other provinces of Hindostan." Seven years later, planters appealed to the Hawaiian Minister of Foreign Affairs for his "assistance in removing the obstacles in the way of introducing East Indian Coolies into these islands." In 1884, when they learned that Japan had decided to permit emigration to the islands, the planters turned away from India for their labor needs.

Although it is true that as late as 1935 storefronts in California carried signs, No Jobs for Japs and Hindus, there was broad perception that the Indian immigrants were diligent workers. In the words of Shashi Tharoor, the Non-Resident "continues to make his [*sic*] way abroad, pri-

marily on the strength of qualities regarded as 'typically Indian'—hard work, discipline, self-sacrifice, and thrift." Tharoor also reports a newspaper wholesaler telling the *New York Times* that the Indians "basically replaced the old Jewish and Italian merchants and they've filled a tremendous void because nobody will put in the fourteen- and sixteen-hour days that they do quite willingly and that you have to put in when running a newsstand."

Today, according to the *Washington Post*, "Indians outnumber other applicants for H-1B visas." These visas are for temporary workers and available for a period of up to six years. I had one. Computer programmers from India, China, and the Philippines, brought into the U.S. on H-1B visas, are employed at wages less than their American counterparts and remain beholden to their employers in "a form of indentured servitude." The *Post* calls such workers "the high-tech incarnations of the braceros of old, those laborers who were brought in to toil on American farms during and after World War II."

More than 35 percent of Silicon Valley programmers and computer engineers are foreign-born. Lewis P. Wheeler, the owner of a computer company, told the *Post* reporter that "U.S. companies often prefer to hire Indians because they are 'better at getting themselves educated' in hotly demanded skills."

The real question is, what could be more likely than a shared response between those in conditions of desperate servitude, whether as immigrant agricultural workers at the turn of the century or as temporary hi-tech workers employed under precarious conditions of stay in a foreign country. Regardless, quite apart from my objections to what some would see as the persistence of a national trait, what interested me in the *Post* story was another detail. When telling us about Satish Appalakutty, an Indian computer programmer in Sunnyvale, California, the reporter describes for us Appalakutty's apartment:

> In his second-floor apartment, the influences of Indian culture mix with those of a bachelor, cyberworker lifestyle. As in India, shoes are left at the door. The living room furniture consists of a television and a stereo. The walls are unadorned except for an Indian calendar, a poster of the Golden Gate bridge and, in a small dining area, a whiteboard above a cluttered dinette table and a few chairs. Lying in a corner are a basketball and a deflated balloon left over from a roommate's recent birthday party.

It is here, in the mapping of the migrant everyday, in this impoverished geography of affect, that I find more clearly the identifying marks of my own history as an immigrant. Each element in this description, in

spite of—rather, *because* of—its bareness, introduces us to an economy of transience and dislocation.

It would be a mistake, of course, to call this a general portrayal of life under late capitalism. I remember far too vividly the landless migrant laborers from Bihar, sleeping under overpasses and bridges in New Delhi and earning their meager livelihood as construction-site workers during the day. But that was never a part of my own lived experience. In being drawn to the details of Appalakutty's life, what I privilege is the material of my own past. In this description of unadorned walls, I recognize immediately the absence of photographs. The occupant is saying there is space away from here that claims me as its own. This space is not mine. If I have a poster of the Golden Gate, it is only because it once again defines me as a tourist. A calendar measures the distance in days from the time that was mine. And walls like a cell's aren't necessarily the occupant's wish; real laws, he knows, claim responsibility for that, laws that prohibit who he can be with now or later. Or the conditions of earning, mobility, return. His universe is reduced to those documents that define him in relation to that world. All that matters in this life—in this portion of life that an immigrant hopes will not last forever, though in some cases it does—are the passport photos and the stamp on the visa.

The bare walls are a reminder that America, as my friend Vijay Prashad puts it, wants our labor but not our lives.

IDENTIFYING MARKS: SCAR ON LOWER LEFT RIB CAGE

Is that how a lover remembers the body of her beloved? In my mind, the question of that intimacy immediately recalls its opposite: is that how a rioting mob uses violence in a fixed economy of signs, finding its victims, reducing their histories as well as *presence* to an identifying mark like the absence of a foreskin? In my imagination, this question finds other corollaries. For instance, the memory of resistance that the state seeks to erase by the marks it inflicts during torture.

During the freedom movement against the British, the authorities used terror to brand the nationalists. Among the most horrifying incidents was the massacre at Jallianwala Bagh in Amritsar, on April 13, 1919. At that time, as writers are apt to remind readers, the British empire extended over one-quarter of the planet. A meeting was in progress that afternoon, with an audience of 8,000 or maybe more. The British Brigadier Gen-

eral Dyer ordered his riflemen to fire on this crowd that had broken no laws. General Dyer provided no warning. The shooting lasted less than 10 minutes, but 1,650 shots were fired on an unarmed public trapped inside a public park with high walls. Official figures about the ensuing casualties were 379 deaths, but reliable reports put the number closer to 1,000. General Dyer's only regret was that his ammunition had run out and that the narrow lanes had prevented him from bringing in the armored cars.

In the days that followed, martial law ruled Amritsar. Dyer had a public platform erected for the whipping of natives. In the Kucha Kuchianwalla lane, where a white woman was said to have been insulted, the brigadier general issued a "crawl order." Indian children today read in their history books that every non-European who used that street was forced to crawl on his stomach.

But the violence didn't end, or even start, with the departure of the British. And this is why the Urdu writer Khwaja Ahmad Abbas responded to the spate of atrocities following the partition riots with the question:

> Did the English whisper in your ears that you may chop off the head of whichever Hindu you find, or that you must plunge a knife in the stomach of whichever Muslim you find? Did the English also educate us into the art of committing atrocities with women of other religions right in the marketplace? Did they teach us to tattoo Pakistan and Jai Hind on the breasts and secret organs of women?

Unspoken among the questions that Abbas asks is a simple, direct one, "Why women?" In her work on the "anthropology of pain," Veena Das argues that there is "a relation between the normal position of women as signs in the matrimonial dialogue of men—to use the evocative phrase of Lévi-Strauss—and their becoming signs through which men create memories for each other by heaping indignities and tortures upon them." Without necessarily seeing "women" as a fixed site but, instead, as a historical marker of the shifting tensions of patriarchal societies, we can follow Das's insight to gain a sense of why it is that postcolonial horrors are so unremittingly gendered. At the end of the twentieth century, a report on a feudal carnage in eastern India begins with the words: "In the 1930s the landlords of Gaya in Bihar used to demand at least one seer of milk a day from Harijans. If they were unable to provide it, the landlords demanded the same amount of milk from their lactating womenfolk."

To guard against any essentialization of "women" as the only site for the inscription of violence and its identifying marks, let us consider the case of the massacre of Sikhs in Delhi and elsewhere in India after the assassination of Indira Gandhi. The Indian prime minister was killed by her Sikh bodyguards in 1984 not on account of her being a woman but because she was directly responsible for the attack on the Golden Temple in Amritsar and the bloodbath that had followed there. In the brutal killings that followed Gandhi's death, thousands of Sikhs died. These were not, for the most part, women. Roving mobs, incited and led by the leaders of the ruling Congress (I) Party, pulled Sikh men from their homes or from their cars and beat them to death or, in many cases, burned them alive. The number of those killed in Delhi alone might be as much as five thousand. The men died because of their identifying marks, their turbans and beards, the most recognizable signs of their belonging to the Sikh fold.

Nevertheless, it is undeniable that the main sign of that massacre inscribed on Delhi's geography today is a quarter in Tilak Vihar that is called Widows' Colony. In this rundown colony live the Sikh women who lost their husbands, fathers, brothers, and sons in the early days of November 1984.

In Arundhati Roy's much-celebrated novel, *The God of Small Things*, the untouchable Velutha has an identifying mark. "A brown leaf on his black back. That made the monsoons come on time." Ammu, the upper-caste married woman, falls in love with this sign. Velutha is a member of the Paravan caste, and Ammu's twins are told by their grandmother that she remembers the days when "Paravans were expected to crawl backwards with a broom, sweeping away their footprints so that Brahmins and Syrian Christians would not defile themselves by stepping into a Paravan's footprint." When the police are informed about Velutha's illicit love affair with Ammu, they find Velutha in the dead of night. "The posse of Touchable Policemen," we are told, "acted with economy, not frenzy." Unlike religious rampaging mobs, the police "didn't tear out his hair or burn him alive. They didn't hack off his genitals and stuff them in his mouth. They didn't rape him. Or behead him." They beat Velutha unconscious with a controlled efficiency. His kneecaps are shattered, his nose and cheekbones smashed, and his lung pierced from one of his four broken ribs.

When they bring out the handcuffs, they notice the painted nails. One constable asks "What's this? AC-DC?" Another flicks at Velutha's pe-

nis with a stick and then brings his boot down on it. When they hand-cuff Velutha's arms across his back, the metal clicks into place below the leaf on his back.

Velutha is also a Naxalite, an ultra-left Communist. We learn as much because the twins saw him in a march with a red flag. But what we do not learn in the novel is that the custodians of the Indian nation-state mete out the same treatment, and worse, to Naxalites and others they consider anti-national, whether or not they enter into a relationship with an upper-caste woman. These are not deaths in custody, ordinarily called "lock-up deaths." Instead, what is common for ultras and other militants is death in what Indian newspapers call "encounters," a code word for staged killings by the police of those whose convictions would require more evidence or whose deaths seem to enjoy popular mandate. At the height of the separatist movement in Punjab, for example, the governor of Punjab had to issue an appeal to the police "to stop fake encounters." Two years previous to that, the Indian Supreme Court had stated: "It is equally important to emphasize that rights of citizens should be protected and no excesses should be permitted. 'Encounter death' has become too common." According to Amnesty International's annual report on India for that period, between 10,000 to 15,000 people had been detained without trial during a single year.

In June 1998 the Indian home minister, L. K. Advani, threatened that the government might institute an anti-terrrorist act to deal with the "Naxalite menace." But, as a political scientist told the media, "It is the extreme poverty and exploitation which draws the villagers towards the [Naxalites]. There is no one to redress their grievances, they find that the law is used only to protect the rich." By claiming that the leftists rather than the structural conditions of deep inequality hindered national development, the Indian home minister conveyed very clearly that his sympathies lay with the feudal landowners and large farmers. By asserting that a draconian anti-terrorist law was on the cards, the minister also revealed, in the words of the Liberation group leader Vinod Mishra, "the vision of a fascist dictatorship." In any case, the home minister's statement holds the ominous promise of continued violence and torture in a situation where large groups of people are grasping for their minimum human rights.

But there is another form of torture that also occurs in the pages of Roy's *God of Small Things*. The struggle against it has very little to do with the public sphere or the fight for the power of the state. In Roy's novel, like "the hidden fish of shame in a sea of glory," is the reality of

domestic abuse. "As a child, she had learned very quickly to disregard the Father Bear Mother Bear stories she was given to read. In her version, Father Bear beat Mother Bear with brass vases. Mother Bear suffered those beatings with mute resignation."

The solidarity that the untouchable Velutha shares with the dizygotic twins, Rahel and Estha, is a solidarity of "small things." No less real is the basis of the love between the mother, Ammu, who has suffered from being in an abusive marriage, and Velutha, who is after all a Naxalite of the Paravan caste. In all these relations, there is a quiet, often hidden, mutual sharing of suffering, bound by taboos. The novel, in a patterned, repetitious cycle, reveals the identifying marks of shame.

The enclosing silences can be seen sometimes as a peculiar kind of quietism, and all the novel's transgressions as limited ones. Kalpana Wilson contests this view:

> Aijaz Ahmad has accused Roy of believing that "resistance can only be individual and fragile . . . that the personal is the only arena of the political." Clearly, *The God of Small Things* is not a novel about mass struggle. Rather it is about the ways which individuals, particularly women, find to resist the conditions imposed upon them by society.

It is the novel's weakness—or, again, it may be its strength—that we do not encounter any other protest during a long journey that leads to the slow madness of language and to silence, to deaths from lonely griefs, and the sweet, small, bitter consolations of incestuous caring. In *The God of Small Things*, there is perhaps a lesson that is often overlooked: the need to pause over the scars of the identifying marks and to study the tortured silences as well as the labor of producing speech or song as protest.

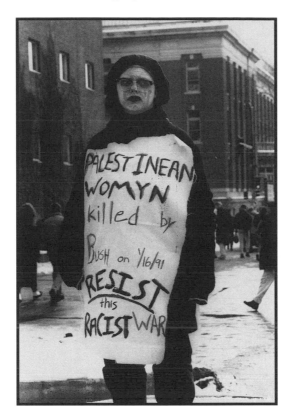

There is an assumption in the mind of the immigration officer. It is the belief that an identifying mark is one that will never change.

An insight, more than a problem, follows from this. We see identity as stable: it's what we are. Of course, it is never that simple. Men have a masculine identity but are dynamic—they are, we assume, on the move. In this same scenario, women have a more stable, often static, essence. A global setting makes this simple division at once more complex and dramatic. Feminized, the East itself takes on the qualities deemed to be womanly, and at the same time women, rather, a phantasmal construction called woman, concretizes this complex identity.

When the Western gaze travels East, it often conjures a single identifying mark: the figure of the veiled woman.

More specifically, in the Western readings of the veil worn by women in Morocco, or Algeria, or India, the ongoing history of colonialism holds in its dominating gaze the veiled woman as a *fixed* sign of oppression.

What would it mean, however, to view the veil as a sign of unstable

identity—and, by implication, the *feminine* as engaged in a struggle, a gendered struggle, within the postcolonial context but also between the East and the West?

We'll have to take note here of how the vastness of a culture, and in this case, many cultures, shrinks to a few identifying marks. The Palestinian feminist writer Samira Haj explains this point very well: "As victims of 'Islam' and Moslem male culture, the study of M.E. [Middle Eastern] women is commonly reduced to the study of the 'harem,' the 'veil,' segregation, arranged marriages and cliterodectomy (which is not even Islamic). The emphasis on Islam and tradition as the source of women's oppression results in a reductive, ahistorical view of women."

Of course, there are no originary gestures in multiple, discontinuous histories; and there are no retrievals of pure voices.

And yet, in dealing with the complex relations between the dominant West and the resistant East—in fact, caught within the terms of my own description—I cannot rule out the long mark that ruptures all histories, the history of colonialism.

Leila Sebbar, born of an Arab father and a French mother, living as a writer in Paris in the early 1990s, rediscovers the veils of the women from her Algerian childhood in the photographs of Gaetan de Clerambault, a French doctor of neuropsychiatry, who took pictures of veiled Moroccan women in 1915.

The vigilance of the doctor, it seems to Sebbar, was a "fixation with arranging these women's bodies, freezing them on his glossy paper like corpses stiff with death, stilled in the ritual folds of veils become white shrouds." Beneath the veils, the women themselves refuse to be sealed by the severity of the Western man's gaze. "But he has not been able to master those gestures, those infractions, that tell of an unheard voice, of a laugh stopped up by the gag that shuts a young woman's full mouth. The glittering black of an eye pierces through heavy cloth."

Let's pay attention to an encounter between the photographs and this woman whose own life maps the displacements of the postcolonial realities:

> I look at these Arab women, and I hear them, through the language of my French mother, and through the eyes of the photographer doctor who wanted to hear nothing at all. They are not exiled behind their immense lengths of fabric, with its surfeit of folds and creases; they are not exiled in the house where they live unveiled, noisy in the little square courtyard; they are not exiled sitting in the jumbled cemetery where olives and poppies grow, their white veils blowing in the evening wind.

Exhibition of these photographs in alien cities like Marrakech, Bordeaux, Toulouse, Arles, and Strasbourg creates for Sebbar the conditions that seem to exile these women to spaces of eternal, frozen enshrouding. "I hear the voices of these Arab women, the sisters of my Arab father, as truly exiled on the Western shore, in France, deprived of their clothes' tender, supple, silken folds. Their bodies are the more invisible, graceless, for being seen unveiled."

The motions of Sebbar's pen as she writes get amplified on the faraway streets of the distant city of her childhood, Algiers. We learn from the voices in the streets and the homes of Algiers that there is a contestation over what a true *hijab* (veil) is.

A journalist's report concludes: "The Muslim sisters, though, are succeeding brilliantly at beating men at their own game. Where traditional society has refused women the slightest social status or means of protest, they have taken the back door in. The once invisible woman now shines brightly in her dark robe as a bold, black exclamation mark, a constant reminder of her presence, her number, and her will."

One group, led by the Al-Salaf Al-Akhiar (our perfect ancestors) movement, considers the Iranian *chador* or *jelbab* to be the only authentic veil. Others believe the hijab is not the chador—a dark piece of cloth covering the entire figure—but smaller scarves and tunics. In the troubled Jammu and Kashmir valley in India, where militant Kashmiri separatists struggle with the Indian armed forces for autonomy, the movement for separation involves a struggle over the veil and what constitutes proper *purdah* or adequate cover for women. In a letter published in *The Daily Alsafa News* in Srinagar, India, on June 9, 1990, a woman by the name of Sara Bano wrote that the militants' demand that all Muslim women wear the *burqa* (veil that covers the whole body) was unfair, and all that was required was the *dupatta* (scarf loosely draped over a woman's chest and shoulders): "Burqa is a symbol which makes the woman feel inferior. How can a religion which gives equal status to men and women compel the woman to feel inferior? A woman's modesty lies in her rightful dress and dupatta. That is the true purdah and not the burqa."

In the context of the Palestinian intifada, women's protests—voicing sentiments similar to Bano's in Kashmir—prompted the Unified Leadership of the Uprising to issue a statement that declared, "Nobody has the right to accost women and girls in the street on the basis of their dress or the absence of a headscarf."

Instead of a fixed mark of identification, we can see the veil as a field of meaning marked by varieties of conflict. Gendered protest overlaps

other struggles there and elsewhere. A critique of modernity, failed nationalism, global inequality, and, last but not least, local injustice, is visible in this statement made by a Syrian woman: "A lot of these women [choosing to wear the veil] are not from families that traditionally wore the hijab. For want of a better reason, I think you could call it Islamic militantism, but it is more of a disappointment with Western culture and with local government's inability to solve outstanding problems like the economy and the Palestinian issue. These societies are not what everybody hoped they would become after independence. This is why a lot of women across the Moslem world—from Malaysia to Morocco—have taken on the hijab in large numbers."

The veil invites discussion as a sign, and hence its status as being open to contrary readings and caught in a struggle over history, once we begin to hear the voices that not only conflict but also introduce a series of disparate concerns into this discussion. Aicha, an Algerian woman who wears a hijab, says: "Listen, if I'm able to take on the hijab against the wishes of my father, another woman is also able to decide not to wear it, despite the wishes of her father. No woman should let herself be intimidated by a slap, a whack of the belt, or blackmail. A woman must stand up for her rights."

Aicha's words turn the hijab into a less easily readable sign, one that requires the labor of intervention in a complex framework; other views, even when they are in utter opposition, do not undermine the fundamental point about the veil being open to contestation. I am thinking, for example, of the words of Samira, a French-educated professor of psychology at the University of Algiers: "It just makes me sick! It's neurotic behavior. It's unhealthy. Most of the girls are uptight and inadequate in some way. Sometimes it's repression of their own sexuality; other times it's their inability to communicate with their parents."

More radical than the mere opposition of the views of Algerian women on this question is their forcing a rereading of what is generally accepted in the West as being either traditional or modern. Listen to Sabera: "The problem of Algerians today is that of identity. My parents adhere to traditional Algerian Islam, which is strongly influenced by western civilization. They prefer to see their daughters well dressed and showing off their beauty. I follow modern Islam, which has been purified of these influences. . . . But a woman must know how to wear the hijab. It's not just a tunic. It's internal, too. To take on the hijab is to say, 'I'm afraid of nothing.'"

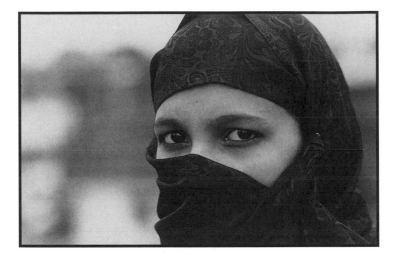

[Trinh T. Minh-ha writes:] If the act of unveiling has a liberating potential, so does the act of veiling. It all depends on the context in which such an act is carried out, or more precisely, on how and where women see dominance. Difference should neither be defined by the dominant sex nor by the dominant culture. So that when women decide to lift the veil, one can say that they do so in defiance of their men's oppressive right to their bodies; but when they decide to keep or put back on the veil they once took off, they may do so to reappropriate their space or to claim a new difference, in defiance of genderless hegemonic standardization.

The idea of unchanging identifying marks presumes an unchanging subject fossilized in time and space. One of the principal contributions of the feminist movement and feminist scholarship has been to fracture the unity of the subject and explode the homogeneity of time or space.

One of the arguments that follows from this is that the figure of the veiled woman on a street in New York City, or for that matter on CNN, presents a problem for easy identification. Our attention to the category of gender has to strive for its particularity (black South African women are different from Canadian women) and at the same time insist that this heterogeneity is bound to and is often the product of systemic histories (the black South African women are different from their Canadian sisters because the latter still exist in a relationship of colonial dominance over the former). Let me provide very briefly some details of a case that puts the argument into the Indian context.

In April 1985 a 73-year-old Muslim woman named Shahbano won the rights to a meager maintenance from her husband, who had divorced

her. The judgment was based on the secular Criminal Procedure Code rather than Muslim law (*sharī'a,* religious law), which lacks legal status in India because of the social position of Muslims as minorities. In a social battle that swept the whole country, feminists, jurists, politicians, partisans for various communities, and many women from different faiths who had struggled with divorce laws, all fought to address the many different questions that gave this battle its heat and energy. In a highly controversial move the ruling party, eager to garner Muslim votes, passed a bill to save Muslim law. In this context of widespread attention, particularly after Hindu communalists used this case to attack the Muslim community as being patriarchal and even immoral, Shahbano requested the Indian Supreme Court to rescind its judgment. She was giving back the maintenance that was granted her, and, at the same time, she was signaling her refusal to occupy the position given her by the dominant Hindu community and the discourse of liberal law premised on the concept of the unitary subject.

In their reading of the Shahbano case, Zakia Pathak and Rajeswari Sunder Rajan wrote: "In the ideal, subjects in law are undifferentiated, nondescript, equal, and singular. The Shahbano case points to the contradictions inherent in such 'ideal' subjectification."

The phenomenon of Shahbano is of radical importance because in calling into crisis the constitution of subjects as unitary and unmarked by shifting traces of otherness, this event also opens itself to a new politics of cooperation and critique. To quote Pathak and Rajan again: "When translated into an oppositional strategy, this situation seems to lend itself to a free play of alliances between reformist groups, to a politics of association which is oriented to specific issues."

According to these writers, the wide-ranging response to the Shahbano affair, addressing diverse issues on collective, and at other times more specific, platforms was an adequate demonstration that "the feminist collectivity, by embracing the individual woman's cause, converted her resistance into a significant operation within a (collective) feminist politics." The power of this response is seen by Pathak and Rajan in the reconciling of two contradictory aims, in the bringing together of what I described earlier as the local and the systemic: on the one hand, "the specificity of the problem of Shahbano as a woman living in poverty, in order to focus on concrete, pragmatic, end-directed action," and on the other, the placement of "the specific issue in the larger context of Indian women's secondary social and legal status, in order to avoid the danger

of isolating women of the community, of targeting their religious identity as regressive, speaking therefore on their behalf, even usurping their 'victim' status, and ending by offering 'protection.'"

To engage with the veil/woman/gender/Shahbano as a contested sign is to read the social text—that is to say, all identifying marks—as a terrain of change inhabited by multiple meanings and fissured subjectivities. Let me draw once again on Pathak and Rajan: "The fragmented subject, refusing to be protected, seeks access to the public realm by erupting into its discourses, problematizing the shared assumptions across those discourses, and disrupting their harmony. 'Shahbano' is to be found in the transformative power of gender operating in such analytic categories as 'minorities,' 'citizens,' and 'working classes.' The contradictions of the gendered situation cease to be socially inert at historical junctures. Shahbano activated these contradictions, even as other women have pushed them toward a crisis."

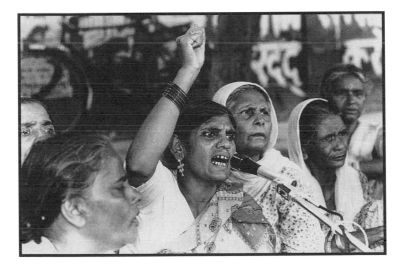

Ten years passed after the controversy (and, to a lesser extent, a movement) called "Shahbano" had raged in the Indian press. Then it was up to a grassroots organization, Bhopal Gas Peedith Mahila Udyog Sanghatan (BGPMUS: the Bhopal gas-affected women's trade union), to call into crisis what Rajan and Pathak call "the contradictions of the gendered situation." Eighty-five percent of the union's members were women. In an interview, Abdul Jabbar Khan of the BGPMUS put the matter this way: "Throughout I have found that women have been more com-

mitted to the struggle than men. Men fought to have the government reserve jobs in the railroad coach repair center for those who had suffered injuries from the gas leak. But women fought harder. I think it is partly because women feel so responsible for the family." My photograph of the Bhopal women's protest outside the walls of India's Supreme Court is an early record of what later erupted as a historic mobilization by those who were most affected and most concerned.

In Arun Sinha's *Against the Few*, I read a tale about the coming to political consciousness of a young Communist leader in the state of Bihar in India. The future leader, as a boy, once asked a senior Communist party functionary, "Isn't it true that what you people really want to do is hand over India into the clutches of Soviet Russia as soon as we get rid of the British?" The boy's questions grew even more pointed when he asked the older Communist: "Aren't you just interested in making all Indian women prostitutes?" The boy recalled conversations he had heard in his father's sitting room about the Soviet Union ("Every woman is *nationalized* there"; "There is no sister, no wife, no mother"). Later in life, now himself a Communist, the boy was to reminisce that after he joined the party in 1958, he realized that the stories he had heard "were all part of the Roosevelt plan of anti-Communist propaganda."

More than the role of rumors, certainly more than the comfortable closure that Roosevelt provides in the young Communist's mind, what is remarkable here is the deployment of the trope of endangered womanhood, especially the way in which women in this discourse remain simultaneously valorized and without volition. So here we rediscover the scenario where resistance to the challenge of new ideologies goes on in the name of (and for the salvation of) women who themselves seem to have little say in the matter. As in the Shahbano case, where Hindu men were trying to rescue a Muslim woman from Muslim men, we see the mobilization of the discourse of protection in order to secure hegemony in the name of women.

Today, when the question of the identifying marks of being a Communist has the ghostly echo of a dead past, how is the spread of global capitalism taking a toll on women in poor countries?

Let's once again consider an Indian context. The adoption of the New Economic Policy, based on the notorious IMF structural adjustment model, will have devastating effects on the lives of working-class households, particularly women. As the planners assume that the reforms will

benefit all households and all members of each household *equally*, they blatantly disregard the disadvantaged poor and, most notably, working-class women. Anuradha Seth, an economist, presents the case in stark terms: "As real wages decline and the purchasing power of households falls, women have come under increased pressure to secure their families' survival." Quoting an earlier study, Seth reveals the grave future threatening Indian women in the informal labor market (where 73 percent of urban women workers are currently employed as casual workers or are employed as domestics):

> As family income becomes insufficient, women will have to put in more time to make less stretch for more. They will spend more time in domestic labor with little help, except from their older daughters. This burden of multiple jobs and extended domestic labor will sooner or later take a toll on their health. The combination of this with the pre-existing discrimination in food allocation to women and girls will result in a serious health crisis. A fall in nutrition levels will leave them prone to illness, disease and pre- and post-natal complications.

These changes are already with us now. In her address at the 1997 Conference of Working Women, the veteran left leader Vimal Ranadive said: "It is a fact that women are the first victims whenever the closure or modernization issue is raised. When the textile and jute industries were closed in many states, thousands of women in reeling, spinning and binding were retrenched without much protest." These conditions are also in many ways common to other countries of the Third World. Ranadive went on to add:

> In Brazil, young girls have to eat less, as family incomes dropped.
>
> In Zambia, the girl child has been the first victim of severe cuts in spending on education.
>
> In Costa Rica, women hold the least skilled, the lowest paid, least secure jobs.
>
> In India, jobs for women in the organized sector already limited in number, will further shrink.
>
> The question is asked: What is common in all these countries mentioned above?
>
> An International Monetary Fund, World Bank, Structural Adjustment Program.

Confronted by the new realities of such free-market Stalinism, especially in a situation where even mainstream agencies like UNICEF have

condemned the toll that IMF-World Bank reforms are taking on children and the poor in the Third World, it becomes necessary to insist on a democratic, socialist future. At the end of the twentieth century, how shall we describe the contours of that future?

Introducing a poem by Franco Fortini entitled "Communism," written in another age and about poets who had survived Stalinism, Lucien Rey spoke of "the difficulty of writing in an age when the poet is trapped between epitaphs and manifestos." Rey's introductory note is a statement for a third path, the path of "irony, paradox, cunning" in the tradition of Bertolt Brecht. This third path was to be distinguished from the two paths of surrealism and socialist realism.

Today, our use of Rey's image of the poet "trapped between epitaphs and manifestos" has to be for a different, more contemporary purpose. As writers, we are caught between the demise of traditional socialist systems and the uncertainty of the outcome—and sometimes, even the strategies—in the battles against the new onslaughts of multinational capital. In the emergent third space, which belongs neither to the orthodoxies of the dead bureaucratic left nor the killing machine called late capitalism, what will be our identifying mark? There is a prior question. In the moment when we are free of none of our histories and have no space that absolves us of our pasts, perhaps the important task that falls on us is that of a scrupulous accounting of our choices and, sometimes, their plain absence. In other words, I am conscious of the ways in which we are identified in our present daily lives—and, therefore, the opportunities that are given us for reading those marks differently. Consider the voice on the phone from a bank or school registration office or credit card company that asks, "for security reasons, your mother's maiden name." At times that voice sounds just like the immigration officer's voice. And I have a question for that voice on my phone: What is the precise knowledge about my mother that would identify me as the one I claim to be? Why is it only my knowing her maiden name that would thus distinguish me—or her? What is it that *makes* me?

These are, in a sense, as they have often been in these pages, purely rhetorical questions. However, as an attempt at elaborating what I called a scrupulous accounting of choices or their plain absence, let me offer in closing a poem written for my mother, who bears the marks of the IMF-World Bank combine in ways that my long-distance nationalism can do very little to combat.

This book is dedicated to the one whose maiden name is Lakshmi Nidhi Singh.

A MOTHER WRITES IN HER LETTER FROM INDIA

When the bicycle
bell rings twice at the door
I get up in a rush
forgetting that your cycle
is there in the store-room
locked-up
and it couldn't possibly be you, my son.
The truth strikes me
even before, my head spinning
I turn the handle of the door.

The summer sun is blinding.
I pray it is the postman.
Sometimes, it is.

Your letters come each week.
I am sorry I don't write
often. And when I do
I can only speak
of waiting and loneliness:
These choices, somehow, were never mine.

Conclusion **Forms of Departure**

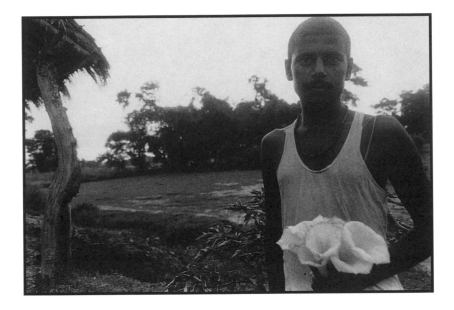

Partition infiltrated into the South Asian imagination that ubiquitous imagery of modern politics: the pornography of borders, an imagery that at once excites actually existing and aspiring nationalisms ("separatisms") with the fantasy of fulfillment, and must always leave them with permanent disillusion, the melancholia of endless corridors of no man's land.

Sunil Khilnani

"Two hours before the train had arrived at the station, I had returned home."

That is what I should have said into the new tape recorder that had been smuggled across the border the previous night. I was seven years old. An aunt was getting married, my father's cousin. Over several days, relatives kept arriving at the old house in Raxaul, which is only a few miles from the border that divides India and Nepal.

The thrill of these visits to Raxaul was mixed with the pleasure of going to Birganj in Nepal. There were Japanese electronic goods and the shiny display of American cigarettes and candy on the other side. Whenever we went to Birganj, in rickshas that were always checked by security guards at the border, we returned with smuggled goods. The women in the family came back with Chinese fabrics, chiffons and the like, that would be used as saris. The shopkeepers took the sari-clad women into their backrooms and, using twine, wrapped the new fabrics around these female customers' torsos. The men generally did not want to risk a frisking. All large electronic goods were brought to the Indian side by hired "carriers" who crossed the river after dark.

I had never seen a tape recorder before. In the shop, it had looked different. It was also silent. It looked larger now and gleamed in the morning sunlight. The man who had purchased the machine was the husband of another of my father's cousins. Now I cannot even remember his face, but I remember very well his asking me to recite a poem. His voice was unnaturally loud, perhaps for the benefit of the microphone. He then played back for me my own voice asking him what was it that he wanted me to recite.

There were people standing around. Most of them had come from the villages—those two or three hamlets where my grandfather's family and his elder brother's wife owned land. I was different from them. I was studying in an "English-medium" school run by the Jesuits in the state's capital. It used to take a whole day of travel to reach the city, first by road or train, and then across the river Ganges by ferryboats called "steamers."

The tape recorder was switched on again and the man gave me a sentence to translate.

Train ke station aane ke do ghante pehle main ghar wapas laut aaya tha.

Two hours before the train had arrived at the station, I had returned home.

But I could not say those words in English. It was because I was embarrassed: of the language but also of the question; the manner in which it was always an attempt to establish difference. More often than not, I'm sure such exchanges were more a way for someone else to show others that they knew some English and could exchange words with the city-returned kid. On that occasion, however, I could see only resentment—and feel shame at having become better than those around me. Because that is what I believed then. That I had become better and could spell the word "kettle" correctly if someone were to ask me.

Until I climbed into my late teens, it wouldn't be unusual for a lawyer or a teacher, on a visit to our village while I too was there on a holiday, to interrupt a conversation to ask me to translate a line or two of Hindi into English. The exchange was all the more strange because, up to that point, both my questioner and I would have been conversing in a dialect spoken in that region, Bhojpuri.

When I would go over to another part of the house, where the women were, in purdah, and joke with my grandmother or my aunts, the women from the village would remark how nice they felt as they listened to me speaking Bhojpuri. Not one of them ever asked me to translate English words.

None of them knew that language.

But I also felt, I don't know whether rightly or not, that if they had gone to school and learned English, they would still have behaved in a way different from the men. They would have spoken to me in Bhojpuri. Our use of the familiar dialect hid from us our own growing alienation. Or, for that matter, the reality of the divisions that made one language that of the home and another that of the workplace.

I was reminded of all this some years ago when I read a poem by the Nicaraguan poet Ernesto Cardenal. The poem was about parrots that were being smuggled to the United States where "they would learn to speak English." In the poem, the poet's friend Michel releases the parrots from the cages, precisely 186 of them (47 birds had died). The image of the parrots, freed, flying straight to their mountains, makes Cardenal link it to his own happiness at the memory of liberation:

This is the same thing, I think, that the Revolution did to us:
it took us out of the cages
 in which they'd carried us off to speak English.
It brought us back the homeland from which they'd uprooted us.

The soldiers green like parrots
 gave the parrots their green mountains.

The memory of the poem as well as my own childhood memory of being the one in the village who spoke English has suffered a change in recent times. While reading American newspapers and journals that commented on India's fiftieth anniversary of independence, I saw frequent references to India's newfound freedom in the open markets. My mind returned to the incident of the tape recorder being smuggled across the border, and its use as an instrument for a brief display of the dominant language, the only language deemed worthy of learning or display. The new technologies being imported to India now will all perhaps only reinforce the older exploitative orders. The border is a marketplace. The invisible hand of the powerful governs the crossings.

And yet, the parrots don't always prove good learners. Or perhaps only parrots prove good learners. Even in the space in which the child is asked to repeat in another language simple words, other considerations enter and make the space of translation also a space of failure. Failure of the symmetries of dominant intentions, failure also of the mechanical mimeticism represented by that instrument called the tape recorder. In the hybrid space of migration, contestatory battles rage over the language of representation, and what is often celebrated as real is as quickly revealed to be only a promotional ad campaign for a shop set up at the border.

On a visit to India, I discover that my young nephews pore over a weekly column, "Objects of Desire," in the *Times of India*. The main purpose of this column, it would seem, is to provide the vast Indian middle class with an inventory of new gadgets manufactured in the West, anything from cordless video phones to tweezers that have magnifying lenses attached to them. The consumers of this item of news are not in the least likely to be able to afford such goods; however, they do assure the Indian readers, especially the urban youth, of the life that awaits them outside India's borders in Europe and North America. For my nephews, home is always somewhere else. It is a place where they have never visited. It is America.

In a news report in late August 1997 I learn that India's largest carmaker, Maruti Udyog Limited, produced 338,690 cars during the previous financial year in collaboration with Suzuki. Its net profits totaled $138.1 million. Capital, rather than people, is crossing borders: during 1995, $1.3 billion of foreign capital was invested in India. The result is that well-to-do citizens have better, faster cars to drive. Visitors cheerfully note the change. A recent editorial in *Granta* includes a panegyric

to progress: "Before I went back in November last year, I telephoned one of my oldest friends in Delhi. Was there anything she would like me to bring? She mentioned a kind of dishcloth that was peculiar to Woolworth's. Nothing else? No disposable nappies (in great demand at one time), colour film, wine, replacement parts for word processors? 'No,' she said, 'everything is available in the market here.'"

The sheer volume of exchange of commodities prompts faith in the thought that even the writers producing oppositional books on the subject of the market and the border are only a required part of that dominant economy. The production of about 400,000 new cars each year stacks up rather formidably next to the pile of books from India that become a part of the syllabi for courses in multiculturalism in the U.S. Of course, what the dominant forces of the market cannot set is how—and what—in these writings will be received by the actual students in class or even in the culture at large. Looking through a U.S. magazine with a memoir piece by Abraham Verghese, a reader may find there incontestable evidence that India needs more electronic equipment to aid clinical work. But what is to prevent the same reader from drawing another conclusion entirely, one about the U.S. health-care system and the place of immigrant doctors in it, from the following account in Verghese's story? Here, Verghese recalls his experience as a rookie doctor receiving advice during dinner from an older expatriate from India:

> He laughed. "Don't be so bloody naive, bugger," he said. "Learn from the experience of others. Look." He pushed a chili-sauce bottle to the center of the table. "This, my dear friend, is an Ellis Island hospital. Mark my words, every city has one. Such a place is *completely* dependent on foreign medical graduates, and that's where you will go. No ifs and buts. Think of it as a quarantine period, before you can move on and do your land-of-opportunity fantasy. Your elders and betters have passed through these places. Why should you think you are different?"
>
> Now he put a saltshaker as far away from the chili-sauce as he could. "That," he said, "is a Plymouth Rock hospital—university- and medical-school affiliated, of course. It has *never* taken a foreign medical graduate. Except for the occasional South African white or Brit or Australian, who—don't ask why—is a different species of foreign medical graduate from you and me. Don't even bother with that kind of place. The cowpath from India never goes through there. Unless you want to take a job as bathroom sweeper."

A reading like the one I propose does allow a critical understanding of the relation between continents to emerge, within its translation in

space and among people. Such a reading, however, is hardly facilitated by a venue like *The New Yorker*, whose special issue on Indian fiction included the piece by Verghese. The special issue of the magazine was released to mark the fiftieth year of Indian independence, and even its cover quickly plunged the reader into ahistorical splendor. On the bright cover, topped with turmeric sunset hues, sat a stone Lord Ganesha browsing through a couple of books, the task made easier because he has more than two hands. And emerging from the thicket nearby, dressed for a safari in khakis, were a white couple, their mouths agape with wonder. Nothing could have better announced this as the season of the discovery of India. As readers we enter the dark jungle of unknowing. We follow others who are lost but who nevertheless hold out their privileged ignorance like maps.

Several years ago, in the *New York Times*, the publication of Rushdie's *Midnight's Children* was characterized as "a Continent finding its voice." "As if one has no voice," the Delhi-based critic Aijaz Ahmad remarked caustically, "if one does not speak in English." More recently, *The New Yorker*, in its special issue, repeated the same fiction. I grew up in India under the stultifying shadow of the nationalist myth that we were all the children of Mahatma Gandhi; now, if *The New Yorker* is to be believed, we are all the children of Salman Rushdie. "And to be an Indian novelist is to be something that has been changing, utterly, especially since 1981. That was the year that Salman Rushdie published *Midnight's Children*, a book that, as most of the authors . . . would grudgingly acknowledge, *made everything possible.*"

The above quote is from Bill Buford's editorial introduction. In it, he insisted on talking of what he calls "Indian fiction" as the literary output in only *one* language, English, and that too by recent, mostly expatriate, authors. Buford reduced the history of writing in India, in at least eighteen other languages but also in a variety of other contexts, not the least of which was the nationalist movement, to one single publication. But more egregious is his not following the line of thought that even if what he claims were true, such a contention would beg the question: Why is it so? Or what does it say about the historical invisibility of others and their languages, and the gross inequalities of the planet that we inhabit?

Buford's statement isn't true for a number of reasons. Let me cite just one. Even if we take the novels written only in, say, Hindi or Urdu, around the singular event of the partition of India in 1947—the event that constitutes, after all, the bloody underside of what *The New Yorker* was seem-

ingly commemorating—very little that has been written in English in India ever approaches the eloquent expressions in those novels of the woes, the divided hopes, or the numb, demented silences of ten million uprooted lives.

In his own survey of Indian writing in the same issue of *The New Yorker*, Rushdie showed his awareness of some of the narratives produced around the issue of independence. Yet, rather briskly and a bit disingenuously, he brushed away post-independence writing in the rest of Indian languages as being less "strong" or "important" than the literary output in English during the same period. "Admittedly," he said a little later, "I did my reading only in English, and there has long been a genuine problem of translation in India." But this confession wasn't intended as a genuine qualification, it would seem, and it only inoculated his judgment against further inquiry. No mention was made of the explosion of *Dalit* (literally, the oppressed, referring to the untouchable castes) writing in Marathi, for example, which represents a radical rewriting not only of the canon but of the very notion of the literary.

A bit like Pepsi, which has become one of the biggest soft-drink sellers in India and sponsored the Independence Cup cricket tournament in India in the anniversary year, *The New Yorker* and other publications in the West managed to play guardian angels for the independence celebrations. Not only was there little scrutinizing of their own relation to the events being celebrated, there was a nearly unchallenged trotting out of misinformation as well as unchecked glee at the so-called free-market reforms. The seemingly global consensus conceals the challenge not only of active resistance to the claims to progress but also the plain historicity of those realities that call out for systemic change and not merely dealings in foreign exchange. In this instance, Indian freedom is just another name for something that is still left to lose.

The North African writer Tahar Ben Jelloun, calling for a rhetoric of integration in the anti-racist struggles, asserts that the talk about "difference" is now "a hollow and dangerous gimmick [that has been] prostituted and above all appropriated by the opportunism of advertising to the point that it will have to be left to the unimaginative politicians and the peddlers of cigarette lighters." This point becomes all the more pertinent at a time when immigrant populations inside Western nations demand recognition and rights as citizens. Only a few years ago, more than 1.8 million people in Germany sought protection from murderous racist attacks. Turkish "guest workers" invited to Germany during the boom

years of the earlier decades are still *ausländer* (foreigners). In May 1993 a banner with the words "Born Here, Burned Here" hung in front of the house where five women and children were fire-bombed.

Such cases instantiate the fact that the battle over representation does not hinge on some essentialized adherence to difference or a fixed understanding of integration. The terms of exchange called international migration require scrutiny and even stringent critique. Because, to begin with, often the commodities are people, and they are parts of an unequal and unjust exchange. On Christmas Day in 1996 a shipwreck off the coast of Malta led to the drowning of at least 280 people, including Indians, who were being smuggled into Europe. Several days later Greece deported the survivors to Pakistan, India, and Sri Lanka. Among the dead were more than 200 Indian youth, mainly from Punjab, who were in search of a better livelihood. I cite this instance not simply to mourn the tragedy but also to underline its circumstances: if the conditions between countries of exchange are so unequal as to necessitate the smuggling of humans across borders, the youth would have had to adapt and struggle under very harsh conditions if they had indeed managed to make it across the seas and into Europe. At a meeting to coincide with India's fiftieth anniversary of independence, an activist for Workers Awaaz (a group that fights for the rights of low-wage South Asian immigrant women) said that when she came to the U.S. from Bangladesh in 1993, her job in a garment factory earned her only $35 every week. Later, as a domestic worker, she fared marginally better with $50 as her weekly payment from a Pakistani couple. Her duties included taking care of three children and doing all the housework. She was fired without warning when the couple found elderly relatives to come and stay with them to take care of the children. For many, the conditions are worse.

In Udayan Prasad's *Brothers in Trouble*, a film about working-class illegal Pakistani immigrants in an industrial town in northern England, only one person is finally able to find legitimate status. At the film's end, the protagonist runs into an old friend, a white working-class woman who had once stayed with them, and the first thing she says is: "So you made it . . ." But he is only a survivor. While he has succeeded in finding the job of a letter carrier, one of his roommates is dead, many are lost, and one has become insane. And the viewer is hardly able to forget that even while there are others who seem to be doing all right, earning and saving, it still means that they live under conditions of acute deprivation: one man has been able to see his wife, who lives in Pakistan, only eight times in the twenty years he has spent in England, and never for

longer than a month. "I do send her money on the first of the month," we hear him say with pride.

There is difference and then there is difference. It might be the task of critical postcolonial intellectuals to work relentlessly on the seams of that distinction. That is, distinguish between the forms of departure. In order to illumine the conditions described by the activist from Workers Awaaz, or those workers portrayed in Prasad's film. And set them apart from the kind of difference embodied by a cosmopolitan immigrant like Pico Iyer, the writer for *Time* magazine who notes self-critically the privilege of being able to select his identities: "We don't have *a* home; we have a hundred homes. And we can mix and match as the situation demands."

There are other *forms* of departure.

Edward Said, in the introduction to his powerful, moving book *After the Last Sky*, published with images of Palestinian lives by Jean Mohr, writes that his book's "style and method—the interplay of text and photos, the mixture of genres, modes, styles—do not tell a consecutive story, nor do they constitute a political essay." In a very clear sense, Said's book constitutes a form of departure not only from the standard social science books written by academics but also from the tales told in the mainstream media. And his choices are tied to the subject at hand. As a Palestinian without a country to call his own, Said writes:

> Since the main features of our present existence are dispossession, dispersion, and yet also a kind of power incommensurate with our stateless exile, I believe that essentially unconventional, hybrid, and fragmentary forms of expression should be used to represent us.

In writing *Passport Photos*, in the peculiar juxtaposition of images and words, and also divided sites and subjects, I follow Said's lead. At the same time, I must recognize that in the current milieu, particularly in the field of cultural studies, my project is not entirely unusual. The field of postcolonial studies, to the extent that it has also been a critical enterprise constituted within the First World, has perforce meant seeing Lahore in London. The challenge, therefore, lies in grasping, in a political sense, the historical valence of these forms. We get a feel for this in the changes described by Rushdie in the painting style of Aurora Zogoiby in his novel *The Moor's Last Sigh*. Zogoiby abandoned the hill-palace and seashore motifs of her earlier work for a collage style. In this series of works, people's lives took on a composite character, and the artist used

the detritus of life in the city to compose the fragmentary picture of their existence. But I see a shift here too, a shift from an eclectic celebration of difference to a premonition of difference as tearing despair. In it I find a critique of bland multiculturalism and a coming to terms with the limits of the rhetoric of difference, as survivors would when they walked among the smoking buildings and charred bodies after a religious riot. This point becomes clearer in Rushdie's description of the shift in the political aesthetic:

> Aurora had apparently decided that the ideas of impurity, cultural admixture and mélange which had been, for most of her creative life, the closest things she had found to a notion of the Good, were in fact capable of distortion, and contained a potential for darkness as well as for light. This "black Moor" was a new imagining of the idea of the hybrid—a Baudelairean flower, it would not to be too far-fetched to suggest, of evil.

In that spirit, I might also add that the recent entry of the personal voice in much of literary criticism remains a limited exercise. Lit-crit memoirs no doubt represent a salutary change because they often foreground valuable histories and vital stakes that are otherwise occluded from a reader's reception of criticism. And yet these memoirs, mostly written by established scholars and tenured professors, seldom call into crisis the settled prejudices of the institutions of higher learning. Their juxtapositions are usually familiar ones and their most prized values remain comfortably literary.

In this regard, if I understand Rushdie's point above about the contextual validity of different forms, I invite a strategy like the one practiced in Lisa Lowe's *Immigrant Acts*. Although in many ways a book of straightforward scholarly literary criticism, *Immigrant Acts* places a new Asian American novel next to the testimony of a working-class immigrant woman in San Francisco. In putting "literary" and "evidential" forms of narrative together, Lowe draws attention to "their dialectical relationship to common historical and social processes." Moreover, she asks us, as readers, to think of "immigrant acts" as transformative performances across a range of social sites—whether they be schools or sweatshops, novels or churches, boardrooms or bedrooms. In an emergent field like Asian American Studies, the foregrounding of a sweatshop testimonial alongside a well-received novel provides a radical agenda for young scholars entering the field.

Passport Photos aligns scholarship and activism. Putting these two aspects of social life into dialogue, it also calls them into crisis. And its en-

gagement with both aspects reflects the need to fashion a political aesthetic, to find expression in a public forum, to resist the suffocating air of a fixed materialism that is, in John Berger's memorable phrase, "oppressive and literal."

Our search, too, is not without its own detours. A fellow postcolonial, Rashid Husayn, a Palestinian poet, writes: "No one taught you to read, mother! / but all taught you not to read, / that is why / I always try / to set my poems / in simple words." I understand the sentiment, but I do not try to follow suit. Not because a poet must not seek a broader public, but because I use poetry for another purpose. To present an inventory of the real often elided by prosaic fictions; to set down side by side not so much comparative realities as much as the invisible ones that make up the totality of our global existence; to produce, regardless of the kinds of words used, a circuit board of memories.

And, besides, I am aware that simpler words would not solve much. I use words to protest the fact that in countries like India the budget allocation for education in real terms has been falling to a meager 3.5 percent or thereabouts. In recent years, with the new economic reforms, the use of child labor has been on the rise, announcing the demise of all chances of producing an educated citizenry.

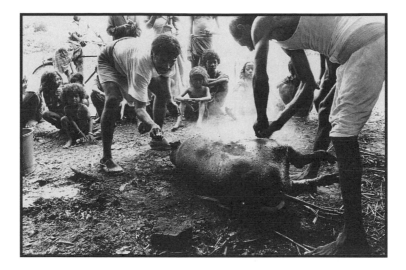

I sometimes simplify things in these pages. I try in that manner to erect oppositions where they had been rather easily erased. In doing this, I am reminded of two photographs I'd like to lay side by side. One I entitle "Pig, U.S.A," and the other, "Pig, India." I took the first picture at a wedding in Minneapolis. A roast pig, with an apple between its teeth and red strawberries for eyes, was being carved by a chef in a white cap. The occasion for the second picture was a visit to my birthplace, Ara. A member of a political organization took me one morning to a small slum where the untouchables lived. A pig had died and two men were searing its skin there on the road. Children sat on the ground in a circle and other people watched as the men then got to the business of cutting the meat before the sun climbed high and everything came to a stop in the heat.

The plain opposition of these pictures allows me to tell a certain story that I believe to be true. The reality is a good deal more complex. Not in the sense that another side to this tale would make us deny the massive inequality between the First World and the Third or misconstrue some abstract notion of history. But without explanation and narrative, the construction of oppositions also erases a good deal. Binaries are often necessary and even productive in writing and in teaching. Even so, one of the most crucial aspects that gets elided in the erection of binaries is the entire narrative of the tussle in between, the often decisive and eloquent set of negotiations through which history comes to be. And we

need to pay attention to the transactions of history for the sake of those who, in ordinary ways, have struggled to bridge the more overwhelming binaries of Poverty and Wealth, Peace and Injustice, Equality and Bigotry. For those people, the vast border that lies between those binaries is their—our—real life.

In those spaces, so predominantly true of diasporic lives, lives shaped in the spaces between the pure appeals of home and adopted nation, the culture that springs forth is inevitably mixed up and in its more dynamic forms represents a threat to fixed binaries. In those forms, such culture also reshapes the fixed oppositions and gestures toward a third space of possibility.

Hanif Kureishi's journal from the making of *Sammy and Rosie Get Laid* describes his being taken to an Asian get-together. This is in England, in West London, at a time when the country is about to reelect Thatcher. Meanness, like police presence, is solidly in evidence on the streets. Dereliction and decay have been growing in the inner cities. In his journal, Kureishi writes that he is unsure of what to expect at the gathering. It's like being at an Asian wedding. With a hint of disappointment, if not also distaste, he notes that the women have taken the trouble to dress "in much jewellery, in shalwar kamiz's threaded with silver and gold." When the band comes on, there are "eight men in red and white costumes" who "look like assistants in a fast-food joint." And then:

> The music starts. The music is extraordinary. After years of colonialism and immigration and Asian life in Britain; after years of black American and reggae music in Britain comes this weird fusion. A cocktail of blues and r 'n' b shaken with Indian film songs in Hindi, cut with heavy guitar solos and electric violin runs and African drumming, a result of all the music in the world being available in an affluent Asian area, Southall, near Heathrow Airport—it is Bhangra music! Detroit and Delhi, in London!
>
> For a few seconds no one moves. The dance floor is a forbidden zone with everyone perched like tense runners around it. Then no one can hold themselves back. Men fly on to the floor. They dance together, thrusting their arms into the air and jerking their hips and thighs, tight-buttocked. Sometimes the men climb on each others' shoulders or wrap their legs around the others' waists to be swept in dizzy circles inches from the floor. Women and girls dance with each other; women dance with tiny babies.

I do not mean to romanticize diasporic culture as the true site of a new politics. After all, it is Kureishi himself who reports, in an essay entitled "Wild Women, Wild Men," about the lesbian double-act of two Pakistani Muslim girls, Zarina and Qumar, in Southall. The women "had

more enemies" there than anywhere else. "The Muslim butchers of Southall had threatened their lives and, according to Zarina, had recently murdered a Muslim prostitute, by hacking her up and letting her bleed to death, halal style."

What I do, however, want to insist on is the potential for culture, any culture, to escape the dictates of law and custom. Real lives, therefore, represent a departure from any stagnant point of being. In the diaspora, especially, culture and lives can, and often do, find new undiscovered forms. So that immigrants balance the conceit of a preserved heritage against the unanticipated and fairly uncanny elaboration of new identities that are liberating. Although identityty politics in the diaspora unfortunately traps certain groups in ever-increasing isolation, the freedom from familiar constraints and from the dominance of the surrounding culture encourages other new coalitions. Possibilities emerge among those bodies that are milling around even those shops set up at the border only to earn profits for a few.

I want to conclude with a poem that is a report on the acts that take place around, rather than within, the body of official celebrations. In my argument for the possibilities of diasporic culture, there breathe possibilities that resist national wills and narrowly nationalist identities. Differences collapse, sometimes out of ignorance, sometimes because of reconfigured conditions, as political choices, or as more mysterious shifts: the white patron in the restaurant doesn't know how to tell a Bangladeshi from an Indian, a Nepali queer activist joins a group of South Asian gay and lesbians, Indians and Pakistanis live and make music together.

INDIA DAY PARADE ON MADISON AVENUE

> *India is 50! (Where's my Nehru jacket?)*
>
> *New York Times*

I.
You, however,
Soraiya Hasan Ali from Pakistan, whom I've just met,
you are not wearing any Nehru jackets today.
You've cast your dupatta aside and come out
wearing an ivory-hued kameez with the tiniest
mirrors that make your shape look thirsty like shiny water.

The parade is not going to pass for another hour.
Passing my finger down the pale brown line in the middle,
in a South Indian restaurant two blocks away,
I pretend to read your palm.

The restaurant owner has stuck a sign Giuliani for Mayor
beside his ornate blue clay cow.
You wait here with a Hindu
Communist for the India Day parade.
I'm having trouble reading these lines
in your palm without drawing your hand closer to my heart.

It's been two days since I met you.
The world that was two days ago seems so old now.

Two days ago,
the *New York Times* found out
that more and more Indians and Pakistanis
"live peaceably together" in Queens.
It seems love was in the air, for even the right-wing
A. M. Rosenthal wrote a column entitled "India, Mon Amour."
Soraiya Hasan Ali, I am writing this poem for you
because your laughter
was not invented by the man from the *New York Times*.
And because the failure of your poet Faiz—
kuch ishq kiya, kuch kaam kiya
"I loved a little, I labored a little"—
unable either to labor or love alone,
leaving both incomplete in despair,
shares none of the seriousness, worn as a mask,
by Harrison Ford a.k.a. Indiana Jones.
And, in the end,
because even where mines and tall sentry-posts
divide my country from yours
the wind carries words
of a common language, like dried
petals, across the lines of barbed wire.
It is their lightness
that rests in your touch.
The same words
fragrant with the smell of our belonging,
the smell of the same earth, the same trees,
the same seasons of our knowing,

I discover as difference in the slow spiral of your ear
and, turning, in your naked glance.

II.
In this month of the summer, during evenings
when lights come on after rain showers, there are new words
being born on the streets of our native cities.

Tell me about us. Will our meaning change
because those words will remain foreign to our memory?

Each time I drew breath today
I took your name but not once
the name of the new bomb called *bidesia*
that has come recently to my town from Calcutta.
There were ads for pressure-cookers when I left India
asking you how much you loved your wife.
In all these days, unknown to me and to you,
in so many different ways
new ads must be teaching people how to love.

Standing on the roof of your home,
looking at the Empire State Building
lit up with the saffron, green, and white
of the Indian flag, you tell me of your love
for a woman during your undergraduate years.
On the streets of Lahore,
have they found a name
for lesbians—a name that you'd like?

I have lost India. You have lost Pakistan.
We are now citizens of General Electric.
In this country, there are no new words for exile.
And if you have nothing to sell,
you have nothing to say
that this, or that, is indeed you.

But I still want my words. I still want
to give back to you in the silence
that follows our love-making
the words I have gathered
from a part of your body that is dark
like monsoon clouds in July.
The heavy words, like gold coins,
that I can bite with my teeth,
the familiar ones that the vegetable seller
returns to me like small change.
Words, numerous and glittering, drawn like
shiny fish in nets by men with darkened skins.
Words that swing like the new cricket
ball on the pitch surrounded by the hills of Peshawar.
Those words that the women burn in their fires
to keep hearts from shutting with malice.
Words that repeat themselves like the music
in the wheel of the postman's bicycle.
Words that are secret, holding close a hidden love.

If there are no words like that, I want those essential few
that will say north, that will say south.

That will say past, that will say future.
That will say poor, poor, poor, poor.
That will say fight, fight, fight, fight.
That will say hope, hope, hope, hope, hope.

III.
When the parade comes down Madison Avenue
it is led by a man who made his fortune playing
the part of the poor in Bombay films.
By the time the lights came on
in the theater, he had succeeded
as the underworld king,
ready to buy the seaside
skyscraper during whose construction
his mother had carried bricks
on her head.

If I fight as hard to be poor as did Amitabh Bachchan,
I too will own a penthouse in Manhattan.

Among the thousands that stand on both sides of the street
there are grandmothers in saris
and an old man in an achkan suit
quiet in the shadow of the Citibank office.
At the corner of 32d St. and Madison,
we choose to stand with the South Asian lesbians and gays.
I stand close to a man, his bright eyes
are lined coal-black and his throat stitched
with ornate silver.

On one float passing by, a man leans
toward the crowd, his voice thick
like sandpaper on the microphone.
Kashmir Hindustan Ka, Nahin Kisi Ke Baap Ka.
"Kashmir is India's, Not your father's."
What would this man be doing during a riot?
Women, on hearing his voice
for the first time, outside their bedrooms
where they were hiding with their children,
would not know that it belonged to a face
that had sold them grains and ghee for over a year.
And was now in upstate New York handling real estate.

We caught a cab and the driver said he liked parades:
next Tuesday we are going on strike,
turning Broadway into a sea of yellow cabs.

In the East Village, there are Bangladeshi
restaurants that have names like "Indian Delight."

We stepped in one
where the Sikh playing the sitar
smiled at you through our dinner, Soraiya Hasan Ali.
At the next table, an older white man
asked the Bangla waiter if there was anything special
to celebrate the Indian independence. "No, sir," he apologized,
his thick glasses shining, "it is special here every day."

Whether it is because of poetry's affectation, an affectation that is traceable to the strains of Western romantic tradition, or whether it is because poetry everywhere must mourn the absence of the reader, especially if the reader is thought of in terms of a collective, whatever be the reason, it is true that the postcolonial poet speaks from—and even, sometimes, only about—the condition of solitude.

Maheshwar, a journalist and poet of the Indian People's Front, writes from his hospital bed just before his death: "My friends do not want to stick by my side / beyond the ritual exchanges about our well-being. / It is right at this point / that my loneliness descends / and like the dusk spreading in the sky / fills the corners and the insides of my brain. / This loneliness alone is my strength / in its womb / takes birth my desire to live. . . . // You will be finished— / you will be killed / because— / when did you learn in life / the politics of sharing with someone / someone's loneliness."

This is no ordinary loneliness, after all it insists on a shared condition. And there are always, in poets who are joined with what are prosaically called "broader struggles"—why not call one such "broad struggle," a friend writes, "a fist striking through the scrims of civic order?"—there are always in such poets other inflections, as when the Hindi poet Alokdhanwa laments: "It is not the government—it is this country's / cheapest cigarette that has kept me company." This is no ordinary loneliness because it will not go away with the arrival of a person, or a toy, or a park; it unequivocally demands a new and fair social order of living.

This writing finds its echo in the diaspora in the admirable, oppositional poetry of the Indian poet Ved Prakash Vatuk who, in his poem-letter to Clinton takes stock of each innocent killed by the imperialist-killing machine. And yet, here is his poignant lament as an immigrant in the U.S.: "To each community / I have become / nothing more / than a lost

part / of some other 'they.' / My home is a prison of time / the world my exile." Is this the most effective one available to us? Because, especially when repeated, it marks the poet as nevertheless solitary. I say this self-critically because I have found this also in my own poetry.

My point, therefore, is this: our South Asian writing in the diaspora must simultaneously invent and embrace its public. This has to be a writing against solitude. For this to happen, poetry will have to step into the world, become worldly, speak from everywhere—like a newspaper, like television, like a friend visiting your home. It will need to inaugurate another politics of affiliation. And disaffiliation. That is what Pash, the Communist poet from Punjab, had in mind when he wrote after the death of Sanjay Gandhi, or was it Indira Gandhi, or Rajiv Gandhi—and does it even matter?—"I have against whom all my life thought and written / if it is the sorrow for them that unites this country / then remove my name from this country. . . ."

Against the fatal virulence of the right, against some of the solemn pieties of the left, but resisting any equivalence between them, this writing must be one of a movement—both in the sense of an engagement with a mass, and hence one that is tested on the grounds of the communities it opens, engages, interrogates in dialogue, but also in the sense of mobility, and hence, a political aesthetics that has the swing, the agility, of history itself.

Selected Addresses of Immigrants' Support Groups and Other Immigrant Organizations

Apicha
Asian & Pacific Islander Coalition
 on HIV/AIDS INC.
275 Seventh Avenue, 12th Floor
New York, NY 10001–6708
(212) 620–7287

Arizona Border Rights
 Project/Derechos Humanos
631 S. 6th Ave.
Tucson, AZ 85701
(520) 770–1373

Center for Immigrant Rights
48 St. Mark's Place
New York, NY 10003
(212) 505–6890

Coalition for Humane Immigrant
 Rights of Los Angeles (CHIRLA)
1521 Wilshire Blvd.
Los Angeles, CA 90017
(213) 353–1345

Coalition for Justice in the
 Maquiladoras
(210) 732–8957

Forum of Indian Leftists (FOIL)
http://www.proxsa.org

Human Rights Watch
485 Fifth Avenue
New York, NY 10017
(212) 972–8400
hrwnyc@hrw.org

"Luchas Laborales," a comic book
 by and for immigrant workers.
 Discusses common abuses and
 ways to respond to them. $4 in
 Spanish or English. Write:
The Workplace Project
91 N. Franklin St., Suite 207
Hempstead, NY 11550
(516) 565–5377

New York Taxi Workers Alliance
122 West 27th St., 10th Floor
New York, NY 10001–6281
(212) 539–2628

SAKHI (for South Asian women
 facing domestic abuse)
P.O. Box 20208
Greeley Square Station
New York, NY 10001
(212) 695–5447
http://www.sakhi.com

South Asian Workers' Rights
 Project
http://www.nelp.org.sawrp.htm

South Asian Youth Action (SAYA!)
54–05 Seabury Street
Elmhurst, NY 11373
(718) 651–3484
sayany@worldnet.att.net

Support Committee for
 Maquiladora Workers
(619) 542–0826

La Resistencia
 in San Diego (619) 497–1035
 in Los Angeles (213) 227–4678
 in San Francisco (415) 487–5167
Houston National Office
P.O. Box 2823
Houston, TX 77252–2823
(713) 521–3099
Impacto 2000
Director: Hector Correan
http://www.serve.com/impacto
P.O. Box 4282
Whittier, CA 90607

National Network for Immigrant
 and Refugee Rights
310 8th St., Suite 307
Oakland, CA 94607
(510) 465–1984
http://www.nnirr.org

Naz Project
Palingswick House
241 King St.
London, W6 9LP, UK
(181) 563–0191

South Asian Lesbian & Gay Assoc.
 (SALGA)
P.O. Box 1491
Old Chelsea Station, NY 10113
(212) 358–5132
http://www.salganyc.org

Trikone Resources
P.O. Box 21354
San Jose, CA 95151–1354
(408) 270–8776
http://www.rahul.net/trikone/

Workers Awaaz
South Asian organization
 committed to fighting inhumane
 wages and poor working
 conditions.
(718) 707–9432

PREFACE

This book is a forged passport: the book's epigraph comes from Chandra Tal-pade Mohanty's essay "Defining Genealogies: Feminist Reflections on Being South Asian in North America," in *Our Feet Walk the Sky: Women of the South Asian Diaspora*, ed. The Women of South Asian Descent Collective (San Francisco: Aunt Lute Books, 1993).

Starting in 1830 Indian workers: a comprehensive account of early immigration to the U.S. from India, and the history of the Ghadar Party, is available in Joan M. Jensen, *Passage from India: Asian Indian Immigrants in North America* (New Haven: Yale University Press, 1988); **"duty bound to take part":** for the quote from the Ghadar Party manifesto, I have relied on Jan Myrdal, *India Waits* (Chicago: Lake View Press, 1980).

"immigritude": my use of the word draws on the coinage, albeit more critical, by Vivek Dhareshwar, "Toward a Narrative Epistemology of the Postcolonial Predicament," *Inscriptions* 5 (1989); **"Chaat organizers":** its website address is <http://www.chaat.org>.

Bombay, now called Mumbai: see Suketu Mehta's "Mumbai," photos Sebastião Salgado, *Granta* 57 (spring 1997).

Forum of Indian Leftists: FOIL's address is <http://www.proxsa.org>.

New World Border: documentary directed by Casey Peek (Rollin' Deep Production, 1997).

Richard Rodriguez: the quotes come from his article, "Illegal Immigrants: Prophets of a Borderless World," *Harper's Magazine*, April 1995.

INTRODUCTION: THE SHAME OF ARRIVAL

A book is a kind of passport: the chapter's epigraph comes from an essay on Günter Grass in Salman Rushdie, *Imaginary Homelands* (London: Granta, 1981). Other quotes from Rushdie in this chapter are also taken from the same essay.

T. M. Luhrmann: see *The Good Parsi: The Fate of a Colonial Elite in a Postcolonial Society* (Cambridge: Harvard University Press, 1996); **V. S. Naipaul:** his most relevant works are his *Area of Darkness* (New York: Macmillan, 1964) and *India: A Million Mutinies Now* (New York: Viking, 1990), although all quotes in this essay are taken only from the latter.

Ashis Nandy: *The Intimate Enemy: Loss and Recovery of Self under Colonialism* (Delhi: Oxford University Press, 1983).

I was living in a part of Brooklyn populated by Arab migrants: my critique of the media reportage on the Oklahoma bombing is indebted to *Extra!*, July–August 1995.

Naipaul's brief excavation of history: for a succinct introduction to subaltern studies historians, see Ranajit Guha and Gayatri Chakravorty Spivak, eds., *Selected Subaltern Studies* (New York: Oxford University Press, 1987).

In Amitav Ghosh's *In An Antique Land:* in addition to this book (London: Granta, 1992), I also cite his *The Shadow Lines* (New York: Penguin Books, 1988).

There is a danger here in migrancy: Aijaz Ahmad's remarks come from the chapter "Rushdie's Shame," in *In Theory: Classes, Nations, Literatures* (New York: Verso, 1992).

Mahasweta Devi: see *Imaginary Maps*, trans. and intro. Gayatri Chakravorty Spivak (New York: Routledge, 1995); the quote from **Rakim** comes via Paul Gilroy, "One nation under a groove," in *Small Acts* (London: Serpent's Tail, 1994).

LANGUAGE

Everytime I think: Sujata Bhatt, "Search for My Tongue," in *Brunizem* (Manchester: Carcanet Press, 1988).

Those of us who do use English: Salman Rushdie's essay "Imaginary Homelands," in *Imaginary Homelands* (London: Granta, 1981).

Guns N' Roses: the song's lyrics are taken from Nicolaus Mills, "Lifeboat Ethics and Immigration Fears," *Dissent* (winter 1996).

another grocery store, in the film *Falling Down:* for the dialogue transcript, I am indebted to Rita Chaudhry Sethi's essay "Smells Like Racism," in *The State of Asian American Racism: Activism and Resistance in the 1990s*, ed. Karin Aguilar-San Juan (Boston: South End Press, 1994).

Vincent Chin: my source for the details of Vincent Chin's murder as well as the auto companies is Ronald Takaki, *Strangers from a Different Shore: A History of Asian Americans* (Boston: Little, Brown, 1989); the reference to Takaki later in the chapter is also from this book.

the Swiss linguist Ferdinand de Saussure: on Saussure and his legacy in critical theory, see Catherine Belsey, *Critical Practice* (London: Methuen, 1980).

Abraham Verghese: see "The Cowpath to America," *The New Yorker*, June 23 and 30, 1997.

Americans learned recently: the news report is discussed in Patricia J. Williams, "Monica, the Musical," *The Nation*, February 23, 1998.

Salman Rushdie: "Good Advice Is Rarer than Rubies," in *East, West* (New York: Pantheon, 1994).

an epic poem: Krisantha Sri Bhaggiyadatta, "Aay Wha' Kinda Indian Arr U?" (Toronto: Up Press [Un]Ltd., 1997).

It was the British who: the politics of teaching in English in India is usefully discussed in Rajeswari Sunder Rajan, ed., *The Lie of the Land: English Literary Studies in India* (Oxford: Oxford University Press, 1992).

In Rushdie's novel: Salman Rushdie, *The Moor's Last Sigh* (New York: Pantheon, 1995).

another Third-World writer: Michelle Cliff, *Abeng* (New York: Dutton, 1984).

"When I first got to England": Stuart Hall, "The Local and the Global: Globalization and Ethnicity," in *Dangerous Liaisons: Gender, Nation and Postcolonial Perspectives,* ed. Anne McClintock, Aamir Mufti, and Ella Shohat (Minneapolis: University of Minnesota Press, 1997); my emphasis.

Sunil Khilnani points out: in *The Idea of India* (New York: Farrar, Straus and Giroux, 1997).

Upamanyu Chatterjee: *English, August* (London: Faber and Faber, 1988).

Lord Macaulay's Tail: see my work *No Tears for the N.R.I.* (Calcutta: Writers Workshop, 1997).

Shashi Tharoor: the quote comes from his essay "Scheduled Castes, Unscheduled Changes," in *India: From Midnight to the Millennium* (New York: Arcade Publishing, 1997); **Pankaj Mishra:** *Butter Chicken in Ludhiana* (New Delhi: Penguin Books, 1995).

Those men, although I did not know: see Salman Rushdie, *Midnight's Children* (New York: Penguin Books, 1980).

I leave the door open: see *No Tears for the N.R.I.*

"Say, did you ever watch *Saturday Night Live*": my reconstructed border patrol officer's view of the show benefits from Bill Carter's news obituary, "Michael O'Donoghue, 54, Dies: Writer for 'Saturday Night Live,'" *New York Times*, November 10, 1994.

If we were swapping stories: the details of Sprint's billing practices are taken from a report entitled "Double Billing," *The Nation*, May 25, 1998.

To cite a historical example: the discriminatory language test comes from Joan M. Jensen, *Passage from India: Asian Indian Immigrants in North America* (New Haven: Yale University Press, 1988).

a Texas judge ordered: see Sam Howe Verhovek, "Mother Scolded by Judge for Speaking in Spanish," *New York Times*, August 30, 1995.

More revealing of the ties: Alfred Arteaga, "An Other Tongue," in *An Other Tongue*, ed. Alfred Arteaga (Durham: Duke University Press, 1994).

They are ably assisted: the poem "I Love America" distributed by William J. Knight was reprinted in *Harper's Magazine*, November 1993.

Homi Bhabha: the quote appears in his essay "Unpacking My Library . . . Again," in *The Post-Colonial Question: Common Skies, Divided Horizons*, ed. Iain Chambers and Lidia Curti (New York: Routledge, 1996); for a report on **Fauziya Kasinga**, see Celia W. Dugger, "Woman's Plea for Asylum Puts Tribal Ritual on Trial," *New York Times*, April 15, 1996.

I brought two bags: an extract from my title poem in *No Tears for the N.R.I.*

Guillermo Gómez-Peña: two of his recent books are *Warrior for Gringostroika* (St. Paul: Graywolf Press, 1993) and *The New World Border* (San Francisco: City Lights, 1996); **What if the U.S. was Mexico?:** the Gómez-Peña poem is quoted from Jean-Luc Nancy, "Cut Throat Sun," trans. Lydie Moudileno, in *An Other Tongue*, ed. Alfred Arteaga (Durham: Duke University Press, 1994).

PHOTOGRAPH

Wait a minute!: this epigraph comes from A. K. Ramanujan, "Annayya's Anthropology," in *From Cauvery to Godavari: Modern Kannada Short Stories*, ed. Ramachandra Sharma, trans. Narayan Hegde (New Delhi: Penguin Books, 1991); later quotes from Ramanujan in this chapter are from the same source.

The woman in these images: I photographed the protester in 1991 outside the Indian Supreme Court in New Delhi, during a meeting called to draw attention to the state's and Union Carbide's broken promises stemming from the 1984 Union Carbide gas leak in Bhopal. What made the protest especially significant was the identity of those who called the meeting: women, most of them affected by the gas, who formed a grassroots organization—the Bhopal Gas Peedith Mahila Udyog Sanghatan (Bhopal gas-affected women's trade union)—to press the group's unmet demands and fight against continuing apathy and victimization.

shooting at the Empire State Building: my commentary is based on the following news reports: Robert D. McFadden, "Gunman Fires on Tourists at Empire State Building," *New York Times*, February 24, 1997; N. R. Kleinfield, "A Move to America Ended in Outrage at Financial Ruin," *New York Times*, February 24, 1997.

A Foreigner Carrying in the Crook: see this work of poetry by Edmond Jabès, trans. Rosmarie Waldrop (Hanover: Wesleyan University Press, 1993).

I have looked at the newspaper: the photo I discuss comes from the *New York Times*, February 25, 1997.

Yehuda Amichai: the quotes from his poems come taken from Carolyn Forché, ed., *Against Forgetting: Twentieth-Century Poetry of Witness* (New York: W. W. Norton, 1993).

If we are so inclined: the eyewitness quotes are taken from Frank Bruni, "Rock Band's Promise Was Bright Until Gunman Shattered Their Hope," *New York Times*, February 25, 1997.

"Despair is still": the quote from Adonis also comes from Forché, ed., *Against Forgetting.*

Amiri Baraka: see *The Dutchman and the Slave* (New York: Morrow, 1964).

Claudine K. Brown's essay: "Mug Shot: Suspicious Person," in *Picturing Us: African American Identity in Photography,* ed. Deborah Willis (New York: New Press, 1994).

INS unveils: the news item appeared in *India Abroad*, May 1, 1998.

Chandra Talpade Mohanty: see "Defining Genealogies: Feminist Reflections on Being South Asian in North America," in *Our Feet Walk the Sky: Women of the South Asian Diaspora,* ed. The Women of South Asian Descent Collective (San Francisco: Aunt Lute Books, 1993).

Benedict Anderson: "Exodus," *Critical Inquiry* 20 (winter 1994).

John Tagg: the quotes in this chapter are taken from his essay "A Means of Surveillance: The Photograph as Evidence in Law" in *The Burden of Representation: Essays on Photographies and Histories* (Minneapolis: University of Minnesota Press, 1993).

Réda Bensmaïa: *The Year of Passages,* trans. Tom Conley (Minneapolis: University of Minnesota Press, 1995).

Jim Naureckas: "The Oklahoma City Bombing: The Jihad That Wasn't," *Extra!*, July–August 1995.

Here was an African American male: the statistics come from Mumia Abu-Jamal, *Live from Death Row* (New York: Addison-Wesley, 1995).

Victor Burgin: "Looking at Photographs," in *Thinking Photography,* ed. Victor Burgin (London: Macmillan, 1982).

Walter Benjamin: "The Author as Producer," in *Reflections,* trans. Edmund Jephcott (New York: Schocken Books, 1986).

Amitava Kumar: in my article from the *Star Tribune,* June 27, 1993, and also later in the chapter, the quotes from **Susan Sontag** come from her book *On Photography* (New York: Dell Publishing, 1973); also, in my *Star Tribune* article, the quote from **Alice Walker** is taken from her essay "In Search of Our Mothers' Gardens," in *In Search of Our Mothers' Gardens* (San Diego: Harcourt Brace Jovanovich, 1983).

John Berger: "Uses of Photography," in *About Looking* (New York: Pantheon, 1980).

on the seat beside me: I refer to Sam Sue, "Growing Up in Mississippi," in *Asian Americans: Oral Histories of First to Fourth Generation Americans from China, the Philippines, Japan, India, the Pacific Islands, Vietnam and Cambodia,* ed. Joann Faung Jean Lee (New York: The New Press, 1991).

I'm reminded of the story: Anton Shammas, "Amérka, Amérka: A Palestinian abroad in the Land of the Free," *Harper's Magazine,* February 1991.

Eugene Richards: *Below the Line: Living Poor in America* (New York: Consumers Union, 1987).

While writing of Palestinian lives: for a photographer's compassionate image of the "missing" Palestine, and for a sensitive commentary, see Edward W. Said, *After the Last Sky: Palestinian Lives,* photos Jean Mohr (New York: Pantheon Books, 1985).

postcolonial critic Gayatri Chakravorty Spivak: see her "Acting Bits, Identity Talk," *Critical Inquiry* 18 (summer 1992).

Martha Rosler: "in, around, and afterthoughts (on documentary photography)," in *The Contest of Meaning: Critical Histories of Photography,* ed. Richard Bolton (Cambridge, Mass.: M.I.T. Press).

the Brazilian photographer Sebastião Salgado: *Workers: An Archaeology of the Industrial Age* (New York: Aperture, 1993).

Roland Barthes: *Camera Lucida: Reflections on Photography,* trans. Richard Howard (New York: Hill and Wang, 1981).

In his riveting account: John Berger, *A Seventh Man: Migrant Workers in Europe,* photos Jean Mohr (New York: Viking, 1975).

Ross informs us: Andrew Ross, ed., *No Sweat: Fashion, Free Trade, and the Rights of Garment Workers* (New York: Verso, 1997); **Jacob Riis,** *How the Other Half Lives: Studies Among the Tenements of New York* (New York: Dover, 1971).

Richard Wright: *Twelve Million Black Voices,* photos Edwin Rosskam (New York: Thunder's Mouth Press, 1941).

This is a photograph: I took the sugarcane worker's photograph in a field near Port of Spain in February 1997.

NAME

Púchho tó, kiská hai yeh shav?: the epigraph's source is a Hindi poem, "Kashi Mein Shav," in *Magadh,* by Shrikant Verma (New Delhi: Rajkamal Prakashan, 1984); my translation.

V. S. Naipaul: "Prologue to an Autobiography," in *Finding the Center: Two Narratives* (New York: Alfred A. Knopf, 1984).

Fae Myenne Ng: *Bone* (New York: Harper Collins, 1993).

Paul C. P. Siu: *The Chinese Laundryman: A Study of Social Isolation,* ed. John Kuo Wei Tchen (New York: New York University Press, 1987).

Gauri Viswanathan: "The Naming of Yale College: British Imperialism and American Higher Education," in *Cultures of United States Imperialism,* ed. Amy Kaplan and Donald E. Pease (Durham: Duke University Press, 1993).

Gayatri Chakravorty Spivak: for her analysis of Hervey's writings, see "Can the Subaltern Speak?" in *Marxism and the Interpretation of Culture,* ed. Cary Nelson and Lawrence Grossberg (Urbana: University of Illinois Press, 1988).

When I come across the mention: the names are taken from Joan M. Jensen, *Passage from India: Asian Indian Immigrants in North America* (New Haven: Yale University Press, 1988).

Hanif Kureishi: *The Buddha of Suburbia* (London: Faber and Faber, 1990).

Michael Ondaatje: *The English Patient* (New York: Vintage, 1992).

as Spivak points out: Gayatri Chakravorty Spivak, interview with Alfred Arteaga, "Bonding in Difference," in *The Spivak Reader,* ed. Donna Landry and Gerald MacLean (New York: Routledge, 1996); my reference to the **Green Revolution** and its critique is indebted to Vandana Shiva, *The Violence of the Green Rev-*

olution: Ecological Degradation and Political Conflict in Punjab (Dehra Dun: Research Foundation for Science and Ecology, 1989); also see the section titled "The Green Revolution to Prevent a Red One," in *Agrarian Unrest and Socio-Economic Change in Bihar, 1900–1980,* by Arvind N. Das (New Delhi: Manohar Publications, 1983).

Shashi Tharoor has written an engaging account: see Shashi Tharoor, "Scheduled Castes, Unscheduled Changes," in *India: From Midnight to the Millennium* (New York: Arcade Publishing, 1997).

Riots in India: for the details of the Bhagalpur riots, I have relied on the Delhi People's Union for Democratic Rights Report, April 1990; see also Amitava Kumar, "In the Shadow of Death," *Indian Express Magazine*, September 2, 1990.

Rushdie: Salman Rushdie, *Midnight's Children* (New York: Penguin Books, 1980).

Arvind N. Das, *The Republic of Bihar* (New Delhi: Penguin Books, 1992).

Aadhi Zameen is published by All-India Progressive Women's Association (156, M.L.A. Flats, Birchand Patel Path, Patna 800 001, India).

"Beautiful Fair Convented": with minor changes, I reproduce the matrimonial ads from the pages of the *Times of India* (Patna edition) and *India Abroad*.

Your name is Pal, or Kal, or Dalal: my extract comes from the title poem in *No Tears for the N.R.I.* (Calcutta: Writers Workshop, 1997).

Hanif Kureishi: "We're Not Jews" is one of the stories in *Love in a Blue Time* (New York: Scribner, 1997); the quote from **Chandra Talpade Mohanty** is taken from her essay "Defining Genealogies: Feminist Reflections on Being South Asian in North America," in *Our Feet Walk the Sky: Women of the South Asian Diaspora,* ed. The Women of South Asian Descent Collective (San Francisco: Aunt Lute Books, 1993).

the French philosopher: Jean-Luc Nancy, "Cut Throat Sun," trans. Lydie Moudileno, in *An Other Tongue,* ed. Alfred Arteaga (Durham: Duke University Press, 1994).

This is a culture: my Buffalo Bill/diasporic multiculturalist warning is inspired chiefly, if not solely, by Gayatri Chakravorty Spivak, *Outside in the Teaching Machine* (New York: Routledge, 1993).

When I ask myself: see Amitava Kumar, "Conditions of Immigration," in *Whiteness: A Critical Reader,* ed. Mike Hill (New York: New York University Press, 1997).

The picture conjured in my mind: for a fine editorial commenting on the deputies' illegal acts, see Marc Cooper, "Border Beat," *The Nation*, April 29, 1996, and

for a more general coverage see David Cole, Leslie Marmon Silko, Elizabeth Kadetsky, and Peter Kwong's articles, *The Nation*, October 17, 1994.

Today you are wearing: the fragment of Evelyn Lau's poem "Crack" is published in *Premonitions: The Kaya Anthology of New Asian North American Poetry*, ed. Walter K. Lew (New York: Kaya, 1995).

In a suburban, American home: see my poem "Mistaken Identity," in *No Tears for the N.R.I.*

In present-day U.S.: Peter Brimelow, *Alien Nation* (New York: Random House, 1995); emphasis added by Brimelow to Contreras's original.

For a dissenting view: Julian L. Simon, *The Economic Consequences of Immigration* (Oxford: Basil Blackwell, 1989).

In fact, the gap between what is commonly believed: I don't really want to remind readers of a report from Leadership Education for Asian Pacifics explaining that fifteen of the most successful high-tech companies in the U.S. were founded by Asian-American immigrants and that they now have a combined revenue of $22.25 billion (reported in the on-line journal *India News Network Digest* 26, no. 817 [April 1996]). My point here isn't really to say, "look, immigration can also work for white America." Real education will begin when white America takes stock of its unequal gain from such phenomena as "brain drain" from the nations of the Third World, or its disproportionate share of savings from legal immigration: now immigrants pay $90 billion in taxes and get only $5 billion in services; **these facts cited in an article:** Priscilla Labovitz, "Immigration—Just the Facts," *New York Times*, March 25, 1996.

Farrukh Dhondy: *Bombay Duck* (London: Jonathan Cape, 1990).

PLACE OF BIRTH

Hamaar gaon hai ala babua: the epigraph's couplet by the Magahi poet Mathura Prasad Navin is quoted in Arvind N. Das, *The Republic of Bihar* (New Delhi: Penguin Books, 1992), but in my translation.

Naheed Islam: "Signs of Belonging," in *Contours of the Heart: South Asians Map North America*, ed. Sunaina Maira and R. Srikanth (New York: Asian American Writers' Workshop, 1996).

Salman Rushdie: *The Moor's Last Sigh* (New York: Pantheon, 1995).

Shashi Tharoor: "India at Forty Nine," in *India: From Midnight to the Millennium* (New York: Arcade Publishing, 1997); **the non-Indian's use of the word** para-

phrases a section of my review article "Catachresis is her middle name: the cautionary claims of Gayatri C. Spivak," *Cultural Studies* 11, no. 1 (January 1997).

My genealogy of "curry" is borrowed from **Ziauddin Sardar,** *Introducing Cultural Studies,* illustr. Borin Van Loon (New York: Totem Books, 1998), though unfortunately Sardar ignores the reality—full of multiple ironies—of Bengali restaurants in London situating their identities in an entirely different claim to geographic specificity: the menu in a restaurant on Brick Lane where I ate recently informed patrons that "Balti is a type of Kashmiri curry whose origins go back centuries in an area which is now North Pakistan called Baltistan." Some contend that the balti house actually originated in Sparkbrook in Birmingham.

The place where I come from: see my poem with this title in *No Tears for the N.R.I.* (Calcutta: Writers Workshop, 1997).

the poet Sarveshwar: from the title poem in Sarveshwar Dayal Saxena, *Kuano Nadi* (New Delhi: Rajkamal Prakashan, 1973); my translation.

"the people's poet," Nagarjuna: from the poem "Bhojpur" in *Nagarjuna: Pratinidhi Kavitayen* (New Delhi: Rajkamal Prakashan, 1984); my translation.

In 1986 a detailed document: *Report from the Flaming Fields of Bihar* (Prabodh Bhattacharya, 10B Radha Madhab Dutta Garden Lane, Calcutta 700 010).

Vinod Mishra: see Amitava Kumar, "The Specter of Europe Is Haunting the Third World," *The Collective Voice,* November–December 1991.

Alokdhanwa: for a longer version of this introduction to Alokdhanwa's poems, as well as translations of more of his poems from which some of the quoted phrases in this section of the book are drawn, see Amitava Kumar, "The Poet's Corpse in the Capitalist's Fish Tank," *Critical Inquiry* 23 (summer 1997).

"The real controller": see Marjorie Perloff, *Radical Artifice: Writing Poetry in the Age of Media* (Chicago: University of Chicago Press, 1991).

This is the twentieth April: in this poem the term *daroga* refers to a "head constable" and *godown* to a "warehouse."

A recent travelogue: Pankaj Mishra's *Butter Chicken in Ludhiana* (New Delhi: Penguin Books, 1995); the quote from the **Lonely Planet Publications** guidebook comes from Arvind N. Das, *The Republic of Bihar* (New Delhi: Penguin Books, 1992)—as do all other quotes in this chapter attributed to Das.

"There is no denying": Jan Myrdal, *India Waits* (Chicago: Lake View Press, 1980).

Chandrabhushan: from my interview with him in Ara, July 1996.

Kalyan Mukherjee and Manju Kala: "Bhojpur: The Long Struggle," in *Agrarian Relations in India,* ed. Arvind N. Das and V. Nilakant (New Delhi: Manohar Publications, 1979).

the Trinidadian Indian writer: for Naipaul's more recent report on Bihar, see William Dalrymple, "Caste Wars," *Granta* 57 (spring 1997); **His younger brother, Shiva:** Naipaul, "A Dying State," in *Beyond the Dragon's Mouth* (New York: Viking, 1984).

Bhuruth: the list of names is taken from Gerard Besson and Bridget Brereton, *The Book of Trinidad* (Port of Spain: Paria Publishing, 1992).

***Time* magazine writer:** see Pico Iyer, "The Soul of an Intercontinental Wanderer," *Harper's Magazine*, April 1993; also see Pico Iyer, *Tropical Classical: Essays from Several Directions* (New York: Alfred A. Knopf, 1997).

the Marxist writer: C. L. R. James, "A Study in Confidence," in *At the Rendezvous of Victory* (London: Allison and Busby, 1984).

In that area of darkness: Edward R. Gargan, "Shackled by Past, Racked by Unrest, India Lurches Toward Uncertain Future," *New York Times*, February 18, 1994.

I read the introduction: see Kenneth Vidia Parmasad, "The Changing Socio-Historical Context of Cultural Symbols in the Indian Community with Comparative Reference to the Bhojpur-speaking Region of India, 1845 to the Present" (Ph.D. dissertation, Jawaharlal Nehru University, New Delhi, 1993).

Derek Walcott: see Judy Raymond, "Rama Routs Ravana, Long Live Lord Rama," *Sunday (Trinidad) Express*, October 22, 1995.

In India the television version: for a detailed study of the epic phenomenon, see two articles in *Quarterly Review of Film and Video* 16, no. 1 (1995): Bhaskar Sarkar, "Epic (Mis)takes: Nation, Religion and Gender on Television," and Sujala Singh, "The Epic (On) Tube: Plumbing the Depths of History. A Paradigm for Viewing the TV Serialization of the *Mahabharata*."

the Marxist playwright: for a succinct presentation of Brecht's dramaturgy, see Walter Benjamin, "What Is Epic Theater?" in *Illuminations*, trans. Harry Zohn (New York: Schocken Books, 1969).

Among those who traveled: my travel advisory quotes the *Demerara Daily Chronicle*, December 22, 1899. The next photo comes from my short 1996 video, also titled *Travel Advisory*.

DATE OF BIRTH

The summer of 1947: the chapter's epigraph comes from Khushwant Singh, *A Train to Pakistan* (New York: Grove Press, 1956).

Arithmetic: readers of my poem (from "Translating Resistance," in *Articulating the Global and the Local*, ed. Ann Cvetkovich and Douglas Kellner [Boul-

der: Westview Press, 1997] might be unfamiliar with *mandir* (temple) and *kirtan* (singing of religious hymns), as well as Jagjiwannagar—the colony named after a famous politician from Bihar, Jagjiwan Ram, a member of an untouchable caste; Babasaheb Ambedkar—the most influential untouchable leader that India has produced to date and the architect of India's constitution; D-S4—a political organization of Dalits (or "downtrodden," the name adopted by the untouchables); Naxalbari and Srikakulam—legendary names in the postindependence movements of agrarian protest in India (see "Place of Birth").

Yeh daagh daagh ujaala: Faiz Ahmed Faiz, "The Dawn of Freedom (August 1947)" (in Agha Shahid Ali's splendid translation), *SAMAR* (winter 1997); see also Faiz Ahmed Faiz, *The Rebel's Silhouette*, trans. Agha Shahid Ali (Amherst: University of Massachusetts, 1995).

Anand Patwardhan: "Republic Day Charade," *Times of India*, January 25, 1997.

As a commentator pointed out: Pankaj Mishra, "A New, Nuclear India?" *New York Review of Books*, June 25, 1998.

those we might call "midnight's grandchildren": on the politics of protests against child labor, see FOIL pamphlet ser. 1 (series coordinator V. Prashad, 214 McCook Building, Trinity College, Hartford, CT 06106).

A remarkable document: Vasantha Kannabiran and K. Lalitha, "That Magic Time: Women in the Telengana People's Struggle," appears in *Recasting Women: Essays in Colonial History,* ed. Kumkum Sangari and Sudesh Vaid (New Delhi: Kali for Women, 1989); emphasis in original.

The term *postcolonial:* see Homi Bhabha's conference presentation in *Critical Fictions: The Politics of Imaginative Writing,* ed. Philomena Mariani (Seattle: Bay Press, 1991).

Limit Poem: this poem first appeared in *Rethinking Marxism* 3, no. 3–4 (fall–winter 1990).

Urvashi Butalia: see her memoir, "Blood," *Granta* 57 (spring 1997).

Saadat Hasan Manto: see Khalid Hasan's introduction to *Kingdom's End and Other Stories,* by Saadat Hasan Manto (London: Verso, 1987).

In a recent piece: Salman Rushdie, "Damme, This Is the Oriental Scene for You!" *The New Yorker*, June 23 and 30, 1997 (also published in Rushdie's introduction to *Mirrorwork: 50 Years of Indian Writing 1947–97,* ed. Salman Rushdie and Elizabeth West [New York: Henry Holt, 1997]).

I am half Hindu: the opening lines of Ajai Singh's poem "Desh Prem Ki Kavita Urf Saare Jahan Se Acchha," *Pahal* 55 (January–March 1997).

In several places like Vijaynagar: quoted in Amitava Kumar, "Names," *Critical Quarterly* 36, no. 2 (summer 1994).

Gyanendra Pandey: "In Defence of the Fragment: Writing about Hindu-Muslim Riots in India Today," *Economic and Political Weekly*, March 1991.

Rustom Bharucha: "Around Ayodhya: Aberrations, Enigmas, and Moments of Violence," *Third Text* 24 (autumn 1993); see Walter **Benjamin**'s "Theses on the Philosophy of History," in *Illuminations,* trans. Harry Zohn (New York: Schocken Books, 1969).

Changes: see *Contours of the Heart: South Asians Map North America,* ed. Sunaina Maira and R. Srikanth (New York: Asian American Writers' Workshop, 1996) (also published as "Tabdiliyan," trans. and intro. Neelabh, in *Samkaleen Janmat,* May 16–31, 1995).

A Final Note on Time: I adapt my critique, "The world we call America," *Gainesville (Florida) Sun,* September 7, 1996.

PROFESSION

Two books had recently appeared: Pankaj Mishra, *Butter Chicken in Ludhiana* (New Delhi: Penguin Books, 1995).

Khushwant Singh: *A Train to Pakistan* (New York: Grove Press, 1956).

Gauri Viswanathan: the long quote comes from her essay "English in a Literate Society," in *The Lie of the Land: English Literary Studies in India,* ed. Rajeswari Sunder Rajan (Delhi: Oxford University Press, 1992); see also the essays, in the same volume, by Sunder Rajan, "Fixing English: Nation, Language, Subject," and Suvir Kaul, "The Indian Academic and Resistance to Theory."

Ashis Nandy argues: this chapter's quotes of Nandy are, once again, from his book *The Intimate Enemy: Loss and Recovery of Self under Colonialism* (Delhi: Oxford University Press, 1983).

While I'm listening: Roque Dalton, "Recuerdo y Preguntas" (Memory and questions), in *Poemas Clandestinos* (Clandestine poems), trans. Jack Hirschman (San Francisco: Solidarity Publications, 1986).

One night my father telephoned me: in a longer and much different version, this section appeared in *Rethinking Marxism* 10, no. 3 (1998); the translation of **Maheshwar**'s poem "Atmalaap" (My soul's lament) is mine, and for more of his poetry, see Maheshwar, *Aadmi Ko Nirnayak Hona Chahiye* (You should be decisive) (Allahabad: Neelabh Prakashan, 1996).

And yes, in the end: the obituary was a part of a longer article, Amitava Kumar, "*1942: A Love Story* ké bahané Maheshwar ko yaad karté hué," (in memory of

Maheshwar, by way of *1942: A Love Story*) *Samkaleen Janmat*, October 16–31, 1994.

History: see Amitava Kumar, "Poems," *Rethinking Marxism* 1, no. 3 (1988).

N.R.I.: see my work *No Tears for the N.R.I.* (Calcutta: Writers Workshop, 1997).

Susan Buck-Morss: "Walter Benjamin—Revolutionary Writer," *New Left Review* 128 (July–August 1981) and 129 (September–October 1981).

The *Gainesville Iguana:* I adapted this section from my article "Performing at the Border," *Gainesville Iguana*, December 1993.

In an act reminiscent of George Bush's 1988 campaign: see this section's slightly altered form, "Translating Resistance," in *Articulating the Global and the Local,* ed. Ann Cvetkovich and Douglas Kellner (Boulder: Westview Press, 1997).

This stereotypical quotation: see Edward Said, *Covering Islam* (New York: Pantheon, 1981).

Gayatri Chakravorty Spivak: "Can the Subaltern Speak?" in *Marxism and the Interpretation of Culture,* ed. Cary Nelson and Lawrence Grossberg (Urbana: University of Illinois Press, 1988).

Primary Lessons in Political Economy: from *No Tears for the N.R.I.* (Calcutta: Writers Workshop, 1997).

Marcos is gay in San Francisco: see *Harper's Magazine*, April 1995. For the original, see *Shadows of Tender Fury: The Letters and Communiqués of Subcomandante Marcos and the Zapatista Army of National Liberation,* trans. Frank Bardacke, Leslie López, and the Watsonville, California, Human Rights Committee (New York: Monthly Review Press, 1995).

I was headed for the Omni Park Central Hotel: see my shorter version, "The MLA President's Column," in *Confessions of the Critics,* ed. H. Aram Veeser (New York: Routledge, 1996).

"the multifoliate": June Jordan, "Toward a Manifest New Destiny," *The Progressive*, February 1992.

Daphne Patai: "Minority Status and the Stigma of Surplus Visibility," *The Chronicle of Higher Education*, October 30, 1991; see **Frantz Fanon**, *Black Skin, White Masks* (New York: Grove Press, 1967).

my "skin is": the reference to George Lamming is a direct quote of one of his novels, *In the Castle of My Skin* (New York: McGraw-Hill, 1954).

I turn from the board: the lines come from my poem "So You Don't Understand Your Foreign T.A.?" (quoted in full in "Language"); also see Amitava Kumar,

"Brecht and His Friends: Writing as Critique," *Journal of Advanced Composition* 11 (fall 1991).

I. The cigarette smoke lingered: the full text of my "Poems for the I.N.S." appears in *Minnesota Review* 47 (1996).

NATIONALITY

Our tryst with destiny is complete: Shiv Vishvanathan, "Patriot Games," published in the Internet magazine *Chowk* (http://www.chowk.com/CivicCenter/svisvanathan_may1898.html). *Barfis* are Indian sweets.

"Douloti the Bountiful": in *Imaginary Maps,* by Mahasweta Devi, trans. Gayatri Chakravorty Spivak (New York: Routledge, 1995).

Committee for Initiative on Kashmir: see its study, *Kashmir Imprisoned: A Report* (New Delhi, 1990).

I visited Kashmir in July 1994: all the photographs from Kashmir come from in and around Srinagar, during that visit.

Salman Rushdie: "The Prophet's Hair," in *East, West* (New York: Pantheon, 1994).

Amitav Ghosh: see *Shadow Lines* (Delhi: Ravi Dayal Publisher, 1988).

In 1996 the film *Maachis:* I translate the militant leader's discourse from Hindi here and later in the chapter.

Arvind N. Das: see *Agrarian Unrest and Socio-Economic Change in Bihar, 1900–1980* (New Delhi: Manohar Publications, 1983).

Sumit Sarkar: *Modern India 1885–1947* (Delhi: Macmillan, 1983).

in and around the Telengana region: see discussion in "Date of Birth" of this struggle focused on the politics of gender.

as Arun Sinha writes: see the 1986 CPI (ML) document, *Report from the Flaming Fields of Bihar* (Prabodh Bhattacharya, 10B Radha Madhab Dutta Garden Lane, Calcutta 700 010).

Thus we come back: see quote in "Place of Birth" from the poet Alokdhanwa.

I saw them bury a dead child: I quote the fragment of Arrago's poetry from Mir Ali Raza, "Global Technoscapes and Unborn Voices: Gendering Globalization," *Sanskriti* 7, no. 1 (October 1996), and draw on Raza's article in the rest of this section (including his example of Medha Patkar's leadership).

Of 13,400 abortions: Shashi Tharoor, *India: From Midnight to the Millennium* (New York: Arcade Publishing, 1997).

Edward Goldsmith: see "Development as Colonialism," *The Ecologist* 27, no. 2 (March–April 1997).

Gopal Siwakoti: "Who Gives a Dam? Nepal, Technology and the World Bank," *SAMAR* (summer 1996).

the words of the masters of the game: see the quotes from Eugene Black and Nixon in Radhika Lal, "IMF, Capital and Us: The Economics of Imperialism," *Sanskriti* 7, no. 1 (October 1996).

For each group / I have become: Ved Prakash Vatuk, "Poems," *Naya Pratik*, December 1976; also see Vatuk, "Clinton Ke Naam," *SAMAR* (winter 1997); my translation of both fragments.

A poem written by Vatuk in memory: "Jab Kabhi" comes from his manuscript (my translation).

the writings satirized in Rushdie's novel: Salman Rushdie, *The Moor's Last Sigh* (New York: Pantheon, 1995).

And yet I hesitate: Kwame Anthony Appiah, "Is the Post- in Postmodernism the Post- in Postcolonial?" *Critical Inquiry* 17, no. 2 (winter 1991); for a taste of the debates in postcolonial theory, see *Public Culture* 6, no. 1 (fall 1993), a special issue devoted to the discussion of Aijaz Ahmad's powerful, though overly polemical, book, *In Theory: Classes, Nations, Literatures* (New York: Verso, 1992).

the 1978 Grunwick's strike: Kalpana Wilson, "The Experience of Asians in Britain," *Liberation*, February 1994; **Gayatri Gopinath**, "Notes on a Queer South Asian Planet," *Rungh* 3, no. 3 (1995).

the late poet of Punjab: Avtar Singh Pash's poem "Apni Surakhsa Se" was published in *Samkaleen Lokyudh*, 1–15 June, 1998; my translation.

In front of the immigration officer: see Arundhati Roy, "The End of Imagination," *Frontline* (August 1–14, 1998; reprinted in *The Nation*, September 28, 1998). To add detail to Roy's remarks, a recent editorial in an Indian leftist publication brings news of the nuclear tests' "hidden victims": poor tribal villagers at the uranium mining facility in Jadugoda, in Bihar, are sick and dying—fifty-three workers have died in the past three years, thirty-one others are suffering from radiation effects, and there are reports of the general incidence of leukemia and tuberculosis (see *Economic and Political Weekly*, September 5–11, 1998).

I remember Rushdie: Salman Rushdie, "Notes on Writing and the Nation," *Harper's Magazine*, September 1997.

SEX

When a lion emerges from the forest: Nizammudin Auliya, *Manushi*, nos. 50–52 (January–June 1989).

A few summers ago: see Sudhir Kakar, *Intimate Relations* (New York: Penguin Books, 1990).

Namdeo Dhasal: *Golpitha* (Pune: Nilkantha Prakashan, 1973).

Manda: the fragment from Dhasal's poem is taken from "Mandakini Patil: The Collage I Have in Mind," in *Modern Indian Poetry*, ed. Pritish Nandy, trans. Dilip Chitre (New Delhi: Arnold-Heinemann, 1974).

A different kind of discontinuity: Naipaul's account of his meeting with Dhasal comes from his *India: A Million Mutinies Now* (New York: Viking, 1990).

One of Dhasal's poems: for "What Grade Are You in, What Grade?" I have relied on Laurie Hovell's translation in her article, "Namdeo Dhasal: Poet and Panther," *Bulletin of Concerned Asian Scholars* 23, no. 2 (1991); for a general introduction to the Dalit movement, see Barbara R. Joshi, *Untouchable! Voices of the Dalit Liberation Movement* (New Delhi: Selectbook Service Syndicate, 1986).

women are clearly not even permitted institutional access: the Dalit woman in the photograph carries the burden of housework and child rearing, as well as taking care of the goats and chicken, while her husband migrates for several months each summer to Punjab to work as a day laborer.

the critical theorist Gayatri Chakravorty Spivak: see Howard Winant's interview, "Gayatri Spivak on the Politics of the Subaltern," *Socialist Review* 20, no. 3 (July–September 1990).

a goddess-centered religion: on the Devi movement and contemporary politics, see Gayatri Chakravorty Spivak, "Subaltern Studies: Deconstructing Historiography," in *Subaltern Studies*, ed. Ranajit Guha, vol. 4 (Delhi: Oxford University Press, 1985).

the case of Mira: see Parita Mukta, "Mirabai in Rajasthan," *Manushi*, nos. 50–52 (January–June 1989); for her more elaborate study on Mirabai, see *Upholding the Common Life: The Community of Mirabai* (Delhi: Oxford University Press, 1994).

Ten Steps to Burning: to quote from the extended caption that accompanied this photograph in one of its publications, "When Deviji, the wife of popular, illiterate poet Akariji, died, the leftist activists there (in a village near Ara, in eastern India) decided that instead of a funeral ceremony with food for the Brahmins, the villagers would be urged to participate in a *shokh sabha*, a condolence meeting to honor the memory of the dead comrade. The meeting, the first of its type organized in the village, was an attack on a traditional, exploitative custom; the mourners gathered there saw the virtue of not borrowing money—money that wasn't there for medicines for the dying woman—to appease the stomachs and the souls of the lordly Brahmins" (Amitava Kumar, "Mixed Reviews: Two Collections of Short Stories by Indian Women, Two Images, and a Recoding of

a Broken Conversation between History's Divided Subject," *College Literature* 21, no. 2 [June 1994]).

In such cases, she asks: see Robert Stam, "Eurocentrism, Afrocentrism, Polycentrism: Theories of Third Cinema," *Quarterly Review of Film & Video* 13, nos. 1–3 (1991).

I notice in your questions: Gayatri Chakravorty Spivak, interview with Rashmi Bhatnagar, Lola Chatterjee, and Rajeswari Sundar Rajan, "The Post-colonial Critic," in *The Post-colonial Critic: Interviews, Strategies, Dialogues,* ed. Sarah Harasym (New York: Routledge, 1990).

In her sensitive review: see Lata Mani, "Gender, Class and Cultural Conflict: Indu Krishnan's *Knowing Her Place,*" in *Our Feet Walk the Sky: Women of the South Asian Diaspora,* ed. The Women of the South Asian Descent Collective (San Francisco: Aunt Lute Books, 1993).

I work as the media coordinator: the group is Forum of Indian Leftists and its address is <http://www.proxsa.org>; among others, see an article by **John F. Burns,** "India's Muslims Frightened by Rising Hindu Tide," *New York Times,* February 20, 1998.

Sitting in a Florida movie theater: this section is a slightly altered version of Amitava Kumar, "It's a love triangle," *India Abroad,* June 20, 1997 (also printed in *Gainesville [Florida] Sun,* May 24, 1997).

While being served Nair's rich and utterly banal feast: this section is a slightly altered version of Amitava Kumar, "Romance with Kama Sutra," *Economic and Political Weekly,* May 17–24, 1997.

As I watched *Kama Sutra:* see Pankaj Mishra's travelogue, *Butter Chicken in Ludhiana* (New Delhi: Penguin Books, 1995).

late Hindi poet Dushyant Kumar: *Yahaan Darakhton Ke Saaye Mein Dhoop Lagti Hai* (New Delhi: Radhakrishna Prakashan, 1975); my translation.

Quite recently I read a news report: Krishna Kumar, "Women as Protesters: Repression in the Narmada Valley," *The Times of India,* 24 July 1998.

the poet Alokdhanwa: quoted in Amitava Kumar, "The Poet's Corpse in the Capitalist's Fish-Tank," *Critical Inquiry* 23 (summer 1997).

Robert I. Friedman: "India's Shame," *The Nation,* April 8, 1996; the responses to this article's reports—including a collective letter signed by thirty-five South Asians and endorsed by groups like Sakhi for Women—were published in a subsequent issue of *The Nation,* June 24, 1996; for a radical presentation of the struggles for women's rights, including organizational advances made by South Asian women in the U.S., see Sonia Shah, ed., *Dragon Ladies: Asian American Feminists Breathe Fire* (Boston: South End Press, 1997).

In a short story: see Chitra Banerjee Divakaruni, *Arranged Marriage* (New York: Doubleday, 1995); it is worth mentioning here that in the Western imaginary, the motif of the arranged marriage closely competes with those of burning women and the begging bowl to typify India. A recent three-part documentary on immigrants in the U.S. in the *New York Times* devoted one whole part on Indian immigrants and arranged marriages (Celia W. Dugger, "In India, an Arranged Marriage of 2 Worlds," *New York Times*, July 20, 1998); see report in *Business Week*, November 8, 1993. See also Madhu Kishwar, "The Continuing Deficit of Women in India and the Impact of Amniocentesis," in *Man-made Women: How New Reproductive Technologies Affect Women,* ed. H. B. Holmes and B. B. Hoskins (Bloomington: Indiana University Press, 1987).

the film theorist E. Ann Kaplan: *Looking for the Other: Feminism, Film and the Imperial Gaze* (New York: Routledge, 1997).

This film, its Indian-Canadian filmmaker said: see Bapsi Sidhwa, interview with Deepa Mehta, "Playing With Fire," *Ms. Magazine,* November–December 1997; Ginu Kamani, "Burning Bright: A Conversation with Deepa Mehta about *Fire,*" *Trikone Magazine,* October 1997.

We get help from Spivak: Gayatri Chakravorty Spivak, "Sammy and Rosie Get Laid," in *Outside in the Teaching Machine* (New York: Routledge, 1993).

Arjun Appadurai notes: *Modernity at Large* (Minneapolis: University of Minnesota Press, 1997); elaborating this argument, Appadurai suggests that the critical exploration of modernity addresses global cultural flows in the form of ethnoscapes, mediascapes, technoscapes, financescapes, and ideoscapes.

There is some truth to the remark: the quote about the Indian filmviewer appears in Pico Iyer, *Video Night in Kathmandu* (New York: Vintage, 1988).

IDENTIFYING MARKS

A brown leaf on his black back: Arundhati Roy, *The God of Small Things* (New York: Random House, 1997).

The feet of a landless worker: I took this photograph of a worker from Yadavpur in 1996. During my childhood, on visits to my ancestral village there, I remember poor men and women pouring kerosene into the cuts in their feet. They said it was water that had caused the deep ruts in their unprotected skin. Actually, more often, their feet had cracked from dryness. But their remedy was not entirely misplaced. Their skin needed oil, but kerosene was all they could afford.

Saint Nihal Singh: see his 1909 comments, "The Picturesque Immigrant from India's Coral Strand," quoted in Ronald Takaki, *Strangers from a Different Shore: A History of Asian Americans* (Boston: Little, Brown, 1989).

Using the work: see Lisa Lowe, *Immigrant Acts* (Durham: Duke University Press, 1996).

In the U.S. context, however: for a fine analysis of the anti-black racism among Indians, see Vijay Prashad, *The Karma of Brown Folk* (University of Minnesota Press, forthcoming).

"Where shall we look": the quote from Takaki is in *Strangers from a Different Shore*.

In the words of Shashi Tharoor: *India: From Midnight to Millennium* (New York: Arcade Publishing, 1997).

Today, according to the *Washington Post:* William Branigin, "Visa Program, High-Tech Workers Exploited, Critics Say Visa Program Brings Charges of Exploitation," *Washington Post*, July 26, 1998.

Among the most horrifying incidents: see Sumit Sarkar, *Modern India 1885–1947* (Delhi: Macmillan, 1983).

And this is why: the quote from Khwaja Ahmad Abbas and the following one come from Veena Das, *Critical Events* (Delhi: Oxford University Press, 1995).

Instead, what is common: see Farzand Ahmed, "A Macabre Ritual," *India Today*, July 31, 1991; Amnesty International India Report, 1991.

The enclosing silences can be seen: see Kalpana Wilson, "Arundhati Roy and the Left: For reclaiming 'small things,'" *Liberation*, January 1998; see Aijaz Ahmad, "Reading Arundhati Roy politically," *Frontline*, August 8, 1997; also see Amitava Kumar, "Rushdie's Children," *The Nation*, September 29, 1997.

the labor of producing speech or song as protest: I took the photograph of the woman protester, her face veiled in white paint, on the day after the first bombs were dropped on Iraq during the Persian Gulf War.

The Palestinian feminist writer: see Samira Haj, "Patriarchal Relations and Palestinian Women," working paper no. 7, The MacArthur Interdisciplinary Program, University of Minnesota.

Leila Sebbar: "Under the Veil," *Artforum*, January 1992.

A journalist's report concludes: see Jim Coffman, "Choosing the Veil," *Mother Jones*, November–December 1991.

In a letter published in *The Daily Alsafa News:* the fragment from the letter is taken from Committee for Initiative on Kashmir, *Kashmir Imprisoned: A Report* (New Delhi, 1990).

In the context of the Palestinian intifada: see Rema Hammani's "Women, the Hijab and the Intifada," *Middle East Report*, May–August 1990.

A critique of modernity: the quote from the Syrian woman is taken from Malu Halasa, "Beyond the Veil," *In These Times*, November 20–26, 1991.

Aicha, an Algerian woman: all quotations from the Algerian women are taken from Jim Coffman, "Choosing the Veil," *Mother Jones*, November–December 1991.

Trinh T. Minh-ha writes: see *When the Moon Waxes Red* (New York: Routledge, 1991).

One of the arguments: for a fine analysis (though at times it reads the veil only in unitary ways), see Fatima Mernissi, *Beyond the Veil* (Bloomington: Indiana University Press, 1987).

In April 1985: my discussion of the Shahbano case very closely relies on Zakia Pathak and Rajeswari Sunder Rajan, "Shahbano," *Signs* 14, no. 3 (spring 1989).

other women have pushed them toward a crisis: the women involved in this Bhopal grassroots movement (see "Photograph" note on the protest) had changed their status from victims to vocal activists. As Amrita Basu reports, these women were forging new solidarities across religious lines. Many of the Muslim women had given up purdah in the process of getting involved in the movement. One observer explained that "as women got used to being out in the streets for demonstrations, purdah didn't make sense to them anymore" (see Amrita Basu's two articles in *Bulletin of Concerned Asian Scholars* 26, nos. 1–2 [January–June 1994]: "Bhopal Revisited: The View from Below" and "Interview with Jabbar Khan").

Arun Sinha: *Against the Few* (London: Zed Books, 1991).

Anuradha Seth: "Who Gains from Economic Liberalization? Working-Class Households and the New Economic Policy," *SAMAR* (winter 1994).

In her address at the 1997 Conference: Vimal Ranadive, "Impact of New Economic Reforms and Working Women," in the Centre of Indian Trade Unions report on the 5th Conference of Working Women, Kochi, 1997.

Introducing a poem by Franco Fortini: see Lucien Rey's introduction in *New Left Review* 38 (1966).

CONCLUSION: FORMS OF DEPARTURE

Partition infiltrated into the South Asian imagination: Sunil Khilnani, *The Idea of India* (New York: Farrar, Straus and Giroux, 1997).

I was reminded of all this: Ernesto Cardenal, "The Parrots," in Cardenal, *Flights of Victory* (Willimantic: Curbstone Press, 1985).

A recent editorial: *Granta* 57 (spring 1997).

Looking through a U.S. magazine: Abraham Verghese's memoir and other references to *The New Yorker* are drawn from the magazine's special India Fiction double issue, June 23 and 30, 1997.

Several years ago, in the *New York Times*: on *Midnight's Children* and Ahmad's response, see Aijaz Ahmad, *In Theory: Classes, Nations, Literatures* (New York: Verso, 1992).

The North African writer Tahar Ben Jelloun: quoted in Winifred Woodhull, "Exile," *Yale French Studies* 82 (1993).

Pico Iyer: "The Soul of an Intercontinental Traveller," *Harper's Magazine*, April 1993.

There are other *forms* of departure: Edward Said, *After the Last Sky: Palestinian Lives*, photos Jean Mohr (New York: Pantheon Books, 1985).

We get a feel for this: Salman Rushdie, *The Moor's Last Sigh* (New York: Pantheon, 1995).

In this regard, if I understand: Lisa Lowe, *Immigrant Acts* (Durham: Duke University Press, 1996).

John Berger: *The Success and Failure of Picasso* (New York: Pantheon, 1965).

Our search, too: the fragment of Rashid Husayn's poetry is quoted in Khalid A. Sulaiman, *Palestine and Modern Arab Poetry* (London: Zed Books, 1984).

Hanif Kureishi's journal: "Some Time with Stephen: A Diary," in *Sammy and Rosie Get Laid* (New York: Penguin Books, 1988).

After all, it is Kureishi himself: see Hanif Kureishi, "Wild Women, Wild Men," *Granta* 39.

APPENDIX 1: AGAINST SOLITUDE

Whether it is because: first published in India in *Liberation*, April 1998.

Illustrations

CONCLUSION: FORMS OF DEPARTURE

Acknowledgments

This is a small book, but I'm indebted to a large number of people. A look at the illustrations list will reveal that I took the photographs in this book in five countries. My thanks to all those who so generously gave me opportunities to make pictures.

My students—their questions and concerns—provide the immediate motivation for the attempt at communication that this book represents. My debt to all the undergraduate and graduate scholars—too many to name here individually—who have enriched my classroom experience is immense.

Written over a period of the past several years, this book is a sum total of a variety of dialogues in diverse settings. I would be most remiss if I didn't thank my comrades—the late Maheshwar, Ramji Rai, Irfan, Chandrabhushan, Ajai Singh, Bhasha, Santosh Chandan, Alokdhanwa—at *Samkaleen Janmat* and *Liberation* for having given me an intellectual forum and, equally important, a political community.

In a slightly more personal sense, but in ways more generally relevant given the title of this book, I want to thank those friends, colleagues, and guiding spirits who wrote letters to the INS on my behalf and helped me secure a green card without which this book would not be what it is. Thank you, George Lipsitz, John Mowitt, Chris Anson, Daniel Cottom, Colin MacCabe, Greg Ulmer, and Gayatri Chakravorty Spivak.

Bruce Robbins was the first to read the whole manuscript, and my work has benefited from our shared interest in political aesthetics. Avery Gordon was very generous in her reading of the first draft, and she has left her identifying marks on this book. Michael Bérubé, friend and professional colleague, worked with me through the process of producing this work and I'm greatly indebted to him for inspiring me to retain a public voice in everything I do. I want to express my appreciation to Lisa Lowe as one of the readers for the University of California Press, who provided an encouraging (and elegant) orientational reading of issues of immigrant poetics and politics.

My fond fighting comrades from the Forum of Indian Leftists, Vijay Prashad, Gautam Premnath, Ali Mir, and Priya Gopal, read separate portions of the book and saved me from many errors. Ira Livingston read an early draft of the book

and responded with good advice and an earring. Thanks to Eleanor Zelliot and Laurie Hovell for making available to me the Namdeo Dhasal poems. Thanks also to Lelen Bourgoignie who provided access to a darkroom, photo paper, chemicals, and cigarettes.

For their early and consistent support of the project, I owe George Lipsitz and Henry Giroux several light-years of undocumented labor. For the final production of this book, I want to beam my coolest vibes to the ultraserene and efficient editor at University of California Press, Monica McCormick. For her gifts of precision and poetry, my special thanks to the book's copyeditor, Edith Gladstone. For her expert attention to all variety of detail, a warm note of thanks to the project editor for this book, Rachel Berchten, and also to the designer, Nola Burger, for enhancing my prose and photographs with more elegance than they deserve.

The work on this book was initiated when I was on a semester-long postdoctoral fellowship at the Humanities Institute at SUNY, Stony Brook. The project's completion was greatly aided by a summer research grant from the University of Florida. I also want to express my sincere gratitude to all my colleagues in the English department at the University of Florida for the enormous goodwill and professionalism shown by them during all my days here. Robert Ray, Norm Holland, and Mark Reid read my work and commented on it in detail. The outgoing chair, Ira Clark, deserves quick thanks for his fine and consistent display of non-psychotic behavior.

Warm thanks to Homeboy One, Arun Agrawal, who has been a patron and provider of both mundane and scholarly pleasures. Homeboy Two, Sanjeev Chatterjee, has been my collaborator on film projects and, in addition, makes a mean pure chutney.

H. Aram Veeser, Jeff Williams, and Mike Hill, apart from providing vital venues for my work, have been wonderful friends. I am fortunate to count among those who have been smart, supportive editors of my work: Ann Cvetkovich; Walter Lew; Sunaina Maira and Rajini Srikanth; all my comrades in the *Rethinking Marxism* editorial collective; Bino Realuyo; Deepika Bahri; David Siar; John and Sue Leonard at the *Nation*; the *SAMAR* collective; Umair Khan at *Chowk;* Hazel Waters at *Race and Class;* Achal Mehra, my main man at *Little India;* and my friends at *Himal.* I am greatly indebted to Mick Taussig, Abdul JanMohamed, Donna Landry, Gerald MacLean, Partha Chatterjee, Judith Halberstam, Tony Alessandrini, E. Ann Kaplan, Manoj Shrivastava, Fawzia Afzal-Khan, Tim Watson, Peter Hitchcock, and Ron Strickland who generously provided occasions for me to share my work at their institutions.

For academic and non-academic adventures in the social landscape, thanks to Andrew Ross, Wahneema Lubiano, George Yudicé, Rosemary Hennessy, Bob Holman, Agha Shahid Ali, Neil Larsen, Tim Brennan, Keya Ganguly, Barbara Foley, Mukul Sharma, Charu Gupta, Chris Newfield, Rachel Buff, Charlie Sugnet, Paula Rabinowitz, Andrew Parker, Laura Kipnis, Kamala Visweswaran, Pe-

ter McCauley, Subir Sinha, Tom Kenny, Maria Damon, Laura Schere, Animesh Shrivastava, Ved Vatuk, Ilan Kapoor, John Hutnyk, Fred Pfeil, and Janet Lyon.

Special thanks to dear friends Mona Ahmad Ali, Biju Mathew, Sangeeta Kamat, Raju Rajan, the DJs Siraiki and Rekha, as well as others in YSS, SALGA, and SAWCC in New York City; ditto to the organizers of Desh-Pardesh festival and my friends in Toronto, especially Saniya Ansari, Samir Gandesha, DJ Vash, and Ali Kazimi; *lal salaams* to the SASSY organizers in Boston, in particular Raju Sivasankaran, Aparna Sindhoor, Satish Kolluri, Sangeeta Rao, Jayanta Dey, and the ineffable Raza Mir.

My younger sister, Divya, has been a great friend and support. Fellow Non-Resident Indians, she and I came to this country and for long carried around— in our pockets and stuck among the pages of our books— passport photos of those we had left behind. I know Divya's story is different from mine; it is a reminder to me that where one story lives, there can always be two.

Index

Design:	Nola Burger
Composition:	Integrated Composition Systems
Text:	10/13 Sabon
Display:	Univers Condensed Bold
Printing and binding:	Thomson-Shore, Inc.